W9-DCD-108

The Paintings of Joan Mitchell

The Paintings of

Joan Mitchell

Jane Livingston

With essays by Linda Nochlin, Yvette Y. Lee, and Jane Livingston

Whitney Museum of American Art, New York
In association with
University of California Press
Berkeley • Los Angeles • London

This book was published on the occasion of the exhibition
The Paintings of Joan Mitchell
at the Whitney Museum of American Art, New York,
June 20–September 29, 2002.

Exhibition Itinerary:
Birmingham Museum of Art, Alabama
June 27–August 31, 2003
Modern Art Museum of Fort Worth, Texas
September 21, 2003–January 7, 2004
The Phillips Collection, Washington, D.C.
February 14–May 16, 2004

The Paintings of Joan Mitchell is supported by grants from
The Florence Gould Foundation and the National Endowment for
the Arts.

This accompanying catalogue was published with the support of
the Dedalus Foundation, Inc.

Research for Museum publications is supported by an endowment
established by The Andrew W. Mellon Foundation and other
generous donors.

A portion of the proceeds from the sale of this book benefits the
Whitney Museum of American Art and its programs.

Published by
Whitney Museum of American Art, New York
in association with
University of California Press
Berkeley and Los Angeles, California
and University of California Press, Ltd.
London, England

Library of Congress Cataloging-in-Publication Data

Livingston, Jane.
 The paintings of Joan Mitchell / essays by Linda Nochlin, Yvette Y. Lee, and Jane
Livingston.
 p. cm.
Catalog of an exhibition held at the Whitney Museum of American Art, New
York, June-Sep. 2002 and at three other institutions.
Includes bibliographical references and index.
 ISBN 0-520-23568-1 (cloth : alk. paper)—ISBN 0-520-23570-3 (pbk. : alk. paper)
 1. Mitchell, Joan, 1926—Exhibitions. 2. Abstract expressionism–United
States–Exhibitions. I. Mitchell, Joan, 1926- II. Nochlin, Linda. III. Lee, Yvette.
IV. Whitney Museum of American Art. V. Title.
 ND237.M58 A4 2002
 759.13–dc21

 2001058514

© 2002 Whitney Museum of American Art
945 Madison Avenue at 75th Street
New York, NY 10021
www.whitney.org

Printed in England
8 7 6 5 4 3 2 1

Cover: Joan Mitchell, *Untitled*, 1960 (detail). Oil on canvas, 78¾ x 69 in.
(200 x 175.3 cm). Estate of Joan Mitchell (pl. 22)
Title page: Joan Mitchell, *Untitled*, 1953–54 (detail). Oil on canvas, 81 x 69¼ in.
(205.7 x 175.9 cm). Estate of Joan Mitchell (pl. 4)
Pages 8 and 45: Joan Mitchell, *Two Pianos*, 1980 (detail). Oil on canvas, diptych,
110 x 142 in. (279.4 x 360.7 cm). Estate of Joan Mitchell (pl. 45)
Page 29: Joan Mitchell, *Untitled*, 1963 (detail). Oil on canvas, 108 x 79½ in.
(274.3 x 201.9 cm). Estate of Joan Mitchell (pl. 25)
Page 48: Joan Mitchell, *Untitled*, 1954 (detail). Oil on canvas, 96 x 77 in.
(243.8 x 195.6 cm). Estate of Joan Mitchell (pl. 5)
Pages 60 and 75: Joan Mitchell, *La Grande Vallée IX*, 1983–84 (detail).
Oil on canvas, diptych, 102⅜ x 102⅜ in. (260 x 260 cm). Fonds Régional d'Art
Contemporain de Haute-Normandie, Sotteville-lès-Rouen, France (pl. 49)

Contents

Joan Mitchell. Courtesy Robert Miller Gallery, New York

Foreword

The Whitney Museum of American Art has a long tradition of both discovering new talent and rediscovering neglected genius. In the case of the great American abstract painter Joan Mitchell, we are managing to do both. Mitchell's career had its vicissitudes; few American museums honored her fully during her lifetime. I am happy to say that the Whitney was her most important champion. In 1974 the Museum mounted the first American museum retrospective of her work, and we have acquired and shown other important works by Joan Mitchell in the decades since.

Partly owing to Mitchell's relocation to France, and partly because of the difficult fate shared by so many other "second-generation" Abstract Expressionists, her true contribution was never fully appreciated during her lifetime. Although she is a mythic character among artists and insiders, the public reputation she deserves has perhaps never been fully developed. I genuinely believe that the present exhibition of her work, spanning the years 1951 to 1992, will redress this situation.

As the contemporary art world has increasingly embraced both imagery and media far removed from past traditions in painting, some of us have forgotten the unique energy, courage, and passion of the American Abstract Expressionist phenomenon. In these first few years of a new century, a reassessment of this fairly recent achievement is becoming an urgent obligation for art historians and institutional interpreters. It may be that *The Paintings of Joan Mitchell* will be the first of many reviews of American painters from the 1950s, 1960s, and 1970s. If so, it is safe to predict that none will outstrip this exhibition's sheer excitement and quality.

The exhibition is supported by grants from The Florence Gould Foundation and the National Endowment for the Arts. The catalogue was published with the support of the Dedalus Foundation, Inc.

I would like to acknowledge the indispensable commitment of Jane Livingston in conceiving and executing this project. She worked hand in hand with Yvette Y. Lee, assistant curator for special projects; the two of them have been unstinting in their research and painstaking curatorial discrimination. The Whitney has been invaluably assisted by the Estate of Joan Mitchell, represented by John Somers. We are equally indebted to Mitchell's former dealers Robert and Betsy Miller, John Cheim, and Jean Fournier. We are all very grateful to those who have worked tirelessly to realize this important project.

Maxwell L. Anderson, *Alice Pratt Brown Director*

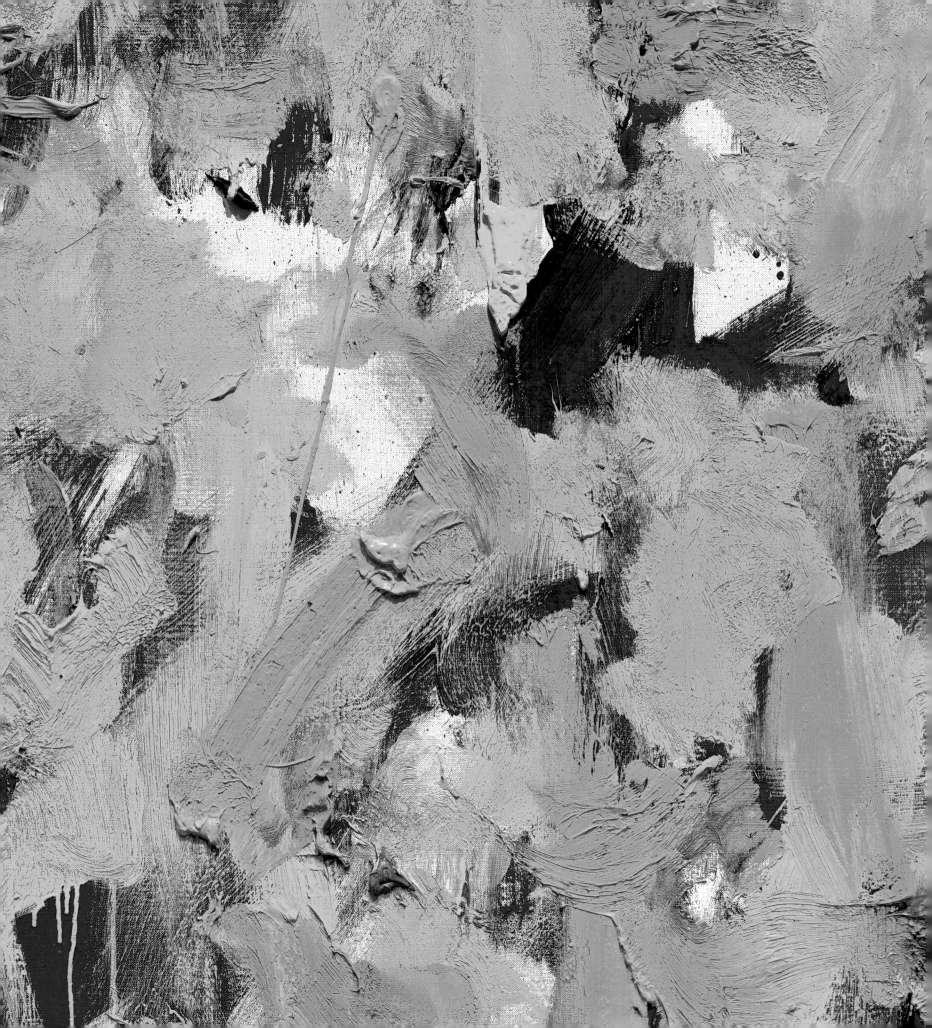

JANE LIVINGSTON

The Paintings of Joan Mitchell

My acquaintance with Joan Mitchell's art began dimly, in the way it probably did for any historian of modern art coming of age in the 1970s. My basic education had provided me with the received view of American Abstract Expressionism: there was a sort of pantheon, and one learned to revere it. Willem de Kooning, Arshile Gorky, Franz Kline, Jackson Pollock, and Mark Rothko reigned. Hans Hofmann was admired more as a teacher than a painter, but he was up there. Philip Guston could claim a big place; Barnett Newman and Ad Reinhardt occupied a spot slightly off-center. For me, as a Californian working as a curator at the Los Angeles County Museum of Art, certain figures loomed almost equally large because of their association with the West Coast scene, such as Clyfford Still, Bradley Walker Tomlin, Sam Francis, and Richard Diebenkorn. (The latter two were true California sons, and a little younger than the others, but they were among my early heroes.) Robert Motherwell's primacy as a thinker *and* painter, a catalytic presence, gave him a certain edge. People like Joan Mitchell were sort of lumped together with a whole lot of other important but less stellar painters like James Bishop, Robert Goodnough, Al Held, Alfred Leslie, David Park, Jack Tworkov, Jack Youngerman, and of course the women: Helen Frankenthaler, Grace Hartigan, and Lee Krasner. There were at least a dozen other real players. Along the way, I ended up working with some of these artists both in Los Angeles and Washington, D.C., installing major retrospectives of de Kooning, Motherwell, Reinhardt and other artists of the era, such as Guston and Adolph Gottlieb, coming to know a few of them, and organizing a definitive exhibition and catalogue on Richard Diebenkorn.

Mitchell's work did not truly engage me until I had abandoned Los Angeles for the East Coast in 1975. When I arrived at The Corcoran Gallery of Art in Washington, my focus shifted more toward New York and Europe. I began to notice Mitchell's exhibitions at the Xavier Fourcade Gallery on East Seventy-fifth Street, and to hear stories about her from my friends James Harithas and Norman Bluhm. I also began to wonder where she had been for my whole education in recent American art. What was the story with this utterly singular, sometimes over-the-top-baroque master of oil paint, who never seemed to achieve the reputation or exposure that she so plainly deserved? At first I came to believe—based on the innuendo I began to perceive about her idiosyncrasies, and the fact of her self-imposed exile from the

United States—that she simply chose to be carefully and rather narrowly exposed. She lived in France and showed up once in a while in New York or California, where her sister lived. According to my friends who knew her, she was scary and unpredictable and needed neither fame nor sales because she was rich. A few people thought she was still working at the top of her form; most emphatically did not. A few of her present or past close friends chose to say very little about the matter.

The more I saw of her work, the more I wondered why she was not more frequently equated with the best artists who occupied the second tier of Abstract Expressionist fame, let alone the members of the pantheon. I decided to find out more about her. Working with Xavier Fourcade, in 1981 I selected a group of her recent paintings to be shown at the Corcoran. Her appearance at the opening of that show was my first introduction to this remarkable woman, and frankly she frightened me. Though she seemed to accept and even like the installation I had devised for her five overscaled paintings, on opening night she complained to the press that "the way it was hung, everything canceled out everything else." It was more than a hint that any idiot could have done better. Somehow, as disconcerted as I was (I was standing right there when she talked to the *Washington Post* reporter), I managed to take it in stride.[1] That was my first lesson about Joan Mitchell. One needed to expect the unexpected, whether undermining or supportive.

I spent more time with her when her 1988 retrospective, organized by Cornell University's Herbert F. Johnson Museum of Art, launched its national tour at the Corcoran. Joan came to Washington for about a week in May 1988, accompanied as always by a number of dealers and friends. On that occasion I immersed myself in studying her work and came to know her better. While I was thrilled with the paintings I had to install in the Corcoran's enormous, sky-lit second-floor galleries, I was disturbed by what I thought was an uneven show. It was far too big, with too much emphasis on recent work. I learned that the artist herself had a hand in its selection, and as is not unusual in such circumstances, she simply could not edit out the works that had most recently come out of the studio. I made a private note that I would like to revisit this oeuvre one day and try to do it more justice.

Joan herself made a series of indelible impressions during her week in Washington—on me, on my staff, on the museum trustees and collectors who entertained her, and on the members of her entourage. That occasion provided an extraordinarily rich crop of gossipy encounters, outright insults, and clever comebacks that would become oft-repeated art world anecdotes. Some of them haunt me to this day. Mitchell was incorrigibly outspoken, unpredictable in her responses to virtually everyone and everything she saw on museum walls or in private collections, and truly unstoppable in her behavior. Though I was occasionally on the receiving end of one of her barbed comments, I nevertheless found myself fascinated by her, longing to know her better and somehow to gain her friendship or approval.

For better or worse, that never happened. Though she casually invited me to visit her home at Vétheuil, near Paris, I did not make it there until after her death. We never crossed paths again, and after a brief correspondence in 1988, the thread was broken. Now that I have reengaged with her career and her life, and now that I more fully appreciate the majesty of her talent and the force of will and energy she summoned to achieve her spectacular legacy, I regret more than ever not having known her better. Joan Mitchell was, among other things, a classic victim of her gender. Generally she dealt with that problem as though it was merely an annoying, temporary handicap. She fought through other obstacles—such as her intractable loneliness, depression, and alcoholism—to create the body of work whose presentation here may help to right the balance of our estimation of this great American painter.

Joan Mitchell was born on February 12, 1926, in Chicago, the second and last daughter of James Herbert Mitchell and Marion Strobel Mitchell. Mitchell's mother was socially prominent, the daughter of the engineer and entrepreneur Charles Louis Strobel, who, among other major accomplishments, was the structural engineer for the Chicago Stadium and the designer of a number of bridges, including some on the Chicago River. Charles Strobel's family immigrated to Cincinnati from Germany, where they had been in the toy-manufacturing business; Charles himself returned to Stuttgart to study engineering. His granddaughter Joan remembered studying his school notebooks from that era, which contained, she said, "Fabulous drawings of steel . . . bridges."[2] Bridges were to echo in Joan Mitchell's life and work from childhood on, appearing literally in one of the many gouache and

watercolor paintings she did in her student years, before she became an abstract painter (fig. 1). She seems to have liked and admired her maternal grandfather, who amassed a fortune in the same era as the Carnegies and Fricks, but whose ethical sense his granddaughter felt was far sterner than theirs. He would visit the family most Sundays, "wearing spats and a cane and morning coats—he was very shy, I guess. He never spoke—[but I knew] he liked me. I didn't speak either."[3] Charles Strobel died in 1935, when Joan was nine.

Marion Strobel (fig. 2) became less noted for her inherited wealth and distinguished lineage than for her role in coediting, with Harriet Monroe, *Poetry* magazine. *Poetry* had been founded in 1912 by Monroe (it continued until 1943) and was the first to publish the poems of Carl Sandburg, as well as the first American outlet to publish Ezra Pound and T. S. Eliot. Marion Strobel was also a serious if not widely known writer of poetry and prose; many of her short stories were published in popular magazines. She also wrote a number of plays, which she diligently sent to producers and directors. She was more successful as a fiction writer than as a playwright but seems to have worked at least as hard, and been perhaps most ambitious, in the latter genre.[4] Marion Strobel's literary accomplishments are all the more remarkable in light of her many years of deafness; she lost her hearing when Joan was a child. Later, though it was not often mentioned, Joan would make glancing references to this fact, as when she remarked that she "would have liked to share her silence." It is fair to say that except for adolescent friends, most of Mitchell's closest confidantes never knew of Marion's handicap. Mitchell described her mother as a "tender and sensitive companion."[5]

Thanks to Marion Strobel's consuming vocation, Joan and her older sister, Sally, were introduced at an early age to such figures as Edna St. Vincent Millay, Dylan Thomas, and Thornton Wilder, who Joan said used to read to her as a child. These artists and many others visited the family at their large, comfortable Chicago apartment overlooking Lake Michigan. Joan always characterized the house as full of books and literary people. The heyday of Marion Strobel's and Harriet Monroe's collaborative publishing career occurred well before Joan Mitchell was a mature artist herself. But as late as 1950 *Poetry* published a strange and radical text called "Projective Verse" by the poet Charles Olson, who became a seminal figure in the early development of such

1. Joan Mitchell, *Student gouache—Bridge*. Gouache on paper. Estate of Joan Mitchell

2. *Marion Strobel Mitchell*. Estate of Joan Mitchell

artists as Robert Rauschenberg and Cy Twombly through their shared experience at Black Mountain College in North Carolina. In this and myriad other ways, the web of associations that grew out of Marion Strobel's literary efforts continued to reach Mitchell, even if indirectly, for her whole life.

Mitchell's father, James Herbert Mitchell (fig. 3), was an eminent physician who had put himself through Rush Medical School at The University of Chicago by working in a pharmacy. He eventually attained the position of president of the American Dermatological Association and received many other professional accolades. Joan Mitchell related that her paternal grandparents died when James was "between four and six" and that he was brought up by an older sister. He married Marion Strobel when he was in his early forties. James Mitchell was a lifelong amateur artist. His portrait sketches of friends and colleagues were exhibited at The Arts Club of Chicago; they still exist in the mats made for that occasion. The little ink drawings are sketched rather casually, like notes to himself, on the backs of theater programs or meeting agendas. They capture their subjects economically but as concise, literal likenesses, having a faint quality of caricature (figs. 4 and 5). Yet James Mitchell's sharp attention to detail allowed him to capture his subjects' appearances, if not their personae. He depicted pianists, cellists, a vivid face positioned on a sheet at varying angles, individuals observed across an office desk, and colorful anonymous "types." Joan Mitchell has been quoted as characterizing her father's drawings as "rather like Toulouse Lautrec."[6]

Sally Mitchell (fig. 6)—the blond, pretty, and energetically social older sister—attended Chicago's "correct" Girls Latin School, where she was a schoolmate of Nancy Davis Reagan. Joan, by contrast, opted to spend all twelve years of her precollege education at the Francis W. Parker School, located next to Chicago's Lincoln Park, which she said was "progressive, not conventional, full of Jews—Chicago was very racist [at the time] and still is."[7] A fellow student at Francis Parker, Barney Rosset, later described Joan's demeanor at the school as "self-assured, defiant, aloof from the political ardors of the Parker School, and already working hard on her painting."[8] She took part in an experimental program that ended in 1942, the year she graduated, which expressly waived the College Board examination requirement for its students, working to place them in appropriate colleges and universities based on their performance strengths. She says, for example, that she did not study any mathematics but took a lot of Latin—a "very lopsided kind of education. Other people had only math."[9] Mitchell's first exhibition was at Francis Parker, where, at age twelve, she showed a group of casein paintings. In 1939 her painting teacher, Malcolm Hackett, introduced her to the work of Oskar Kokoschka, which struck her almost as hotly as had that of Vincent van Gogh, which she saw at The Art Institute of Chicago at a very early age, along with the work of Matisse, Cézanne, Manet and Goya, Titian and Chardin, Soutine and Kandinsky— all before 1942.[10]

In her childhood it was often her father who took Joan to visit art museums, as well as the zoo, which she adored and re-created in at least one childhood artwork (fig. 8). Later— partly at the urging, or at least Joan's sense of the urging, of her highly competitive father—she became a championship figure skater, a competitive diver, and an accomplished tennis player; at age thirteen she was Lake Forest's junior tennis champion. In 1941 she won the Midwest Junior Pairs Title in ice-skating with partner Bobby Specht, and in 1942 she attained fourth place in the Junior Women's Division of the U.S. Figure Skating Championships (fig. 7). According to more than one of Mitchell's intimate friends, she often talked about her father as the driving force behind her early competitiveness, wanting to please him, but also resenting his strict demands. She said that she decided to become a painter because it was an area in which her father could not compete with her; painting would "liberate her from the eye of her father."[11]

By the time of her graduation from Francis Parker, Mitchell's life ambition to paint was determined, at least in her own mind. But she says that her father felt that at sixteen she was "too young" to go to art school, so she applied to Bryn Mawr, Bennington, and Smith. "I wanted to go to Bennington, but [Father] said that was too arty. And Bryn Mawr I had seen and I thought that was death warmed over. So, since I'd never seen Smith and it was the biggest, I thought Smith. There were 2000 women. However, it was during the war, and so Smith had W.A.V.E.S in it, and Amherst had all the Navy groups. It was very, very much more mixed than it is now."[12] She majored in English, and an inspiring literature teacher, Helen Randall, reinforced her love of literature and poetry. It was Randall who introduced her to one of the poets of whom

3. *Joan and Dr. James Herbert Mitchell*. Estate of
Joan Mitchell

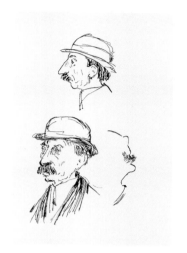

4 and 5. James Herbert Mitchell, *Ink drawings*.
Ink on paper. Estate of Joan Mitchell

6. *Sally and Joan Mitchell*. Estate of Joan Mitchell

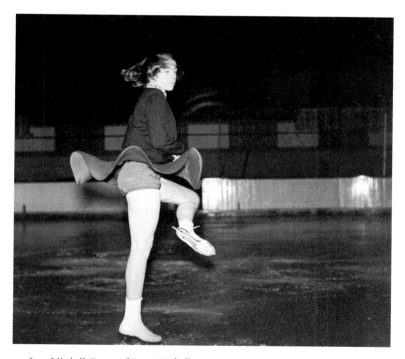

7. *Joan Mitchell*. Estate of Joan Mitchell

8. Joan Mitchell, *Childhood watercolor—Zoo*.
Watercolor on paper. Estate of Joan Mitchell

9. Joan Mitchell, *Student gouache—Yellow boats*,
c. 1942–43. Gouache on paper. Estate of Joan Mitchell

10. Joan Mitchell, *Student gouache*, c. 1942–43.
Gouache on paper. Estate of Joan Mitchell

11. *Joan Mitchell and Zuka Polansky*, c. 1945–46.
Courtesy Robert Miller Gallery, New York

she never tired, William Wordsworth. "I [remember that I] got a B-plus in art. There's a nice little museum there, and there was [a teacher named] Hyman George Cohen. I did watercolors out under the apple trees. [Rufino] Tamayo came and did a fresco in the art library. I watched."[13]

During the summers of 1942 and 1943 Mitchell visited Oxbow, an art colony in Saugatuck, Michigan, run by The Art Institute of Chicago. There she first worked in the medium of lithography and worked intensively out of doors, painting the landscape during the afternoons, drawing from life for six hours a day, and sometimes painting from life for three hours. A number of her early plein air landscapes survive; none has ever been shown or even framed (fig. 9). Some are extraordinarily original and beautiful, slightly reminiscent of such American watercolorists as Charles Burchfield. One of these landscapes includes a peculiar double stripe of color, yellow and pink, placed at the top of the tree-filled composition (fig. 10). It is just *put* there, seemingly as an afterthought. Yet it animates this little casual gouache. It certainly shows Mitchell experimenting with unexpected color combinations, prefiguring her later restless trial-and-error exploration of chromatic juxtapositions.

One of the teachers who encouraged her at the time of these paintings on paper was Louis Ritman, who had lived in Giverny, France, and painted there—"they had a lot of Impressionists who lived around there when Monet lived there"—before coming to Chicago. She said she "refused to draw hands the way he did." She also recalls Robert Von Neuman, "a German with a wooden leg that he lost in the First World War . . . a wonderful man, his etching sort of like Dürer, not avant-garde at all. . . . It was a very classic education, and I was trying to win a traveling fellowship, which I did. There were certain requirements like anatomy and art history."[14]

Some of the friendships that would endure for the rest of her life took root during those summers at Oxbow. For example, during the first summer she met Zuka Polansky (later to be Zuka Mitelberg), who had come from Los Angeles with Dan Lutz, her painting teacher at the University of Southern California, and who would become one of Mitchell's closest friends (fig. 11). Among her other fellow students at Oxbow or later at the Art Institute were Leon Golub, Ellen Lanyon, and Nancy Beauregard, who became another longtime friend.

The workshops at Saugatuck earned Mitchell credits at The Art Institute of Chicago, to which she transferred after her sophomore year. She entered the Art Institute in September 1944 as a second-year student on a full scholarship. From 1944 until June 1947 she immersed herself in a rigorous, classical fine art education, studying art history, figure drawing, anatomy, and printmaking. She spent long hours in the museum galleries, becoming intimately familiar with the collections. "[It] was the real inspiration, in a way," she recalled years later. "It was mostly the French that you looked toward, nineteenth and twentieth [century]. Manet, that lovely fish that I saw again in Paris [in 1982]. The Chester Dale collection, Picasso. *Guernica* was first shown there, in the back stairs, in 1938." Mitchell also remembered attending shows at The Arts Club of Chicago, where her father had shown years earlier, "a fancy society thing then," where she saw exhibitions of Brancusi and Braque. Among the many distinguished individuals Mitchell came to know in those years was the formidable critic and curator Katharine Kuh, of whom she said, "I was terrified of her and admired her immensely. I still do."[15]

During the summers of 1945 and 1946 Joan and Zuka traveled by train to Mexico City, settling in nearby Guanajuato to paint intensively. Zuka recalls that they carried "two bags of medications Joan's father made us take, including pills to sterilize water. Plus we had easels, art supplies, paint, turpentine. We traveled heavy." The two girls went to Mexico City expressly to meet José Clemente Orozco, who was "charming to us, though I don't know what he must have thought of these two American girls," and David Alfaro Siqueiros. During the course of these two summers, both young women took up with Mexican "boyfriends," according to Zuka, "hers a darling poet, small and blond, named Manuel de Escurdia, from Guanajuato. My boyfriend was a law student, Señor Olivares. Guanajuato had its university—a group of professors and students would meet in the center of town at 'el estudio.' The boys brought us there." Zuka pointedly noted Joan's competitiveness with her: "Joan had gone to Berlitz to study Spanish, but I was more talented at languages, and that used to bug her. . . . Even though she hated competition, she was the most competitive person I knew. She couldn't stand being at a dinner if she wasn't the most important person there. I was prettier, but men liked her better. Men always gravitated to her because she was daring and flirtatious."[16]

On graduating from the Art Institute in June 1947, with a bachelor of fine arts degree, Mitchell was awarded the Ryerson fellowship for travel and study abroad, which, for her, meant Europe. "[It] was $2000 [and we] were supposed to live a year on that."[17] But instead of going immediately to France, deterred by the difficulty of the postwar recovery there, she decided instead to go to New York.

During her years at Francis Parker, in the late 1930s, Mitchell knew Barney Rosset. They did not truly connect during their school years. After briefly attending the University of California, Los Angeles, where he went in 1941, Rosset joined the U.S. Army. After a stint in Officer's Candidate School, he was sent to a Signal Corps photographic school in Flushing, New York. He was stationed in both India and China, which he described as "arriving at the place where [I] could live out Edgar Snow's *Red Star over China* and André Malraux's *Man's Fate*." During these years Rosset learned the crafts of still photography and motion-picture making.[18] Upon his return to Chicago in 1946, he and Mitchell reconnected, establishing what quickly developed into a passionate love affair. Like Mitchell, Rosset came from a prominent Chicago family; he was the only child of an entrepreneurial Jewish banker (president of the Metropolitan Trust Company at the time of Mitchell and Rosset's relationship) and his Irish Catholic wife. And like Mitchell, Rosset had gravitated from an early age to literature, art, and the lifestyle of the avant-garde. By early 1947 he had moved to New York, where he was working on a film project called *Strange Victory*. He later described his ambition for the film: "[It would be] a reminder to victorious America that Hitler was still alive and well wherever bigotry persists, and that no victory could be claimed until racism and anti-Semitism were confronted at home."[19] Joan Mitchell's lifelong hatred of anti-Semitism and racism, and her occasionally voiced conviction that her parents were racist, was certainly among the many emotional and intellectual bonds between her and Barney Rosset.

Rosset rented an apartment at One Fulton Street, underneath the Brooklyn Bridge on the Brooklyn side, and the couple decided to live together. In a number of letters to Rosset written in February and March of 1947 from her parents' address, 1530 North State Parkway, Mitchell expressed her yearning for him, her general malaise, and her impatience with her life at home. "I think I've been mad at something or someone ever since you left," she wrote

on February 24, 1947. "I don't know—something violent is eating me and painting has been like walking up an escalator when it's going down—it's so easy to hate. You told me to be happy but B.R. isn't around and so there isn't any me to be happy with—the best is a kind of neutral condition that likes sun in the morning and there's no sun anyway."[20]

Finally, in December 1947, Mitchell went to New York and moved into the flat beneath the Brooklyn Bridge. The months in this intimate space with her passionate lover—during which she was first daring to plot her career as a professional painter, living through her first true independence from her family, and daily experiencing a closeness to a bridge and a river that would echo both backward and forward in her life and work—marked Mitchell's irreversible departure from home. Significantly, even during this period, when she seemed to combine personal intimacy and professional excitement, she evinced the strange aura of loneliness that would haunt her all her life.[21] She simply could not sustain either emotional closeness or domesticity for as long as both she and Barney would have liked. Rosset was as attached to the place under the bridge as he was to the woman with whom she shared it. He related to Richard Milazzo that this apartment was "in a rooming house with painters, actors and poets, who were attracted to that incredibly romantic spot. Over the years, I took Marguerite Duras, Samuel Beckett, Robbe-Grillet and many others back to this site."[22]

Like many other painters of her generation, Mitchell aspired to work with the famous teacher Hans Hofmann, but she attended only one of his classes: "I couldn't understand a word he said so I left, terrified."[23] But she clearly saw enough to be skeptical of Hofmann's teaching: "He was talking about the push and pull, and he was erasing people's drawings and saying: 'This goes this way.' The nude [model] was sitting there, and 'this angle is there and that angle is there,' he said. I could see that, but did I have to make that nude into that angle. . . . So, now I was sitting, watching Hofmann erasing drawings. They were only drawings, but I wondered why and why and why? But I liked his painting very much."[24]

Nineteen forty-seven was a crucial year in the education of Joan Mitchell. She saw exhibitions of work by Gorky and Pollock, she continued to study Kandinsky's early paintings, and she decided to go to Paris. In the spring of 1948 she sailed on a Liberty ship bound for Le Havre. It was a stormy and uncomfortable ten-day journey, and her arrival in Paris was somewhat traumatic owing to the recentness of the war and the lingering sense of both chaos and paralysis. Zuka had married the political cartoonist and refugee activist Louis Mitelberg, and Mitchell stayed with them in the Pigalle neighborhood until she located a primitive studio at 73, rue Galande, for which she paid four dollars per month rent. Located across the Seine from Notre Dame, overlooking the beautiful Romanesque church Saint Julien-le-Pauvre, this apartment afforded her a relatively spacious studio space and an unendurably smoky coal stove. Here Mitchell was still painting in a representational or figurative manner. She worked alone but occasionally saw such acquaintances as the artists Philip Guston and Herbert Katzman, who lived in the rue Galande building, as did the Mitelbergs. She worked so steadily in such cold conditions that eventually she ended up in the American Hospital with serious bronchitis; her doctors advised her to "go south for the winter."[25]

Rosset joined Mitchell at rue Galande; from Paris they traveled to Czechoslovakia, where Rosset managed to sell *Strange Victory*. They were offered the use of a villa in the South of France owned by their friends Sidney Simon and Joan Lewisohn Simon, and heeding Mitchell's doctor's advice, they immediately decided to relocate. They set up house and work at Le Lavandou, a resort on the Côte des Maures in Provence. "It was a wonderful house they had rented for all of $75 a year, and she [Joan Lewisohn] was having a baby, so she gave us the house. . . . So I spent [about six months] there." At Le Lavandou, Mitchell painted "expressionist landscapes, or boats on the beach or something like that. . . . Sort of going abstract . . . and Cézannish. . . . Moving cubistically . . . into abstraction. Sort of cubed-up landscapes."[26]

Among her Lavandou paintings was a singular work, now apparently lost, of bicycles in motion. It is somewhat reminiscent of Italian Futurism (fig. 12). Eventually Rosset persuaded Mitchell to return with him to New York. He recounts that "[I] got her to marry [me] by promising to somehow get the paintings from her studio in France back to the United States."[27] On September 10, 1949, shortly before sailing for New York from Cannes—bringing with them "all my French stretchers"—they were married in Le Lavandou.

Mitchell and Rosset stayed for a time at the Chelsea Hotel before renting a small space on West Eleventh Street in Greenwich

Village. With the exception of summer travels with Rosset to Haiti, Cuba, and the Yucatan, Mitchell focused on making a career as an abstract artist, in the center of its milieu. When she returned by herself from Mexico, she moved the Rosset-Mitchell quarters from Eleventh Street to West Ninth Street, helped by her new friends Paul Brach, Mike Goldberg, and Miriam Shapiro. She had met them at Stanley William Hayter's Atelier 17, the graphics studio where many artists of their circle worked at least once. They would become a kind of support system qua battleground for the next few years. It was in the unheated quarters above the living room of the Ninth Street apartment that Mitchell began seriously to expand the size of her paintings.

In the year 1950 Mitchell's true painting career commenced. Her experience as a struggling young artist in New York seems to have been unusually free of the anxieties and insecurities of the new émigré to the cultural capital of the United States. Determined to meet and get to know the artists she had admired from afar, she proceeded to do just that. She was of course financially independent. Yet she meticulously abjured the lifestyle she could have afforded. Indeed, for the rest of her life she lived modestly. Grace Hartigan commented that she was sometimes "made fun of for pretending to be poor."[28] Her financial security, though it inevitably gave her a certain confidence lacking in many of her peers, did not alleviate an underlying shyness and sense of separateness from them. Though she always seemed to know who her sources were, it must have taken a certain courage to actually meet her artistic heroes. She was especially interested in Gorky, and she soon became familiar with Pollock, though she never sought them out. De Kooning and Kline, however, became relatively close friends because of her determined initiative. She recalled that "everybody . . . when you were going 'modern,' [looked to] Picasso. I mean *everybody*. But I avoided that like the plague. I loved Picasso, but it just wasn't for me."[29]

By the look of Joan Mitchell's first mature canvases, it was Arshile Gorky more than any other artist whose vocabulary she adopted. We know that Mitchell saw the Gorky exhibition at the Whitney Museum of American Art in January–February 1951. *Cross Section of a Bridge* (1951; pl. 1), one of her first monumentally scaled and consciously heroic canvases, clearly adverts to some of Gorky's work of the mid- and late 1940s, while also referencing both earlier Cubism and Italian Futurism. Mitchell

12. *Joan Mitchell and Barney Rosset, Chicago,* 1949. Collection of Barney Rosset

mentioned having seen a major Matta exhibition in Paris; the 1951 paintings reflect both Matta and Gorky, embodying the only phase when Mitchell seems to have been acknowledging the many roots in Surrealism that so many of her peers took as a departure point. If one were to predict a career for this clearly precocious twenty-five-year-old painter based on such works as *Cross Section of a Bridge* and her untitled canvas of 1951 (pl. 2), most observers would place her closer to the dense, edge-filling, Cubist-Surrealist–derived style of Pollock, than to her more significant mentors, de Kooning and Kline.

But very soon, indeed by 1952, Mitchell began to reflect the less Cubist, more calligraphic and delicate side associated with Philip Guston and to assert her uniqueness vis-à-vis the rest of her immediate influences. By the mid-1950s de Kooning won out as a visible source of inspiration and competition. Returning to New York from France, Mitchell determined that she wanted to meet de Kooning and Kline. She recalled many years later that Kline's was the first studio (on Ninth Street) she found her way to and that it was an epiphany. "There were all these [black-and-white] Klines, unstretched, hanging on the brick walls. Beautiful. You know, with the telephone book drawings all over the floor, and Kline yakking away, and it was just, I was out of my mind!" Mitchell tracked down de Kooning at his Fourth Street studio, the beginning of a cordial friendship, and she solidified her relationship with Guston, moving easily into reciprocal studio visits. She soon became involved with the regular crowd at the Cedar Street Tavern on University Place and was invited to become involved in the Ninth Street Club (a.k.a. the Artists' Club, a.k.a. "The Club"), where, as "one of the very few women, I was included for $35 a year."[30] The Club held Wednesday evening discussion groups, which Mitchell regularly attended, sometimes doing her duty by volunteering to serve refreshments. It had been founded by Conrad Marca-Relli, Philip Pavia, de Kooning, Kline, and others.

Mitchell's rapidly burgeoning social life among the New York School painters, and her increasing seriousness about her own work, coincided with a gradual estrangement from Rosset. Although she and her friend Francine Felsenthal, a classmate at The Art Institute of Chicago, were instrumental in helping Rosset found his historic literary empire with the acquisition of Grove Press in 1951, and though she and Rosset would remain close

friends until her death, Mitchell's marriage to Rosset was essentially over well before their divorce in 1952.

By 1951 her immersion in her studio, and her rapid acceptance into the heart of the New York art world, led to an invitation to show in the seminal Ninth Street Show, organized by the Artists' Club and selected by the dealer Leo Castelli. Hartigan recalls having met Mitchell for the first time at this exhibition, in which they both participated. "I was living with Al Leslie on the Lower East Side. I thought I was the only woman on the scene—Lee [Krasner] was lying low because of [Pollock's] career. Elaine [de Kooning] at that point was Bill's disciple. And in comes Joan—and I've never heard anyone swear like that. Male or female."[31] The Ninth Street Show marked the beginning of an exhibiting career that thrived during the years Mitchell lived in New York. In 1952 she was given her first solo show at The New Gallery on West Forty-fourth Street, with a catalogue text written by Rosset's friend the art historian Nicolas Calas, and beginning in 1953 she had the first of seven one-person exhibitions at the Stable Gallery. This venue put her into a stellar, if not especially like-minded, company of artists, including Joseph Cornell and the very young Robert Rauschenberg.

In the spring of 1951 Mitchell had moved from the Ninth Street apartment into a studio at 51 West Tenth Street with "a coal stove, a bare place, and Guston lived above me. I knew him [from] when I lived in Paris."[32] Her friends Paul Brach and Miriam Shapiro had studios in the same building; Michael Goldberg was very much on the scene. Beginning sometime before the move to Ninth Street, and continuing until sometime in 1954, Mitchell and Goldberg more or less lived together, spending summer months together in the Springs, near East Hampton, Long Island, and seeing each other frequently in the city and elsewhere. As early as the summer of 1951 Mitchell and Rosset had been invited by Felsenthal to visit her small Macy's-purchased beach hut at Sammi's Beach, near Three Mile Harbor in East Hampton. This would be the initiation for both Rosset and Mitchell into many summers spent in this bastion of the New York art and literary circles. In the early 1950s Rosset paid $12,000 for a Quonset hut–inspired retreat designed by Pierre Chareau in 1947 for Robert Motherwell. Rosset lived there until 1982; Mitchell often visited the place in later years. But during the summer of 1954—when Mitchell, Goldberg, Brach, and Shapiro together rented "Rose Cottage," at Three Mile Harbor—Mitchell was intensely involved not with Rosset, but with Goldberg.

Hartigan believes that "one of Joan's most important relationships with a man was with Mike [Goldberg]. They were together when her art was being formed, and he had a big impact. Joan was smarter than Mike, but Mike was very instinctive. . . . Mike and Joan painted outside when they were in the Hamptons. Joan had George, the poodle, who she could never train. He ran around at Barnes Hole Beach, and was always out of control."[33]

Along with the creative, bucolic moments of the summer of Rose Cottage, however, the members of this ménage were forced to watch spectacles of violence that Mitchell seemed unable to escape in her relationships, with Goldberg and later with others. Indeed the tenor of that summer occasioned her psychiatrist and close friend, Edrita Fried, to advise her not to repeat such a communal arrangement. It would be largely thanks to Fried's advice that Mitchell traveled to Paris the next year. Despite the atmosphere of friction and excess that seemed to magnify when Mitchell summered in the Hamptons, her close contact with various members of the art and literary circles there led to many decisive long-term relationships, including those with the poets Frank O'Hara and John Ashbery; with Hal Fondren, who later worked at the Stable Gallery and other galleries; and with the writer Joe LeSueur.

In the early 1950s Mitchell's friendships with both Helen Frankenthaler and Jane Freilicher flourished in the environment of the Hamptons summers but failed to make the transatlantic cut that the others did. Mitchell's friendships with women developed most reliably when the women were not direct rivals. And the pattern established at that time of forming close (sometimes enduring) friendships with homosexual men remained with her to the end. Artists and writers attended one another's openings or readings. In 1956, when Sidney Janis organized a show in his New York gallery on Fifty-seventh Street called *4 Younger Americans: Paul Brach, Michael Goldberg, Robert Goodnough, Joan Mitchell*, the four painters helped one another to install the show and celebrated it together with other artist friends. Goldberg recalls that a painting of Mitchell's was badly damaged when it was being moved from a borrowed truck into the Janis Gallery and that he tried to repair it for her. It was eventually refused and a replacement found. She was moderately upset by the incident; he was excessively grateful for the opportunity to try to rescue the situation.[34]

Mitchell's fierce drive and ambition to make it as a painter

on her own terms may have been less psychologically certain in her early career than would appear evident from her style of living and her dedication to work. She had never earned a master of fine arts degree at The Art Institute of Chicago, and something in her, perhaps some insecurity about her future as a professional artist, warned her to keep her options open for a teaching position. Thus, in the summer of 1951 she studied French at New York University and took courses in northern Renaissance and nineteenth- and twentieth-century art at Columbia University. This commitment seems to have been paramount for a time. Yet, despite her good intentions, she never completed her requirements for the M.F.A., and as far as can be gleaned, she never looked back.

In 1952 Mitchell moved into a studio at 60 St. Mark's Place, which she would keep for much of the rest of her life, first using it as the venue for the creation of the most precocious canvases of any abstract painter's career. Later, after she'd moved to France, she often lent it to friends, occasionally returning to work there herself, and always regarding it as her main residence even when not visiting the place for years at a time. Few bodies of work in her career outpace the work done in this place between 1952 and 1958 for sheer energy, quantity, and finesse. This studio, though not enormous, afforded her the distance from the canvas that she always needed to do her best work. She was notoriously farsighted and would constantly back away from whatever she was working on, all the way to the wall. She would pause and look, long and hard. She never lost this habit, always organizing her studios so that she could work against one wall and observe her progress from against another wall. The St. Mark's Place studio had decent north light, not great light, but she may have adapted to this condition in a way that made it possible for her to work henceforth with a combination of artificial and natural luminosity. She began to paint at night, checking the results in the morning.

Her January–February 1952 exhibition at The New Gallery on Fifty-seventh Street marked Mitchell's true entry into the annals of American art history. *Cross Section of a Bridge* and the untitled canvas of 1951 were both included in that show, which received wide acclaim. Paul Brach reviewed the exhibition, saying:

> The debut of this young painter marks the appearance of a new personality in abstract painting. Miss Mitchell's huge canvases are post-Cubist in their precise articulation of spatial

intervals, yet they remain close in spirit to American abstract expressionism in their explosive impact. In *Cross Section of a Bridge*, the artist evokes Duchamp with tense tendons of perpetual energy. Movement is controlled about the periphery by large, slow-swinging planes of somber grays and greens. The tempo accelerates as the forms multiply. They gain in complexity and rush inward, setting up a wide arc-shaped chain reaction of spasmodic energies.

Writing much later, Mitchell's friend the critic Thomas Hess remarked that "one of the Abstract-Expressionist elders proclaimed ruefully that it had taken him eighteen years to get to where Joan Mitchell had arrived in as many months."[35]

"I don't remember selling anything [from that show]," Mitchell recalled, although this state of affairs would have been par for the course for this kind of an early abstract exhibition.[36] With hindsight, however, that body of work, for all its boldness and structural certainty, appears preparatory to what would come next, rather than definitively to mark Mitchell's first maturity. It would be in such paintings as *Rose Cottage* (1953; pl. 3) and the untitled canvases of 1953–54 and 1954 (pls. 4 and 5) that Mitchell's extraordinarily distinctive compositional, chromatic, and textural qualities began to show themselves. These works mark the beginning of that unique combination of bravura and delicate subtlety that would remain with the artist for the rest of her life. The 1953–54 painting shows Mitchell at the closest she ever came to emulating, or perhaps even foreshadowing, Guston's early mature style. This work deploys virtually the entire picture surface, right up to the edges, without relying on the centripetal or centrifugal compositions she would soon use almost exclusively until quite late in her career. It seems to be a conscious experiment in the use of closely valued and closely hued tonalities, creating a shimmering, allover yet intricately variegated composition that Mitchell showed she could pull off as well as anyone but that she decided not to develop. What she did continue to use in later paintings was her finely honed technique, perhaps first fully realized in this painting, of using gravity to create drips, or runs, of paint both to enliven and to anchor the pictorial space.

During the years 1955 to 1957 Mitchell consolidated both her painting expertise and her reputation. Two works of this period, *City Landscape* (1955; pl. 6) and *George Went Swimming at Barnes*

Hole, but It Got Too Cold (1957; pl. 12), have become especially iconic, one because of its evident ambition and repleteness, the other for its having been prominently written about in Irving Sandler's article, "Mitchell paints a picture," which appeared in *Art News* in October 1957. *George Went Swimming* is a painting that Mitchell began and finished in the St. Mark's Place studio after abandoning another picture, titled *Bridge*, which she had hoped would be the one featured in Sandler's article. Putting aside the first painting (only later to complete it), she got the idea for a painting that she said was inspired by "thoughts of George, a dog she once owned, on a memorable summer day spent swimming in East Hampton, Long Island. . . . [It] began as a lambent yellow painting, but during the second all-night session, the work changed. The lustrous yellows turned to opaque whites, and the feeling became bleak; therefore 'but It Got Too Cold.'"[37] (George was a black standard poodle, Mitchell's first dog [fig. 13]. Rosset had purchased George in Paris after their divorce, and given him to Mitchell, saying, "A Frenchman was coming."[38]) Sandler's added remarks about this painting, gleaned from his conversations with the artist, reveal many of the essential feelings, or emotional techniques, that she used during her entire career. "It seemed as if the hurricane that struck East Hampton in the autumn of 1954 invaded the picture. Since her early childhood lake storms have been a frightening symbol both of devastation and attraction, and the sense of tempestuous waters appears frequently in her work. Miss Mitchell painted four hurricane canvases based on this experience in 1954. *George* is a return to this series, the realization of what was attempted then."[39] Bridges, trees, and watery landscapes constitute themes to which Mitchell returned inexhaustibly, although never exclusively.

The sense of the city's different energy, its conflict and jarringness and necessity, inform *City Landscape* as few other paintings in Mitchell's oeuvre. This picture and *Hudson River Day Line* (1955; pl. 7) introduce a new structure to the painter's arsenal; now Mitchell was clearly withdrawing from the allover approach with which she had experimented but which she, like de Kooning, found constricting. Sometimes—as with *King of Spades* (1956; pl. 9), *Evenings on Seventy-third Street* (1956–57; pl. 11), or *Ladybug* (1957; pl. 13)—she returned forcefully to a nearly edge-reaching overall drive with her brushwork. *Evenings on Seventy-third Street* is one of the most "classical" of Mitchell's mature early

works; it is clearly a piece that takes cognizance not only of de Kooning and Kline but of other contemporaries as well, such as Tworkov. *Ladybug*, in its exaggerated horizontality and startlingly architectonic character—it is as though its creator was constructing a bridge or something else that must not fall apart—is one of Mitchell's most audacious works. Yet the fundamental centripetalism of the slightly earlier *Hudson River Day Line* and *City Landscape* signal an even more important fact about the vocabulary Mitchell would employ for the rest of her career: she often needed the old-fashioned "figure-ground" convention, for passages to emerge from another space, or for the sides and edges of the canvas to support internal activity as though acting like sky around clouds.

One of the great syntheses between the two modes—figure-ground and a muscularly balanced armature of painting structure—would be achieved in *Hemlock* (1956; pl. 8). This work prefigures the specifically referenced tree or landscape compositions of later years, while belonging firmly within the most maturely resolved style of Mitchell's high Abstract Expressionist period. Mitchell would continue to alternate between these two different ways of composing—centripetal versus allover. Sometimes, as in the so-called Black Paintings or the "Calvi"-style works of the 1960s, she accentuated rather than integrated the figure-ground underpinning.

Although most of her fellow painters felt that Mitchell's best work of the 1950s established a new high mark in Abstract Expressionist painting, there were demurrers. Hartigan, for instance, recently commented that "[At first] she didn't *get* the point of Abstract Expressionism. Those early paintings are very *conceived*, very placed. [But] Joan finally got it. In a way that, for instance, her friend Norman Bluhm never did. He was bravura."[40] And despite the generally favorable reviews from these years, Mitchell did not receive the *quantity* of press that others in her circle did, nor did she win the all-important support of museum curators such as The Museum of Modern Art's Dorothy Miller, or of critics such as Clement Greenberg.

Mitchell's trip to France in the summer of 1955 proved fateful for her future. Her friends Zuka Mitelberg and the American painter Shirley Jaffe had settled in Paris, and artists such as Norman Bluhm, Sam Francis, Paul Jenkins, Kimber Smith, and Saul Steinberg all lived there much of the time; many considered

13. Barney Rosset, *Joan Mitchell and her dog George, East Hampton*, c. 1952. Collection of Barney Rosset

14. *Jean-Paul Riopelle*. Estate of Joan
Mitchell

expatriating themselves from the United States. On this trip
Mitchell took a studio in the rue Jacob; later she moved to a place
in the rue Daguerre, working in a studio in the rue Decrès that
she exchanged with Paul Jenkins for the use of her St. Mark's
Place studio.[41] It was not until 1959 that she moved into the rue
Frémicourt studio apartment where she would do most of her
Parisian work, which became a much-frequented venue for her
many friends and acquaintances. Besides beginning the pattern
of moving back and forth between Paris and New York, in 1956
Mitchell made the first of what would become nearly annual
visits to her sister, Sally, in Santa Barbara, California.

France changed Mitchell's work perceptibly. While she would
never have characterized herself as being particularly influenced
by the French version of American Abstract Expressionism—
a movement created by such artists as Pierre Soulages, Henri
Michaux, and Georges Mathieu—it is perhaps arguable that these
painters' works did make their mark on the young woman artist.
Most decisive, artistically and emotionally, was Mitchell's exposure
to the work and personality of the French-Canadian painter
Jean-Paul Riopelle. Part of the irony of Mitchell's reaction to
the painters around her in Paris, both American and European,
is that it made her at least half-want to leave France for good. She
always said that her reason for staying in France was "personal."
That meant Riopelle (fig. 14). Mitchell was introduced to him by
Jaffe soon after her arrival in Paris:

> I said [to myself], "I don't have no money. Mmm, I don't like
> France." But I wrote Shirley [Jaffe], and I said, "I'll be in
> such and such a hotel and I'm going to go to bed, and so do
> something about it." So she called me from Saint Germain
> des Prés, and I said, "Oh, come to the hotel," and she said,
> "Oh, no! I'm sitting in a café in Saint Germain, and I'll wait
> for you." . . . And I got there and then I met Sam Francis
> and then [Norman] Bluhm and Riopelle. . . . And then I got
> involved [with Riopelle], and that sort of screwed up every-
> thing. And then I would go back and winter in New York,
> and see the shrink [Edrita Fried] . . . and paint, and then I
> would go back. The summer in 1959, I bought a place, or
> bought the key to a studio [on the rue Frémicourt in the
> fifteenth arrondissement] and then I started painting there.[42]

After 1959 Mitchell created virtually all of her work in France.

While Mitchell had established a presence in New York through her many shows at the Stable Gallery from 1953 through 1965, she might have been less known in Paris but for her acquaintance with Lawrence Rubin. From 1957 to 1966 Rubin's Galerie Lawrence, at 13, rue de Seine, showed such American artists as James Bishop, Helen Frankenthaler, Morris Louis, Kenneth Noland, and Frank Stella. Mitchell's first major one-artist show in Europe was organized by Rubin and his partner, Beatrice Monte, in 1962.[43] It is clear that, through Rubin and other connections, Mitchell met many of the American artists who passed through or stayed in Paris, but she said that she never really participated in a social life with them. Her longtime friend the critic Pierre Schneider recalled those days in Paris as "very friendly, very much a group feeling, with Sam Francis, Beckett, Norman Bluhm and David Budd, Georges Duthuit, Jean-Paul [Riopelle], of course Joan. They'd all party all night. I'd quit at midnight."[44] Nevertheless, Mitchell herself insisted, "I never felt there was a group [in Paris at that time]. I thought it was sort of Americans clinging to Americans. I saw a lot of Sam [Francis] in those days, because he was a good friend of Riopelle, and the three of us were together a lot. And I didn't like his work and it took me some time to like it. And then I did—like acquiring a taste for olives or beer."[45]

Two paintings of the years 1960 to 1962 reflect the shift in Mitchell's sensibility away from the aggressively active Abstract Expressionist brushwork, toward a more delicate, subtle, and lyrical style. *Chatière* (1960; pl. 21) and *Grandes Carrières* (1961–62; pl. 24) employ a completely different painting technique from works like *Ladybug* and *Evenings on Seventy-third Street*. Rather than relying on heavy impasto, Mitchell achieved a thinner surface, with a kind of scumbled facture, or sometimes even scraped or wiped passages. And her chromatic range changed dramatically, from an emphasis on primary colors to the introduction of complex lavenders, myriad shades of green, and, most strikingly, a range of rosy orange-reds or rich pinks that contribute to the overwhelming lyrical beauty of these pictures. They are somehow more French, or more grounded in French modernism, than earlier works. The titles, as usual "tacked on" after the fact, reflect France as well. *Grandes Carrières*, for instance, refers to a place in the Montmartre section of Paris.

Interestingly, Mitchell herself viewed the works from this period not as increasingly lyrical or subtle, but as "very violent and angry paintings."[46] She associated them with the events of her life in the early 1960s. In early 1963 her father, Dr. James Mitchell, died at his Chicago home of heart ailments.[47] She told curator Judith Bernstock that at the time she was working on these paintings she was beginning to be irritated by the lack of privacy in her Frémicourt studio and felt that she might have to move; moreover, it was during this period that her mother, to whom she remained close, was diagnosed with the cancer from which she would die in 1967. But, as would so often happen, Mitchell's own characterization of her feelings at various stages of her painting career belie, sometimes diametrically, the nature of the paintings themselves. It is hard to imagine a more opulent, irresistibly delicious abstract canvas than *Grandes Carrières*. It verges on the rococo. That its maker associated it with a period of more than usual upheaval, discomfort, and anger speaks eloquently about the primary (often healthy) disconnection, or splitting off, so often implicit in the creative act.

Mitchell and Riopelle were essentially living together during the entire decade of the 1960s, and they would remain together until 1979. Their relationship was described by virtually everyone who knew them as constantly stormy, with mutual provocation and often physical violence witnessed by many. At first, Riopelle was far better known in Europe than Mitchell and was the more often exhibited of the two artists. Mitchell, by her own admission, was cast in the role of "the mistress."[48] She expressed bitterness on at least a few unguarded occasions. Yet it was not a question of exploitation on either side, nor was the "marriage" an unmitigated competition. Schneider recalls that "Joan and Jean-Paul were helpful to each other. They gave careful advice to each other hanging shows, etc. Despite all the fights, I've seldom seen people who had as much respect for each other as artists."[49] Within three or four years after the onset of their relationship, Mitchell would outstrip Riopelle both in terms of reputation, especially in the United States, and in her development as a painter. But it could never be said that she outdid him in terms of sheer charisma and raw life force. Riopelle's talent was prodigious but is to this day unappreciated in the United States.

Riopelle had outlets other than his art. He collected and raced vintage cars—he owned several Citroëns and Bugattis from the 1930s. In the late 1950s he bought a share of a forty-five-foot single-mast Bermuda cutter called *Serica*, which he kept at Golfe

Juan in the South of France. For several summers he and Mitchell and their various friends and family members—Riopelle has two daughters, Sylvie and Yseult, with whom Mitchell had a relationship that alternated between closeness and estrangement—plied the Mediterranean Sea. Pierre Matisse, son of Henri Matisse, and his wife, Patricia, sailed with them during the summer of 1959. In future summers Rufus Zogbaum, the son of Mitchell's friend the sculptor Wilfred Zogbaum, spent months with them in the South of France and at sea. Rufus Zogbaum recalls that the group "took over a restaurant called Chez Margot in Golfe Juan (fig. 15); it was their place. And everyone, Pierre Matisse and Joan and Jean-Paul and whoever was around, would hang out around the pool above the Fondation Maeght. Jean-Paul kept a little apartment in Golfe Juan; I lived aboard the boat, and they'd be in the apartment. Joan really was afraid of water and didn't really like sailing. She'd do it, but she'd stay below deck. And everyone drank. Especially Jean-Paul and Joan."[50] Mitchell herself recalled that "[Sailing is] very fatiguing . . . a lot of hard work. . . . It's a small space to fight in."[51]

Mitchell's paintings from this period are some of the psychologically darkest of her life. Not only was she less prolific during the early and mid-1960s, but she seemed to renounce, temporarily, her restless experimentation with lush and variegated color. The palette of her best paintings of this moment is unusually subdued and primal—green, white, brown, and black—and the compositions are the most bluntly figure-ground based that she ever constructed. She was thinking about emergent or insistent objects, sometimes suspended, sometimes anchored in an ambiguous atmosphere. As an alternative to her green/brown palette, she sometimes used blue. *Blue Tree* (1964; pl. 26) and *Untitled (Cheim Some Bells)* (1964; pl. 28) represent the mood and vocabulary of this time. Both of these paintings explore the artist's insistent urge to return from the "allover" imperatives of Pollock's (and Greenberg's) Abstract Expressionism to a frankly "figure-ground" structure. At this moment she seemed to be paralleling the development of her confrere Philip Guston, who transited from a prolonged period of making purely allover abstract paintings to a shockingly different mode. He became a "representational" painter and achieved a body of work as successful as that of his classical abstract episode.

Although Mitchell never remotely considered a sea change as radical as Guston's, clearly there were times when she wanted to

ground her images more concretely in nature. During this "Calvi" era, she acknowledged thinking about trees, specifically dusky cypresses seen in a Mediterranean town called Calvi, reached by boat from Juan-les-Pins. She is quoted as saying, "I'm trying to remember what I *felt* about a certain cypress tree and I feel if I remember it, it will last me quite a long time."[52] One of Mitchell's most haunting, indeed transcendent, achievements is the only painting she actually titled *Calvi* (1964; pl. 27). This work sums up an entire episode in her career. It emerged during a fractured time in her personal and professional life, the years when she was probably at her least productive and most willing to succumb to chaos and dissipation.[53] The poignancy of *Calvi*'s being—its childish dark cloud that is also a triumphant echo of the world at its finest, the elusive cypress green organism suspended in the universe of Mitchell's dreaded white eternity—echoes again and again in her best work henceforward.

Joan Mitchell generally bought and used only the most stable and durable paints, and worked on high-quality, preprimed canvas. Nevertheless, some of her paintings from the 1960s and 1970s reveal a great deal about the ways in which she ignored the technical rules of thumb. For example, she tended to use a lot of turpentine, repeatedly thinning and rethinning her paints, which would sometimes sit in her studio (usually in large dog food cans), often unlidded, for months or even years, waiting to be reconstituted when the need arose (fig. 16). Mitchell's close friend the painting conservator Valerie Septembre described the situation: "If she wanted some color, and it was too thick, she'd douse it with turpentine, dissolve the pigment, and use it. . . . She was focused on the *color*, not the durability. She didn't care at all about what I cared about, and she was fascinated with me for that reason. But eventually she got more and more concerned; just before she died, she was very distressed about cracks that were appearing in a particular kind of blue paint."[54] It is becoming increasingly evident that some of her paintings, especially from the 1970s, were constructed with far too much concern for the quickly gratifying appearance of, for instance, the yellow pigments, and too little concern for the integrity of the medium. The powdery yellow or blue or violet pigments were sometimes improperly bound to a stable medium, and simply disintegrated. This was of course a classic occupational hazard for the painters of her generation who

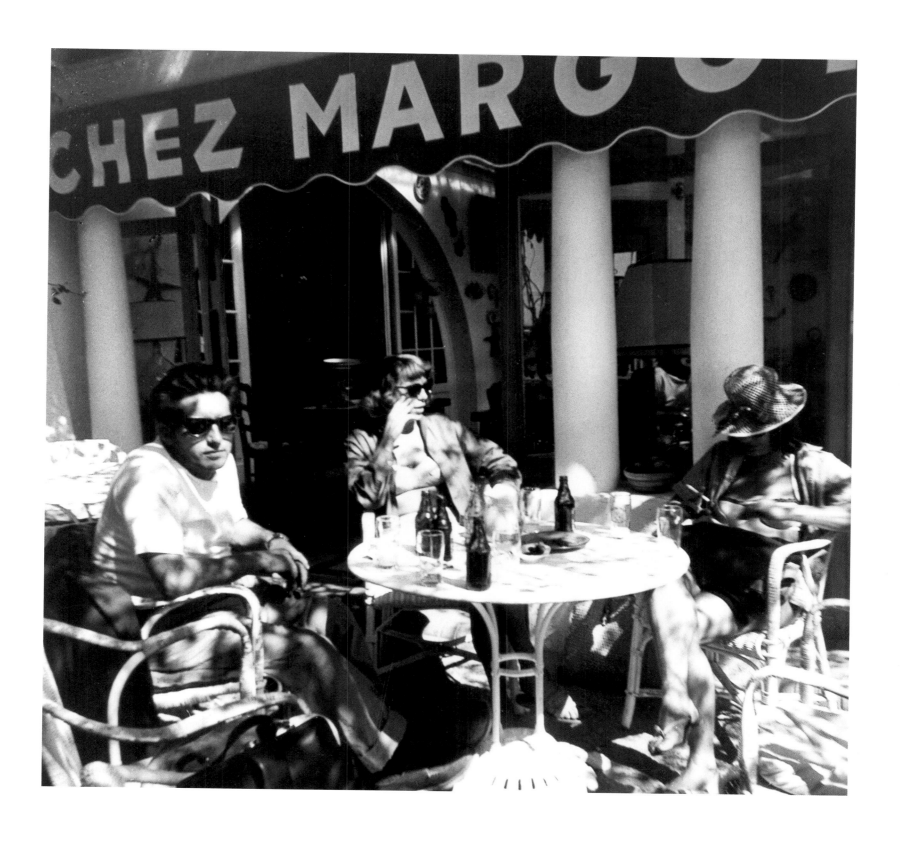

15. *Joan Mitchell at a café with Jean-Paul Riopelle.*
Estate of Joan Mitchell

THE PAINTINGS OF JOAN MITCHELL

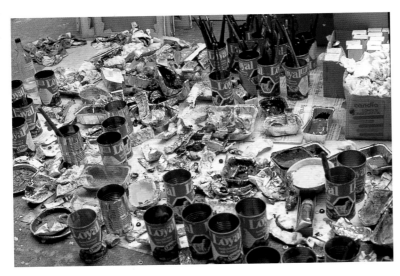

16. Édouard Boubat, *Joan Mitchell's studio, Vétheuil*, 1984. Courtesy Galerie Jean Fournier, Paris

devoutly abjured the use of acrylics and who believed against the odds that intuition and experience were on their side.

Septembre stresses that what Mitchell cared about was not so much the oil content of her paint—the stability of the medium—but how the color looked on the canvas. However typical this ignorance, or malfeasance, was among artists of her generation—many of whom have had great trouble with the condition of their paintings over time—it seems perpetually to recede in the face of the power of the images. Certainly there are exceptions, where "inherent vice" overcomes integrity. Canvases become both visually compromised and technically recalcitrant. Mitchell is not immune from this syndrome. Still, her canvases in general have fared well; particularly in her relatively thin paint passages, virtually no change is occurring. As with Abstract Expressionist painting in general, it is the more heavily laid on, or built up, areas that create problems. Two hues in particular, variously saturated purples and greens she was using during the mid-1960s, have darkened perceptibly. In the Calvi-period paintings, the darkening over time has occasionally worked almost to their advantage, allowing age to introduce a differently acceptable element; it has not usually become an aesthetic problem. In these works greens turned black-olive still seem to convey the painter's intention.

Mitchell constantly sought out good quality pigments and loved art supply stores. When she discovered Lucien Lefebvre-Foinet paints in Paris, she reveled in their distinctive hues and began to use them almost exclusively. It was a small company, and when they discontinued certain colors that Mitchell especially loved, such as "Vert/Émeraude/Viridian," she would begin to hoard her existing tubes, sometimes thinning them more than ever. Part of her attachment to France resided in her feeling for the history of the craft of oil painting, and she never ceased to hunt for and acquire the materials of her French forbears. Her primary American technical adviser and provider of paints was the New York–based painter and art supplier Carl Plansky. Mitchell consulted with him often, especially during her late years. Plansky was both her great professional ally and, inadvertently, her nemesis. He gave her extraordinary support and loyalty, while contributing to problems she experienced with some of his paints.

Despite her ties to the New York art scene, by the mid-1960s Mitchell's practical, personal, and career-oriented life was grounded

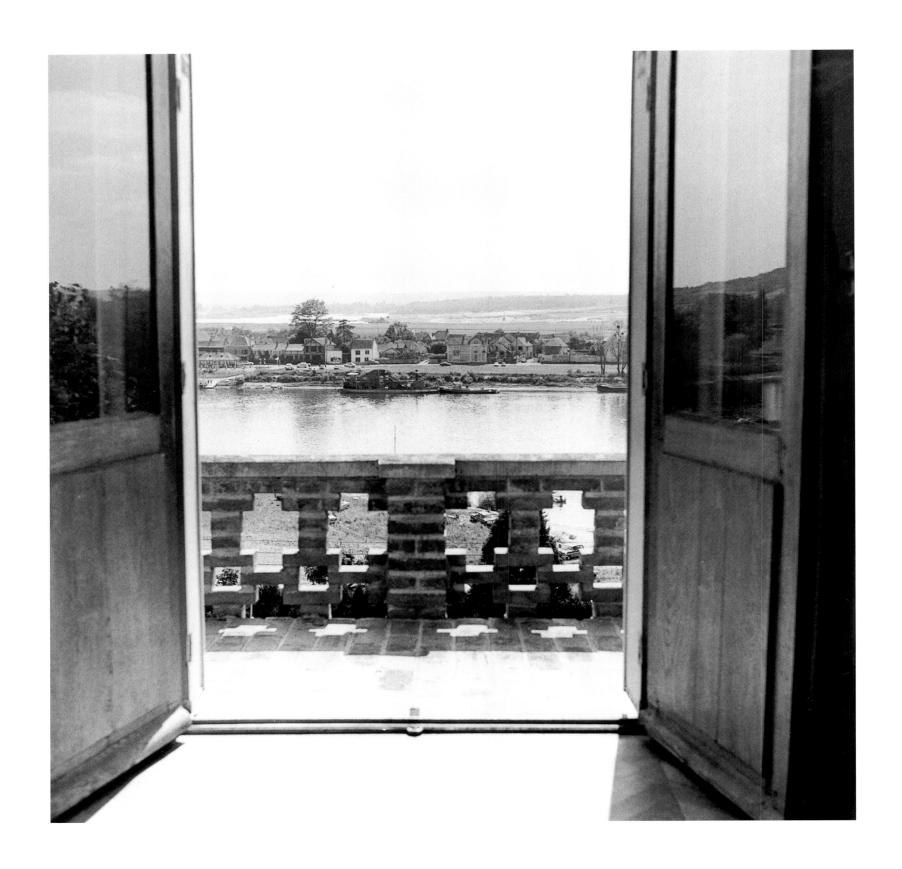

17. *River Seine at Vétheuil*. Estate of Joan Mitchell

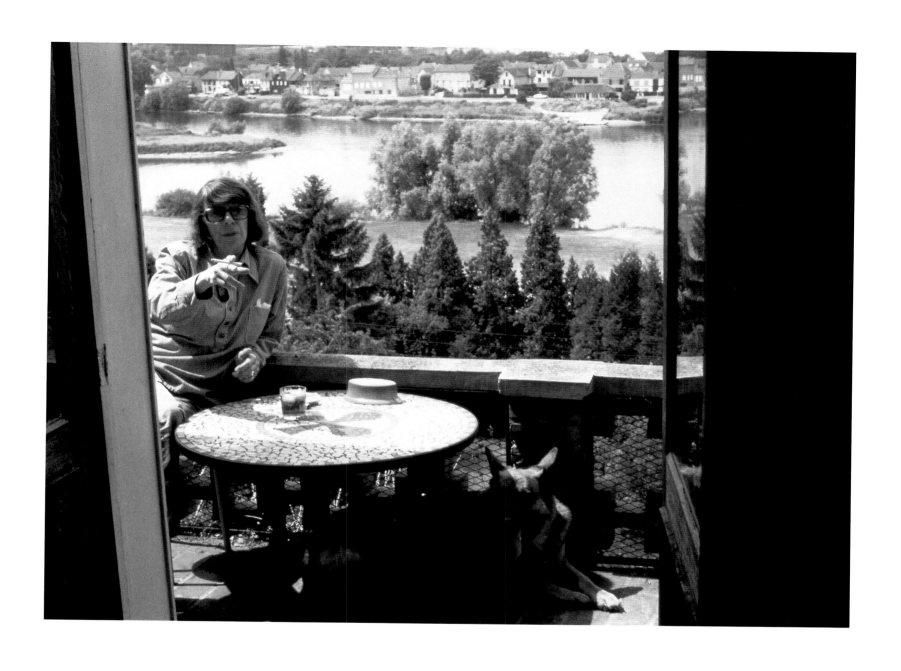

18. Édouard Boubat, *Joan Mitchell on her balcony at Vétheuil*, 1984. Courtesy Galerie Jean Fournier, Paris

in France. Nineteen sixty-seven was the year when she began her important professional and personal relationship with the Paris dealer Jean Fournier, who had an ineffably beautiful sky-lit gallery in the rue du Bac. (For a time, Fournier operated a gallery in the rue Quincampoix, near the Beaubourg, where he also showed her work to exceptional advantage.) The presence of a permanent and endlessly supportive gallery in Paris was to be a significant factor in Mitchell's ability to stabilize her life. Fournier's commitment helped immeasurably in her never-quite-satisfied quest for a sense of permanence and professional grounding in France.

Mitchell's commitment to residing there, as much as it could be, was solidified when her mother died in 1967 and she inherited her share of the Charles Strobel trust. She decided to purchase a property outside Paris. Her friend Betsy Jolas, an American composer and musician who has lived most of her life in Paris, recalled the circumstances of finding the house and grounds near Paris that became Mitchell's base for the remainder of her life: "Jean-Paul and Joan were looking for a country place. My husband, Gabriel [Illouz], and I had a house in Vétheuil; a place nearby was for sale. Joan bought it."[55] The village of Vétheuil lies along the banks of the Seine, about thirty-five miles north of Paris. Its modern cultural status has been enhanced by Mitchell's presence there but was first marked by Claude Monet's sojourn in a house near Mitchell's, where he lived and painted from 1878 to 1881. His wife, Camille, had died there, and Monet had moved on in a state of restlessness and grief. His little cottage was inhabited for most of Mitchell's tenure at Vétheuil by her gardener and his wife, who became close friends and caretakers.

Arriving at Mitchell's address on avenue Claude Monet, one is confronted by a wall interrupted by a small blue-painted gate, unmarked, leading to an upward-sloping path to the main house. A large terrace, dominated by an ancient, spreading linden tree, fronts the two-and-a-half-story stucco building. One enters into a foyer, off of which the dominating space is a large living room, whose most prominent furnishing in all of Mitchell's and Riopelle's days there was a billiard table, usually stacked with books and magazines. A grouping of chairs surrounded the fireplace at the other side of the room. In the earlier years at Vétheuil, paintings by Riopelle hung in this room; in 1972, when the critic Cindy Nemser visited Mitchell, the only painting not by him was a small Mitchell he owned, "located in an inconspicuous

space over a door in an upstairs room."[56] In later years a few small Mitchells were displayed in the house, but never more than a few. On the other side of the foyer are a small dining room, the kitchen, and an outdoor terrace that became Mitchell's primary living space (fig. 17); upstairs were her library, bedroom, bathroom, and guest rooms, including a towerlike room at the top of the house. Here Mitchell kept an antique gun case that held books: first editions of T. S. Eliot, Ezra Pound, Wallace Stevens, and many others that had belonged to her mother.

The heart of the house during the spring, summer, and fall was just outside the kitchen and dining areas. Almost everyone who came to Vétheuil when the weather was even marginally tolerable would end up sitting on the narrow terrace near the kitchen (fig. 18). It overlooks a view of the curving Seine, its lush valley varying in color and light at different times of day and season, trees and flowering shrubs in the foreground, boats on the river. Farther off is a reservoir that from a distance resembles a suspended lake. This prospect captivated the artist and everyone who gazed at it. Mitchell sometimes sat there in silence for hours.

Mitchell's studio was in a separate stone building behind the house, a short walk from the kitchen door up a sloping lawn surrounded by vegetable and flower gardens (fig. 19). The studio itself is a simple rectangular space, approximately thirty by fourteen feet; on the wall above a large worktable Mitchell kept a bulletin board with photographs and postcards and reproductions and notes she wanted to look at every day. The studio also held her record collection and stereo system; Mitchell usually worked at night and often listened to music while she was working or reading—Mozart, Stravinsky, Bach, sometimes jazz. Her record collection was eclectic and discriminating, but by no means elitist. Her friend Guy Bloch-Champfort remembers that she shared his love of opera, particularly Bellini's *I Puritani*, and Bach cantatas.[57] For company, she had her adored German shepherds: Iva and two of her offspring, Marion (named for Joan's mother) and Madeleine. Mitchell had sworn not to have any more dogs after the death of her Skye terrier, Bertie, but was given the six-month-old Iva by Riopelle. It turned out to be more fortuitous than she could have known, as these dogs became one of the centers of her life after Riopelle left.

Mitchell worked under a combination of fluorescent and incandescent light fixtures; the windows were covered, and to look

at pictures in daylight, she would open the wide door to take a canvas outside. This was the first space she worked in that allowed her to move stretched canvases in and out with relative ease. (After years of working on unstretched canvases, stapled or tacked to the wall, she eventually ordered up preprimed and stretched canvases. She sometimes reached their upper areas with a ladder; when she could no longer safely do this, she rigged up a system of long-handled brushes.) Although Mitchell usually painted at night, she always insisted that she did not rely on artificial light. "I often paint during the night but I have nothing to do with night. I like the light. I prefer the daylight. I also work in the afternoon, I check what I have done the night before. Certain colors change enormously with electric light. Blue is one of them. Yellow is another. They all change, but some really change. I do a bit of guessing. The next day, I walk up to the studio at noon and I am excited but also afraid: is it what I thought it was in terms of color? A painting which works in electric light does not necessarily work in daylight. I love daylight."[58]

The first cycle of paintings that seem to have been directly inspired by the new environment at Vétheuil are some of Mitchell's most original, and most misunderstood, works. She clearly saw many of these paintings as derived from landscape, sometimes titling them accordingly (as in *My Landscape II* [1967; pl. 30] and *Low Water* [1969; pl. 31]), and yet most of them seem less directly landscape-oriented than some of her works of the 1950s. *My Landscape II* announces a willingness to cover the painting field edge to edge, something that Mitchell had not wanted to do since the early 1950s, now with an entirely new spirit of "alloverness." She was no longer even remotely interested in the freewheeling Abstract Expressionist approach to the picture surface, implying a limitless field whose boundaries are arbitrary. (One suspects that she never embraced this idea even in her most credulous "action painting" stage.) From now on, each large painting would be composed with the utmost sense of either windowlike space—i.e., a scene experienced as if glimpsed in a more distant plane—or a vast, enveloping, highly evolved "landscape space." And, always, clearly marked signs oriented the pictorial field from top to bottom and side to side. Within these invented, highly disciplined spatial structures, Mitchell allowed color to become the main subject of many of her paintings, using chromatic juxtapositions in ways new not only to her but also to painting itself.

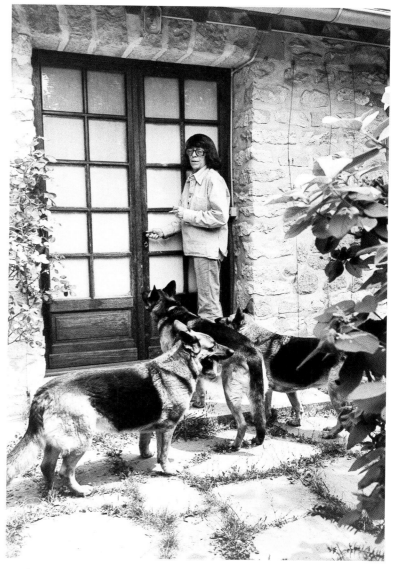

19. Édouard Boubat, *Joan Mitchell outside of her studio, Vétheuil*. Estate of Joan Mitchell

With the new, larger studio, Mitchell increased the scale of her paintings, but she still faced limitations. Because of the transverse beams in this fairly large, open space, finding room to move her canvases remained a problem. The maximum width of a given panel never grew; from studio to studio it stayed at about 80 inches. The vertical dimension of 110 or occasionally even 112 inches allowed for some imposingly tall canvases, from *My Landscape II* to the remarkable *Low Water* and *Sunflower III* (1969; pl. 32). The latter two works are examples of an unexpected, indeed highly anomalous, abstract style that can only be called ravishing. In them, Mitchell abjured the packed composition of the slightly earlier canvases and in a sense reverted to the figure-ground approach—but with a difference. Now she used the white ground as an intensely enlivened part of the picture space, not as background, but as a kind of cradle, or receptacle, for the passages of brilliantly worked color. Evocations of sunlight on flowering trees, or foliage reflected in shimmering water, elevate these paintings to a level of the most intense lyricism. They evoke the sensations created by some of Rainer Maria Rilke's most sensuous poems, which Mitchell read and reread all her adult life. These somewhat open works led immediately into a return to packed surfaces with some of the artist's most stunning achievements—the enormous early polyptychs such as *Wet Orange* (1971–72; pl. 36). Mitchell had first painted multipanel works in her Frémicourt studio, where she had severely limited space, but only when she had fully acclimated to the Vétheuil studio did she thoroughly explore the format of the diptych, triptych, and quadriptych. She came to master, or to own, this kind of sequential approach in a way that eluded her with other experimental formats; the tondo, for example, which she worked at seriously during the last two years of her life, never quite came together for her.

In 1968 Mitchell's first show at the Martha Jackson Gallery in New York, with which she remained affiliated until 1974, presented the last works she made in the rue Frémicourt studio. The subsequent break signified by the so-called Sunflower pictures can be seen as an announcement of the artist's determination to allow her new, bucolic environment at Vétheuil to take her in new directions. Her move from Paris to the quiet and always beautiful two-acre property overlooking the Seine afforded her a new privacy and a physical connection with the landscape. The perceptible shift in her style culminated in an exhibition titled *My Five Years in the Country*, organized in 1972 by James Harithas for the Everson Museum of Art in Syracuse, New York, and later shown in edited form at the Martha Jackson Gallery. Critical and word-of-mouth reaction to this show was mixed and, even when positive, often puzzled. One of the few unreservedly positive reviews was by Peter Schjeldahl, who wrote:

> If the current revisionist study of Abstract Expressionism yields any lasting benefits, I must believe that among them will be a recognition of Mitchell as one of the best American painters not only of the fifties, but of the sixties and seventies as well. . . . This claim will not, I think, seem large to anyone lucky enough to have viewed the recent massive and almost awesomely beautiful Mitchell exhibition—49 paintings, some of them huge. . . . The wonder is that an art of such obviously taxing intensity has been sustained without compromise for so many years—years of comparative neglect that cannot have been easy on a woman as aware of her own talents as Mitchell surely must be.[59]

In 1974 her first major American museum exhibition was organized by Marcia Tucker for the Whitney Museum of American Art. It included several of the same pictures that had been in the Everson Museum exhibition. This was an exhibition that should have garnered major acclaim or at least serious critical attention. That it was lightly received may have been disappointing to the artist, but it would not have been a new experience.

Mitchell genuinely defied the rule of the postwar American artist's craving for notoriety or at least acceptance. Her inner life embraced worlds beyond her own craft; she especially loved literature. Her expertise in poetry led her to befriend a number of poets, among them James Schuyler, Nathan Lerner, and Jacques Dupin, whose poem "La ligne de la rupture" became the title for one of her most arresting paintings (pl. 34). This work is a key example of an influence on Mitchell that has been virtually unacknowledged but that is unmistakable—namely, the oil paintings of Hans Hofmann. Although Mitchell had pursued Hofmann as a studio teacher when she first came to New York, as previously noted, she balked after just one session. She clearly respected his structural approach to both space and color, and she quite specifically learned from him, transforming his style in many of her most magnificent canvases of the 1970s. Both *Mooring* (1971; pl. 35) and *Wet Orange*

would be almost unimaginable without Hofmann's precedent, yet Mitchell managed to create her own, perfectly distinctive adaptation. Blocks of color operate within a fieldlike matrix, creating tensions between figure-ground oppositions, on the one hand, and the dense, flat space of Abstract Expressionism, on the other. The passionate, solidly structured triptych *Wet Orange* achieves a grandness of vision, a complexity of emotion, and a replete, utterly daring chromaticism that combine to make this work one of Mitchell's greatest tours de force. The progression into this work and a few other multipanel pieces from this chapter in her career seems to have begun rather tentatively with *La Ligne de la Rupture* (1970–71; pl. 34), a singularly delicate and idiosyncratic work; this impulse gathered energy and strength until, with the triumphant *Wet Orange*, it could be pursued no further.

Another of Mitchell's most successful triptychs, *Clearing* (1973; pl. 39), shows her returning once more to an open, or figure-ground, mode of composition. *Clearing* juxtaposes three self-contained episodes—or, better, interrelated stanzas—declaring its nature as a bold and, as it turned out, singular experiment. Its use of developing themes, rather like the movements in a symphony, reinforces its ambition to communicate the sense of elapsed time and simultaneity that can be achieved only in the visual arts. *Clearing* introduces a peculiar, ragged, donut-shaped figure, which is incarnated twice, slightly metamorphosed. It is as though this purplish blue circular figure moves through time and space, reconstituting itself in a different plane, speaking of something both sad and lyrical. The middle passage of this triptych echoes a familiar compositional matrix: its bold, brooding rectangular anchor rests within a thinly worked, delicately limned ground. *Clearing* may be said to combine an intense atmospheric lyricism and lightness of being with a strangely melancholy air. It is at once pellucid and somber, lighthearted and meditative.

Mitchell called some of the paintings from this period her "Territory" paintings. Some of them, such as *Blue Territory* (1972; pl. 37), have startlingly thin surfaces. They range not only from heavily impastoed textures to the opposite but also from densely organized compositions to "open" ones, sometimes using whites in ways that are almost impossibly difficult. But it was not only space, or "territory," that she was concerned with in these works. She was dealing more and more searchingly with *light*. It is always difficult to talk about light in painting, as Mitchell herself demonstrated in

a quote from Marcia Tucker's 1974 Whitney catalogue: "Light is something very special. It has nothing to do with white. Either you see it or you don't. De La Tour doesn't have light; Monet hasn't any light; Matisse, Goya, Chardin, van Gogh, Sam Francis, Kline all have it for me. But it has nothing to do with being the best painter at all."[60]

To the extent that Mitchell uses white in the most crafty, least predictable ways imaginable in her large paintings, and to the extent that this use of white seems to be their very source of light, it is difficult to agree with part of her statement. But one knows what she means. In terms of sheer largeness of vision, of solving painterly problems with an almost incredible audacity, these oversize pictures from the 1970s have few rivals in all of modern American painting. The Sunflower, Field, and Territory paintings, at least some of them, forge a synthesis between Mitchell's "landscape I carry around inside me," and the legacies of Cézanne, Matisse, de Kooning, and Hofmann. It can be argued that these works mark Mitchell's ascendancy to a level that few artists have attained, an achievement that would set the stage for her work to come.

In 1976 Mitchell signed on with Xavier Fourcade, a singularly astute and committed dealer of modern art with both European and American roots, beginning a relationship that was probably more intense and focused than those with her other galleries in New York. (Jean Fournier in Paris probably devoted more time, and manifested more loyalty, to Mitchell than anyone except Fourcade. Fournier's tireless dedication in representing this American artist was one of the most positive sources of support of Mitchell's life in France.) She said she liked the "intimacy" of Fourcade's townhouse space on East Seventy-fifth Street, near the Whitney Museum, preferring it, for example, to Leo Castelli's industrially scaled gallery space on Greene Street in SoHo.[61] (It is interesting to note that Mitchell found the relatively intimate space of the Martha Jackson Gallery, where she had a solo show in 1968 and which represented her for several years, "not entirely satisfactory because there was no way of stepping back in that limited space to see the paintings in their proper perspective."[62]) She showed with Fourcade seven times, the last time in 1986, and those exhibitions reflect the rhythm of the events in her career and in her life. After Fourcade's death Mitchell was represented in New York by the Robert Miller Gallery. She established close friendships with both Miller and his gallery director, John Cheim.

During her years with Fourcade, Mitchell seemed, for the first time, to enter into a series of styles, as though she were conscious of painting for a show and then for another show. The later 1970s also represent a time of somewhat restless trial and error and a conscious backing away from the overt decorativeness she had so definitively proved was hers to express at will. She decided to try once again to recapture the idea of the active and complex but also entirely filled picture space—the Pollock-associated approach that created an ambivalence, or indefiniteness, about the relation of the composition to the edge of the canvas. Many of these experiments were done in diptych form, and a few were extraordinarily original and successful. *Aires Pour Marion* (1975–76; pl. 41) juxtaposes two densely filled panels whose drama resides primarily in chromatic exploration per se. The tension and synergy between the two halves prefigure what she accomplished in *Two Pianos* (1980; pl. 45), extending the idea into even more emotionally resonant terrain. The strangely dark *Aires Pour Marion* is a work of electrifying energy and an example of one of Mitchell's several experiments not often repeated at such a high level.

By 1979 Mitchell and Riopelle had lived together, in their desultory fashion, for more than twenty years. Riopelle had long been spending much of his time in a studio he kept near Vétheuil, and their summers no longer meant sailing together. The Vétheuil property was Mitchell's, not Riopelle's. His work was less and less a part of her preoccupation, while her work gradually overwhelmed Riopelle's life, if only by virtue of its constantly dynamic development and the many people who visited her studio for both pleasure and business. Mitchell always had a great many intense friendships, and guests came to Vétheuil continually. A few stayed for months or even years. One of those who came to the house and stayed off and on for nearly two years, often helping out with chores and meals and what Joan called "dogsitting," was a young American artist named Hollis Jeffcoat. Riopelle and Jeffcoat began a relationship that became so serious that they decided to be together; one day in 1979 they informed Mitchell that they were leaving, and they left. Even though Riopelle had had other liaisons with women during their long relationship (perhaps most seriously with the sculptor Rosaline Granet), and in spite of the fact that Mitchell was reaching a point of exhaustion with their incessant fights, his defection—his finally leaving for

good—seems to have been traumatic for her. She was always afraid of being abandoned, famous for hating to say goodbye even temporarily, and the final parting from her embattled lover exacerbated the irrational sense of loss that so often engulfed her. It took her some time to regroup.

For years, beginning in the late 1970s, Mitchell had been in the habit of driving or taking the train into Paris twice a week to visit the psychiatrist she sought out even before her New York psychiatrist and intimate friend, Edrita Fried, died. Madame Rousseau was considerably younger than Mitchell and provided her with a much-needed source of support during many years of illness, both emotional and physical. In 1986 she told Linda Nochlin: "I'm regoing to a French shrink now, and she's helped me a lot. I wish I'd gone sooner, because I think women are inclined more than men to be self-destructive, and I really think I had the masochistic medal there for a while. . . . I think it's also very masochistic to sit and cry in my spilt Scotch for areas in my life that have been very creepy and that I should have cut, left sooner."[63]

During the period immediately after Riopelle's departure, Mitchell found herself unable to work on large canvases. She resorted then, and subsequently, to working in a studio located in Montparnasse, where she set up tables and small easels and worked on pastel drawings. Occasionally she spent nights there—a small bed occupied a loft space—but it was a workplace for smaller-scaled pieces, and a refuge that she kept to herself, with the exception of a few friends. Mitchell's work on paper was something she separated entirely from her painting activity and an endeavor about which she apparently had mixed feelings. She would say that her pastels were "lady paintings." She did not want to be called a lady painter unless she was using the term herself, nor did she truly invest her deepest energies or intellect in these drawings. (Mitchell remarked humorously to Nochlin: "That whole term 'second generation [Abstract Expressionist]' . . . a very boring term . . . seems to have stuck. . . . It's a put-down, but I don't know, I don't care. I call myself a 'lady painter' and AEOH—Abstract Expressionist Old Hat."[64])

Mitchell worked at varying scales at the Montparnasse studio, always on paper, but preferred to show her oversize pastels rather than the small ones (fig. 20). The pastels she did for special occasions, particularly the ones she made collaboratively with five of her poet friends—Jacques Dupin, Chris Larson, J. J. Mitchell,

20. Joan Mitchell, *Pastel*, 1991. Pastel on paper, 47⅝ x
31⁹⁄₁₆ in. (121 x 80.2 cm). Whitney Museum of American
Art, New York; gift of Robert Miller, John Cheim, and
Jean Fournier 92.89

Pierre Schneider, and James Schuyler—had a special meaning for her that set them apart from the small drawings done in series, often "for exercise."[65] On the whole, she was far more invested in the various print series—including lithographs, etchings, and monotypes she made with Maeght Printing Press in Paris, at Limestone Press in San Francisco, at Tyler Graphics in Mount Kisco, New York, or, even earlier, silk screens or lithographs done with others and especially in collaboration with poets, among them John Ashbery. Although making drawings probably never rivaled printmaking in her own priorities, her place in Montparnasse gave her respite, and a way of continuing to work that seems to have been cyclically therapeutic. Ironically, her activity in this studio was literally toxic to her; she worked in a badly ventilated space, using powdery substances, including cadmium, which certainly exacerbated the lung problems that became more and more debilitating. (Some who knew her well thought she was hastening her own end.)[66]

During the months of the Riopelle-Jeffcoat trauma, Mitchell completed a group of paintings inspired by the great, dense linden tree that dominated the courtyard in front of her house. She called these works the Tilleul (French for "linden tree") paintings, and they stand as an anomaly in her oeuvre. A few of the Tilleuls are among her greatest achievements; certainly they are the most directly "representational" works Mitchell made in all of her career after the late 1940s. With alternatingly supple and spindly, upthrusting strokes, she explored a palette ranging from black, gray, and white to dazzling colors in one or two works that seem almost to burst into flame, combining yellows in the background with a series of aquamarines, greens, and blacks to demarcate the bushlike image (pl. 42). The actual tree that Mitchell saw every day looks and feels quite different from its transformation in the paintings. In fact, superficially it appears antithetical. Rather than climbing upward, as would a fruit tree or a great shrub, the old linden tree has a huge trunk and horizontally growing, or even bending, branches (fig. 21). It spreads out rather than reaching up. It was the *feeling of this tree*—as it was always the *feeling* of the body of water, or the landscape, or the sunflower, rather than its literal presence in nature—that Mitchell searched for. The idea of pictorial representation, in her hands, became something more like transformation.

One of the most unsatisfying and yet revealing qualities of nearly every serious attempt to quote or paraphrase Mitchell from

the 1970s until her death is her strange inarticulateness. She was obviously brilliant, sentient, even sometimes unexpectedly literary in her conversational mode. And yet when it came to talking about herself or her work, she became general and vague, especially when at her most forceful in self-diagnosis. She kept insisting that *feeling a place, transforming a memory,* recording something specifically recalled from experience, with all its intense light and joy and perhaps anguish, was what she was doing. She seemed to assume that everyone would understand what she meant. At the same time, she was aware, disconcertingly so, that her verbal communication left most people at a loss. It is difficult to reconcile such stubborn, inarticulate pronouncements as hers when one is trying to parse "abstract" imagery. It takes patience to equate the words of the maker with her works. It is hard to be more precise in summing up her own intentions than to repeat her mantra: These are about feelings about the things I see in nature, and remember from my most intense experiences, and want to re-create.

Mitchell eventually returned to large-scale painting in her Vétheuil studio, accessing a deep reserve of concentration and physical effort. She seemed to enter into a decisively new spirit, demonstrating the characteristically acute memory and visualization she could call upon at will. One of the first ambitious paintings she completed after Riopelle left is the delicate and yet incisive *La Vie en Rose* (1979; pl. 43). It is titled ironically, adverting to the way she felt post–Jean-Paul. By this time, Mitchell had begun to prefer two or four panels to triptychs; this habit would continue. While she was working on these huge paintings, she never saw all four panels together. She described her method of working: "It's quite a narrow studio. I can never see a big four-panel job all at once. . . . I can see two big panels. That's about all. . . . I had an awful lot going on at once, going back and forth. I turn [canvases] to a wall [when I'm not working on them]. . . . I can't paint with everything showing."[67] When one looks carefully at works like *La Vie en Rose* or *Salut Tom* (1979; pl. 44)—the latter named in honor of her good friend, the editor and critic Thomas Hess, who had recently died while traveling in Europe—one feels the full measure of Mitchell's visual intelligence, her almost superhuman ability to plan and build her compositions. One could swear that she sometimes built her structures as an architect would, plan by plan. In fact, after the 1950s she virtually never even drew or sketched on

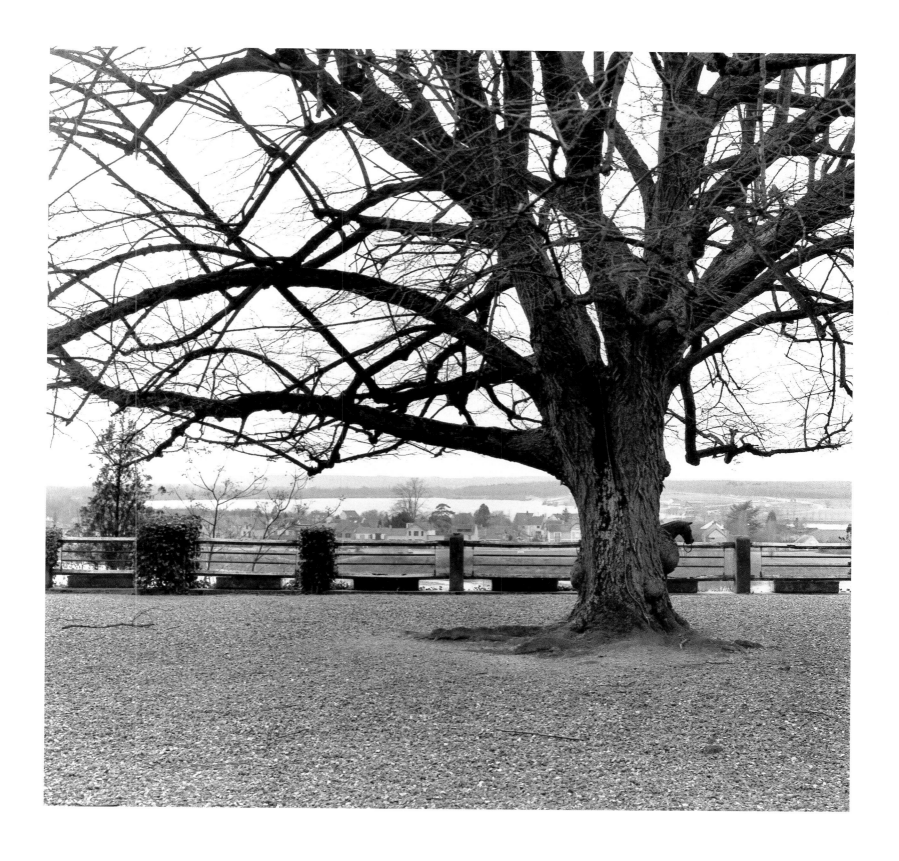

21. Marabeth Cohen-Tyler, *Vétheuil*. Tyler
Graphics Ltd., Mount Kisco, New York

her canvases at the beginning of her process, except for the occasional turpentine-diluted brush stroke to try out a shape or a demarcation.[68]

La Vie en Rose—in contrast, say, to *Aires Pour Marion* of a few years earlier—established a new benchmark for Mitchell's continuing quest to reinvent the figure-ground model in abstract painting. As we have seen, beginning in the early 1950s, the artist seemed to alternate between an urge to extend the "alloverness" of some of the best Abstract Expressionist painters and a search for a language that was more classical, more traditional, than that convention. Now, with the enormous *episodic* polyptychs, especially in *La Vie en Rose* and *Salut Tom*, we find Mitchell forging narratives across an extended, metaphorically *time*-oriented, pictorial plane. *La Vie en Rose*'s two flanking panels, referring to her earlier landscape-oriented work showing horizontally layered areas (foreground, far land, sky), become prologue and coda to the even more important, relatively spare or minimalist, central panels. The implications of a journey, or of contrasting states of an emotional trajectory that might have arisen from a crisis, make this work unmistakably narrative in its structure and effect. *Salut Tom*, by contrast, seems more about other art than about personal struggle. It is the one work that seems unabashedly to point to Monet, that master of the "modernist diorama" whose spirit hovered over her private landscape at Vétheuil. Mitchell always discouraged comparisons of her own work with Monet's, and it is true that many other artists of his immediate historical lineage, including Cézanne and van Gogh, were far more important to her. To distinguish them from Monet's late, heroically scaled "Waterlily" polyptychs, one might say that Mitchell's multipanel works do not try to create a virtual environment for the viewer, to evoke the feeling of standing before a garden or a pond. However epically scaled, they are about making distanced, self-contained objects. The combined synergy and monolithic integration of *Salut Tom*, a work measuring some twenty-six feet in breadth, place it among the monuments of large-scale, serial American abstract painting, including the works of Rothko and Newman.

In 1981 I invited Mitchell to exhibit her work at The Corcoran Gallery of Art in Washington, D.C., along with four other American artists: Richard Diebenkorn, Agnes Martin, Richard Serra, and Frank Stella. Each artist was given a huge, sky-lit gallery in which six to eight pieces were installed; this was the second of two shows I had conceived to present, in a sort of distilled form, the best recent work by mature American artists. (The preceding exhibition had included new work by Willem de Kooning, Jasper Johns, Ellsworth Kelly, Roy Lichtenstein, and Robert Rauschenberg.) Mitchell's six large paintings (including *Two Pianos* and *La Vie en Rose*) were selected from paintings housed at the Xavier Fourcade Gallery in New York. Mitchell was not there when I chose them, but she came to the opening in Washington, as did Serra and Stella. She looked carefully at the exhibition during daylight and planted herself in the gallery with her own works for the entire evening reception. She declined, however, to go on to the postopening gathering at the Hay Adams bar. Except for her periodic shows at Fourcade, she had not had many occasions to be honored for her work in the United States. That evening a surprising number of friends and fellow artists and collectors came to the Corcoran to see Mitchell, far more visitors from near and far than the other artists had, and she seemed both pleased and somehow impatient. Something about the occasion made her feel at the same time satisfied (I think she did like the way her paintings looked) and restless, or awkward. It was clear—she said it to me—that she was entirely at home in the company of the other artists in the exhibition, but it may have been this occasion that led her later to say that she "felt closer to Agnes Martin's precise, sensitive, sensual abstraction than to the American expressionists."[69]

Making her acquaintance in this professional context, I felt that I understood something about the artist's reasons for continuing to live and work outside New York and, finally, outside Paris. Except for her early friendships with de Kooning, Francis, Frankenthaler, Guston, Hartigan, and Kline, her relationships with other artists tended to be with ones who never attained the celebrity of those in whose company she found herself in the Corcoran show. She had a growing ambivalence about being a player in the big leagues. Curator Marcelin Pleynet quotes Mitchell as having said, on the occasion of her first European museum retrospective, at the Musée d'Art Moderne de la Ville de Paris: "My relationship with the art world is distant, and occurs mainly through individuals. As I love painting, I go to galleries, museums, to artists' homes, but the art world has never really interested me."[70] Virtually everyone who visited museums with Mitchell in the last two decades of her life remembers that she went through galleries or museum exhibitions very fast, sometimes seeming

scarcely to look at the walls. She could comment on works without appearing to look at them.

To my eye, Mitchell's work of the early 1980s may be the most uneven, or transitional, of her career. Some of the huge diptychs and polyptychs are patently better than others—*Two Pianos* is one of her best and most resolved works—and some canvases seem provisional, even hasty, in their execution. Many of her finest works from this period are miniature in scale, such as *Gently* (1982; pl. 47). Although it is always dangerous to draw parallels between the vicissitudes of Mitchell's private life and the nature or quality of her work, the decade of the 1980s encompasses the era when it is impossible not to measure the problems in her life against those in her work. One detects an atmosphere of letting down, or diminution, of her powers that simply must relate to emotional setbacks and the health problems she was experiencing. Mitchell's beloved friend Edrita Fried, her psychoanalyst in New York since the 1950s, died in 1981, and her sister, Sally, with whom she had an intense and constant, if sometimes conflicted, relationship, died of cancer in 1982. Both of these losses struck at the deepest reaches of her fragile construct of home, its elusive permanence, and her terror of abandonment. In 1984 she was diagnosed with cancer of the jaw. After this she never smoked again, and she stopped drinking both Scotch whiskey and Ricard, resorting to wine. The years 1984 to 1986 were, in her words, "sick years"; she was in the hospital for treatment several times. In 1985 she underwent the first of two hip-replacement surgeries. In 1986 she lost one of her most beloved German shepherds, Iva. Yet even as her losses increased and her physical well-being worsened, she somehow found the resources to raise her game. Gradually she husbanded her energies during the mid-1980s, and despite the interruptions and irregularity of her work, as early as 1983 she began the so-called Grande Vallée series (pls. 48–50), which evolved into one of her finest achievements.

Mitchell's compositions, as we have seen, were almost always informed by imagined landscapes or feelings about places. Less often, their inspiration was fueled by feelings about people or even about her dogs. Some of her most ambitiously scaled paintings turn out to combine associations both to landscape and to specific relationships. The Grande Vallée works incubated in her imagination based on a series of conversations Mitchell had with her dear friend, the composer Gisèle Barreau, about childhood memories.

As children Barreau and a favorite cousin, Jean-Philippe, who died prematurely in 1982, used to play in a place they called the "big valley"—a landscape that Barreau recalled as singularly flower filled and joyous. Joan heard about this place many times; she let Gisèle's images fill her mind and began to make it come alive in the way she knew best how to do. In the same months when she was developing the Grande Vallée pictures, Mitchell was working on other kinds of compositions in small series she called her River, Lille, and Chord paintings. Out of these grew such later works as *Faded Air I* (1985; pl. 51)—a work she says was based on sunflowers, which "look so wonderful when young and they are so very moving when they are dying"[71]—and *Then, Last Time No. 4* (1985; pl. 52).

In an interview with the critic Yves Michaud, one of the few art writers she seemed to trust, published by Xavier Fourcade in 1986, Mitchell spoke frankly about the desires and emotions that informed her work of this period. In her characteristically generalized and elliptical way, she reveals a great deal about the struggle of her later years. "When I was sick [in the hospital], they moved me to a room with a window and suddenly through the window I saw two fir trees in a park, and the gray sky, and the beautiful gray rain, and I was so happy. It had something to do with being alive. I could see the pine trees, and I felt I could paint. If I could see them, I felt I would paint a painting. Last year, I could not paint. For a while I did not react to anything. All I saw was a white metallic color." (Mitchell always associated the color white with death, horror, and emptiness.) In a sort of valedictory mood, she went on to talk about her deepest longings and her most urgent priorities: "Feeling, existing, living, I think it's all the same, except for quality. Existing is survival; it does not mean necessarily feeling. You can say good morning, good evening. Feeling is something more: it's feeling your existence. It's not just survival. Painting is a means of feeling 'living.' . . . Painting is the only art form except still photography which is without time. . . . It never ends, it is the only thing that is both continuous and still. Then I can be very happy. It's a still place. It's like one word, one image."[72]

One of the facets of Joan Mitchell's character that enabled her to function as productively, and occasionally even lightheartedly, as she managed to do during the last decade of her life was her capacity to admire and engage with younger artists. Among the established artists whose work she sometimes liked were

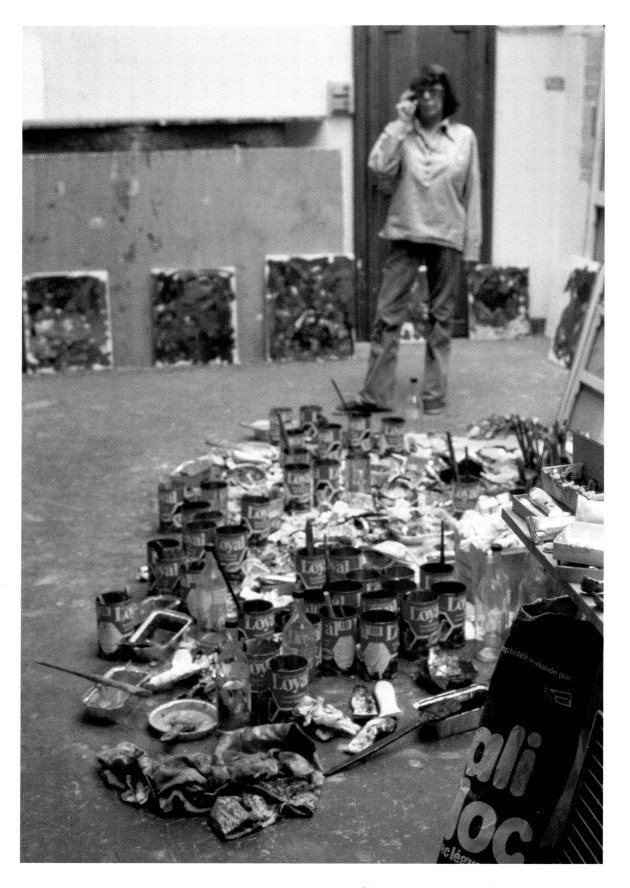

22. Édouard Boubat, *Joan Mitchell in her studio, Vétheuil*,
1984. Courtesy Galerie Jean Fournier, Paris

Georg Baselitz, Brice Marden, and Malcolm Morley (especially his watercolors). But she gave more time and attention to artists whose reputations were not so well established, especially women. She befriended and encouraged the American painters Cora Cohen, Alicia Creuse, Ellen Lanyon, Joyce Pensato, and Rebecca Purdum; some of the men she liked and tried to counsel were Robert Harms, David Humphrey, Peter Soriano, Billy Sullivan, and Rufus Zogbaum. She also had a number of friends among young French artists, including Michaele Andrea Schatt and two artists whom she virtually adopted for a time at Vétheuil: Philippe Richard and Frédérique Lucien. In her final years, Richard and Lucien assisted her in her studio and often cared for her dogs when she traveled. In addition to her many artist protégés, a constant stream of visitors arrived at Vétheuil from the United States or from Paris, usually staying for lunch, but sometimes staying for several days.

In 1988 Barney Rosset visited Mitchell at Vétheuil, accompanied by his companion, Astrid Myers. According to Rosset, it was a strange occasion. Mitchell had arranged lunch for them at her favorite local restaurant. They arrived late, and seemingly irritated, she avoided conversation with Rosset and yet appeared animated and even intimate in her connection with Myers; Mitchell seemed unconsciously—or possibly deliberately—to want to distance herself from Rosset and perhaps from the painful emotions that persisted between them. She refused to show them her studio (fig. 22). Rosset was in France to visit Samuel Beckett, who was ill and would die within months; it also turned out to be the last time he saw Mitchell. Their correspondence between that last visit and Mitchell's death combined painful and loving emotions. They clearly remained connected, in their fashion, until the end.[73]

In the last few years of Mitchell's life, she returned to literature and poetry as a means of turning away from relationships, and from her often vindictive or paranoid thoughts: she still wanted to work and needed to fight against her morbidity, to replenish her creative sources. She deepened her knowledge of Wallace Stevens and developed a particular passion for Hugo von Hofmannsthal's *Lord Chandos Letter* and Rilke's *Letters on Cézanne*. A first novel by a woman in her sixties, Harriet Doerr's *Stones for Ibarra*, had captivated her years before, and she reread it more than once. She read the works of V. S. Naipaul and, oddly,

returned to one of her earliest-discovered texts on modern art, Anton Ehrenzweig's *Hidden Order of Art*.[74] She read and reread Beckett's work, especially his 1959 radio play, *Embers*, which she knew practically by heart, and whose text she and Beckett had considered bringing out in a small edition with some of her etchings. She eventually concluded that her images were supererogatory and abandoned the project.

Despite the many tribulations of the last decade of Mitchell's life, her physical powers seemed to increase, rather than diminish, during the mid-1980s and to intensify spasmodically as late as 1991 and 1992. She continued to work in her garden when she could, and she continued faithfully to exercise at home, especially keeping up her stomach crunches. While she seemed frail to most of her friends and acquaintances, and the problems with her hips could make her appear disabled, she managed to galvanize her energies when needed in the studio. One of the great physical tours de force of her later years is the unheralded canvas *Then, Last Time No. 4* (pl. 52). This painting distills her knowledge of the broad brush stroke, of how to lay down large, calligraphic marks on canvas in a hugely active and yet *essentialized* spirit. She limits herself here to two colors: green and blue. The top portion of the picture masses juicy, richly green swaths of paint that seem effortlessly and yet powerfully laid down. This passage surmounts a tumultuous, curling, pyramidal structure of blue paint. The lower blue figure seems to tumble, both up and down, creating a foundation that both supports and floats free from the discrete passage of green brushwork. The two areas relate to each other but do not intertwine in the manner of most of her other paintings. *Then, Last Time No. 4* is a work whose clarity, strength, and apparent "one-off" quality distinguish it from most of her other work. Its broad muscularity balances its calligraphic lyricism, creating a strikingly monolithic yet complex gestalt.

In the late 1980s Mitchell produced a number of diptychs whose risky palettes and searing, intricate brushwork signal a sporadic burst of physical energy she seemed determined not just to employ, but to escalate. *No Birds* (1987–88; pl. 54) makes a direct reference to Vincent van Gogh's fascination with crows and with sunflower fields. Its palette of yellows surmounted by blackish green brush strokes, invoking a botanical world devoid of birds, bows to van Gogh while it succumbs to its own special obsession with yellow and its uses. Crows, the birds of death, are implied,

not stated. Far from the sunny or ecstatic atmosphere Mitchell achieved in her exhaustive exploration of yellows during the late 1970s, *No Birds* evinces a strangely ominous feeling. Its aerated composition and sharply, almost violently deployed brush strokes make it a singularly foreboding picture.

At the same time Mitchell continued to create some of the most assuredly opulent paintings of her career. One of the most fully achieved, strictly Abstract Expressionist compositions of her late period is *South* (1989; pl. 56), a diptych whose allover, replete palette and driving brushwork hark back to some of the artist's most completely resolved works of the 1950s. For this work, she summoned all the old chops, showing herself and her audience one last time that her life as a disciple of de Kooning and Pollock and the rest had paid off. *South* has none of the temperamental ambivalence of most of her other large-scale works of the last four years of her life, such as *No Birds*, the paintings she called Trees, or even the relatively sumptuous late Sunflowers. *South*'s energy is frantic, unmitigated, with lacerating swipes of blood-red paint crisscrossing many other layers of rapidly worked lattices of pattern and chromatic incident. It buzzes and weaves.

In contrast, the bold and highly charged *Sunflowers* (1990–91; pl. 57), one of several richly worked late compositions, reverts to firm structural discipline. These end-of-life paintings contain massed, ball-like passages, like grids of crumpled paper or piles of hay in a field. *Sunflowers*' firmly controlled structure works contrapuntally to a sort of banked energy, an internalized heat. The Sunflower pictures, like her several Tree and Champs paintings of the 1990s, embody Mitchell's final synthesis of her decades of excruciatingly hard-won expertise as a painter. She achieves an explication of all she has mastered in the intricate, ornate, recalcitrant style so coveted and yet so often derogated by her peers.

A relatively small (approximately nine-by-six-foot) painting of 1991, *L'Arbre de Phyllis* (pl. 58), named for her friend Phyllis Hailey, may be seen as a literal summing-up for Mitchell. This work is virtually the last of a long line of pictures whose central image is treelike, more or less centered in the field, a meditative exposition of landscape and the lush, calligraphic possibilities of oil paint on canvas. Its palette is restrained if high-keyed—mostly yellow, with her beloved green and some black-brown-blue underpinnings, anchored, as ever, by the superbly masterful use of white pigment.

After this, Mitchell veered into some extreme experiments, as if she wanted not only to begin but also to complete another ambitious series of works. Now using either the diptych or single-panel format, she invented at least two new formal, or "textual," structures: first, the strongly vertical, trunklike "trees" and, finally, an oddly festive, motile theme, usually doubled, that can only be described as evoking little whirlwinds with dangling, centered tails. Her untitled painting of 1992 (pl. 59) is one of Mitchell's last complete diptychs. Its confetti-like blitheness, its combined exuberance and delicacy, mark this work as one of the heroic penultimate statements in recent painting. Mitchell painted this work in the full knowledge of her own sickness unto death, with the weight of many recent losses, disappointments, and unfulfilled ambitions in her formidably intelligent consciousness. The indestructible joy and satisfaction of *work*, of that mastery in the studio, has to be the only true subject of this painting. A few other canvases created during the last few weeks she was able to work in the painting studio testify to her final courage and transcendence.

In early October 1992 Mitchell flew from Paris to New York to see the Matisse exhibition at The Museum of Modern Art and to finish a series of prints she was doing for Tyler Graphics in Mount Kisco. When she first arrived in New York, Kenneth Tyler, the director of the print shop, took her to a physician, who diagnosed advanced lung cancer. This doctor thought she had only a few weeks to live. According to Tyler, Mitchell seemed to accept the prognosis with equanimity; she may well have known, or suspected, that she was dying. She had been diagnosed with and treated for throat cancer years before and had recently felt weak and short of breath. But she managed to do all of the final work on the prints and generally to enjoy her weeks in New York before she returned to Paris.

Years earlier, Mitchell had established an almost familial relationship with Tyler and his second wife, Lindsay, whom she first met in 1981 and with whom she worked on several print series. At the time of her final visit to Tyler Graphics, Tyler was married to his third wife, Marabeth, who also became Joan's friend. For more than a week in October 1992, Mitchell lived in the guest suite above one of the studios at Tyler Graphics. Tyler says that every morning she would watch a public television show whose host was a landscape painter with a strong Southern drawl; in each episode

a painting would be created, from primed canvas to the emergence of a mountain scene or a seascape. Tyler remembers that she "adored that show, and she'd be in a good mood when she came down to the studio from the apartment, just out of a shower." She rarely allowed anyone to watch her work, even in the collaborative atmosphere that defines a graphic workshop, but Tyler recalls, "when I got a rare chance to see her drawing, the fluidity and strength of her movement was extraordinary. It wasn't Motherwell's automatism—it was considered, deliberate." In the process of making an etching or lithograph, "she accepted everything quite slowly—normally color was trial-and-error. If the drawing was wrong, she'd throw it out. She wouldn't even try to correct. The second sessions would produce broader strokes. That's true of her paintings as well. I got a lesson in paintbrushes one day, explaining to me how different sizes and textures of brushes produced different results. The tool was always important to her. She criticized others' work technically: 'There's your one-sized brush painting for you.'"[75]

Before Mitchell's flight back from New York to Paris on October 22, John Cheim organized a dinner for her at his apartment on Twentieth Street. A group of her friends—including Brooks Adams, Hal Fondren, Robert Harms, and Lisa Liebman—spent a long evening with her and found her in relatively good spirits.[76] After arriving in Paris, she was apparently able to return to Vétheuil briefly before entering the American Hospital in Paris. Several visitors spelled one another at her bedside during her final days, including her (and Barney Rosset's) old friend the film producer Joseph Strick, her French friends Guy Bloch-Champfort and Hervé Chandès, the young painters Philippe Richard and Frédérique Lucien, Gisèle Barreau (who was perhaps her greatest friend of the later years), and others. Strick says that he brought her wine every day, which she consumed while her nurses evidently looked the other way. Cheim, who also smuggled wine into the hospital room, remembers how whole she looked: "One afternoon the light was coming in the window, and I could see right through the hospital gown. She had an extraordinary body, strong torso, beautiful legs and hands. Except for the cancer in her lungs and throat and mouth, she was perfect."[77] She died in the hospital, heavily sedated with morphine but, according to Strick, "fighting until the last moment," on the afternoon of October 30.

1. Paul Richard, "Abstract Audacity: The Corcoran's Provocative American Biennial . . . ," *The Washington Post*, February 19, 1981, sec. D.
2. Linda Nochlin, "Tape-Recorded Interview with Joan Mitchell, April 16, 1986," transcript, Archives of American Art, Smithsonian Institution, Washington, D.C., p. 2.
3. Ibid., pp. 2–3.
4. Joan Mitchell saved many of her mother's unpublished manuscripts, as well as her correspondence with prospective publishers and producers. Courtesy Estate of Joan Mitchell.
5. Catherine Flohic, "Joan Mitchell," in Flohic et al., *Ninety: Art des Années 90/Art in the 90's. Joan Mitchell*, no. 10 (Paris: Eighty Magazine, 1993), p. 3.
6. Marcelin Pleynet, "Joan Mitchell in France: Painting and Poetry," in *Joan Mitchell*, exh. cat. (Valencia, Spain: IVAM Centre Julio González, 1997), p. 28.
7. Nochlin, "Tape-Recorded Interview with Joan Mitchell," p. 5.
8. Barney Rosset, from the book proposal for his memoir, "Subject Is Lefthanded" (2001), p. 3.
9. Nochlin, "Tape-Recorded Interview with Joan Mitchell," p. 6.
10. Irving H. Sandler, "Is today's artist with or against the past? Part 2, Answers by: David Smith, Frederick Kiesler, Franz Kline, Joan Mitchell" (interviews), *Art News*, 57 (September 1958), p. 41.
11. Flohic, "Joan Mitchell," p. 3.
12. Nochlin, "Tape-Recorded Interview with Joan Mitchell," p. 6.
13. Ibid., p. 7.
14. Ibid., pp. 8–9.
15. Ibid., pp. 11–12, 10.
16. Zuka Mitelberg, interview with the author, Paris, September 26, 1999.
17. Nochlin, "Tape-Recorded Interview with Joan Mitchell," p. 12.
18. Richard Milazzo, from the book proposal for "Caravaggio on the Beach: Essays on Art in the 1990s," p. 7.
19. Rosset, proposal for "Subject Is Lefthanded," p. 7.
20. Mitchell to Rosset, February 24, 1947; courtesy Rosset.
21. Rosset, interview with the author, New York, May 1999.
22. Milazzo, proposal for "Caravaggio on the Beach," p. 8.
23. Nochlin, "Tape-Recorded Interview with Joan Mitchell," p. 13.
24. Judith E. Bernstock, *Joan Mitchell*, exh. cat. (New York: Hudson Hills Press, in association with the Herbert F. Johnson Museum of Art, Cornell University, 1988), p. 17.
25. Nochlin, "Tape-Recorded Interview with Joan Mitchell," p. 15.
26. Ibid., pp. 15–16.
27. Milazzo, proposal for "Caravaggio on the Beach," p. 11.
28. Grace Hartigan, interview with the author, Baltimore, June 18, 2001.
29. Nochlin, "Tape-Recorded Interview with Joan Mitchell," p. 16.
30. Ibid., p. 20. One wonders if Mitchell's citing the amount of her annual dues reflected an act of condescension by the male members, whose dues were higher.
31. Hartigan, interview with the author.
32. Nochlin, "Tape-Recorded Interview with Joan Mitchell," p. 22.
33. Hartigan, interview with the author.
34. Michael Goldberg, interview with the author, New York, April 27, 1999.
35. Paul Brach, "Fifty-Seventh Street in Review: Joan Mitchell," *Art Digest*, 26 (January 15, 1952), pp. 17–18; Thomas B. Hess, "Sensations of Landscape," *New York* (December 20, 1976), p. 76.
36. Nochlin, "Tape-Recorded Interview with Joan Mitchell," p. 26.
37. Sandler, "Mitchell paints a picture," *Art News*, 56 (October 1957), pp. 45, 70.
38. Nochlin, "Tape-Recorded Interview with Joan Mitchell," p. 33.
39. Sandler, "Mitchell paints a picture," p. 70.
40. Hartigan, interview with the author.
41. Paul Jenkins, interview with the author, New York, May 12, 2000.

42. Nochlin, "Tape-Recorded Interview with Joan Mitchell," p. 27.

43. Mitchell recalled in later years, however, that Rubin "kicked me out of [his gallery] because [the critic Clement] Greenberg dropped me. Greenberg said, 'Get rid of that gestural horror'" (ibid., p. 45). In 1972 Mitchell told the critic Cindy Nemser that "Greenberg had done her injuries in the past and had made her career very difficult in terms of getting in with the right collectors or galleries. He and Motherwell and Frankenthaler had helped to ruin many artists—to spoil their careers by making it financially impossible for them to exist. No, she certainly had no love for the Greenberg crowd" (Cindy Nemser, "An Afternoon with Joan Mitchell," *The Feminist Art Journal*, 3 [Spring 1974], pp. 6, 24).

44. Pierre Schneider, interview with the author, Paris, September 30, 1999.

45. Nochlin, "Tape-Recorded Interview with Joan Mitchell," pp. 29–30.

46. Bernstock, *Joan Mitchell*, p. 60.

47. "Dr. James H. Mitchell Rites Will Be Held on Saturday," *Chicago Sun-Times*, February 1, 1963.

48. *Joan Mitchell: A Portrait of an Abstract Painter*. 16mm film, color; 58 minutes. Directed by Marion Cajori, produced by Christian Blackwood and Marion Cajori (New York: Christian Blackwood Productions, 1992).

49. Schneider, interview with the author.

50. Rufus Zogbaum, interview with the author, New York, May 12, 2000.

51. Nochlin, "Tape-Recorded Interview with Joan Mitchell," p. 29.

52. John Ashbery, "An expressionist in Paris," *Art News*, 64 (April 1965), p. 63.

53. Zogbaum, interview with the author.

54. Valerie Septembre, interview with the author, New York, November 10, 1999.

55. Betsy Jolas, interview with the author, Paris, September 29, 1999.

56. Nemser, "An Afternoon with Joan Mitchell," p. 5.

57. Guy Bloch-Champfort, interview with the author, Paris, July 8, 1999.

58. Yves Michaud, "Conversation with Joan Mitchell," in *Joan Mitchell: New Paintings*, exh. cat. (New York: Xavier Fourcade, 1986), unpaginated.

59. Peter Schjeldahl, "Joan Mitchell: To Obscurity And Back," *The New York Times*, April 30, 1972, p. D23.

60. Marcia Tucker, *Joan Mitchell*, exh. cat. (New York: Whitney Museum of American Art, 1974), p. 14.

61. Nochlin, "Tape-Recorded Interview with Joan Mitchell," p. 78.

62. Nemser, "An Afternoon with Joan Mitchell," p. 6.

63. Nochlin, "Tape-Recorded Interview with Joan Mitchell," p. 66.

64. Ibid., p. 32.

65. J. J. Mitchell and Chris Larson were close friends, who, with Joan's longtime friend and correspondent Joe LeSueur, were often invited to Vétheuil. Sometimes they would stay for weeks. Larson lived in Paris for a while and visited on weekends; his suicide in 1983 was a great drama and sorrow for Mitchell and her friends who cared for him.

66. Robert Miller, interview with the author, New York, November 11, 1999.

67. Nochlin, "Tape-Recorded Interview with Joan Mitchell," pp. 38–39.

68. Flohic, "Joan Mitchell," p. 4.

69. Ibid., p. 3.

70. Pleynet, "Joan Mitchell in France," p. 29.

71. Michaud, "Conversation with Joan Mitchell," unpaginated.

72. Ibid.

73. Rosset, interview with the author.

74. This was confirmed by many sources, including Harry Gaugh, "Dark Victories," *Art News*, 87 (Summer 1988), p. 159.

75. Kenneth Tyler, interview with the author, Mount Kisco, New York, April 4, 2000.

76. Robert Harms, interview with the author, New York, October 19, 2000.

77. John Cheim, interview with the author, New York, April 28, 1999.

LINDA NOCHLIN

Joan Mitchell

A Rage to Paint

Rage, violence, and anger have often been deployed as heuristic keys in interpreting the work of Joan Mitchell, especially the early work. In her catalogue of a major 1988 retrospective of Mitchell's work, Judith Bernstock tied Mitchell's 1957 painting *To the Harbormaster* to the Frank O'Hara poem from which Mitchell derived her title by referring explicitly to the lines in which water appears as the traditional symbol of chaos, creation, and destruction. Taking account of Gaston Bachelard's theory that "violent water traditionally appears as male and malevolent and is given the psychological features of anger in poetry," Bernstock went on to maintain that both Mitchell's "frenzied painting" and O'Hara's poem "evoke a fearful water with invincible form ('metallic coils' and 'terrible channels') and voice-like anger, a destructive force threatening internal and external chaos." She concluded with a reference to the formal elements in the painting that evoke the menacing mood of the poem: "the cacophonous frenzy of short, criss-crossing strokes of intense color . . . the agitation heightened as lyrical arm-long sweeps across the top of the canvas press down forcefully, even oppressively, on the ceaseless turbulence below."[1] Of *Rock Bottom*, a work of 1960–61, Mitchell herself maintained: "It's a very violent painting, and you might say sea, rocks."[2]

Of the whole group of canvases created from 1960 to 1962—including *Flying Dutchman*, *Plus ou Moins*, *Frémicourt*, and *Cous-Cous*—the artist asserted: "[These are] very violent and angry paintings," adding that by 1964 she was "trying to get out of a violent phase and into something else."[3] This "something else" was a series of somber paintings Mitchell created in 1964, works that she called "my black paintings—although there's no black in any of them."[4] In their thick, clotted paint application and somber pigmentation they constitute a break from the intensely colored, energetic, allover style of her earlier production. They also seem to mark an end to the self-styled "violent" phase of Mitchell's work and a transition to a different sort of expressive abstraction.

Issues of intentionality aside, what do we mean when we say that violence, rage, or anger—indeed, any human emotion—are inscribed in a work of art? How do such emotions get into the work? How are they to be interpreted?

In earlier art, when anger or violence is the actual subject of the work itself—as, for example, in Antonio Canova's *Hercules and Lica* (1795–1815)—the task of interpretation may seem easier, the emotion itself unambiguously present, even transparent, despite

23. Hans Namuth, *Jackson Pollock painting "Autumn Rhythm," East Hampton*, 1950. Pollock-Krasner House and Study Center, East Hampton, New York

the smooth surfaces and Neoclassical grandeur of Canova's sculpture. Yet even here, in *Hercules and Lica*, with its furious hero and horrified victim, or in the convulsive image of hands-on murder in Paul Cézanne's *Strangled Woman* (1870–72), problems of interpretation arise. Is Cézanne's painting a more effective representation of rage than Canova's sculpture simply because we can read a coded message of violence directly from the formal structure of the work, from its exaggerated diagonal composition, its agitated brushwork, its distorted style of figuration?

Clearly the problem of just what constitutes and hence is *read* as rage or any specific emotion in art becomes both more and less complicated when the painting is abstract—that is to say, when there is no explicit subject to provide a basis for interpretation. In the case of Abstract Expressionist work like Mitchell's, even the titles may prove to be deceptive or irrelevant, appended for the most part after the fact. The task of interpretation is both exhilarating and daunting, the canvases functioning as so many giant Rorschach tests with ontological or, at the very least, epistemological pretensions. Biography, in fact, often looms large in such cases precisely because of the *absence* of recognizable subject matter. The gesture seems to constitute a direct link to the psyche of the artist, without even an apple or a jug to mediate the emotional velocity of the feeling in question.

Yet despite the unreliability of biography as a means to elucidate the work of art, it cannot be altogether avoided, although it certainly must be severed from the naive notion of direct causality (for example, "Mitchell was sad because of the death of her father, so she made dark paintings"). The role of rage in the psychic makeup of the artist and her production is daunting: anger may be repressed; it may be "expressed" in a variety of ways; it may even be transformed into its opposite, into a pictorial construction that suggests to the viewer a sense of calm, joy, or elegance. In any case, its role is always mediated.

Following the general issues of rage and its expression in abstract painting is the more specific issue of *gendered* rage. For Mitchell, of course, was a *woman* abstract painter, even though, quite understandably, she did not want to be thought of as such when she painted the works under discussion. Indeed, there is an apposite story about Mitchell told by Elaine de Kooning in 1971 involving the phrase "women artists": "I was talking to Joan Mitchell at a party ten years ago when a man came up to us and

LINDA NOCHLIN

50

said, 'What do you women artists think . . .' Joan grabbed my arm and said, 'Elaine, let's get the hell out of here.'"[5] Mitchell was fleeing from what, at the time, was a demeaning categorization. Like other ambitious young abstractionists in the 1950s and 1960s who happened to be women, she wanted to be thought of as "one of the boys"—at least as far as her work was concerned. If she did not want to be categorized as a woman painter, it was because she wanted to be a *real* painter. And, at that time, a real abstract painter was someone with balls and guts.

Mitchell was one of many women trying to make it in a man's world, and on men's terms, even if they were not acknowledged as doing so. These women included painters, writers, musicians, and academics. It seems to me, then, important to examine not merely how rage might be said to get into painting or sculpture but also how it gets into women. In order to do so, it is helpful to consider the more general conditions existing for the production and valuing of women's work in the 1950s and 1960s.

Here I think it is instructive to look again at two photographs that have often been compared, and then at a third. The first is the famous Hans Namuth photograph of Jackson Pollock caught in the dancelike throes of sublime inspiration (fig. 23). It is a dynamic icon of the transcendent authority of (male) Abstract Expressionist creation. The second image, by Cecil Beaton, has been used to stand for, to put it bluntly, the corruption of the ideal (fig. 24). In it, a beautiful *Vogue* model stands before a Pollock painting, testifying to the transformation (inevitable in late capitalist society) of creative authenticity, which is a momentary illusion at best, into a saleable commodity.[6] As is usual in such visual demonstrations of social corruption—one thinks here of George Grosz's or Otto Dix's trenchant satires of Weimar society or, later, those of R. B. Kitaj—it is played out on, or with, the bodies of women—inert, passive, lavishly bedecked, sometimes nude or seminude. In Beaton's photograph the model functions as a fashionable femme fatale, embodying, so to speak, the inevitable fate of modernist subversion: the relegation of high art to the subordinate role of mere backdrop for (shudder!) feminine fashion, with fashion itself functioning as the easy-to-grasp sign of the fleeting and the fickle, high art's deplorable other.[7] Beaton's fashion photograph transformed Pollock's painting into "apocalyptic wallpaper," to borrow Harold Rosenberg's term, though in this case the wallpaper is not so much "apocalyptic" as merely pricey.

This comparison and its implications make me angry and uneasy because it is hard to side with either of these visions of art or fashion. My anger, and my uneasiness, have to do with the fact that although I was involved in contemporary art in 1951, I was a young woman who was highly invested in fashion as well. And for me, in my early twenties (only a few years younger than Joan Mitchell), a struggling instructor, a graduate student, and a faculty wife at Vassar, being fashionable was one of the things that helped me and my young contemporaries to mark our difference from the women around us in the early 1950s. Being elegant, caring about clothes, constituted a form of opposition to what I called "little brown wrenism," a disease imported from Harvard by Vassar faculty wives and their spouses along with the postwar revival of *Kinder Kirche Küche*. It was premised on a "womanly," wifely, properly subordinate look: no makeup, shapeless tweeds, dun-colored twin sets, and sensible shoes. Brilliance and ambition *had* to be marked as different. There were several possibilities: for artists like Joan Mitchell or Grace Hartigan, paint-stained jeans and a black turtleneck could be professional attire and constitute an assertion of difference at the same time. The philosopher Elizabeth Anscombe, a strong-minded British eccentric, insisted on complete menswear: jacket, tie, trousers, and shirt. I am told that a special podium, which hid the offending pants, had to be rigged up when she lectured at Barnard College.

As a woman who followed fashion, I could have told you who the model was in the Beaton photograph, just as easily as I could identify Pollock. And I could have told you who had designed the splendid gown she wore. My grandmother had given me a subscription to *Vogue* when I was still in high school, and I followed fashion, as I followed art, avidly. I certainly knew they were not the same thing, but my passionate involvement with both art and fashion (and, I might add, anti-McCarthy politics) made the fact that I was a woman, not a man (and a woman who thought of herself as different from many of the women around her), a vital differential in my relation to the elements of the Beaton versus Namuth opposition.

What, then, are we to make of the 1957 Rudy Burckhardt photograph of Joan Mitchell at work in front of her painting *Bridge* (fig. 25)? Where should it be placed? In the camp of the original, authentic creator, like the Pollock photograph, or in that of the Beaton model? The sitter here is, after all, like the model,

an attractive, slender young woman. I do not know whether Mitchell ever saw the *Vogue* photo, and she was certainly not interested in fashion, but the oppositions offered by the two images were certainly part of the context within which she lived and worked.

Different though they may be as visual objects, the position of the model in the *Vogue* picture is not so different from that of the figure in Willem de Kooning's *Woman I* (1950–52). Both Beaton's photograph and de Kooning's painting implied that woman's place was as the object of the image rather than the creator of it. Her passion was not the "rage to paint," but rather to be "all the rage." The Burckhardt photo of Mitchell, then, is something of an anomaly, the object taking over the subject position, albeit with a difference—and this despite the fact that Mitchell's body, qua body, is an athletic, dynamic, active one— as active in the picture-making process as Pollock's.[8] Yet in terms of the Namuth and Beaton photographs, she is twice "othered": once as the female "other" of the male Jackson Pollock, but once again as the female "other" of the elegant and proper female *Vogue* fashion model.

In other photos taken in front of her work, Mitchell is made to seem less self-assured, less like "one of the boys." But there is one photograph, taken in about 1953, of her with her poodle, George, that brings to mind one of the most famous youthful self-images of the artist as a young subversive, Gustave Courbet's *Self-Portrait with a Black Dog* of 1842.[9] In the photograph of Mitchell and her dog, although she is clearly the "other" of Courbet in terms of gender, she may now be seen as "same" in terms of the chosen elements of the artist's self-representation: like Courbet, she possesses her work and her dog. Mitchell's otherness, in the photograph, swerves back, in this trajectory, to identity; her rage is transformed into mastery, envisioned as a positive vector in the process of creation. For a photographic instant, at least, Mitchell is one of the boys—indeed, a very big boy, Courbet. And yet this is not a completely satisfying resolution to the dilemma of the woman artist. We do not see the brush in Mitchell's hand, after all, as we do in Courbet's in the center of *The Painter's Studio* (1854–55), and we all know, from simplified versions of Freud, if not from various artists and art critics, that the brush is the phallic symbol par excellence. Artists have even been said to paint with their pricks—and how can a woman do that? As Michael Leja has

succinctly put it: "A dame with an Abstract Expressionist brush is no less a misfit than a *noir* heroine with a rod."[10]

What a wholesome emotion rage is—or can be! "Menin aida thea peleadeo Achileus" (Sing, goddess, the wrath of Achilles). The *Iliad* starts on a high note of rage, connecting art itself—the singing of the goddess—with heroic anger. Nietzsche extolled the salutary potential of rage, above all, when it engaged the creative psyche. So did William Blake, who declared, "The tigers of wrath are wiser than the horses of instruction." Yet how unbecoming rage, and the energy generated by it, is thought to be when it comes from women. And all too often women's rage is internalized, turning the justifiable fury they feel against both the social institutions and the individuals that condemn them to inferior status not on others but on *themselves*: cutting up their own work; making it small; rejecting violence and force as possessions of the masculine ego, hence unavailable to the female artist; stopping work altogether; speaking in a whisper instead of a roar; becoming the male artist's support system. Silence has always been a viable, indeed, a golden, alternative for women artists. The fact that Mitchell, though a woman, could take possession of her rage and, like a man, transform it into a rage to paint, was an extraordinarily difficult concept for a male-dominated art world to accept.

Yet it would seem to me that rage, and its artistic corollary, the rage to paint, are both central to the project of Joan Mitchell. Mitchell herself quite overtly rejected attempts to define her work as feminine, although she came to accept the notion of feminism as a political stance. Her paintings forcefully help establish the notion of a feminine other—energetic, angry, excessive, spilling over the boundaries of the formless, the victimized, the gentle, and the passive—but battling, at the same time, those other familiar demons, chaos and hysteria, with a kind of risky, ad hoc structure.

In a long, rambling, beautifully revealing letter she wrote to me in the late 1980s, Mitchell stated: "I have lots of *real* reasons to hate . . . and somehow I can't ever get to hatred unless someone is kicking my dog Marion (true story) . . . or destroying Gisèle [a friend] etc. and then I'll bite—(I can't get to killing—my 'dead' shrink kept trying to get me there—I have never made it—my how I loved her)."[11] Perhaps Mitchell never thought of herself as angry or enraged. I do not suppose she thought of herself as a heavy drinker either. But, then again, neither did the various male artists who depended on rage and alcohol to stimulate their art—

or, at least, to make it possible for them to write or paint and not succumb to darkness and passivity.

Recently, however, women have been discovering the specificity of their rage and anger and writing about it. In 1993, in an article entitled "Rage Begins at Home," literary scholar Mary Ann Caws differentiated rage from anger, asserting: "Rage is general, as I see it, and is in that way quite unlike anger—specific or motivated by something—which can, upon occasion, be calmed by some specific solution, beyond what one can state or feel or see. Rage is . . . one of the great marvels of the universe, for it is large, lithe, and lasting. I have come to treasure my rage, as I never could my anger. My rage possessed and is still undoubtedly possessing me, from inside, and did not, does not, cannot demand that I control it. . . . Energy comes from, and is sometimes indistinguishable from this rage." Later Caws ceased to differentiate between the two, for, as she put it, "I believe they have me both."[12]

In 1992, in a special issue of *RE Search* entitled "Angry Women," Andrea Juno, in an interview with Avital Ronell, declared: "The only way a woman can escape an abusive misogynistic relationship is through full-fledged anger. Anger may also be the conduit by which women in general can free themselves from larger social oppressions." Ronell responded: "Anger must not be confined to being a mere *offshoot* of ressentimental, festering wounds, but must be a channeling or broadcast system that, through creative expression, produces a certain *community*. That image of a mythical, Medusan threat is wonderful."[13]

For Mitchell, rage, or anger, was singular, consuming. When I was with her, I could often feel rage, scarcely contained, bubbling beneath the surface of her tensely controlled behavior. Sometimes it would burst forth, finding as its object a young curator, an old friend. It was icy, cutting, and left scars. Once, when I was staying the night at her house in the country, she had an acrimonious fight with a former partner. It was terrifying; I have never seen or heard a man and a woman so angry at each other, and it went on and on, mounting in its passion, with physical violence always lurking in the background, though it never actually came to blows. I wanted to hide under the table, but I was called upon as a witness to the iniquity of first one, then the other, by the contending parties, mostly by Mitchell herself. Certainly Mitchell's rage constructed no sense of community or connection between herself and other women.[14] Yet I think we must be aware of the power of

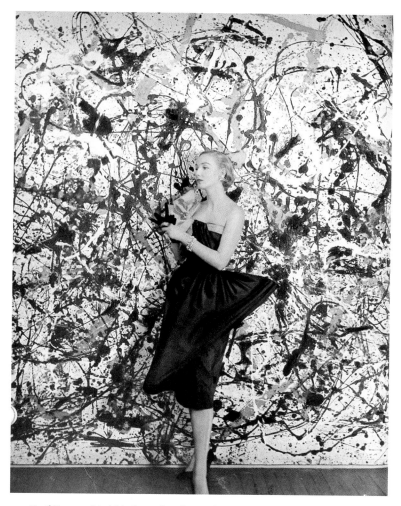

24. Cecil Beaton, *Model in front of Jackson Pollock painting*, March 1, 1951. Cecil Beaton/©*Vogue*, The Condé Nast Publications

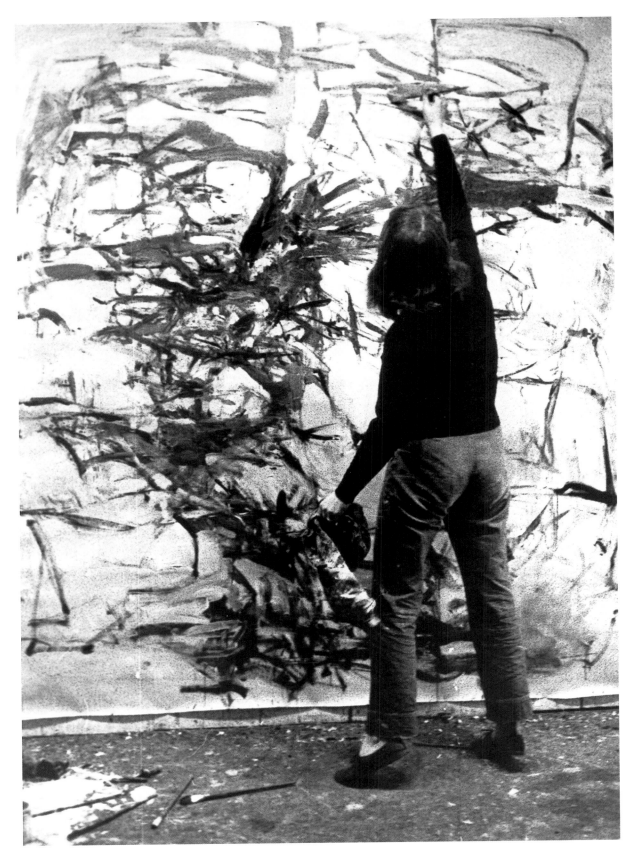

25. Rudy Burckhardt, *Joan Mitchell at work on
"Bridge," New York*, 1957. Estate of Rudy Burckhardt;
courtesy Tibor de Nagy Gallery, New York

individual anger in women's achievement, as revealed in the work of Mitchell and many others of her generation—and after.

Without Mitchell's unerring sense of formal rectitude, however, without her daring and her discipline as a maker of marks and images, her work would be without interest. I would like to look now at a series of images that have often escaped careful examination: the ten original color lithographs, drawn on aluminum plates, that the artist made in 1981 with master printer Kenneth Tyler.[15] These works are in some ways anomalous in the artist's oeuvre in that they are small-scale and are *not* executed in oil paint, Mitchell's preferred medium. And yet for that very reason, because they are, let us say, more approachable, they offer a good starting place to chart the intersection of energy and its articulation in Mitchell's work—the explicit way that meaning comes into being in her imagery. Delicacy, grace, and awkwardness are all present in varying degrees in Mitchell's subtle, nonreferential calligraphy. The constant interplay of same and different is crucial to the production of meaning in these prints, which, though visual in every respect, nevertheless share in the distinctive character of language in the way their images are constructed.

How do visual structures of similarity and difference come into play in a reading of *Bedford I* and *Bedford III*? In both lithographs a bottom layer, which we see as earth or ground, is opposed to an airier, more lightly applied blue "sky" area above. Yet the feeling or mood of each of these prints is very different, the vernal lightness, sprouting bounce, and dancing rhythms of *Bedford I* (fig. 26) produce an atmosphere utterly opposed to that of the petulant, indeed outright angry animation created by the more solid facture of the choppy ground element and the fractured sky area of *Bedford III* (fig. 27). In another print from the same series, *Flower III*, a four-color lithograph, the relationship between more densely worked and more open areas is reversed: now it is the upper portion of the image that is filled with color and incident and meshed strokes of crayon, while the bottom is sketchily adumbrated by a series of open vertical strokes that leave plenty of leeway for the white paper beneath.[16] Two polarities of Mitchell's style are demonstrated in a later group of prints she created in conjunction with Tyler Graphics. In *Sunflowers II* of 1992 two related images are juxtaposed to form a diptych. The subject is really the relation of the downpouring energy of the crayon strokes. These dark, congested rectangles have nothing in common

with Vincent van Gogh's famous flowers except the palpitating excitement of their facture, and there is something perverse about the title. These are dark sunflowers indeed; the one on the right—with its thick, blotchy smears of blue and green pigment and skinny bent supports—is especially ominous. In *Little Weeds II*, of the same date, however, the colors are brighter, the calligraphy dispersed over a broader, emptier horizontal field, the mood more frenetic, and the dynamic more centrifugal rather than contained.

From the very beginning, Mitchell's rage to paint was marked by a very specific battle between containment and chaos. In *Red Painting No. 2* of 1954 a shivering island of agitation is held in check by the composition's central focus, the mazing and amazing dynamism of the brushwork, which pulls together and layers in deep, jewel-colored skeins. A close-up detail of the upper central portion of the canvas reveals something of the complexity of Mitchell's facture, the almost excessive bravado of the gestural center compared with the cool pallor of the gridded margins, as though something wild had escaped from a cage—or needed to be pent up in one.

Mitchell's work has often been compared with that of her contemporaries and immediate predecessors. If we compare Mitchell's untitled canvas of 1956–57 with de Kooning's *Woman* of 1949–50,[17] we see that she accepted the sweep, the slash, the bravura brushwork of his style but rejected what is most striking about his image: the figuration. Comparison, of course, can bring out difference as well as similarity. Much is sometimes made of the "impact" or "influence" of Mitchell's longtime companion, the Canadian-born abstractionist Jean-Paul Riopelle, on her style. Yet I think comparison in this case brings out irrevocable difference: Riopelle's patterning is more regular, less aleatory, more allover, of equal density throughout, which gives his work a preconceived rhythmic formula utterly opposed to Mitchell's poignant visual searching.

In Mitchell's work, as I am trying to demonstrate, meaning and emotional intensity are produced structurally, as it were, by a whole series of oppositions: dense versus transparent strokes; gridded structure versus more chaotic, ad hoc construction; weight on the bottom of the canvas versus weight at the top; light versus dark; choppy versus continuous brush strokes; harmonious and clashing juxtapositions of hue—all are potent signs of meaning and feeling. It is this structural freedom and control, this complexity

26. Joan Mitchell, *Bedford I*, 1981. Lithograph on paper, 42⅝ x 32½ in. (108.3 x 85.6 cm). Walker Art Center, Minneapolis; Walker Art Center, Tyler Graphics Archive, 1983

27. Joan Mitchell, *Bedford III*, 1981. Lithograph on paper, 42½ x 32½ in. (108 x 85.6 cm). Walker Art Center, Minneapolis; Walker Art Center, Tyler Graphics Archive, 1984

of vision that accounts for the fact that, far from being a one-note painter, Mitchell explored a vast *range* of possibilities in her work, from the spreading, ecstatic panoramas to the inward-curdling "black paintings," from the totally covered canvas to the canvas enlivened only by a few dashes of calligraphy. *Field for Two* (1973) could almost be a Rothko, but a Rothko highly implicated in Hans Hofmann's "push and pull."[18] The gridded planes of color hover over and retreat from the surface of the canvas. And what colors they are: pinks, oranges, a touch of vernal green, and then those streaks of hovering darkness that so often seem designed to disrupt easy comfort or harmony in Mitchell's best canvases.

The diptych and the polyptych formats attracted Mitchell increasingly from the late 1960s on. Of course, the two-part or multipartite format was not her invention. On the contrary, it had had a long history, going back to the religious art of the Middle Ages and the Renaissance, when it often assumed heroic proportions in the traditional Christian altarpiece. More recently, in the 1950s, Pollock made use of both the diptych and the polyptych in a series of dramatic drip paintings in which strings of pigment jump over barriers and respond to similar formations in their partner paintings.[19]

But Mitchell's multicanvas creations were different from both the religious art of the past and Pollock's more recent essays into the genre. First, they constituted a response to her own need for greater spatial expansiveness, yet an expansiveness that would nevertheless be held in check by the specific dimensions of the individual panels that constituted the object.[20] Secondly, the diptych or polyptych appealed to her because of the more complex relationships it could induce: not just the play of difference and analogy *within* the single canvas, but response and reaction against another related panel, both like and different. The range of interrelated expressions was vast and open-ended.

At times the notion of landscape, and of the topographic, almost inevitably enters the mind of the viewer of Mitchell's work. There are titles—such as *Plowed Field*, *Weeds*, *The Lake*, or *River*—that conjure up a topographic or landscape experience. The fact that Mitchell lived for a great deal of her mature life in Vétheuil, on the Seine, with its splendid views already immortalized by Claude Monet (who had lived briefly in the gardener's cottage near her property), increases the temptation to ascribe specific paintings to precise locales. But it is important to keep in mind that almost all of Mitchell's canvases were titled *after* the fact, not before. Far from being a painter who worked *sur le motif*, like Monet or Cézanne, one might say that Mitchell was a painter who worked the motif in after. She discovered the analogies to something, place, idea or feeling after she had completed the work, not before. Many of the titles are facetious or arcane, like *The Goodbye Door* or *Salut Tom*. Some of them are flatly descriptive, like *Cobalt* or *Bottom Yellow*. But in all of them we are aware of what art critic Barbara Rose denominated the "struggle between coherence and wild rebellion."[21] That, if anything, is what Mitchell's paintings are "about." As such, they constitute a pictorial palimpsest of multiple experiences; they are never perfect, finished objects. From their brazen refusal of harmonious resolution rises their blazing glory.

In a wonderfully suggestive article about Virginia Woolf and Duke Ellington published in the *New York Times*, cultural critic Margo Jefferson turned her thoughts to "the place of beauty and fury in Woolf's work," explaining that "beauty restores and fury demolishes in her novels. The bond between them . . . is so psychically fraught it remained muted, even subterranean." But, Jefferson continued, "Like grief or longing or moments of transcendence, . . . anger can be changed into something else and made new." She ended her piece by asserting that "elegy and fury [may exist] side by side, beauty and the heart of darkness sharing one language."[22] How apt a description this is of Joan Mitchell's painting at its best, an art in which rage and the rage to paint so often coincide and, indeed, share the same ever-questing, always unformulaic pictorial language.

1. Judith E. Bernstock, *Joan Mitchell*, exh. cat. (New York: Hudson Hills Press, in association with the Herbert F. Johnson Museum of Art, Cornell University, 1988), pp. 47, 51.

2. Joan Mitchell, cited ibid., p. 57.

3. Ibid., p. 60 n. 4.

4. Mitchell, in *Joan Mitchell: ". . . my black paintings . . ." 1964*, exh. cat. (New York: Robert Miller Gallery, 1994), unpaginated.

5. Elaine de Kooning and Rosalyn Drexler, "Dialogue," in *Art and Sexual Politics: Women's Liberation, Women Artists, and Art History*, ed. Thomas B. Hess and Elizabeth C. Baker (New York: Collier, 1973), p. 56.

6. See T. J. Clark, *Farewell to an Idea: Episodes from a History of Modernism* (New Haven: Yale University Press, 1999), pp. 302–08, figs. 177, 178. Serge Guilbaut used one of the Beaton photographs for the cover of his *Reconstructing Modernism: Art in New York, Paris, and Montreal, 1945–1964* (Cambridge, Massachusetts: The MIT Press, 1990).

7. Although, it must be admitted, fashion was greatly admired by some of high modernism's greatest supporters, beginning with the French poet Charles Baudelaire, who claimed that fashion constituted an essential half of beauty itself and wrote an essay in praise of *maquillage*. Likewise, the poet Stéphane Mallarmé wrote for a fashion journal.

8. Mitchell had been a successful ice-skater and always moved with assertive energy and economy. Burckhardt, unlike most of his contemporaries, photographed quite a few women artists. Besides a whole series of images of Mitchell in 1957, he photographed Ann Arnold, Nell Blaine, Elaine de Kooning, Jane Freilicher, and Marisol.

9. See Bernstock, *Joan Mitchell*, p. 212, for the photograph *Joan Mitchell and George, New York* (c. 1953).

10. Michael Leja, *Reframing Abstract Expressionism: Subjectivity and Painting in the 1940s* (New Haven: Yale University Press, 1993), p. 262.

11. Mitchell, correspondence with the author, undated.

12. Mary Ann Caws, "Rage Begins at Home," *Massachusetts Review*, 34 (Spring 1993), pp. 65–66.

13. Andrea Juno, interview with Avital Ronell, "Angry Women," *RE Search* (1992), p. 151.

14. It is hard to think of any sort of utopian community built solely on the power of rage!

15. These works are reproduced with an essay by Barbara Rose, in *Joan Mitchell: Bedford Series. A group of ten color lithographs* (Bedford, New York: Tyler Graphics, 1981).

16. See ibid., p. 15, for illustration.

17. See *Joan Mitchell: Paintings 1956 to 1958* (New York: Robert Miller Gallery, 1996), unpaginated (the painting is the third one illustrated). De Kooning's painting is located at the Weatherspoon Art Gallery, University of North Carolina, Greensboro.

18. Mitchell's *Field for Two* is in the collection of Joanne and Philip Von Blon.

19. See, for example, Pollock's *Silver and Black Diptych* of c. 1950 or his *Black and White Polyptych*, a five-panel piece of 1950.

20. It is interesting to note, in relation to the concept of spatial expansion, that Mitchell never, to my knowledge, worked on the floor like Pollock. She and her canvases had a vertical, one-to-one relationship. Although the paint might be freely and broadly manipulated, and it certainly dripped to good effect, this was not a result of the artist standing over the support and "dominating" it, so to speak.

21. Rose, in *Joan Mitchell: Bedford Series*, p. 6.

22. Margo Jefferson, "Revisions: Fearlessly Taking a Fresh Look at Revered Artists," *The New York Times*, November 1, 1999, sec. E.

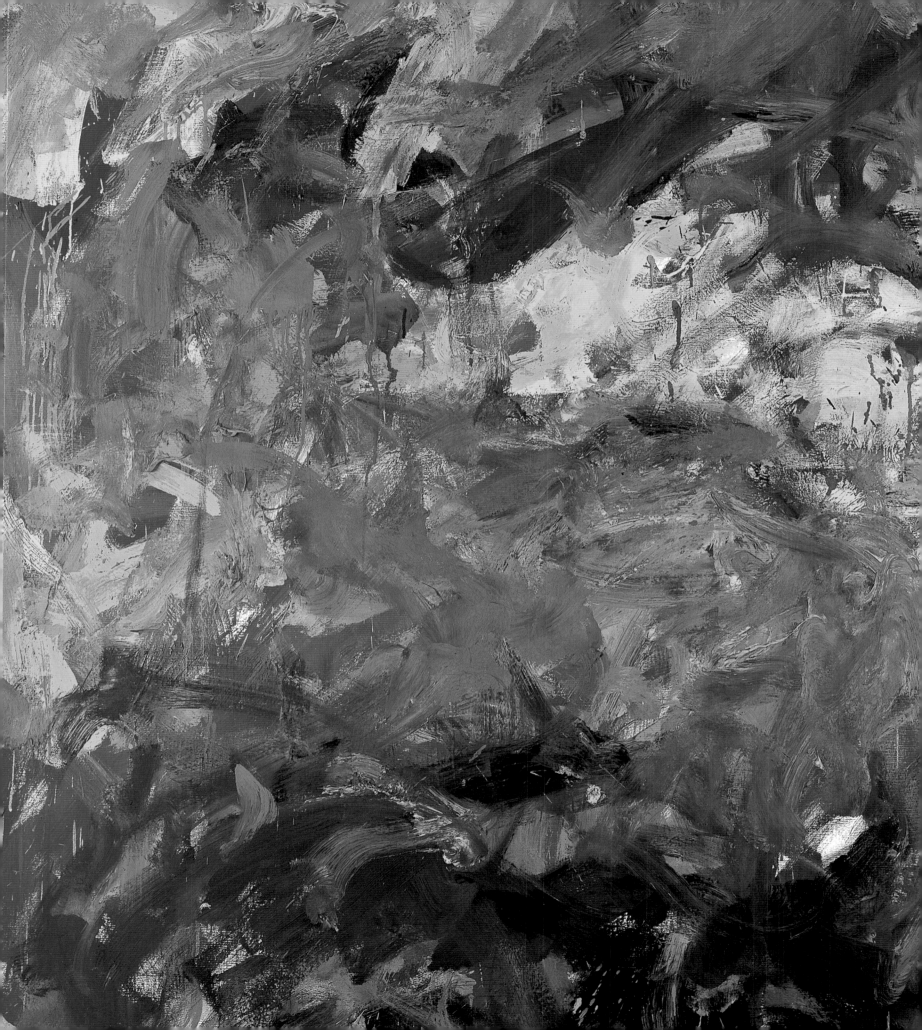

YVETTE Y. LEE

"Beyond Life and Death"

Joan Mitchell's Grande Vallée Suite

Terre magique de l'enfance: harmonie, refuge, abri, quiétude.
Premiers concerts d'insectes, de grenouilles, d'oiseaux, de brises.
Territoires-couleurs: prés vert d'eau, jaunes, bleus, cobalt violet,
douves sombres, fritillaires-damiers par milliers. Vent.
. .
Terre commune transmutée, pure peinture, son essence ainsi affirmée.

Les Toiles, chacune et chacune, sublimes, se sont embrasées,
cathédrales sonores luminantes, radieuses.

Magical childhood land: harmony, refuge, shelter, tranquility.
First concerts of insects, frogs, birds, zephyrs.
A color-filled land: water green meadows, yellows, blues, cobalt
violet, somber ditches, fritillaries by the thousands. Wind.
. .
A common land transformed, pure painting, its soul thus affirmed.

The paintings, each and every one, sublime, ignited into luminous,
resonant, radiating cathedrals.

—Gisèle Barreau, from "La Grande Vallée"[1]

La Grande Vallée is the name given to Joan Mitchell's monumental suite of twenty-one paintings created between autumn 1983 and autumn 1984 in two phases; these works are numbered sequentially from zero to twenty.[2] More than any other body of work in Mitchell's career, La Grande Vallée represents a group of related images that closely resemble one another in spirit and palette and are clearly intended as a unified entity. Collectively the twenty-one works convey an idyllic vision of the joy and innocence of youth, suggesting childhood's fleeting intimations of eternal paradise.

The title La Grande Vallée comes from a story told to Mitchell by her close friend Gisèle Barreau, who grew up thirty miles west of Nantes, in Brittany, France. As a child Gisèle discovered a beautiful hidden valley some eight miles from her house. The valley provided a refuge from her troubles at home; there she spent some of the most precious days of her childhood. Local villagers had referred to this spot as "La Grande Vallée" since the 1950s. It was a wild and untouched land that could be explored only by those who knew the location of the secret entrance. Gisèle's grandmother had introduced her to the valley, telling her how to find it: "When you see the big oak tree, turn left, step over the log, pass the abandoned barn, and then make your way through the opening in the bushes to the right." Gisèle would ride her bicycle to this haven free from cars and people. One could not see the Loire but could feel its dampness in the air and in the ground, and the reeds signaled that the river was nearby.

The valley was undisturbed except for the cows that grazed on its grass, the insects whose buzz filled its air, and the eight-year-old girl who roamed its expanse. Gisèle could walk or ride her bicycle there all day long and still not pass the same spot twice. Tall blades of green grass, fields of yellow dandelions, and other brightly colored wildflowers formed the vast terrain that enveloped the timid little girl. Here she conversed with the animals from sunset to sundown, enjoying the daily symphonies performed by birds, frogs, insects, and the wind in the trees. For Gisèle, who was to become a distinguished musician and composer, the valley offered a rich acoustic environment and a visual pageant of seasonal colors: deep blues, bright oranges and yellows, cobalt violet, green, and pink.

The only person with whom Gisèle shared her secret was her cousin Jean-Philippe. There was a special bond between the two

cousins, and Gisèle knew that the innocent Jean-Philippe would immediately sense the magic of the Grande Vallée. Together the two children explored its every corner; it became their shared paradise. When she was ten, Gisèle was sent away to boarding school in Nantes, and her visits to the valley became less frequent. In fact, her last visit occurred when she was a young teenager. Nevertheless, to this day Gisèle preserves the tender image of the Grande Vallée in her mind and heart.[3]

Gisèle Barreau met Joan Mitchell in New York in May 1979 and soon thereafter took up residence with the painter at Vétheuil, near Paris, to compose music and help care for Mitchell's house, studio, and dogs (fig. 28). From that time forward, Barreau frequently shared with Mitchell her stories and memories of the Grande Vallée. Much like Barreau, Mitchell needed a private haven. She loved the idea of a secret territory inaccessible to all others, where one could roam, uninhibited, and she developed her own vision of this place, later recalling: "In 1984, when I painted the Grande Vallée series, I was completely taken by the visual image. I never saw this place called the Grande Vallée, but I could imagine it."[4] For Mitchell, the valley came to represent complete freedom from facades and boundaries, and harmony with nature.[5]

Mitchell may also have seen the valley as a refuge from mortality. In July 1982 her only sister, Sally Perry, to whom she was very close, died of cancer at the age of fifty-eight (fig. 29). Just three days before that traumatic event, Barreau's cousin Jean-Philippe had also died of cancer at the age of twenty-eight. Shortly before his death Jean-Philippe had asked Gisèle to take him once more to the Grande Vallée. He died before that wish could be granted.

Barreau's captivating story of youth and innocence, made more poignant by Jean-Philippe's and Sally's deaths, prompted Mitchell to create a series of paintings that would attempt to capture the luminosity, wildness, and freedom of this sanctuary seen through a child's eyes and inevitably aggrandized by memory. The chromatic lyricism of the paintings conveys a world of dreamlike innocence, nostalgia, and sublime liberation. Distinguishable from works that appear to reflect Mitchell's preoccupation with death and fear of abandonment, such as Calvi (1964; pl. 27), the Grande Vallée paintings can be seen as representing a triumph over mortality.

Mitchell constantly felt surrounded by death.[6] She confessed:

"I am afraid of death. Abandonment is death also. I mean: somebody leaves and other people also leave. I never say good-bye to people. Somebody comes for dinner and then leaves. I am very nervous. Because the leaving is the worst part. Often in my mind, they have already left before they have come." Her awareness of death eventually forced her to find a means of overcoming her despair. "I think any involvement of any kind is to forget not being alive," she explained. "Painting is one of those things."[7] Painting and working with colors became an absolute necessity, *nourriture* that fed her hunger to live.

Indeed, Mitchell saw the act of painting itself as a means of transcending death. She said, "Painting is the opposite of death, it permits one to survive, it also permits one to live."[8] She would immerse herself so deeply in her work that she was no longer conscious of herself: "I am certainly not aware of myself. Painting is a way of forgetting oneself." Moreover, viewing paintings by other artists also provided Mitchell with a way of forgetting herself and her morbid preoccupations. She recalled going to the Édouard Manet show in Paris in 1982: "My sister had just died and a friend of mine's cousin had just died and it was terrible, but seeing all these paintings, some from my Chicago childhood, with all that silence and no time involved, no terminations, was wonderful. There was no sadness, no death. It was still."[9]

Barreau commented that for Mitchell, "painting is like music —it is beyond life and death. It is another dimension."[10] And indeed the lush, organic quality and radiating light that emanate from the Grande Vallée paintings can seem otherworldly. Mitchell did not portray true likenesses of landscapes, nor did she exactly attempt to represent nature. What she strove for instead, as Yves Michaud has noted, was to capture the emotion that a landscape inspired in her: "The landscape is nothing more than a meditation on evoked feeling, a metaphor of existential experience. This is complex, for here enter notions of nature, colors, and visual mass, not to mention the tone of days, the suggestion of death, the emotional domain of the painter. For Joan Mitchell, places are more than places: they are filled with people, beings, memories of them."[11] As strongly as Mitchell felt the presence of death, this very awareness seems to have compelled her to create paintings that express her engagement with life. Thus, although she conceived the Grande Vallée suite in part for Sally and Jean-Philippe, five of the works (those numbered sixteen through twenty) were

28. Elga Henzen, *Gisèle Barreau and Joan Mitchell*, *Vétheuil*, 1982. Collection of Gisèle Barreau

29. *Joan Mitchell with her sister, Sally Perry, Vétheuil.* Courtesy Robert Miller Gallery, New York

dedicated to living friends: Carl Plansky, a fellow artist; Luc, a Dominican monk; Yves Michaud, the French philosopher and art critic; the gallerist Jean Fournier, who has represented Mitchell in Paris since 1967; and Iva, one of her dogs.

Painted entirely in Vétheuil, the Grande Vallée cycle was created in a kind of frenzy over thirteen months. The twenty-one paintings were not conceived as a series of works. (In fact, according to Barreau, Mitchell did not like the word *series*.)[12] Rather, her vision of this enchanted landscape drove her to paint, and she ceased only when she had fully exhausted all possibilities of its expression. The Grande Vallée paintings form a discrete episode within Mitchell's oeuvre, sharing a common palette as well as certain formal and stylistic traits. They represent Mitchell's most sustained exploration of the "allover" approach, in which the entire canvas is covered with color from edge to edge. Although she allowed portions of the white canvas to remain visible, the Grande Vallée paintings offer a marked contrast to those works that rely on white paint to provide the underlying structure, or those that use large areas of bare canvas.

Large-scale canvases were Mitchell's preferred format. Unlike the often spontaneous gestures of many other Abstract Expressionist painters, each of her strokes was consciously calculated at a distance before it was applied to the canvas. She had been far-sighted since the age of three, and she kept a large round "reducing glass" in the back corner of her studio to help her see her work as if from a distance (fig. 30).

Of the twenty-one paintings in the Grande Vallée cycle, five are diptychs and one is a triptych. Although in a sense the multiple panels reference a passage of time, they are intended not to be read in sequence but rather to be experienced as a whole. While the width of her studio allowed simultaneous viewing of only two large panels set side by side, Mitchell would work on a number of canvases on any given day, shifting back and forth among various works.[13] In addition to the large scale afforded by the multiple panels, she liked the vertical rhythm created by the juxtaposition of the panels: "The break between the different pieces creates a rhythm of different space and a dynamic, a vibration."[14] The multipanel works in this group of paintings stand apart from her other work in at least one technical sense: in some of them, brush strokes actually extend across the adjacent edges of panels. Mitchell's earlier multipanel works were assembled only after each panel was individually completed; each panel could therefore exist as an independent painting.

Two works serve as a prelude to La Grande Vallée: *Gently* and *Begonia*, both of which were painted in 1982. *Gently* (pl. 47) is a gemlike, almost miniature work filled with bold brush strokes of vibrant pink, green, and orange hues. Smaller patches of blue, white, and yellow dance around the periphery. Mitchell's use of the large-canvas format in the Grande Vallée cycle is anticipated in *Begonia* (pl. 46). The great expanse of the canvas is filled with interweaving strokes of radiant yellow, orange, pink, and green. In their "alloverness," palette, and spirit, these two works offer an introductory glimpse of the twenty-one works that follow.

A number of the Grande Vallée canvases appear to represent vast fields of flowers painted on a tipped vertical plane with little illusion of three-dimensional space. Particularly in this cycle of paintings, Mitchell almost completely abandoned the figure-ground relationship, filling the entire surface of the picture with short, lambent brush strokes, which in *La Grande Vallée 0* (1983; fig. 31) produce the effect of luminous yellow, orange, and pink petals that flutter and sway in the cool summer breeze. The sun drenches the wild field in a bleaching light, shifting the green grass to an almost teal hue. Despite scattered patches of black, Mitchell's lyrical blue imbues the painting with a radiating luminosity, serving to harmonize this euphoric picture.

Mitchell experimented with line, space, and color in *La Grande Vallée II (Amaryllis)* (1983; fig. 32).[15] This canvas is filled with tonal variations on green, suggesting wild vegetation, which encircle a central area of pink and purple wildflowers. It resembles a musical piece with carefully intervaled staccato notes and long, fluid phrasing. Some short brush strokes appear to have been applied with a sponge, displaying a rough, tactile texture, while other strokes are longer and the application lighter, revealing parts of the canvas below. There is a loose sense of geometric organization created not only by the placement and grouping of strokes but also by the juxtaposition of color patches, recalling Paul Cézanne's influence on Mitchell. Patches of white are scattered around the central floral area, intensifying the sense of a magical, radiating light.

Since her childhood visits to The Art Institute of Chicago, Mitchell had held Vincent van Gogh in the highest esteem. In *La Grande Vallée XIII* (1983; pl. 48), she echoed van Gogh's technique of counterpoising flecks of highly saturated, opposing

30. Jacqueline Hyde, Installation view of *Joan Mitchell: La Grande Vallée*, 1984, at the Galerie Jean Fournier, Paris. Courtesy Galerie Jean Fournier, Paris

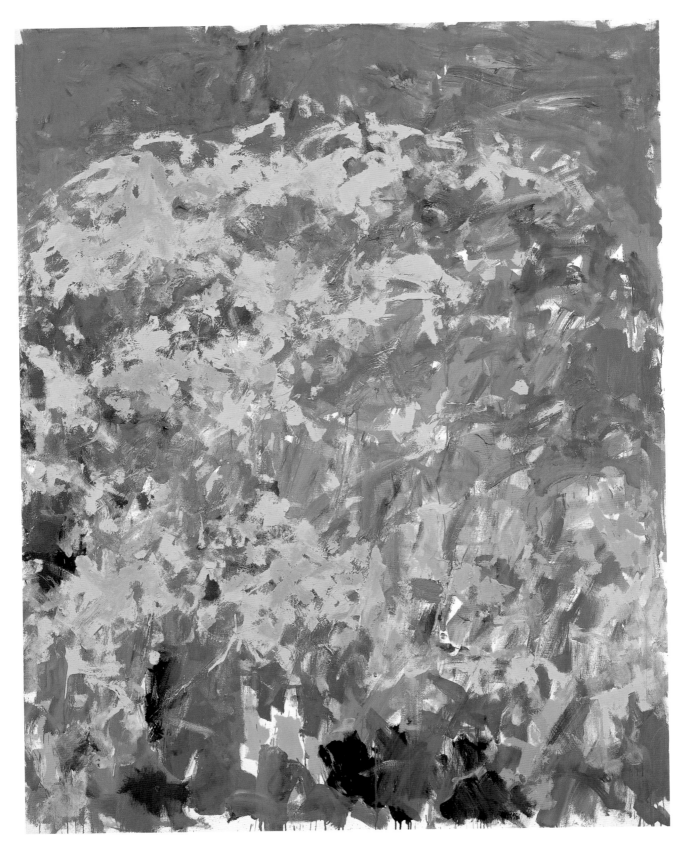

31. Joan Mitchell, *La Grande Vallée 0*, 1983.
Oil on canvas, 102 x 78¾ in. (259.1 x 200 cm).
Private collection; courtesy Edward Tyler Nahem
Fine Art, New York

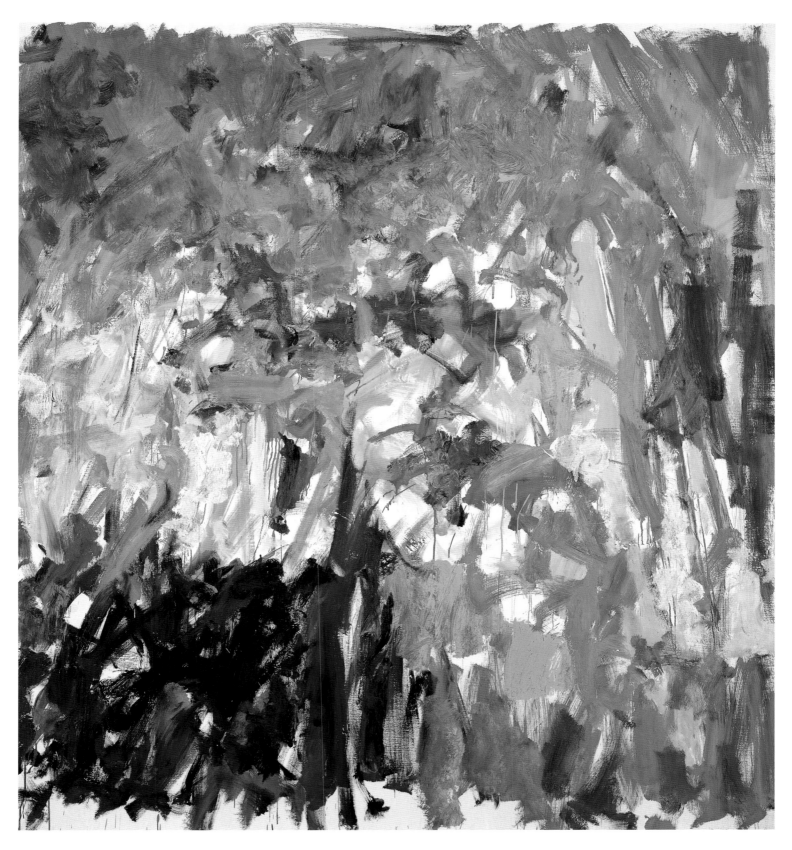

32. Joan Mitchell, *La Grande Vallée II (Amaryllis)*, 1983. Oil on canvas, 88 x 80 in. (223.5 x 203.2 cm). Private collection; courtesy Edward Tyler Nahem Fine Art, New York

colors. A sprinkling of yellow pigment vibrates on a vertical plane of broad blue, green, orange, and black brush strokes. The application of paint in the center resembles children's sponge or finger painting, the scumbled paint creating a quick-tempoed frenzy.

Several of the Grande Vallée works are divided into sections, with the top third taking over the canvas like an expanse of limitless blue sky. In *La Grande Vallée XX (Jean)* (1983–84; fig. 33), an area of light blue, deepened by hints of violet and darker blue, surmounts an arc of triumphant yellow. This work exemplifies Mitchell's habit of diluting oil paint with turpentine to create a fluid, if sometimes unstable, medium.

The size of the triptych *La Grande Vallée XIV (For a Little While)* (1983; fig. 34) sets it apart from the other Grande Vallée works. It measures approximately nineteen-and-a-half feet in width, making it comparable in scale to some of Claude Monet's Waterlily paintings. Unlike Monet, however, Mitchell did not attempt to capture a likeness to an actual landscape, and consistent with its companion paintings, *La Grande Vallée XIV* contains no central action; the brushwork is evenly spread across the canvases, from edge to edge. Similar in its circling, centrifugal energy to Henri Matisse's Dance works, the painting displays broad brush strokes that dance about in a densely interwoven pattern, causing drips to splatter quite thickly in places, while the bold areas of color emphasize a planar flatness. Applied throughout the canvas, black paint heightens a paradoxical sense of sadness and liberation. This sublime landscape may express Mitchell's momentary discovery of the serenity of death, as the subtitle—"For a Little While"—perhaps suggests.

La Grande Vallée VI (1984; pl. 50) is a diptych with bold calligraphic strokes of black amid orange, green, and violet lining the bottom. Mitchell explained: "The permanence of certain colors: blue, yellow, orange, goes back to my childhood: I lived in Chicago and for me blue is the lake. Yellow comes from here [Vétheuil]; I used very little yellow in New York and Paris. It is rapeseed, sunflowers . . . one sees a lot of yellow in the country. Purple, too . . . it is abundant in the morning; the morning, especially very early, is violet . . . when I go out in the morning, it is violet. . . . At dawn and at dusk, depending on the atmosphere, there is a superb blue horizon . . . lasting for a minute or two."[16] This early morning violet that Mitchell refers to spreads over the black darkness in this diptych, capturing a still and silent moment.

Mitchell once stated, "What excites me when I'm painting is what one color does to another and what they do to each other in terms of space and interaction."[17] Her technical expertise in the juxtaposition of colors is particularly evident in two diptychs: *La Grande Vallée VII* (1983; fig. 35) and *La Grande Vallée IX* (1983–84; pl. 49). The sheer physical quality of the execution and the bold, expressive gestures in *La Grande Vallée VII* enliven its entire surface, revealing a heightened luminosity that emanates from within the lush landscape; the juxtaposition and superimposition of brush strokes and colors cause certain areas to appear to emerge from the canvas. The application of dark, rich colors in *La Grande Vallée IX* lends a damp lushness to this sheltered haven. Barreau spoke about the fact that all the green in the springtime irritated Mitchell, as she was constantly awaiting "l'heure des bleus," or the hour of blues.[18] Like van Gogh, Cézanne, and Matisse, Mitchell developed her own brand of intense blue, and this hue dominates many of her later canvases, while green is used more sparingly.

From May 28 to July 15, 1984, the works numbered one through sixteen, the only paintings in the suite that were completed at the time, were displayed in the exhibition *Joan Mitchell: La Grande Vallée* at the Galerie Jean Fournier in Paris (figs. 36 and 37). In an interview with Linda Nochlin, Mitchell recalled, "I was sorry to see that Grande Vallée [was] split up, because it looked so nice there." When Nochlin commented that she saw the Grande Vallée as "an environment," Mitchell agreed: "It was . . . and I think that's the first, the only show I've done like that."[19]

That autumn the Galerie Jean Fournier exhibited numbers fourteen through twenty in the Grande Vallée cycle at the Foire Internationale d'Art Contemporain (FIAC), Grand Palais, Paris. Critical response to both exhibitions was overwhelmingly positive. In a review of the first exhibition, the *International Herald Tribune* cited Mitchell as "one of the most important contemporary painters living and working in France." Françoise-Claire Prodhon praised her work for both its chromatic qualities and its technical execution, noting that "a very majestic poetry" emanates from the paintings. Commenting on the presentation at the FIAC, Michael Gibson described Mitchell as "an outstanding American artist . . . whose powerful work is rooted in the heritage of color left by Monet and the bold brush strokes of action painting."[20]

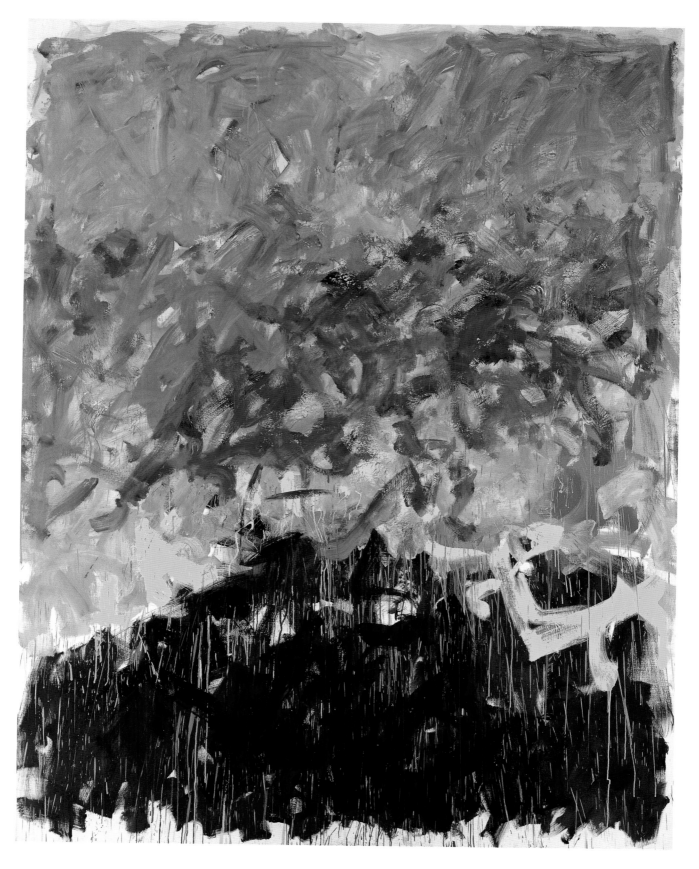

33. Joan Mitchell, *La Grande Vallée XX (Jean)*,
1983–84. Oil on canvas, 110¼ x 78¾ in. (280 x 200 cm).
Collection of Jean Fournier

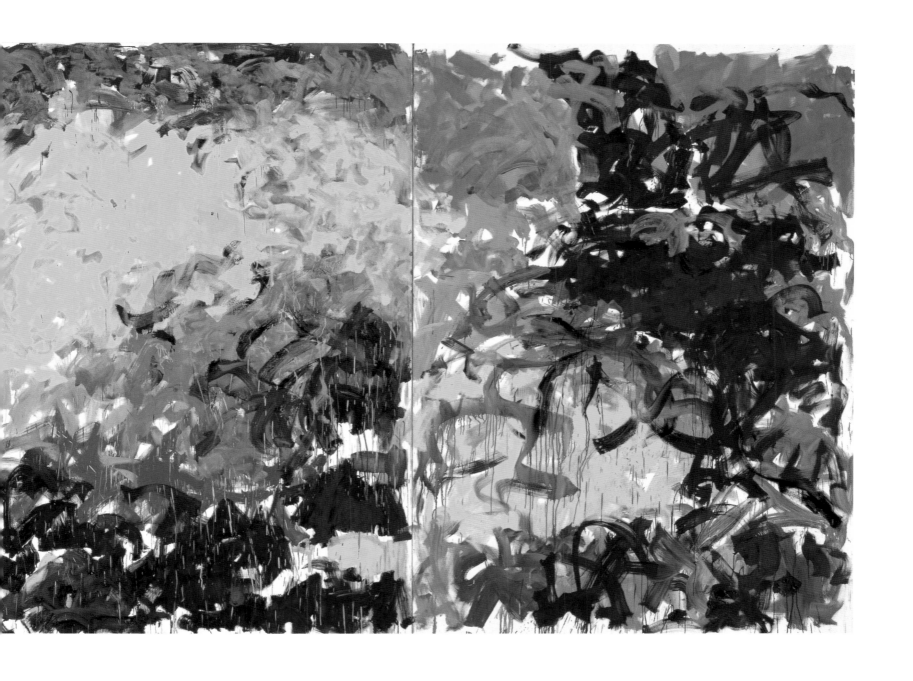

34. Joan Mitchell, *La Grande Vallée XIV (For a
Little While)*, 1983. Oil on canvas, 110¼ x 236¼ in.
(280 x 600 cm). Musée national d'art moderne/
Centre de création industrielle, Centre Georges
Pompidou, Paris

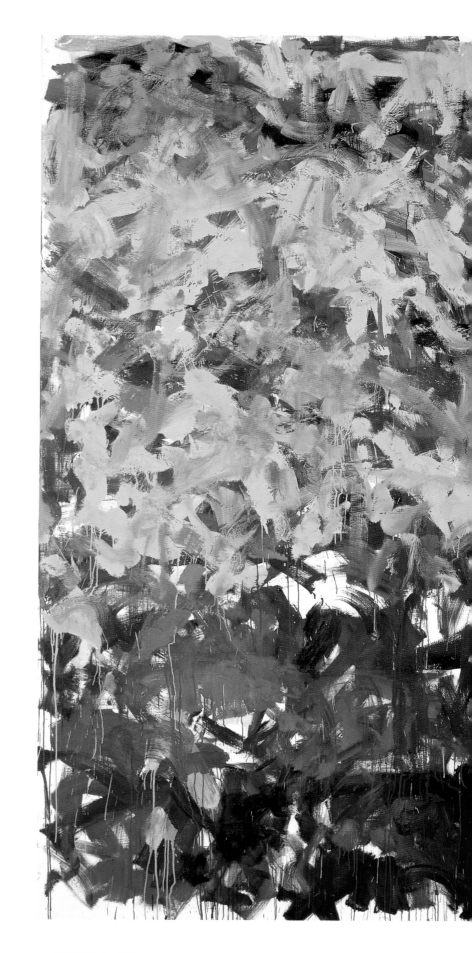

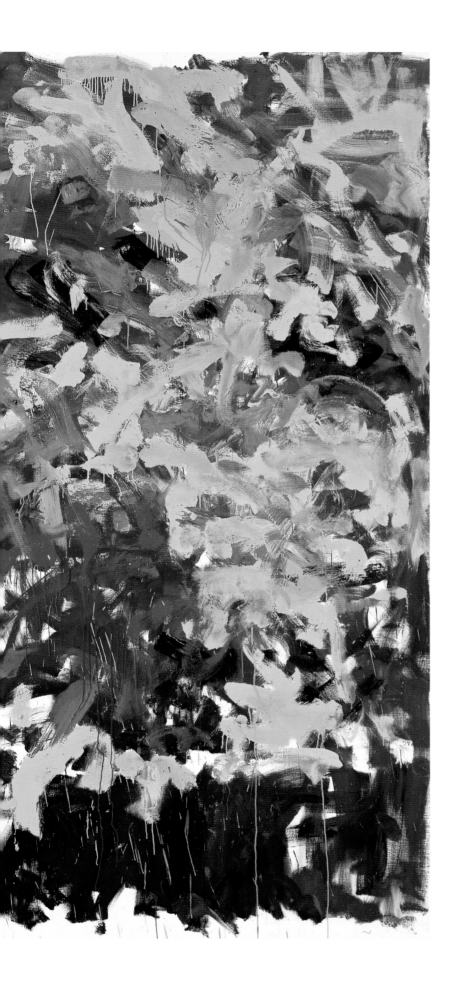

35. Joan Mitchell, *La Grande Vallée VII*, 1983. Oil on
canvas, 102⅜ x 102⅜ in. (260 x 260 cm).
Magasin 3 Stockholm Konsthall, Sweden

Although Mitchell's earlier work attracted the patronage of French collectors, this cycle of paintings seems to have struck a special chord with them. Her work generally sold better in New York than in Paris, but following these two Parisian exhibitions, paintings from La Grande Vallée almost immediately entered public and private collections in France.[21] As a result, only a small, mostly French, audience has seen the entirety of the suite, although selected works have been included in Mitchell's exhibitions in the United States and Spain. Today—with the exception of the handful of the canvases that have entered private collections in the United States, Spain, and Sweden—most of the suite remains in France.

In the catalogue for the Jean Fournier exhibition, Yves Michaud described the emotional landscape of La Grande Vallée: "An atmosphere of grief and sudden liberation as well, the intense and almost intolerable blue of the sky, the yellow and black of dying sunflowers. This evoked valley, both personal and impersonal, is comprised of multiple sensations, of sadness and expectation. It is neither real nor imaginary, but one and the other, a valley of infants and death, a place of transfigurations and meditation, maybe even the refuge of the initiated and of souls. Joan Mitchell's paintings immobilize this vibrant diversity of perceptions and feelings."[22]

Subsequent commentators have responded to the paintings' formal qualities and to the powerful feelings that they evoke. Bill Scott referred to La Grande Vallée as a "seductively lush series," while Klaus Kertess described it as seeming "to evoke creation's dawn." The works "speak in an eloquent, lyric voice that is unexpectedly, defiantly optimistic," according to Michael Kimmelman. Judith Bernstock has written, "Each La Grande Vallée painting is like a living organism, a microcosm of the universe—a world of colors suggestive of sadness and loss, hopefulness and fulfillment."[23]

La Grande Vallée signals a turning point in Mitchell's oeuvre, separating her earlier work—generally singular paintings marked by centralized motifs on sparer canvases on which white is heavily used—from her later, often more intensely worked groups of canvases. The childhood-inspired story provided the imaginative fuel for an extended investigation of the capacity of oil paint on canvas to explore the effects of light and spatial relationships, as well as an opportunity to employ gestural brushwork and variegated surface textures to convey a heightened, dreamlike reverie. It repre-

sents Mitchell at her technical best. After completing La Grande Vallée, she continued to develop her calligraphic prowess and energetic brushwork in sequential works such as the Chord, River, and Lille series. None of these, however, can match the richly inventive chromatic sensation, the life-embracing passion, and the poetic lyricism of La Grande Vallée.

1. From an autobiographical text by Gisèle Barreau; the entire text is available from CPEA, Christine Paquelet Edition Arts, France, © 2001. Unless otherwise noted, all translations are by the author.

2. The Grande Vallée works were not necessarily painted in the sequence in which they are numbered. Rather they were numbered for the exhibitions after their completion. In addition, the works numbered fourteen through twenty are considered a second phase, separate from the sixteen initial paintings in the suite (Jean Fournier, interview with the author, Paris, May 31, 2001).

3. This description of Gisèle Barreau's memories of the Grande Vallée is based on the author's interview with Barreau, Paris, May 27, 2001.

4. Yves Michaud, "Entretiens," in Joan Mitchell, exh. cat. (Nantes: Musée des Beaux-Arts de Nantes; Paris: Galerie nationale du Jeu de Paume, 1994), pp. 29–30.

5. Barreau, interview with the author.

6. Even before the death of her sister, Joan Mitchell had experienced the deaths of her parents (her father, James Herbert Mitchell, in 1963, and her mother, Marion Strobel, in 1967) and of a number of close friends, including the painter Franz Kline (1962), the poet Frank O'Hara (1966), and psychoanalyst Edrita Fried (1981).

7. Michaud, "Conversation with Joan Mitchell," in Joan Mitchell: New Paintings, exh. cat. (New York: Xavier Fourcade, 1986), unpaginated.

8. Joan Mitchell: Choix de peintures 1970–1982, exh. cat. (Paris: ARC, Musée d'Art Moderne de la Ville de Paris, 1982), unpaginated.

9. Michaud, "Conversation with Joan Mitchell," unpaginated.

10. Barreau, interview with the author.

11. Michaud, "Couleur," in Joan Mitchell: La Grande Vallée, exh. cat. (Paris: Galerie Jean Fournier, Editions, 1984), pp. 9–11; translation by James Scarborough.

12. Barreau, interview with the author.

13. Linda Nochlin, "Tape-Recorded Interview with Joan Mitchell, April 16, 1986," transcript, Archives of American Art, Smithsonian Institution, Washington, D.C., p. 38.

14. Joan Mitchell: Choix de peintures, unpaginated.

15. While most of the works in the suite are simply numbered, eight have been given titles in addition to numbers. Apart from those dedicated to friends, number two is titled Amaryllis, number fourteen is For a Little While, and number fifteen is Passage.

16. Joan Mitchell: Choix de peintures, unpaginated.

17. Michaud, "Entretiens," p. 29.

18. Barreau, interview with the author.

19. Nochlin, "Tape-Recorded Interview with Joan Mitchell," pp. 75–76.

20. Michael Gibson, "Leisure: Joan Mitchell," International Herald Tribune (Paris), June 16–17, 1984; Françoise-Claire Prodhon, "Joan Mitchell," Flash Art, no. 5 (Autumn 1984), p. 43; Gibson, "Paris Fair: One-Man Shows the Rule," International Herald Tribune (Paris), October 20–21, 1984.

21. Fournier, interview with the author.

22. Michaud, "Couleur," p. 11.

23. Bill Scott, "In the Eye of the Tiger," Art in America, 83 (March 1995), p. 74; Klaus Kertess, Joan Mitchell (New York: Harry N. Abrams, 1997), p. 37; Michael Kimmelman, "This American in Paris Kept True to New York," The New York Times, April 17, 1988, p. H43; Judith E. Bernstock, Joan Mitchell, exh. cat. (New York: Hudson Hills Press, in association with the Herbert F. Johnson Museum of Art, Cornell University, 1988), p. 192.

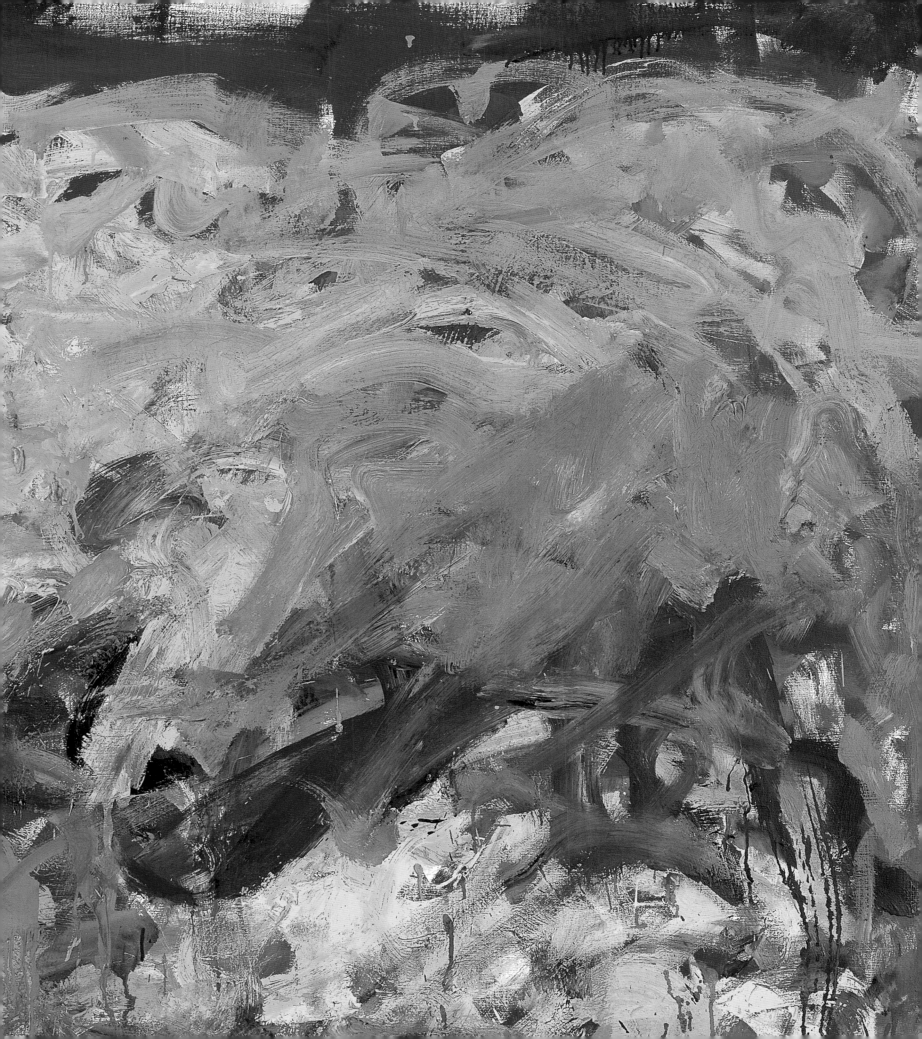

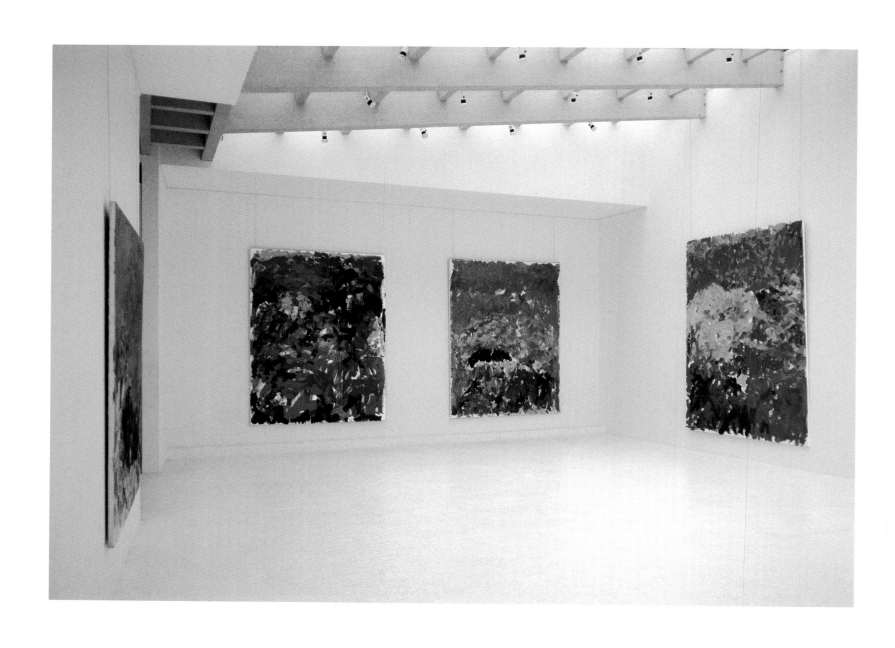

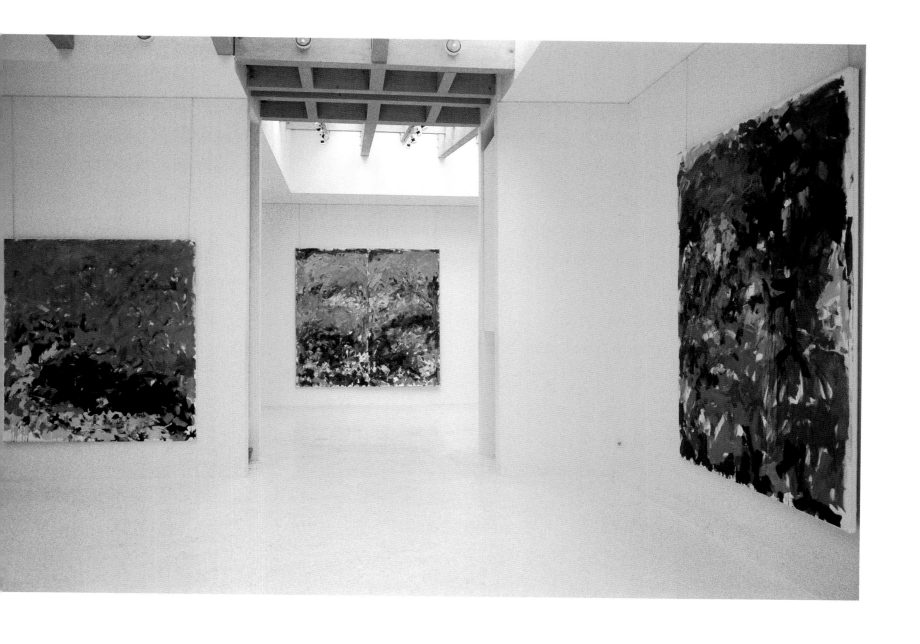

36 and 37. Jacqueline Hyde, Installation
views of *Joan Mitchell: La Grande Vallée*,
1984, at the Galerie Jean Fournier, Paris.
Courtesy Galerie Jean Fournier, Paris

JOAN MITCHELL'S GRANDE VALLÉE SUITE

77

Plates

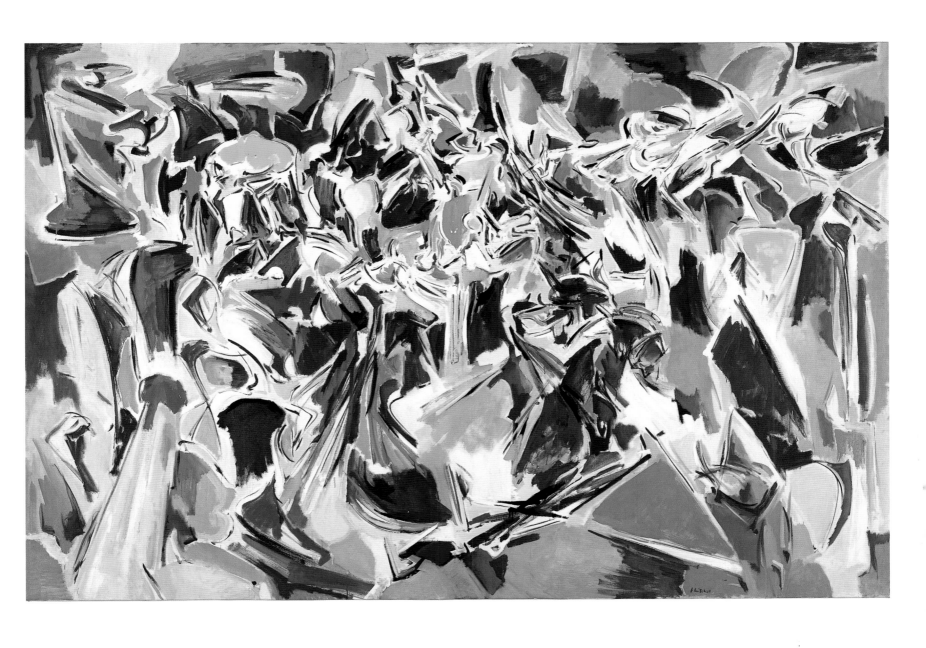

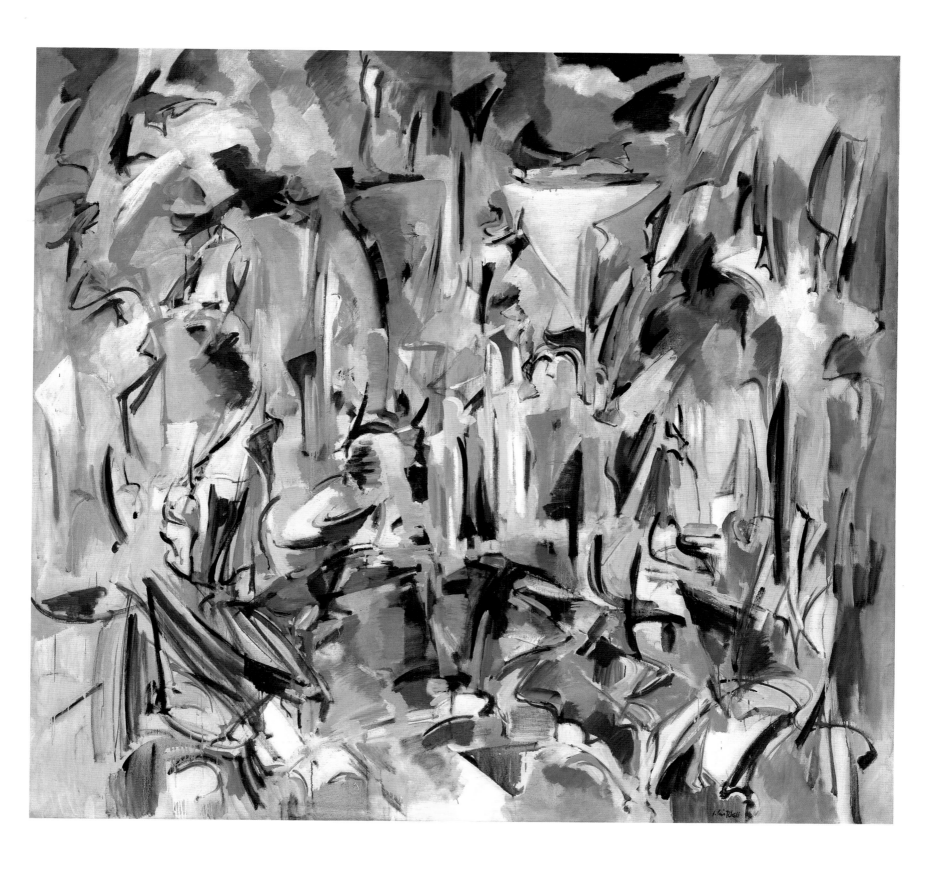

PLATE 2

Untitled, 1951

Oil on canvas, 72 x 78 in. (182.9 x 198.1 cm)

Estate of Joan Mitchell

83

PLATE 3

Rose Cottage, 1953

Oil on canvas, 71¼ x 68¼ in. (182.2 x 173.4 cm)

Collection of W. Stephen Croddy

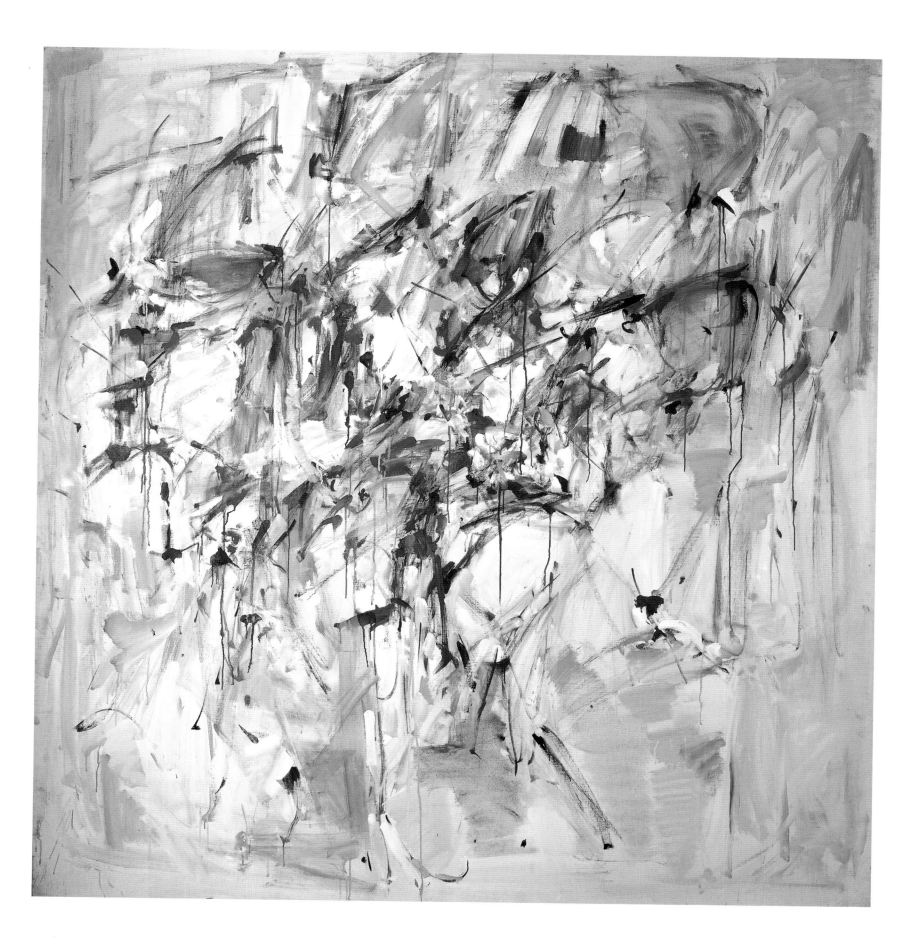

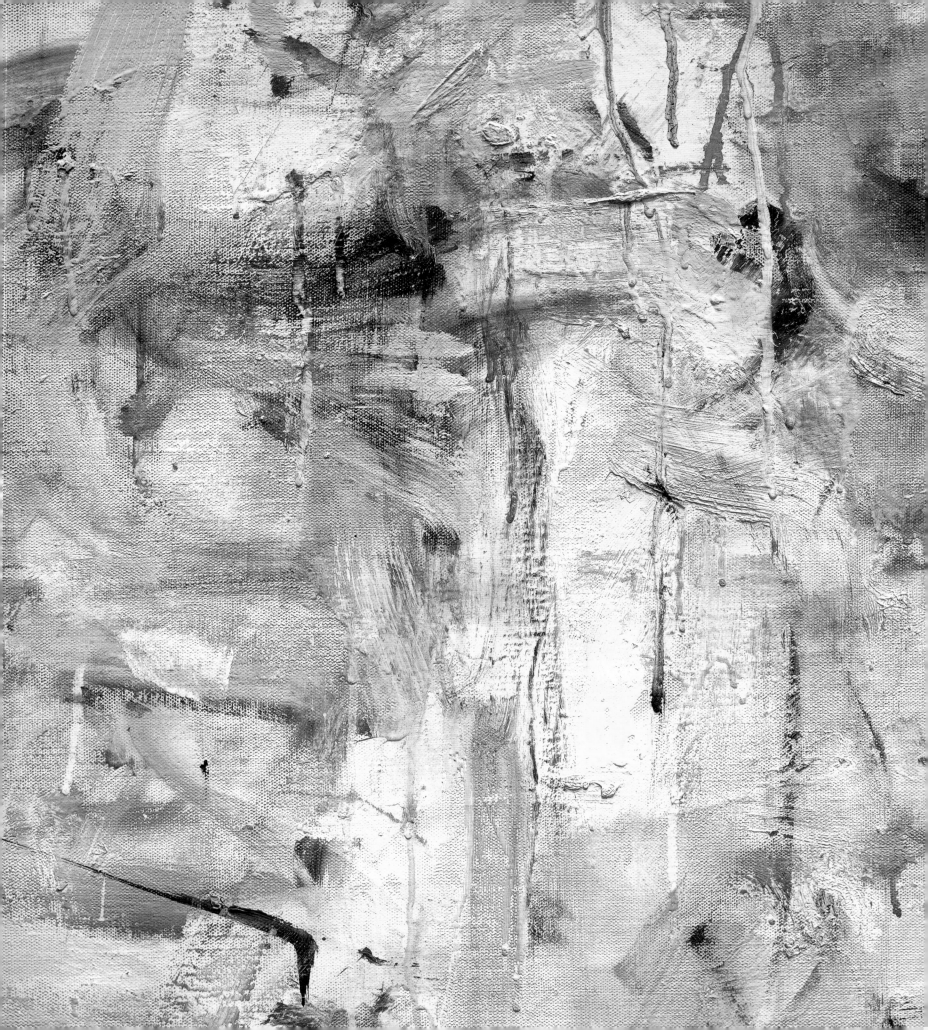

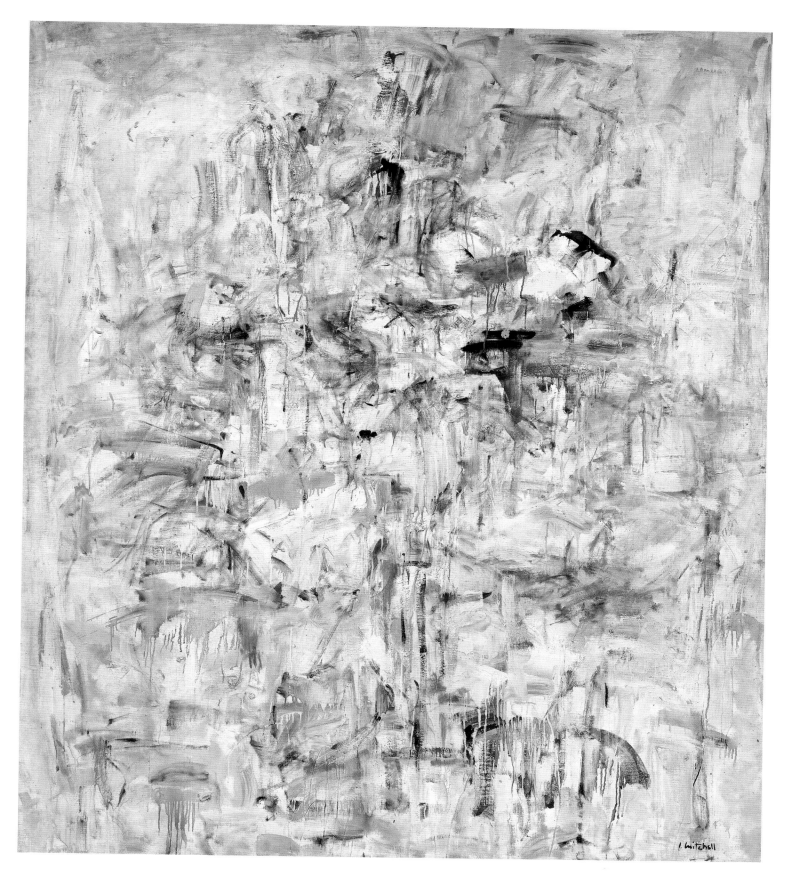

PLATE 4
Untitled, 1953–54 (detail opposite)
Oil on canvas, 81 x 69¼ in. (205.7 x 175.9 cm)
Estate of Joan Mitchell

PLATE 5

Untitled, 1954
Oil on canvas, 96 x 77 in. (243.8 x 195.6 cm)
Estate of Joan Mitchell

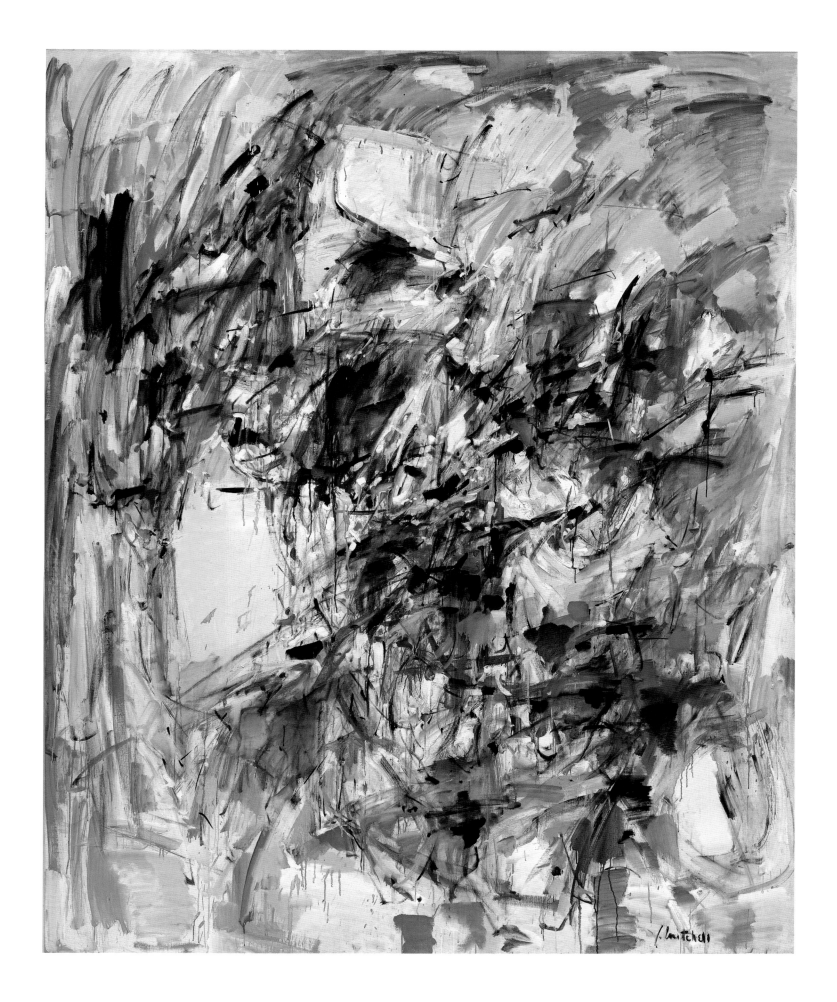

PLATE 6
City Landscape, 1955
Oil on canvas, 80 x 80 in. (203.2 x 203.2 cm)
The Art Institute of Chicago; Gift of the Society for Contemporary
American Art

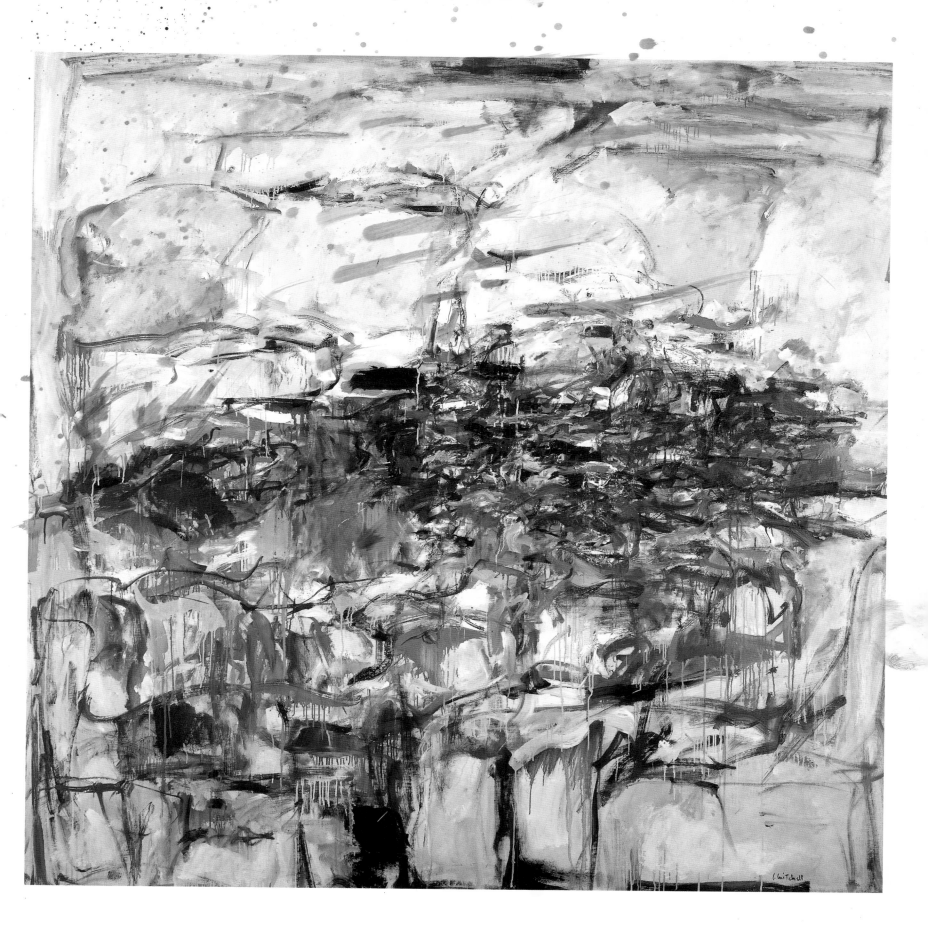

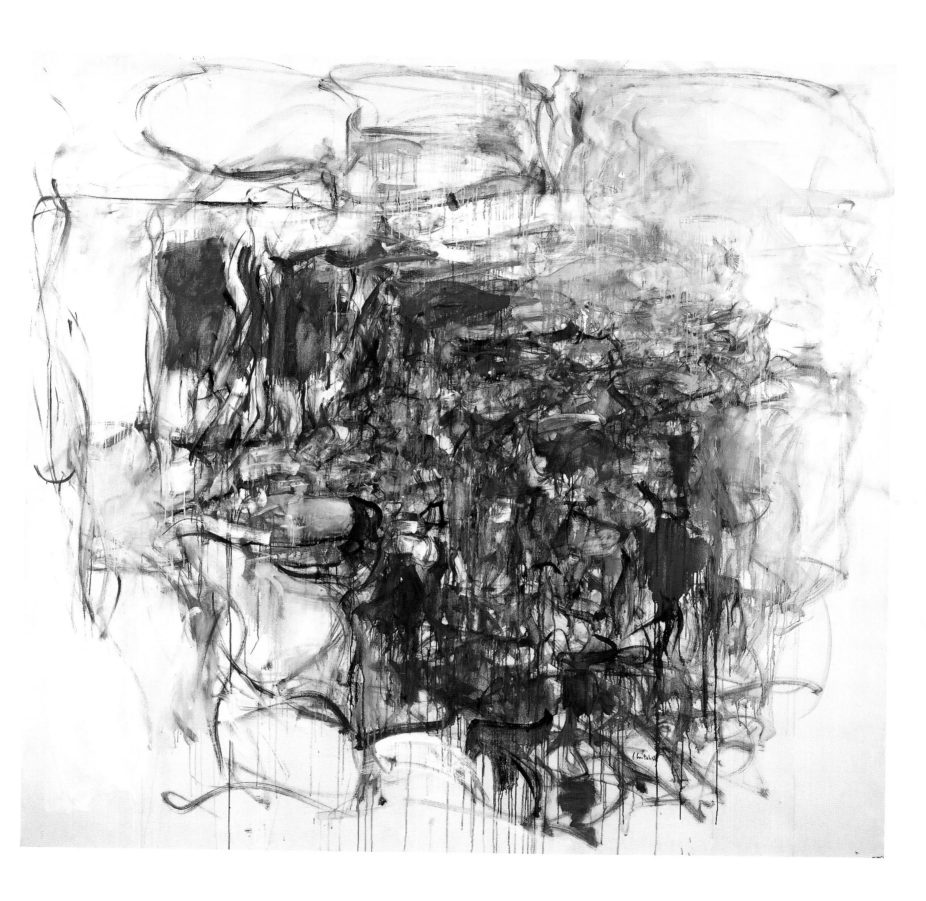

PLATE 7

Hudson River Day Line, 1955
Oil on canvas, 79 x 83 in. (200.7 x 210.8 cm)
McNay Art Museum, San Antonio; Museum purchase with funds from
the Tobin Foundation

PLATE 8

Hemlock, 1956

Oil on canvas, 91 x 80 in. (231.1 x 203.2 cm)

Whitney Museum of American Art, New York; purchase, with funds
from the Friends of the Whitney Museum of American Art 58.20

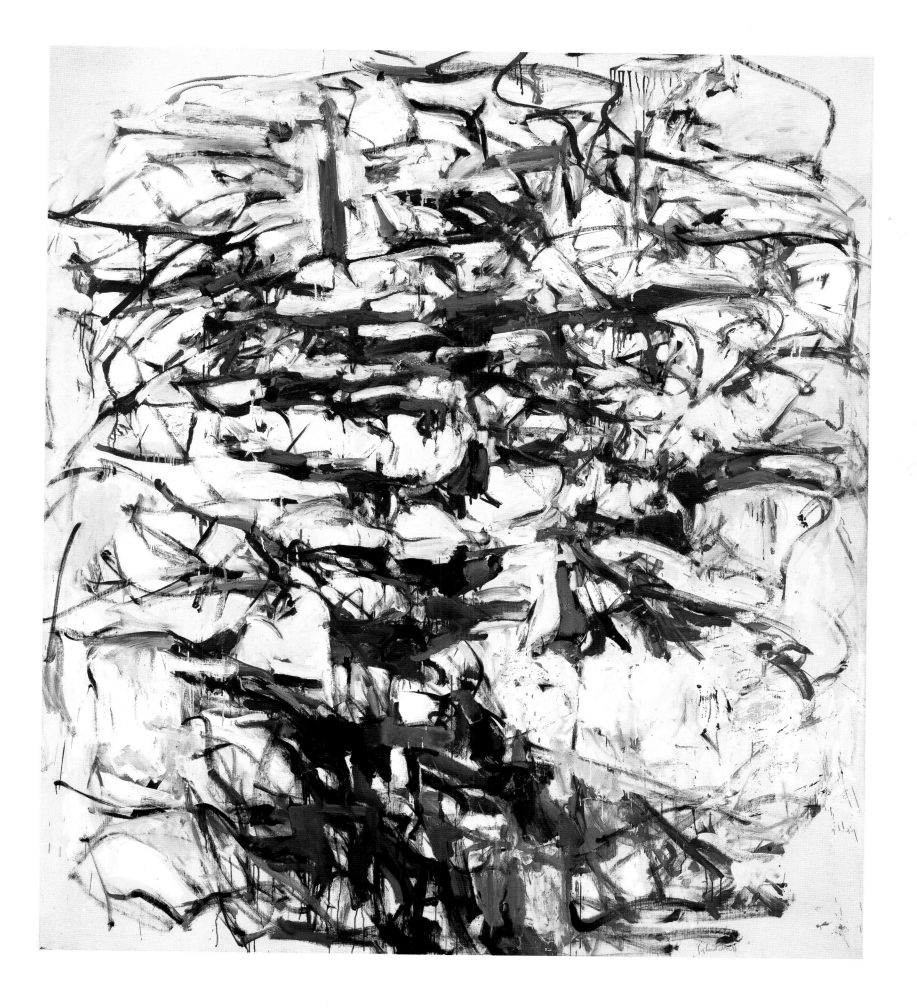

PLATE 9
King of Spades, 1956
Oil on canvas, 91½ x 78½ in. (232.4 x 199.4 cm)
Private collection; courtesy Edward Tyler Nahem Fine Art, New York

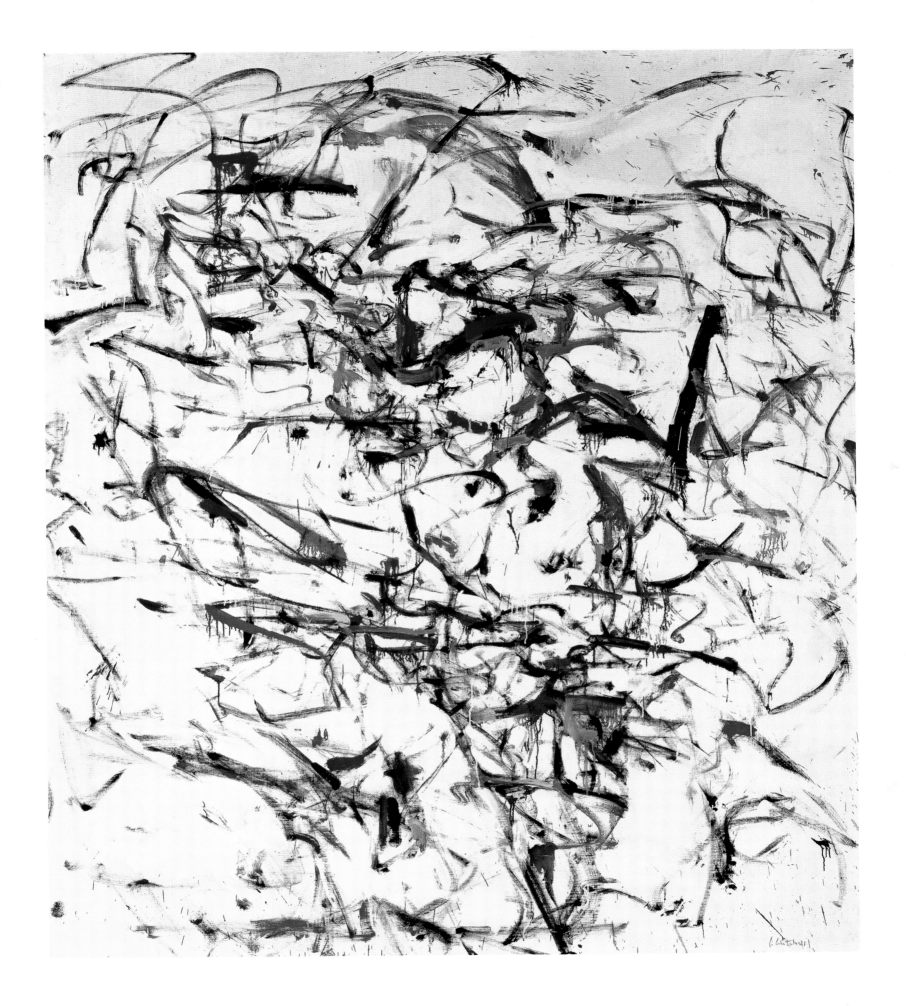

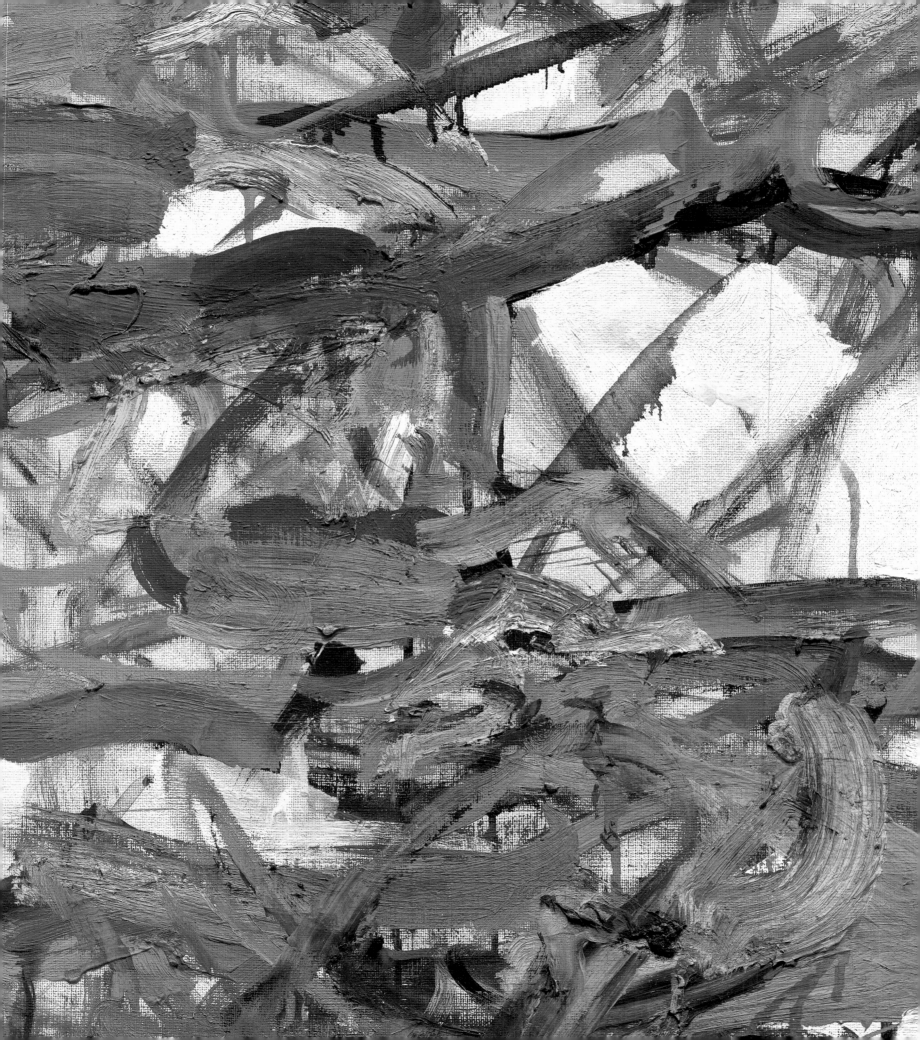

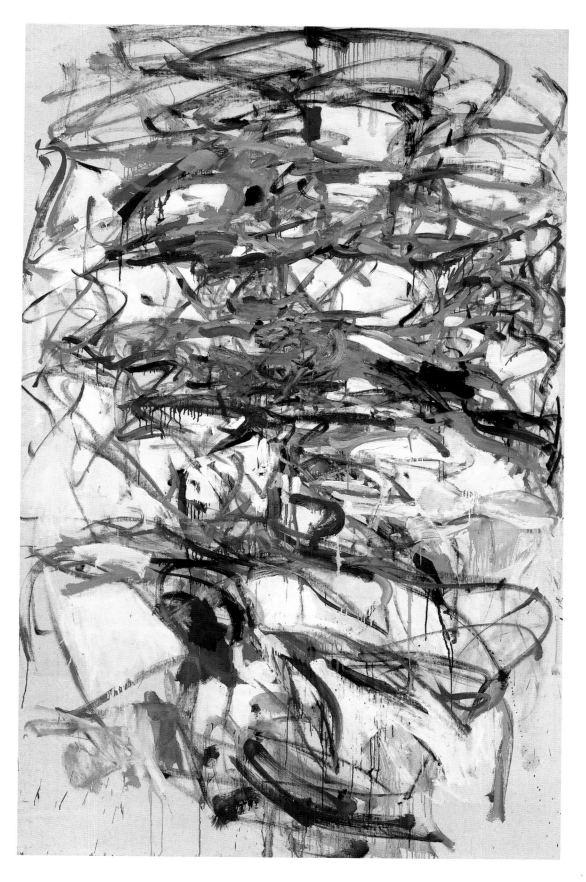

PLATE 10

Untitled, 1956 (detail opposite)
Oil on canvas, 94⅜ x 59⅝ in. (239.7 x 151.4 cm)
Estate of Joan Mitchell

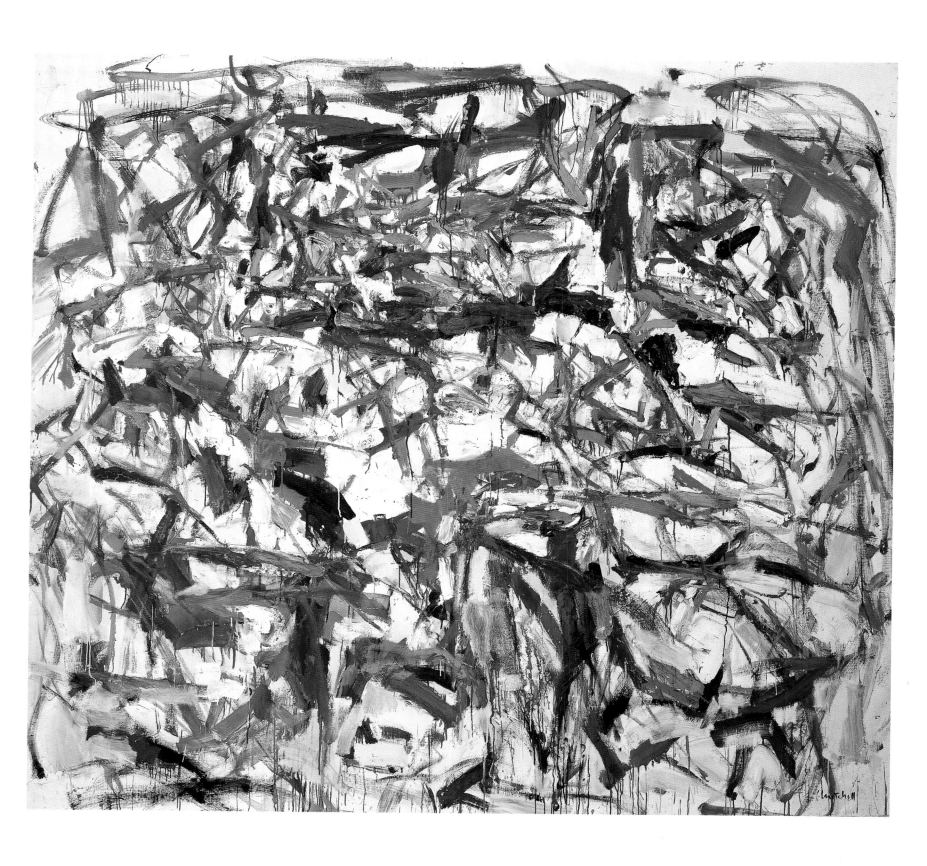

PLATE 11

Evenings on Seventy-third Street, 1956–57
Oil on canvas, 75 x 84 in. (190.5 x 213.4 cm)
Collection of Bunny Adler

PLATE 12

George Went Swimming at Barnes Hole, but It Got Too Cold, 1957

Oil on canvas, 85¼ x 78¼ in. (216.5 x 198.8 cm)

Albright-Knox Art Gallery, Buffalo, New York; Gift of Seymour H. Knox, Jr., 1958

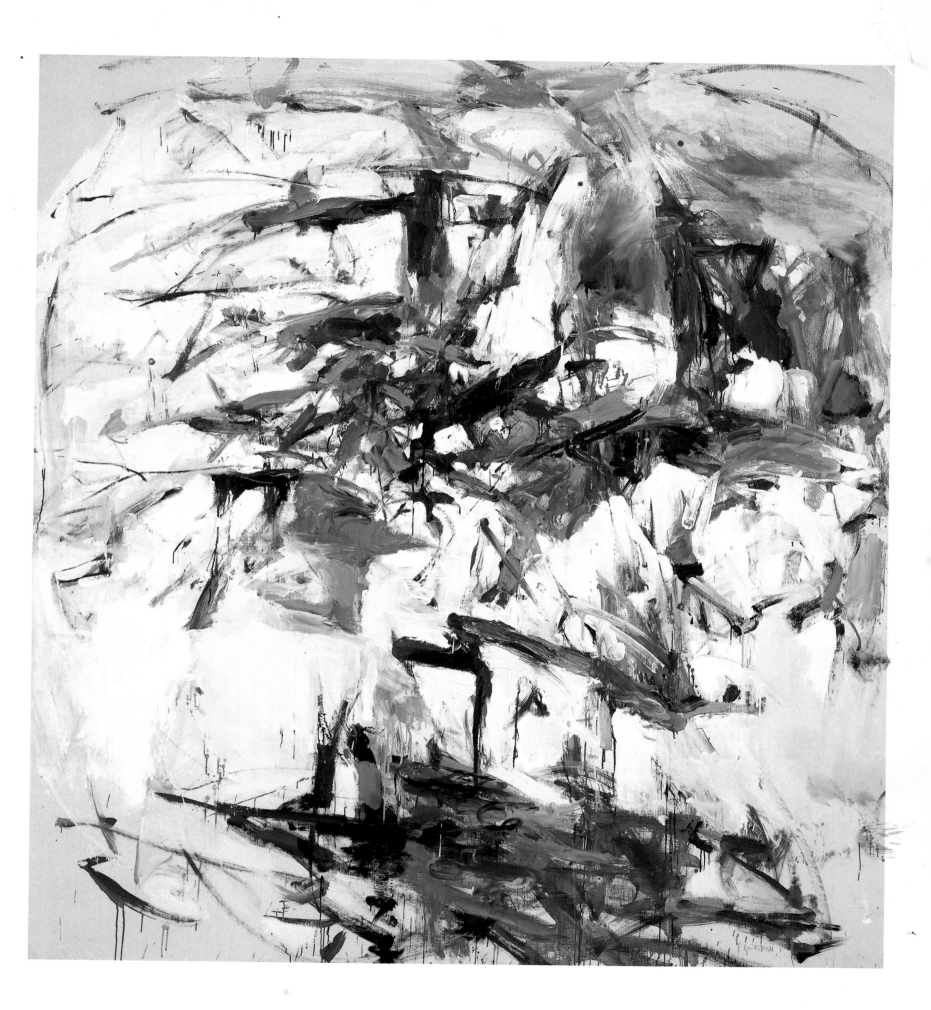

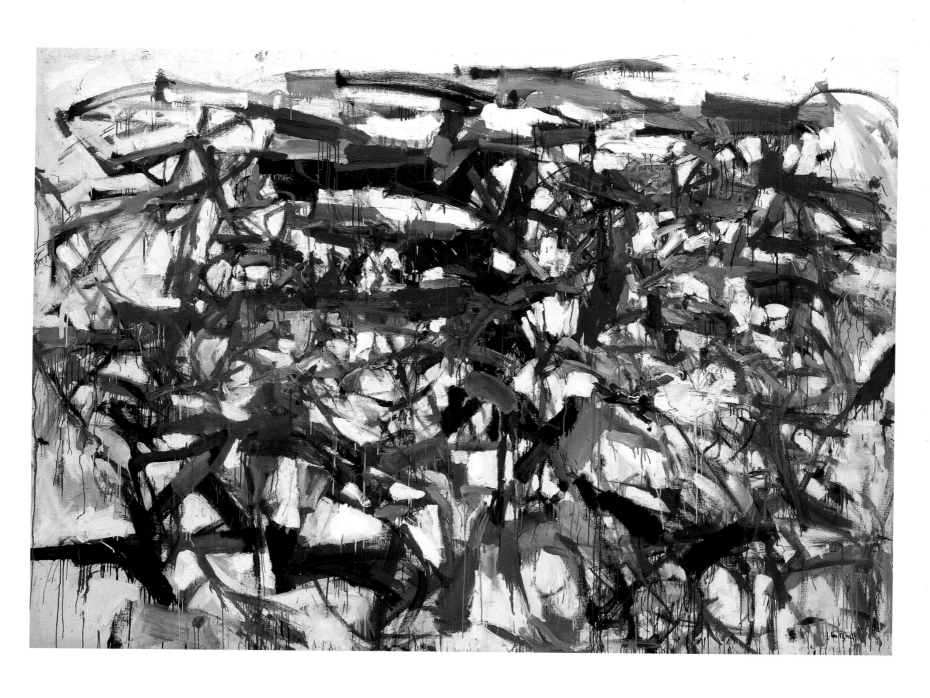

PLATE 13

Ladybug, 1957

Oil on canvas, 77⅞ x 108 in. (197.8 x 274.3 cm)

The Museum of Modern Art, New York; Purchase, 1961

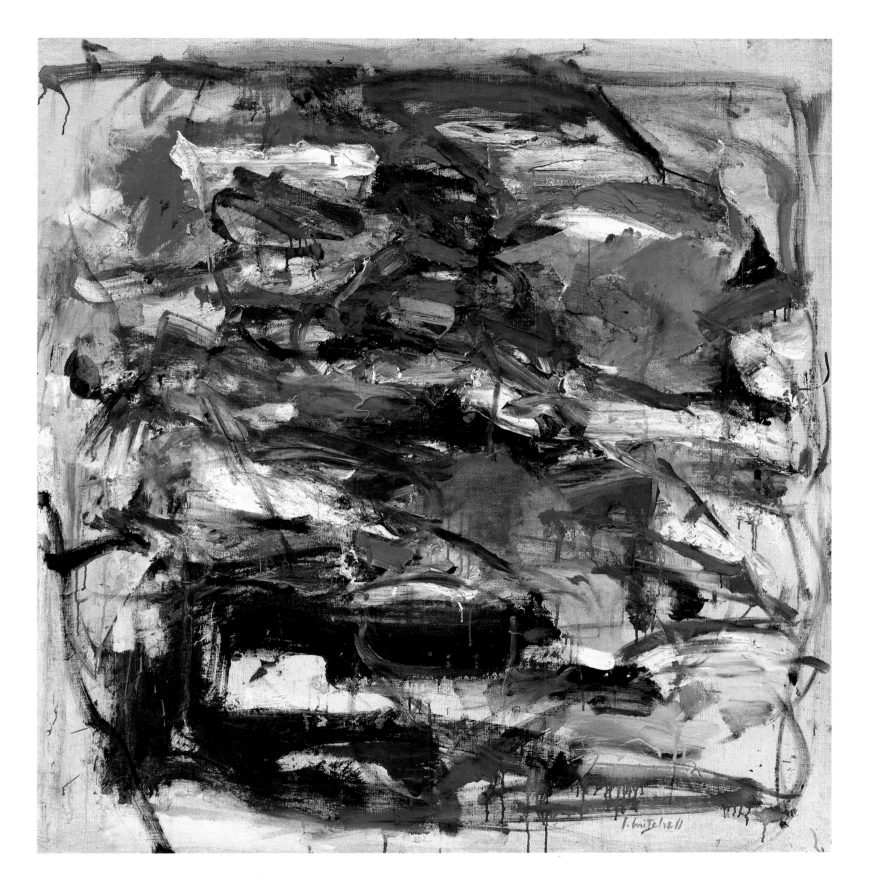

PLATE 14

Untitled, 1957

Oil on canvas, 40⅝ x 38⅜ in. (103.2 x 97.5 cm)

Estate of Joan Mitchell

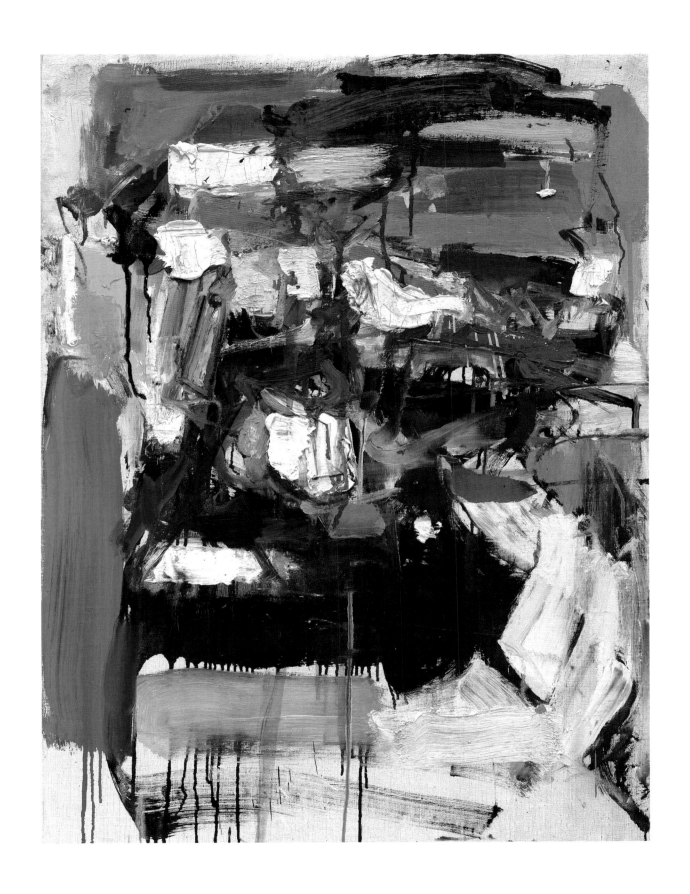

PLATE 15

Untitled, 1957

Oil on canvas, 29½ x 22 in. (74.9 x 55.9 cm)

Estate of Joan Mitchell

109

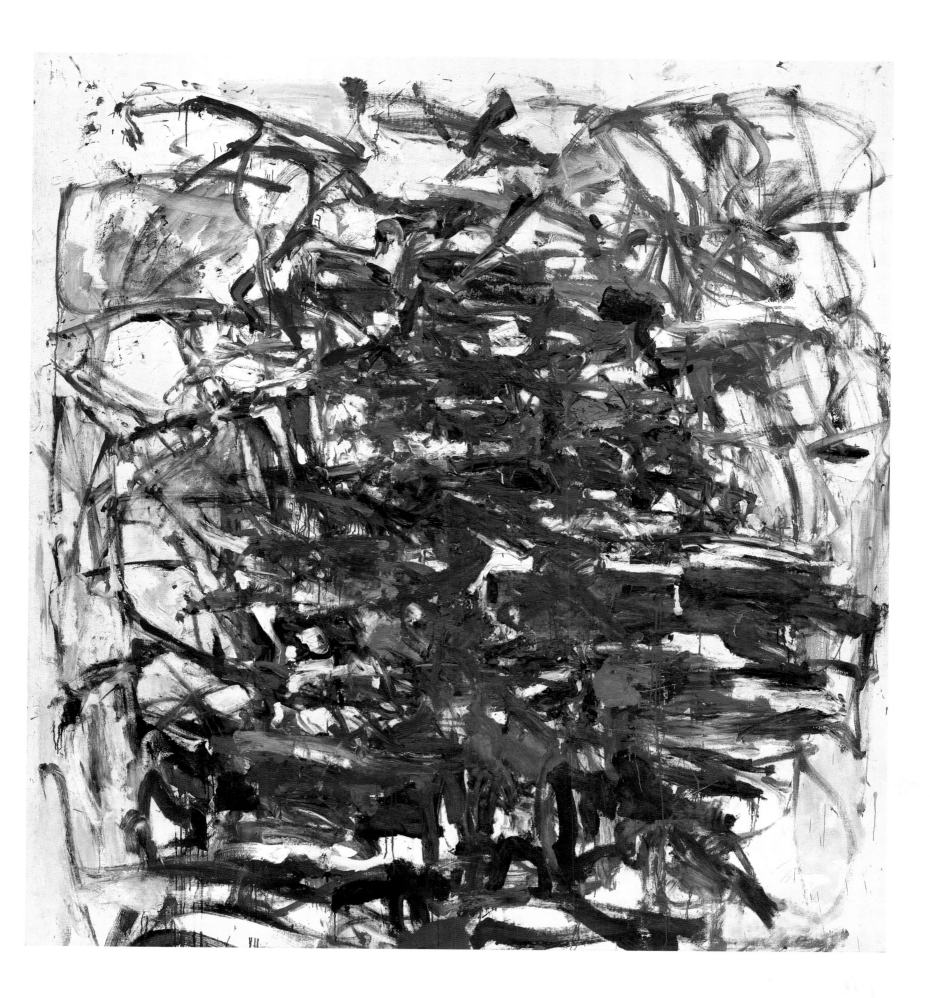

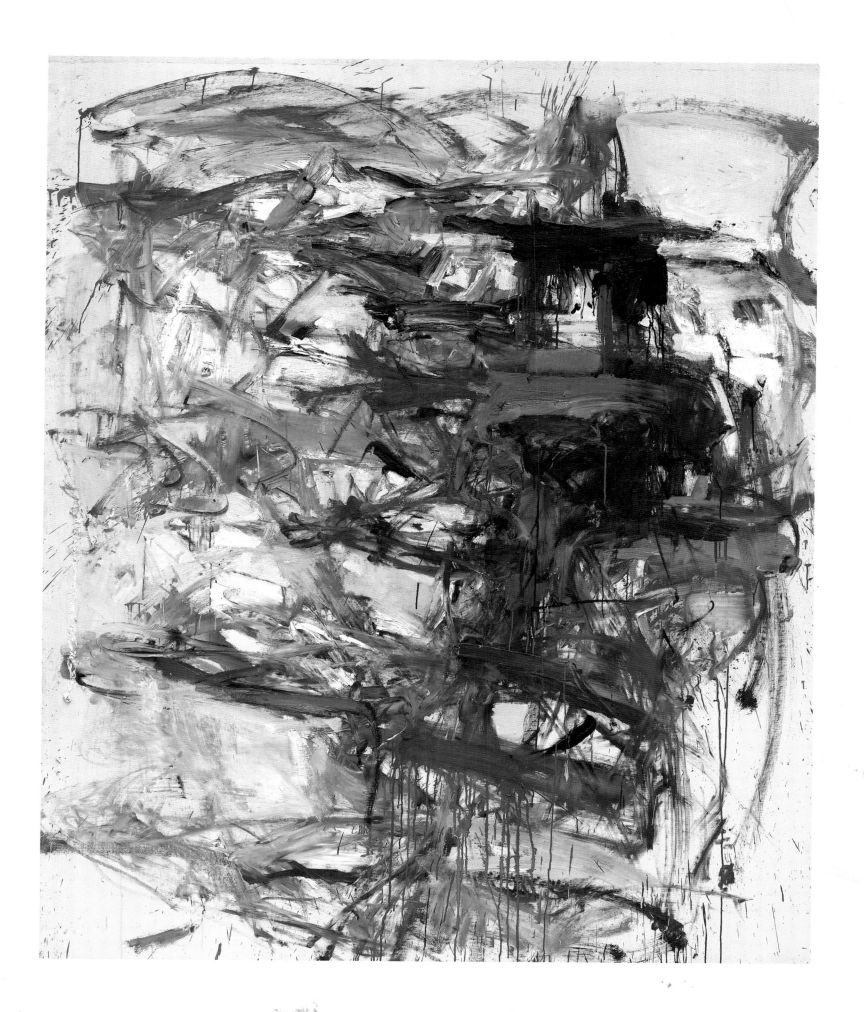

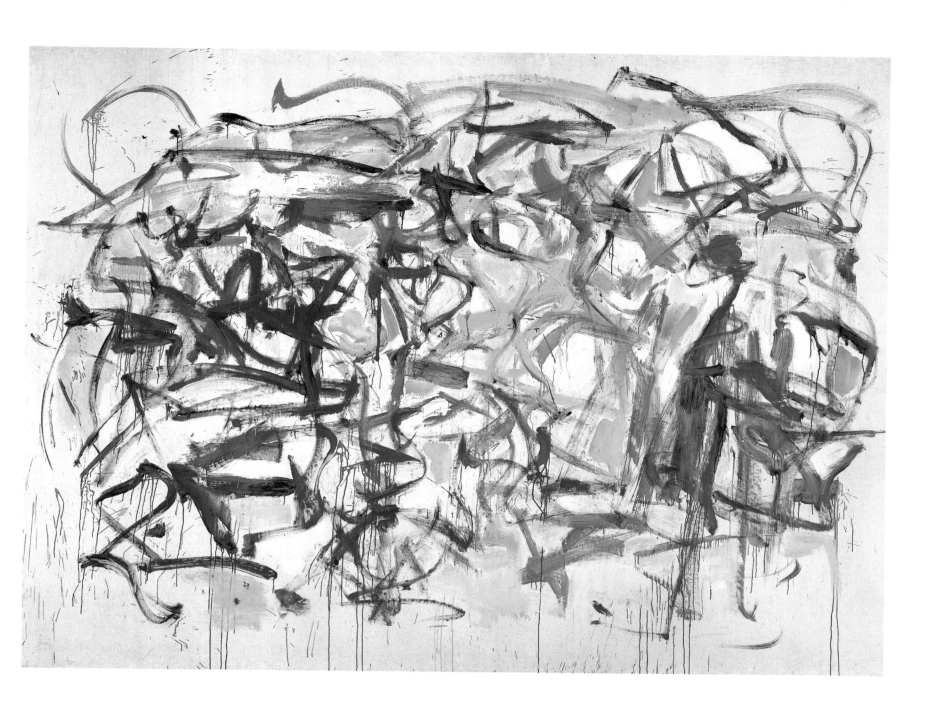

PLATE 18

Untitled, 1958
Oil on canvas, 80¾ x 108 in. (205.1 x 274.3 cm)
Estate of Joan Mitchell

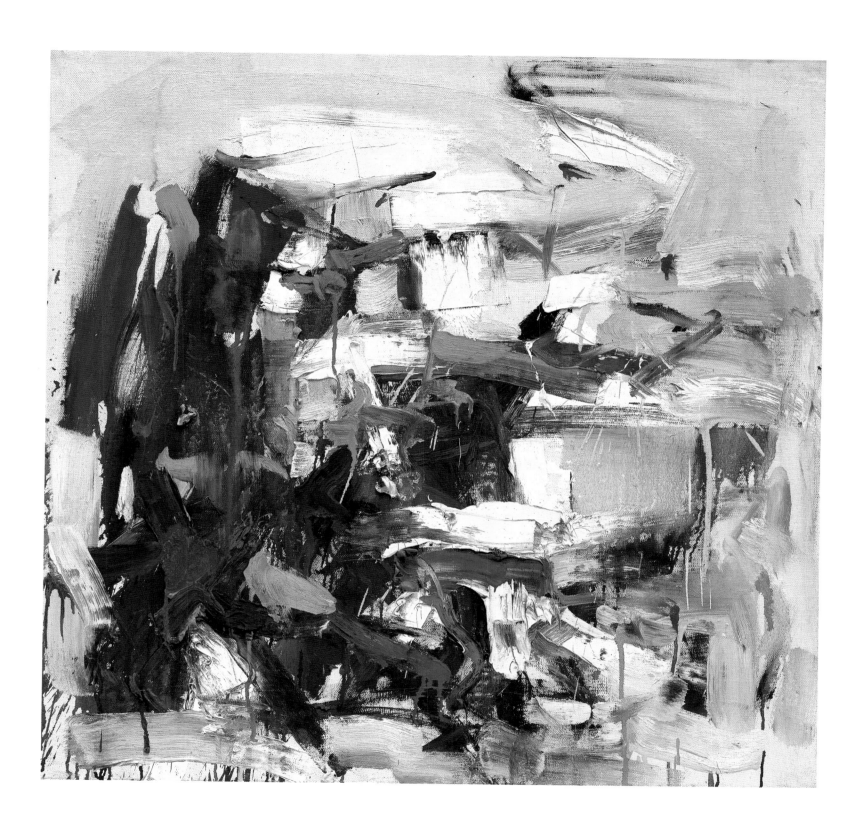

PLATE 19

Untitled, 1958

Oil on canvas, 29⅜ x 30 in. (74.6 x 76.2 cm)

Estate of Joan Mitchell

117

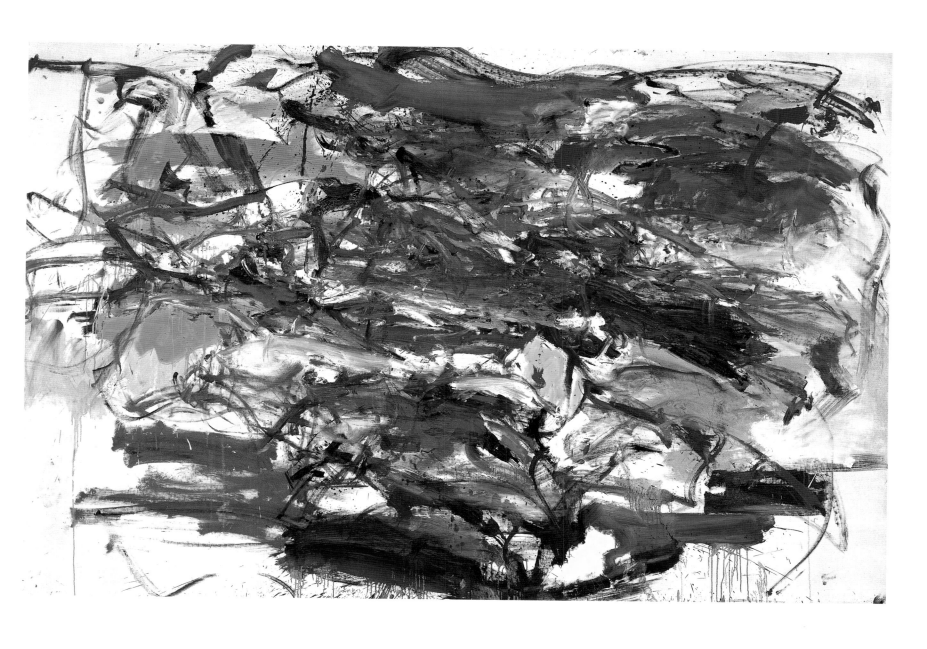

PLATE 20
Untitled, 1959–60
Oil on canvas, 76 x 114 in. (193 x 289.6 cm)
Kemper Museum of Contemporary Art, Kansas City, Missouri; Bebe and
Crosby Kemper Collection, Gift of the Enid and Crosby Kemper
Foundation

Chatière, 1960
Oil on canvas, 76¾ x 58 in. (194.9 x 147.3 cm)
Estate of Joan Mitchell

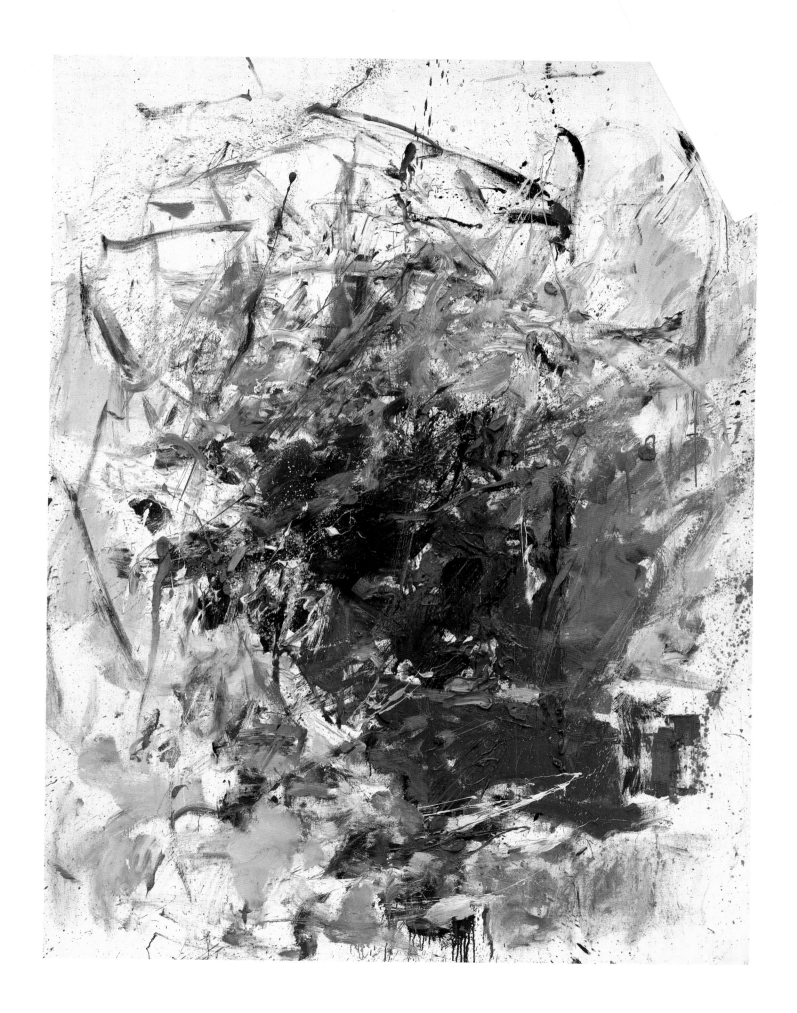

122

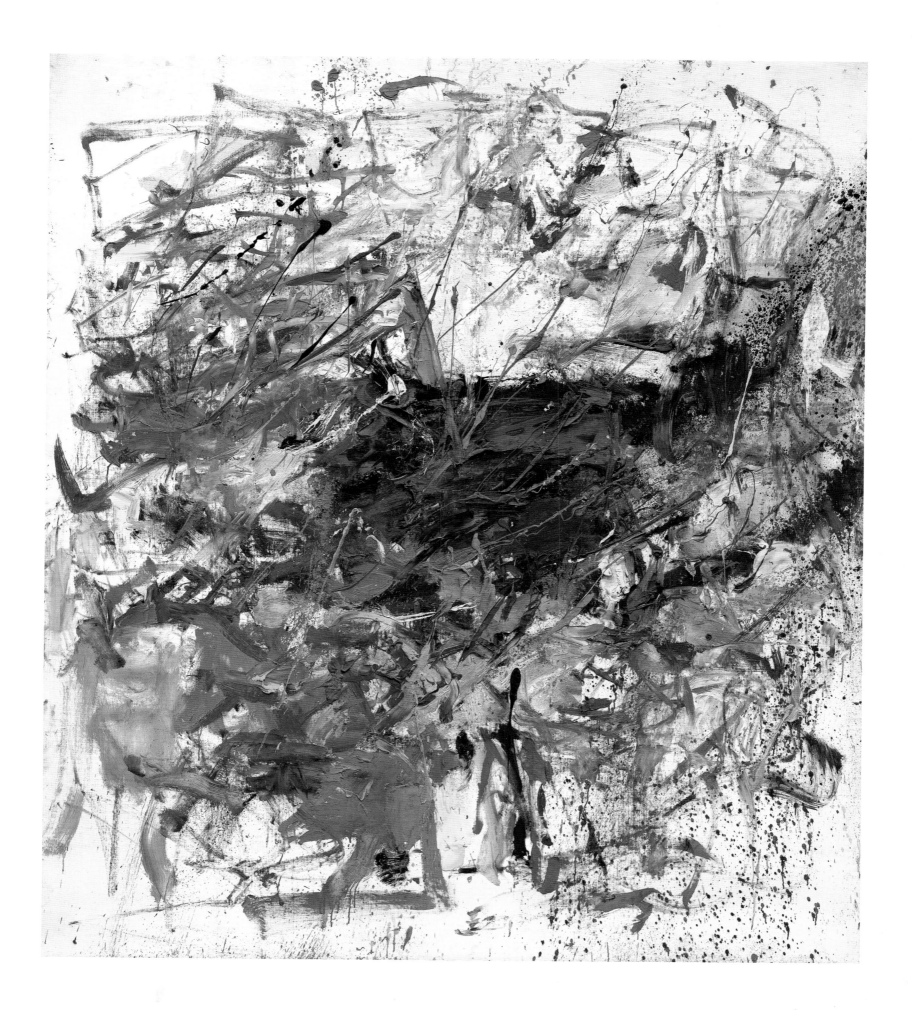

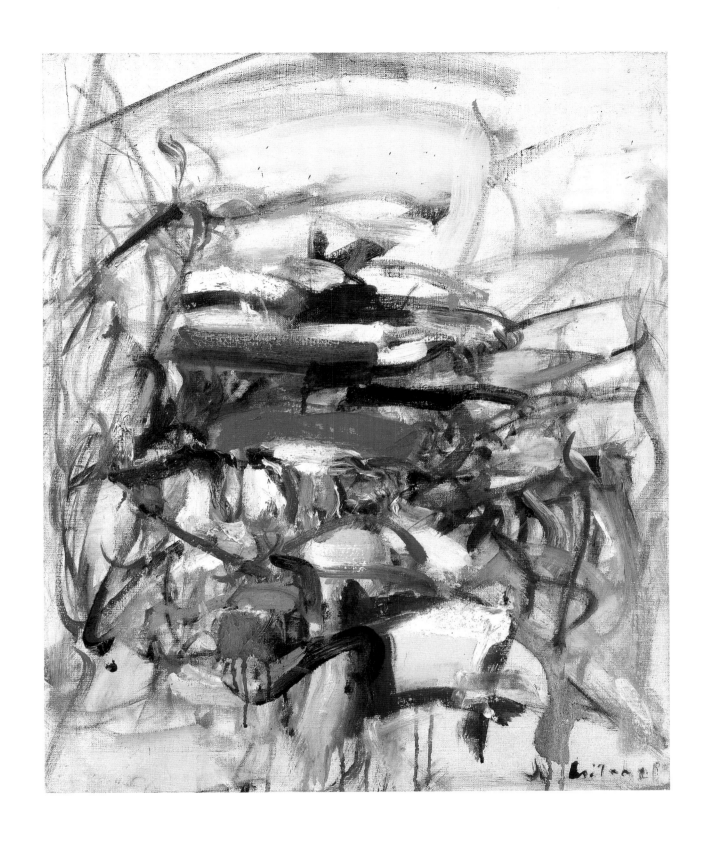

PLATE 23

Untitled, c. 1960

Oil on canvas, 24 x 19⅝ in. (61 x 49.9 cm)

San Francisco Museum of Modern Art; Gift of Sam Francis

125

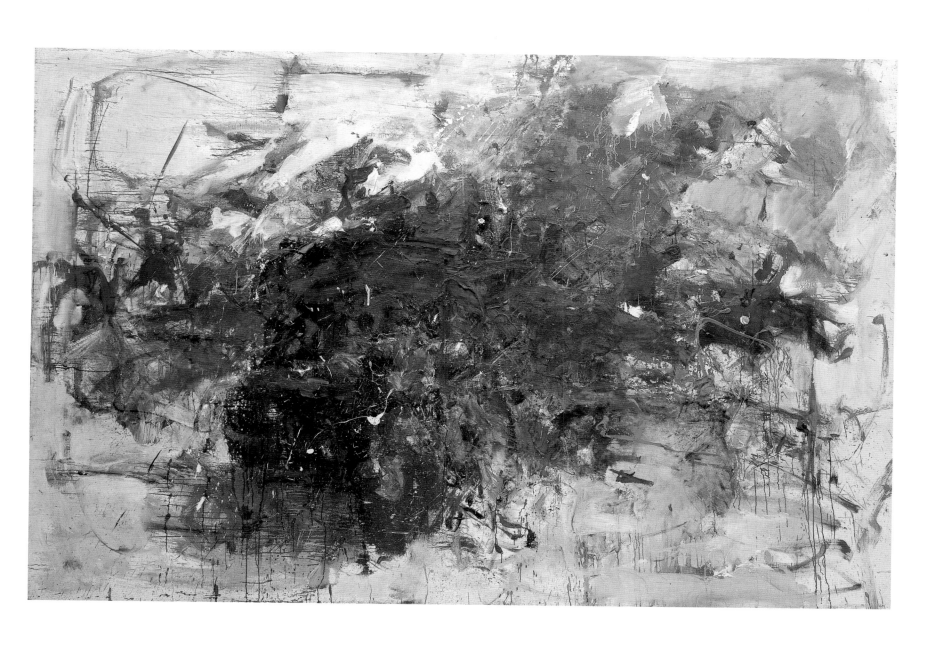

PLATE 24

Grandes Carrières, 1961–62

Oil on canvas, 78¾ x 118¼ in. (200 x 300.4 cm)

The Museum of Modern Art, New York; Gift of The Estate of Joan

Mitchell, 1994

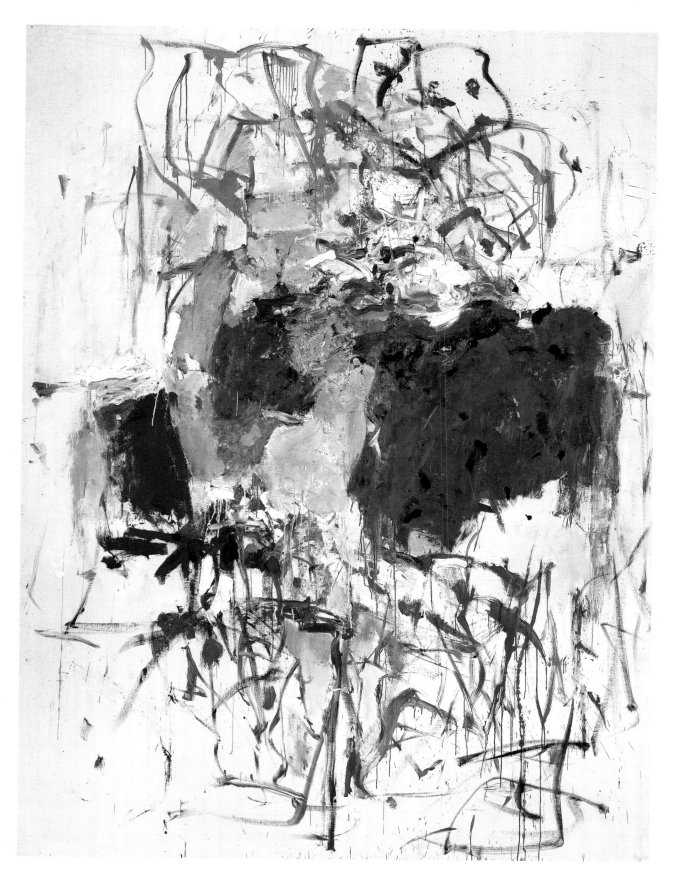

PLATE 25

Untitled, 1963 (detail opposite)
Oil on canvas, 108 x 79½ in. (274.3 x 201.9 cm)
Estate of Joan Mitchell

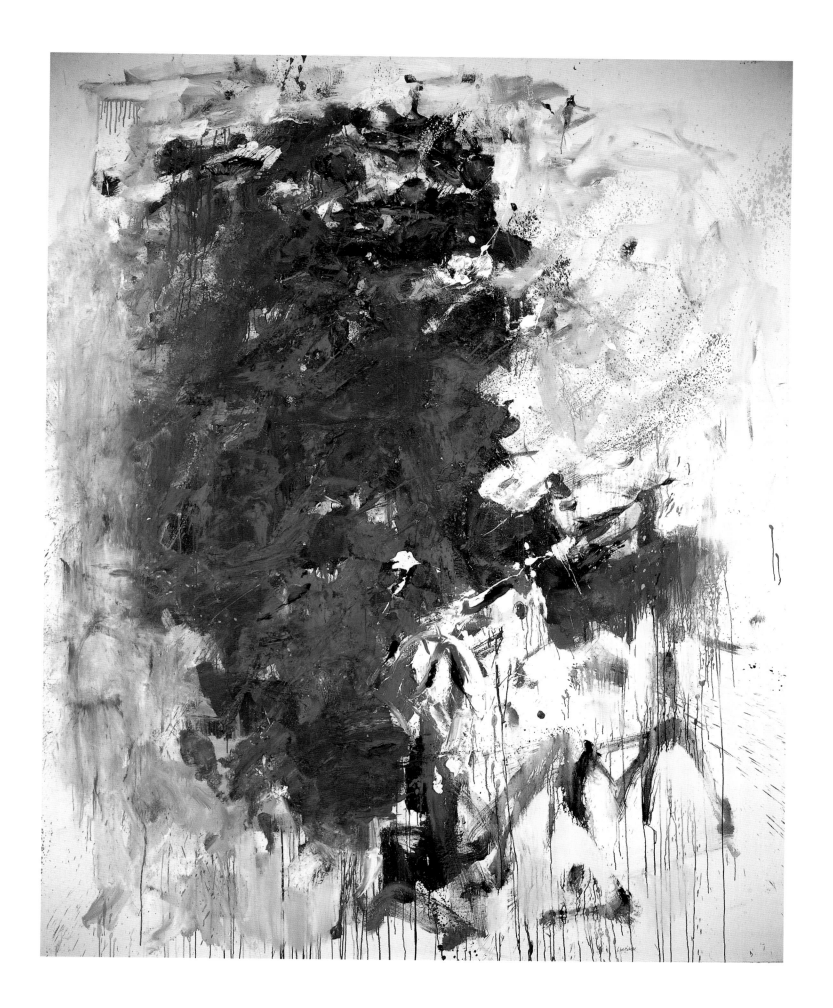

PLATE 27

Calvi, 1964

Oil on canvas, 96 x 78 in. (243.8 x 198.1 cm)

Private collection

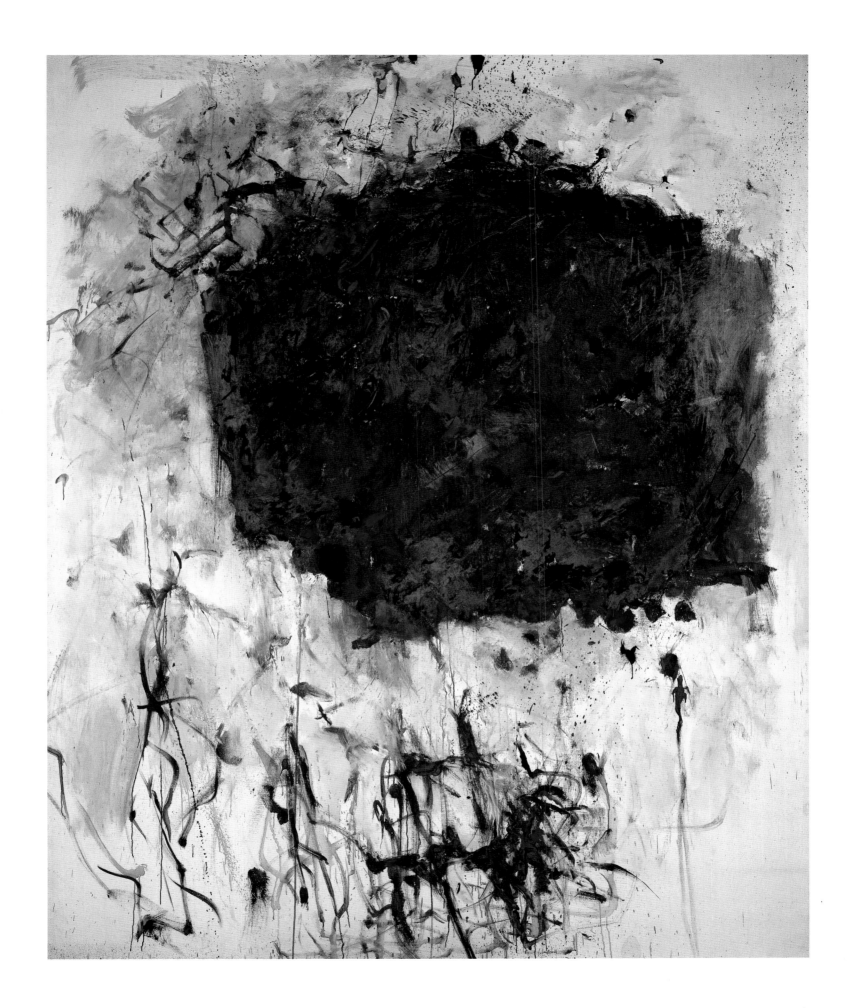

PLATE 28

Untitled (Cheim Some Bells), 1964
Oil on canvas, 84 x 78¼ in. (213.4 x 198.8 cm)
Collection of John Cheim

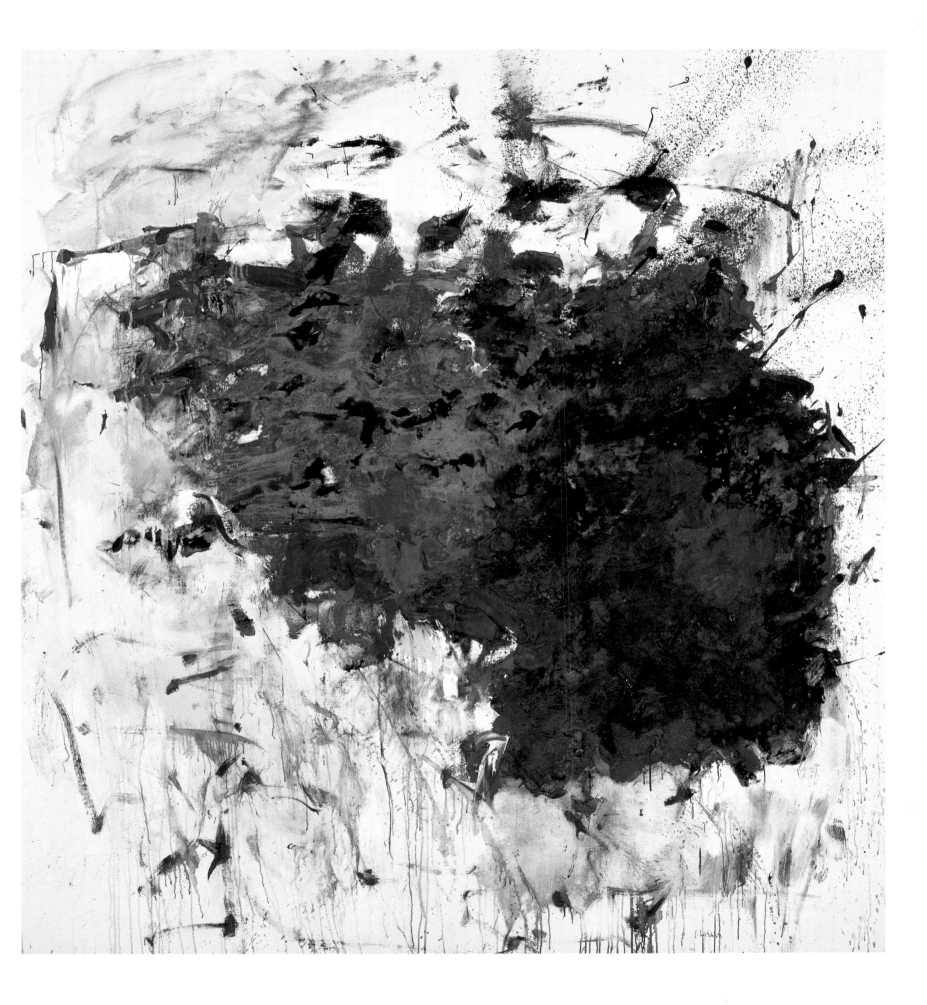

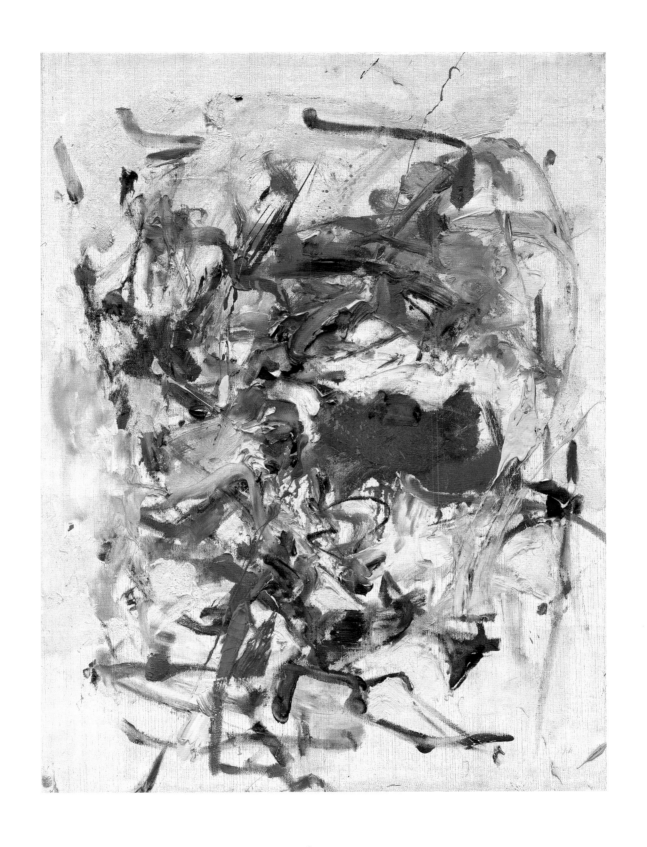

PLATE 29

Untitled, 1965

Oil on canvas, 28½ x 21 in. (72.4 x 53.3 cm)

Estate of Joan Mitchell

137

PLATE 30

My Landscape II, 1967
Oil on canvas, 103 x 71½ in. (261.6 x 181.6 cm)
Smithsonian American Art Museum, Washington, D.C.; Gift of Mr. and
Mrs. David K. Anderson, Martha Jackson Memorial Collection

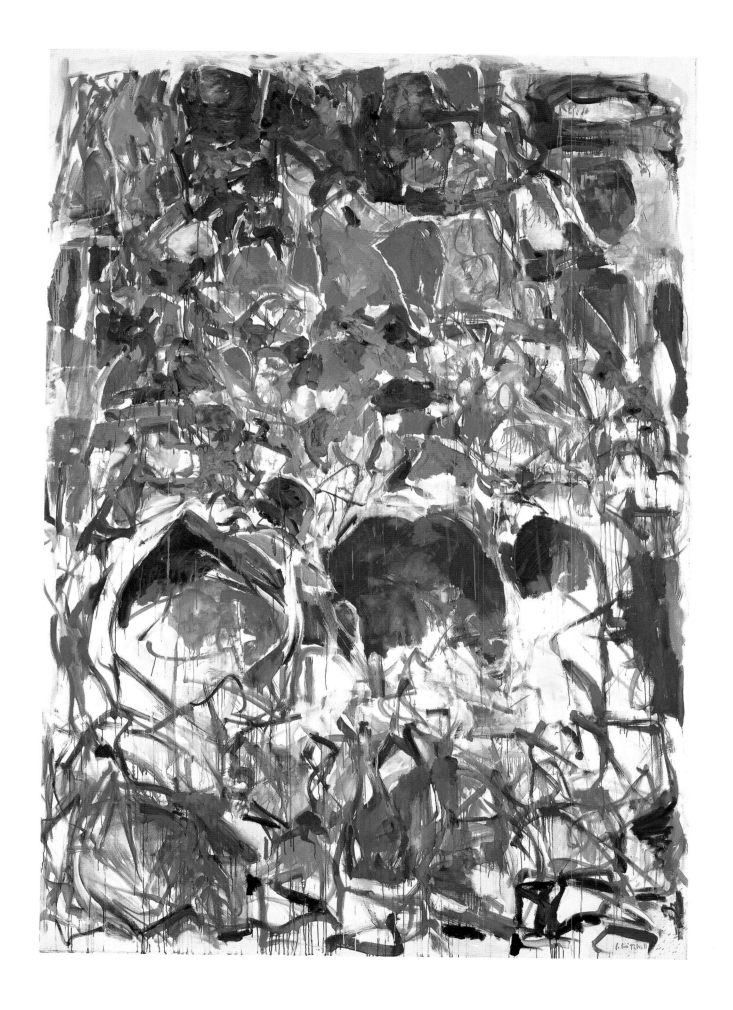

PLATE 31

Low Water, 1969

Oil on canvas, 112 x 79 in. (284.5 x 200.7 cm)

Carnegie Museum of Art, Pittsburgh; Patrons Art Fund, 1970

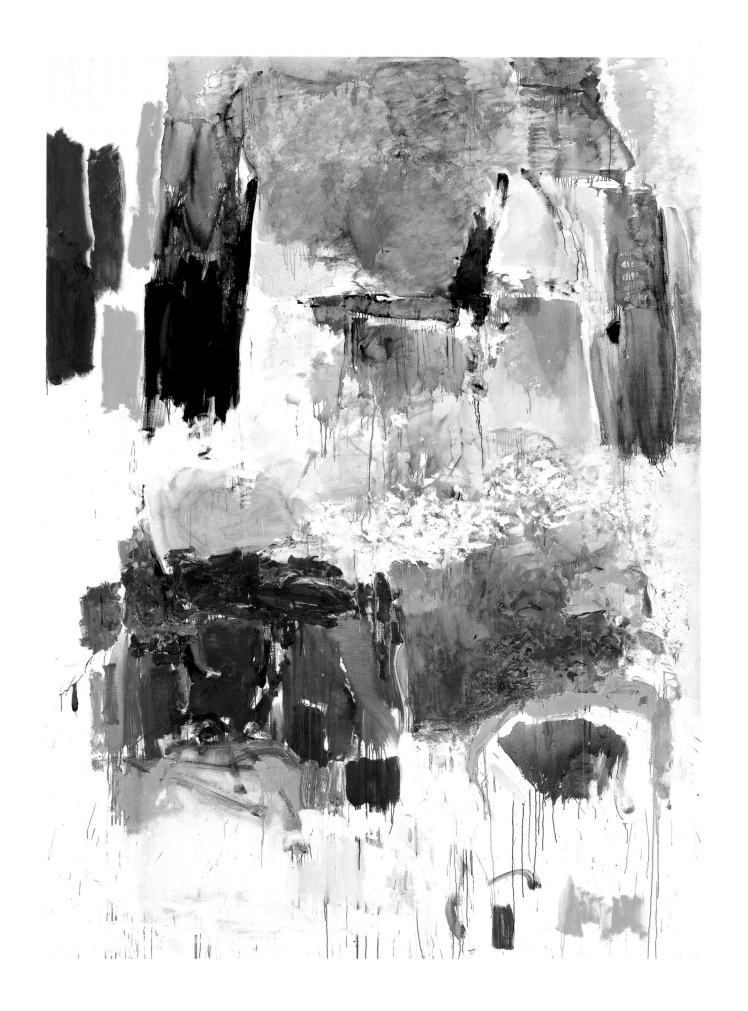

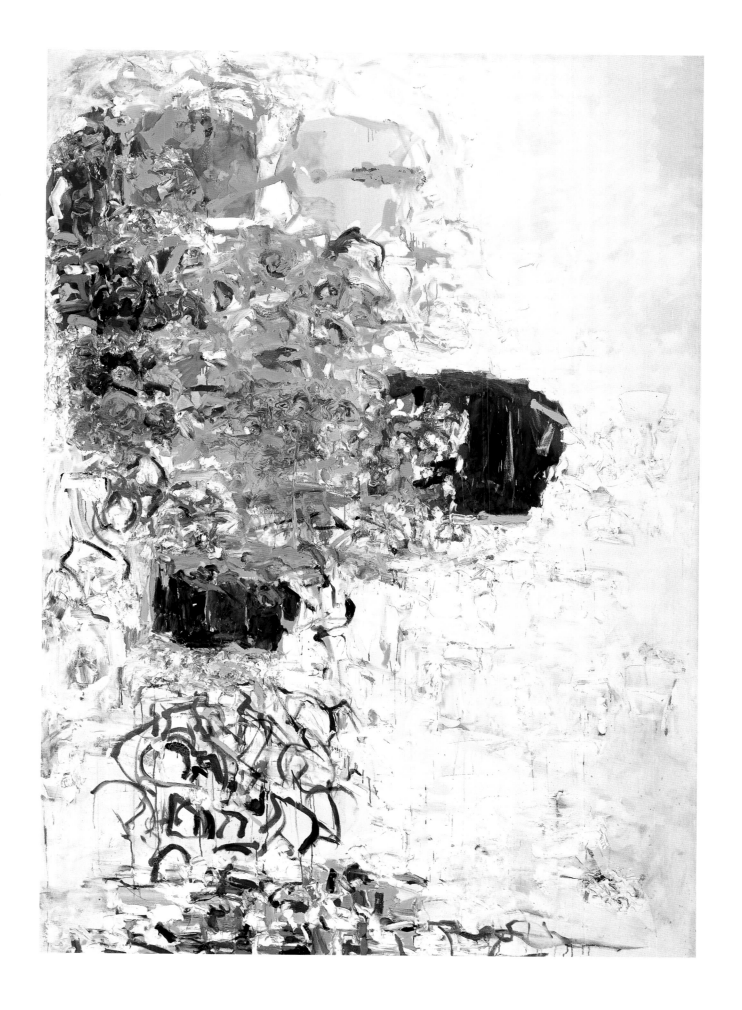

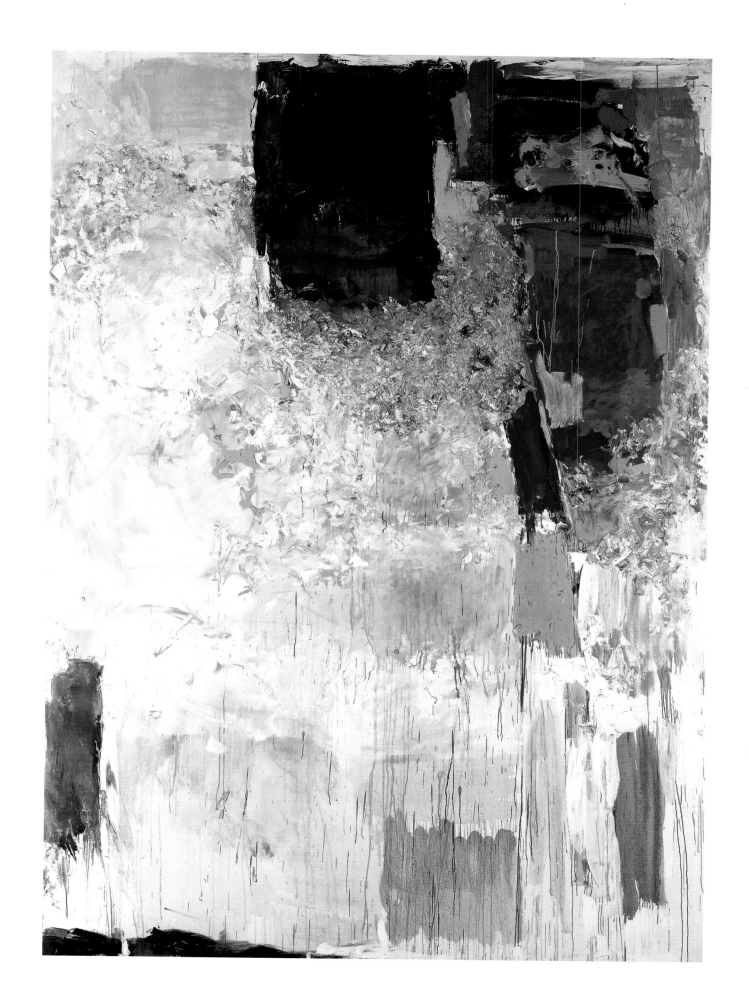

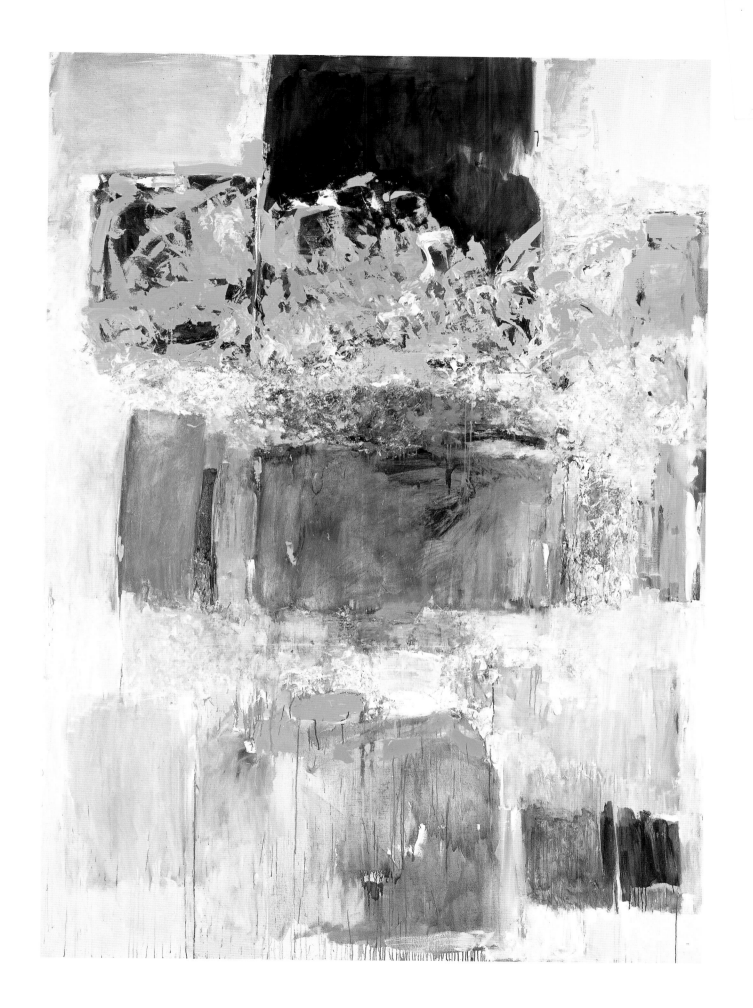

PLATE 35
Mooring, 1971
Oil on canvas, 95 x 71 in. (241.3 x 180.3 cm)
Museum of Art, Rhode Island School of Design, Providence;
Gift of the Bayard and Harriet K. Ewing Collection

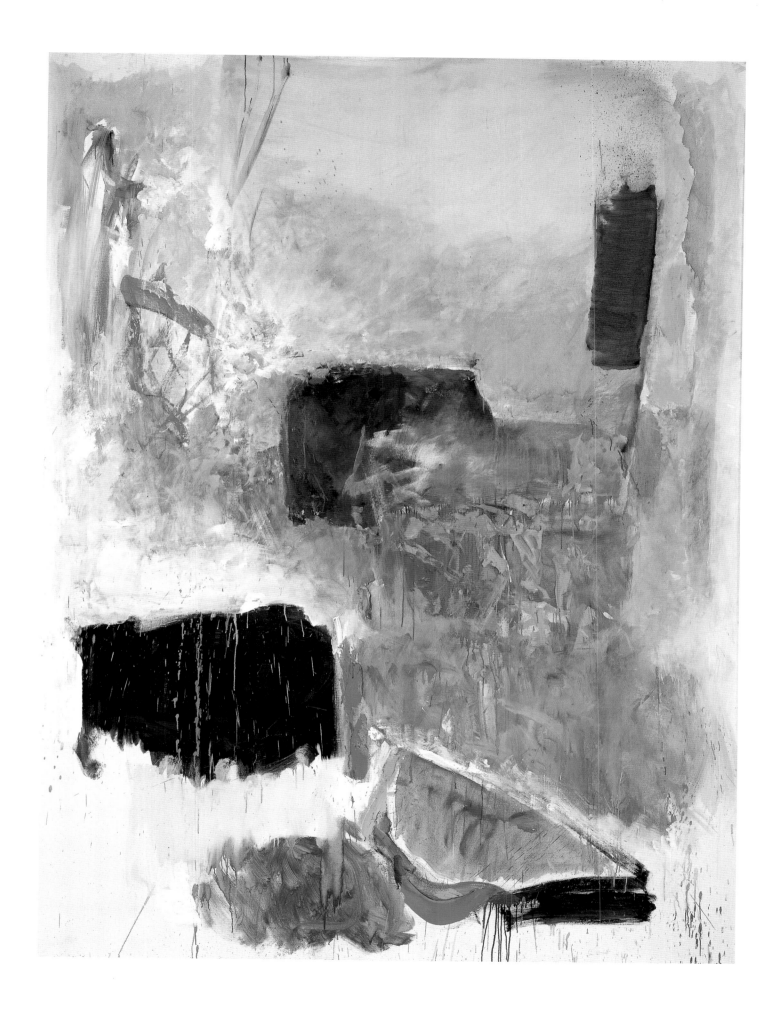

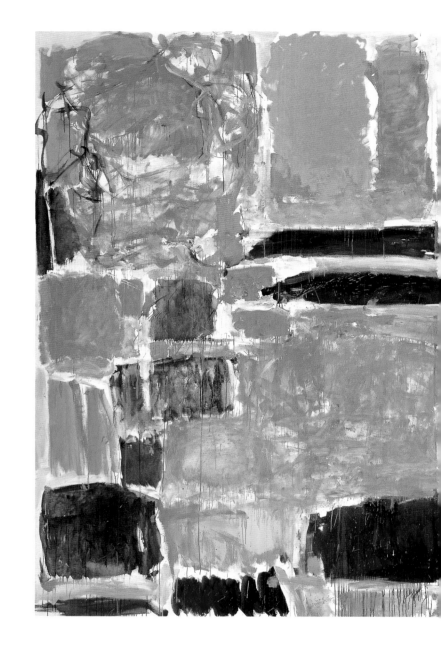

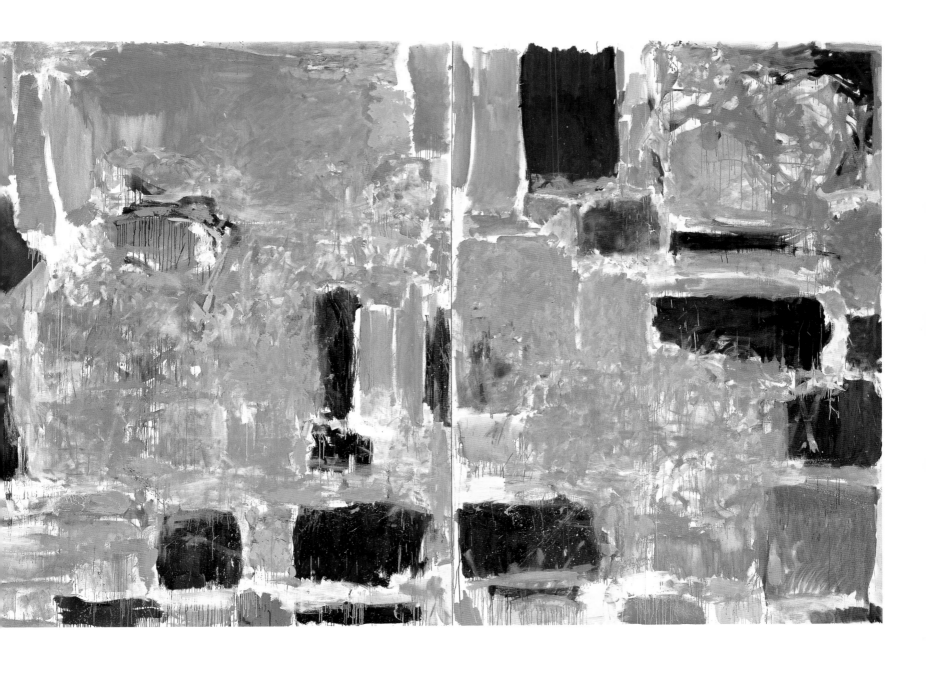

PLATE 36

Wet Orange, 1971–72

Oil on canvas, triptych, 112 x 245 in. (284.5 x 622.3 cm)

Carnegie Museum of Art, Pittsburgh; National Endowment for the Arts

Matching Grant and Kaufmann's Department Stores Purchase Grant, 1974

151

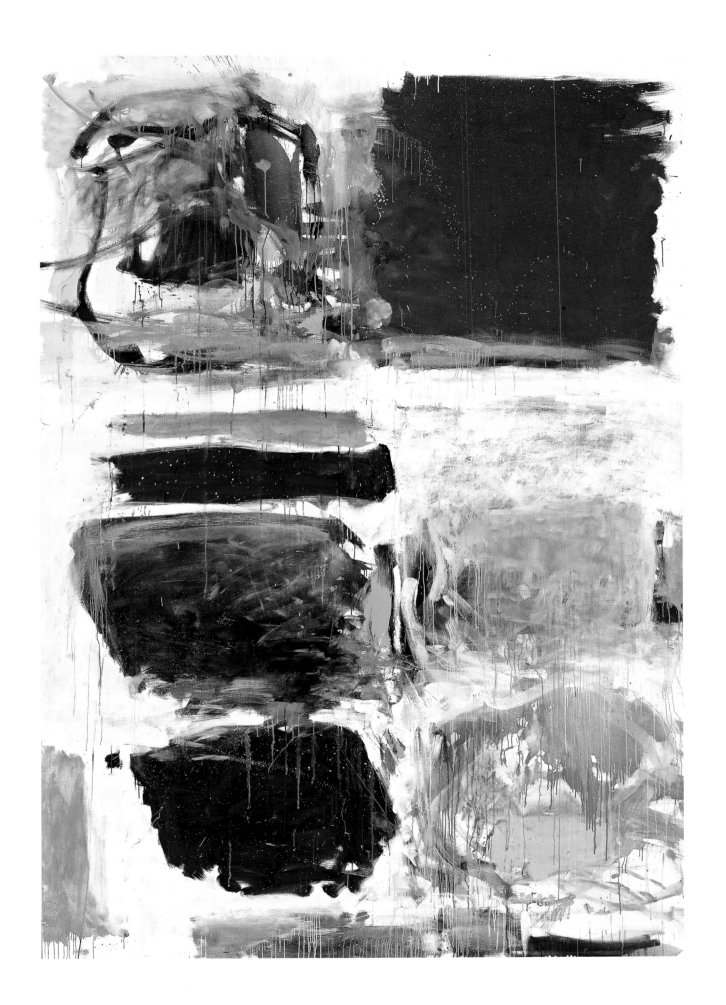

PLATE 38

Belle Bête, 1973
Oil on canvas, 102¼ x 70¾ in. (259.7 x 179.7 cm)
Private collection; courtesy Edward Tyler Nahem Fine Art, New York

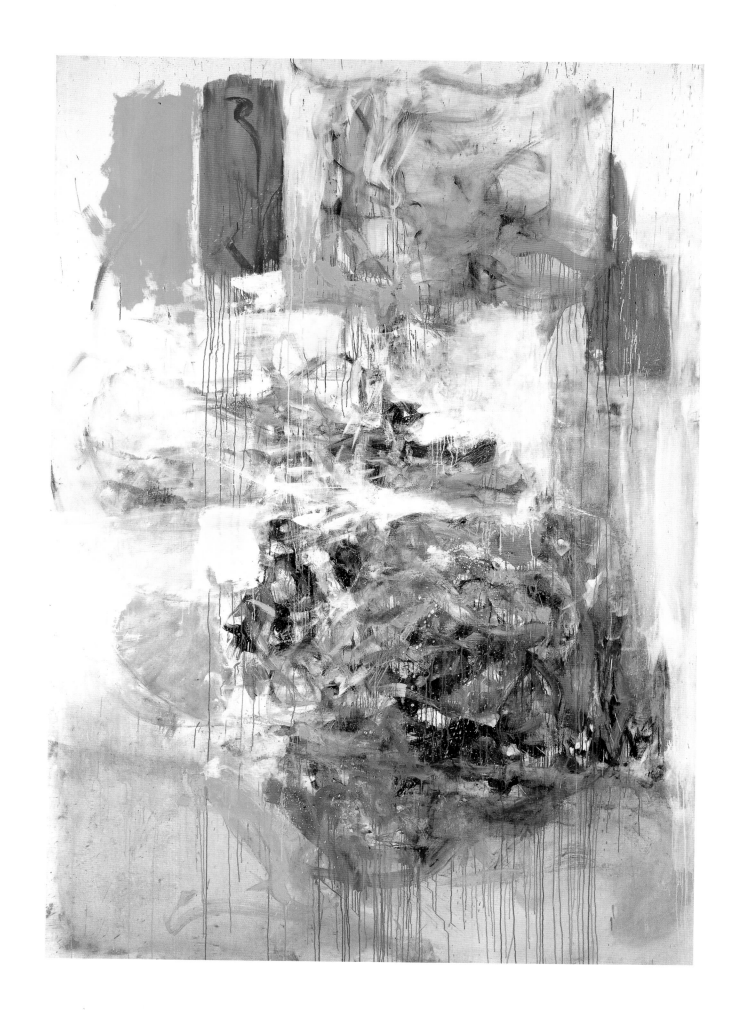

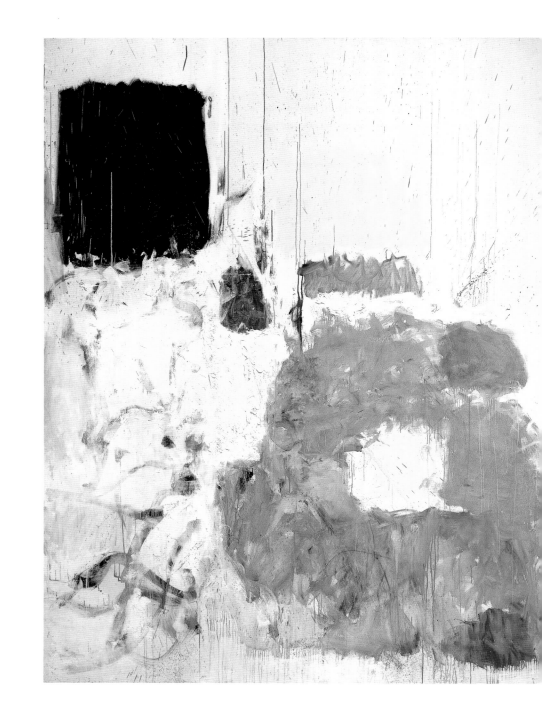

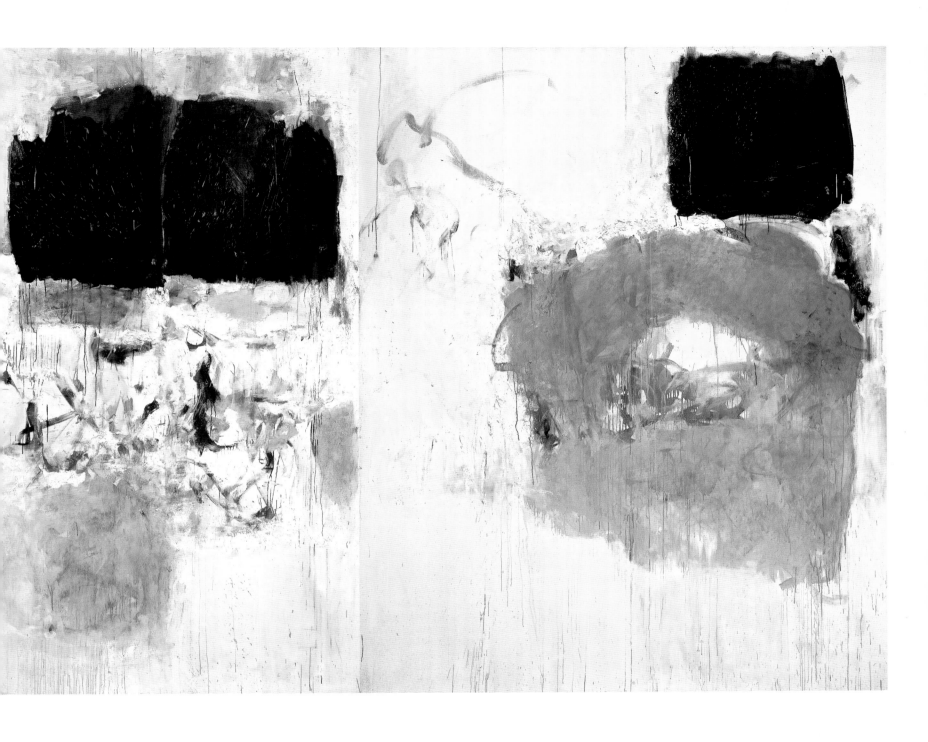

PLATE 39
Clearing, 1973
Oil on canvas, triptych, 110¼ x 236 in. (280 x 599.4 cm)
Whitney Museum of American Art, New York; purchase, with funds
from Susan Morse Hilles in honor of John I.H. Baur 74.72

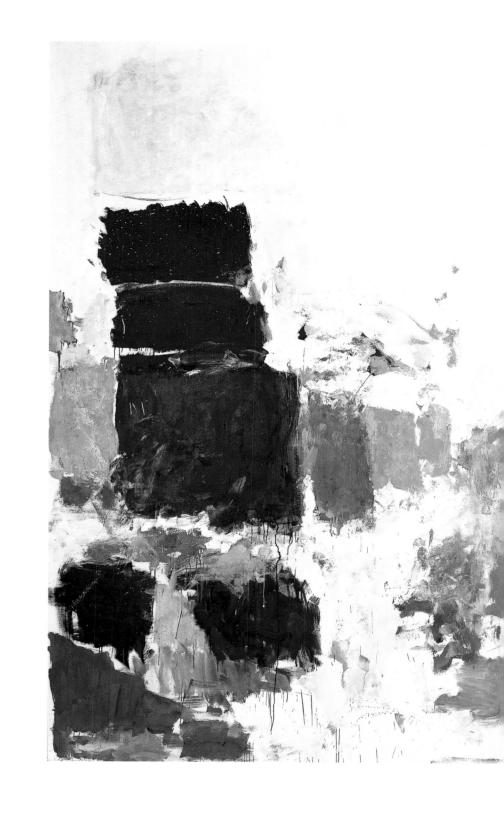

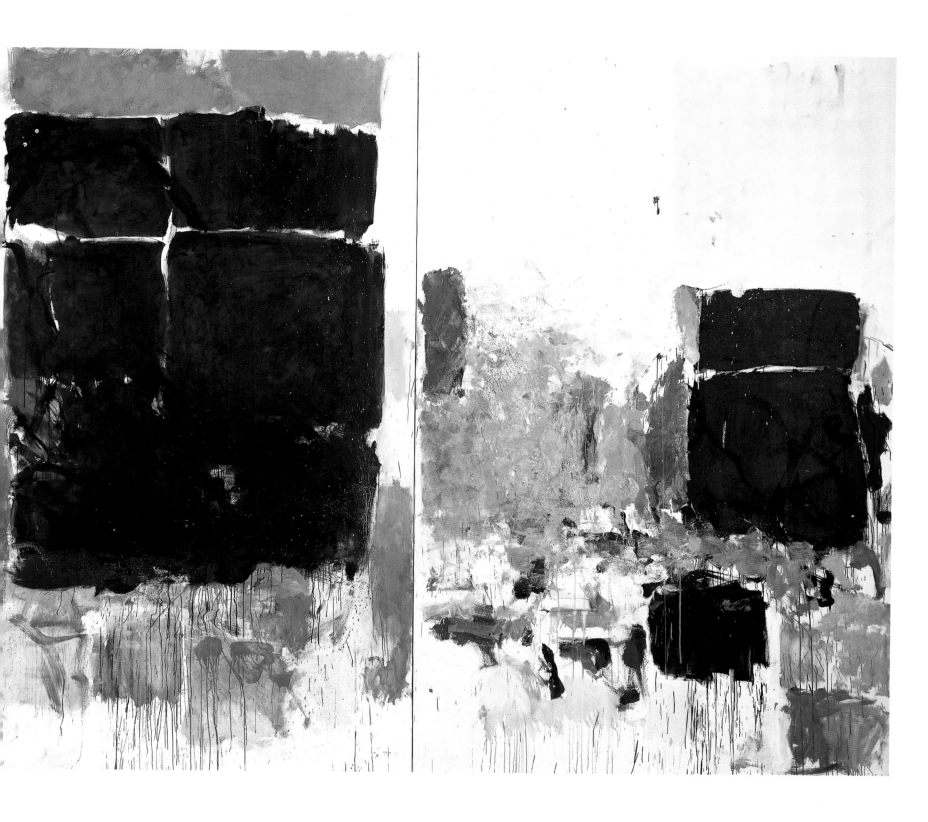

PLATE 40

Field for Skyes, 1973
Oil on canvas, triptych, 110¼ x 204¾ in. (280 x 520.1 cm)
Hirshhorn Museum and Sculpture Garden, Smithsonian Institution,
Washington, D.C.; Gift of Mr. and Mrs. David T. Workman, 1975

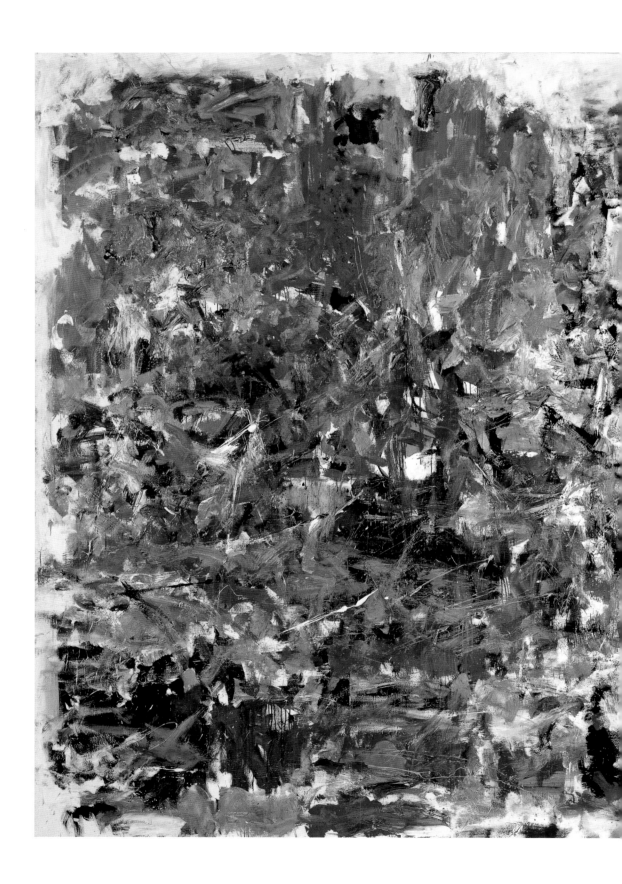

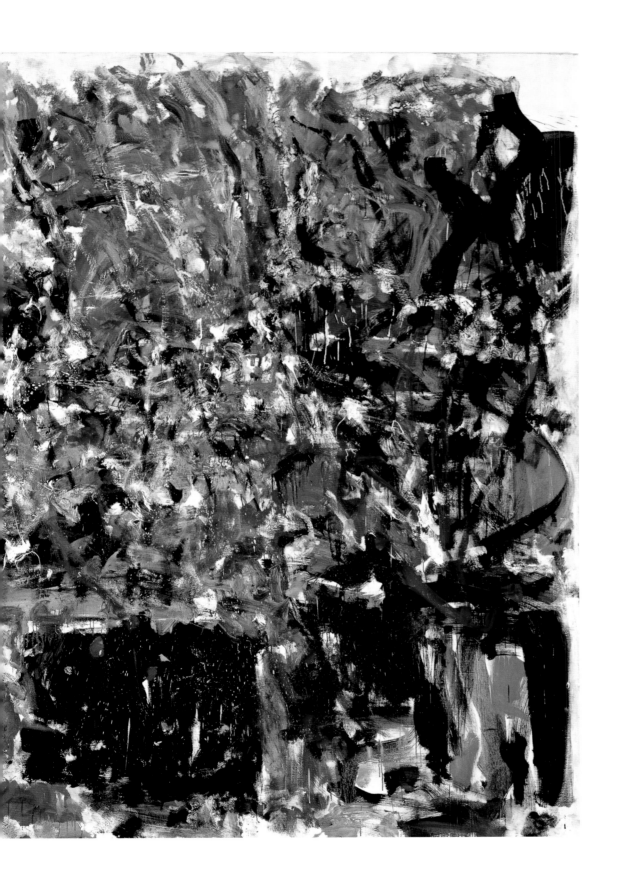

PLATE 41

Aires Pour Marion, 1975–76

Oil on canvas, diptych, 94 x 142 in. (238.8 x 360.7 cm)

Collection of Phil Schrager

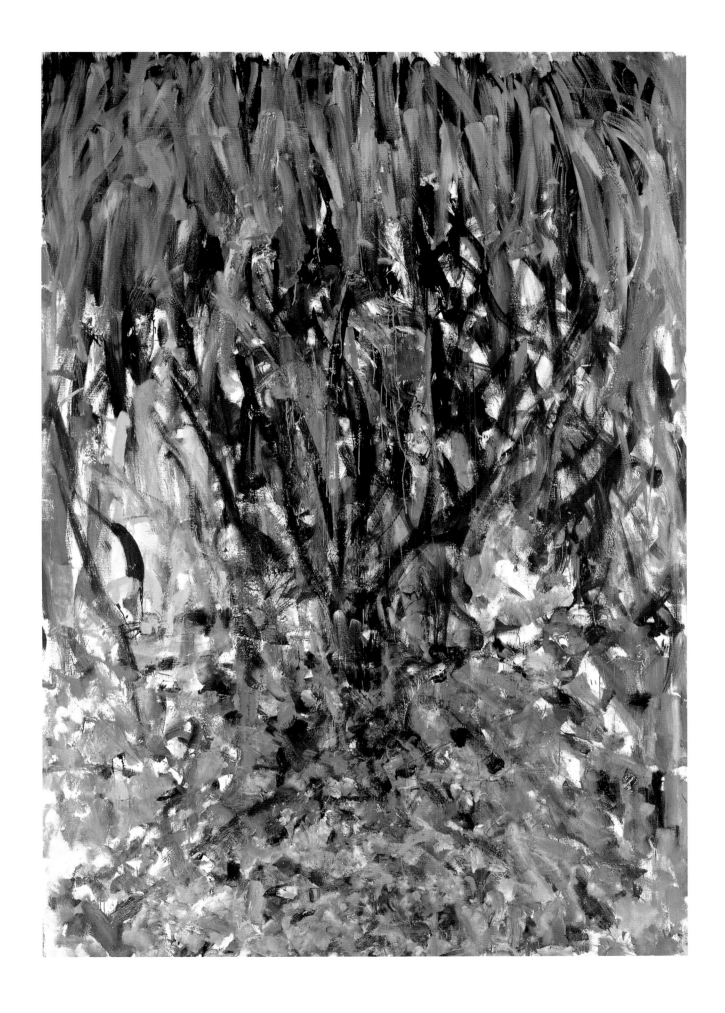

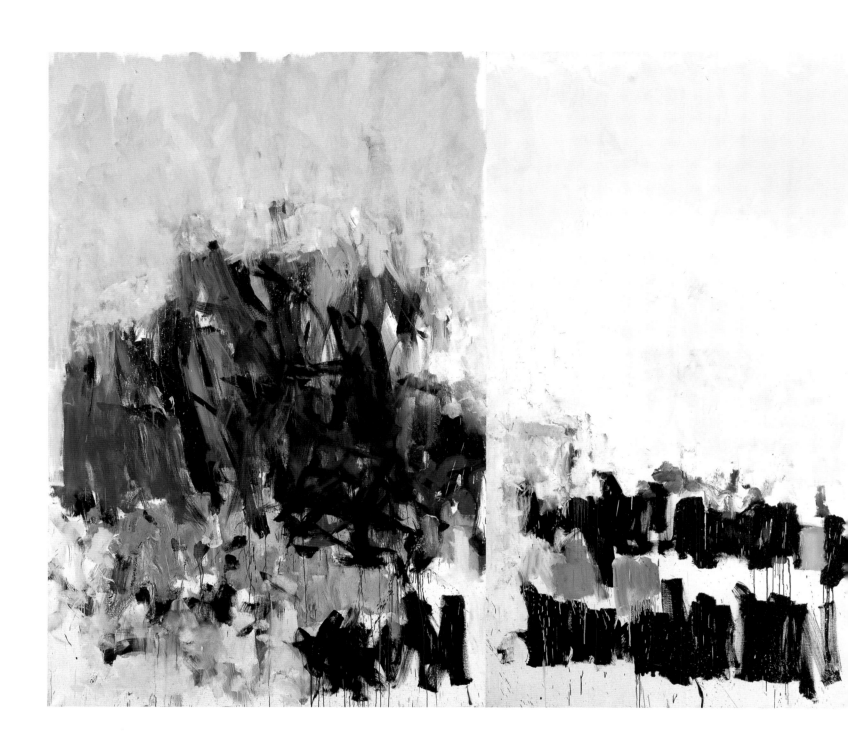

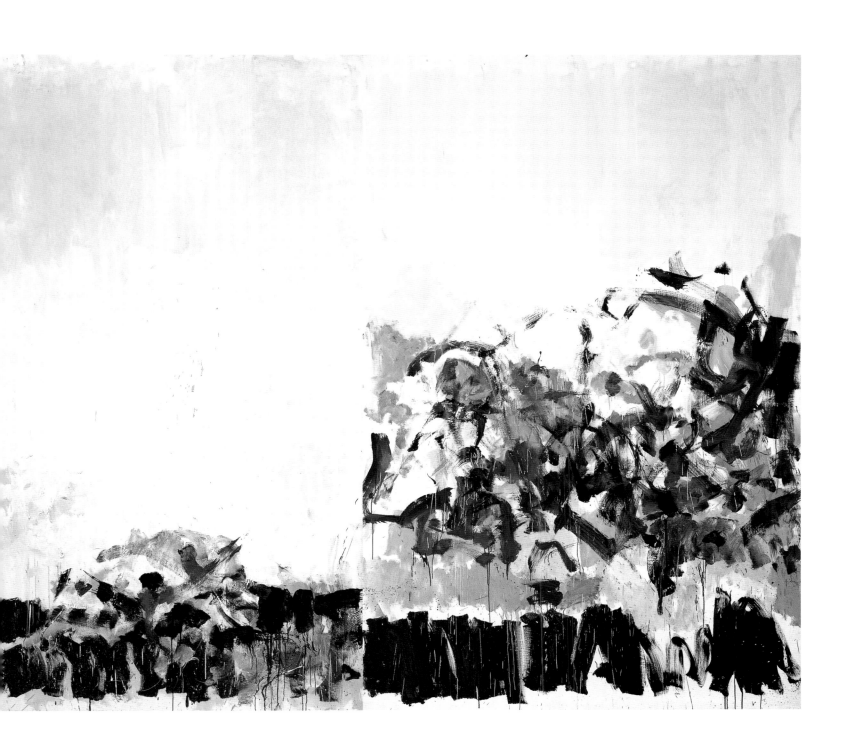

PLATE 43
La Vie en Rose, 1979
Oil on canvas, quadriptych, 110⅜ x 268¼ in. (280.4 x 681.4 cm)
The Metropolitan Museum of Art, New York; Purchase and
Anonymous Gift, George A. Hearn Fund, by exchange, 1991

165

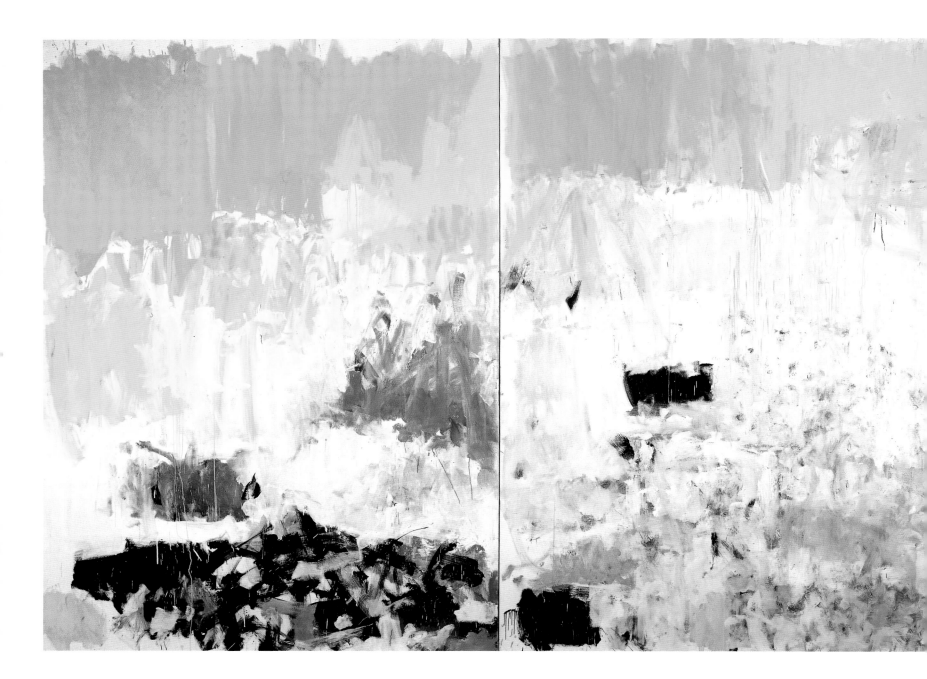

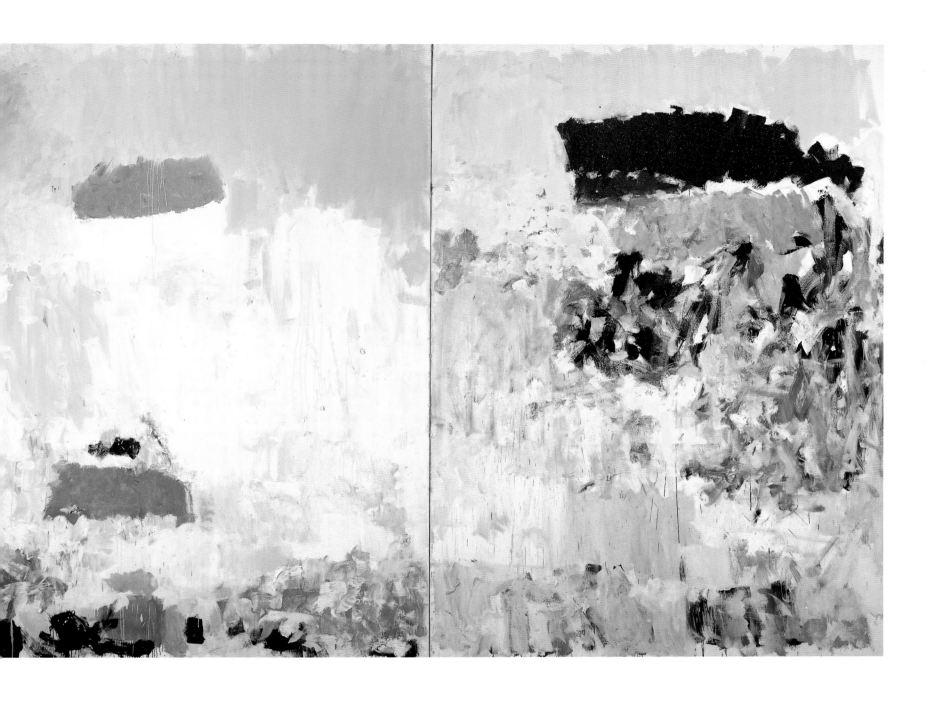

PLATE 44

Salut Tom, 1979

Oil on canvas, quadriptych, 110⁷⁄₁₆ x 314½ in. (280.5 x 798.8 cm)

The Corcoran Gallery of Art, Washington, D.C.; Gift of the Women's
Committee of The Corcoran Gallery of Art, with the aid of funds from
the National Endowment of Arts

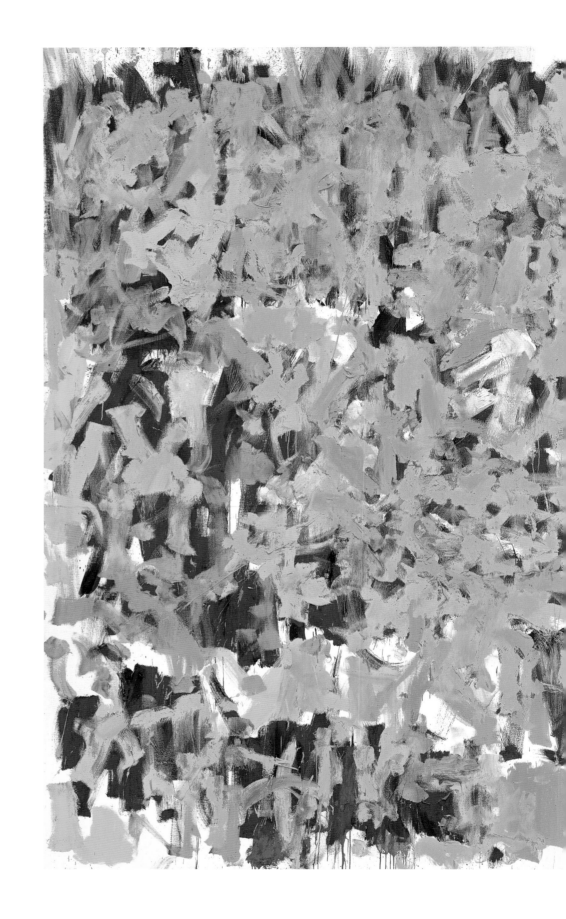

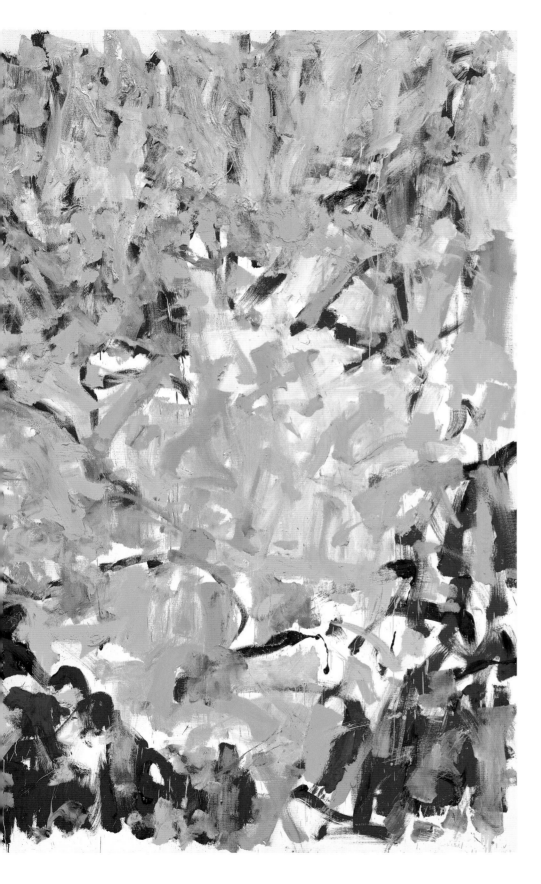

PLATE 45
Two Pianos, 1980
Oil on canvas, diptych, 110 x 142 in. (279.4 x 360.7 cm)
Estate of Joan Mitchell

PLATE 46

Begonia, 1982

Oil on canvas, 110 x 78¾ in. (279.4 x 200 cm)

Castellani Art Museum of Niagara University Collection, Niagara
University, New York; Gift of Dr. and Mrs. Armand J. Castellani, 1991

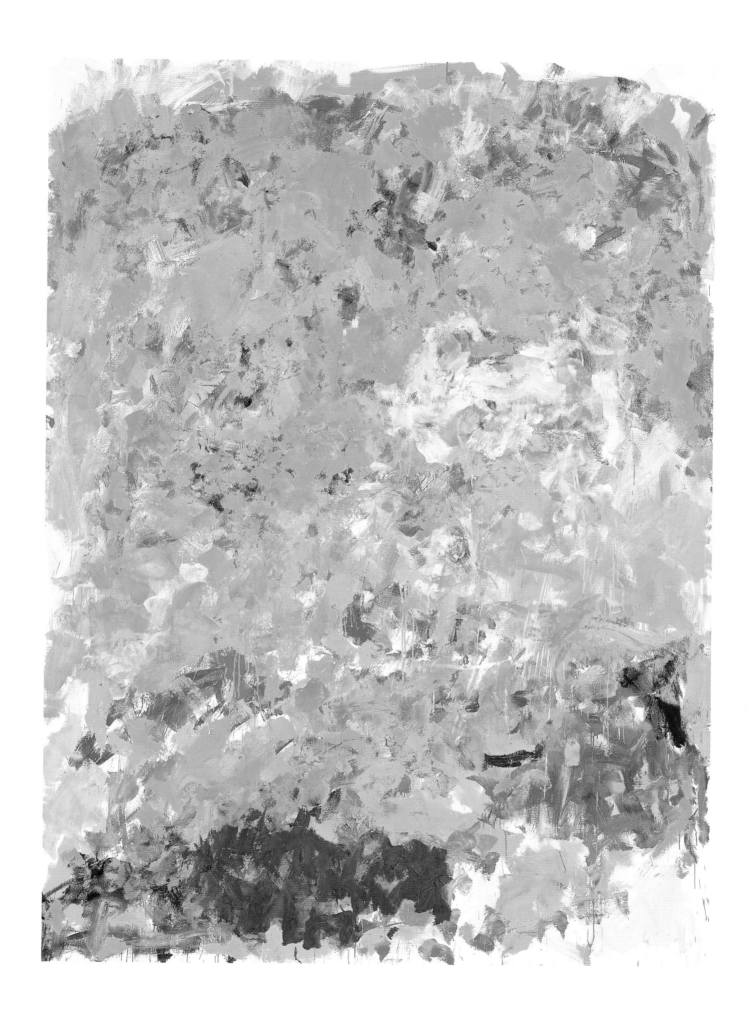

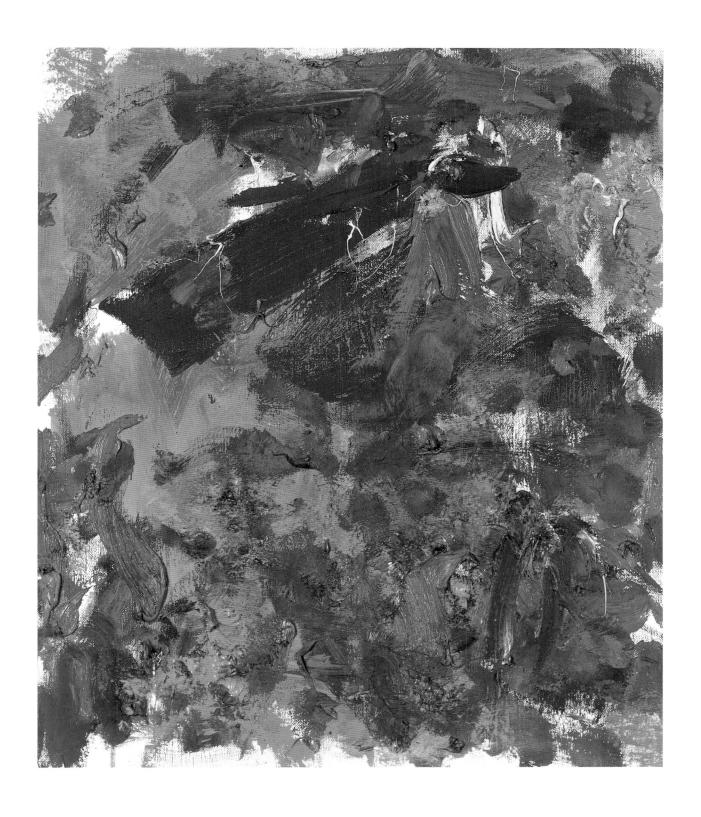

PLATE 47
Gently, 1982
Oil on canvas, 21½ x 18 in. (54.6 x 45.7 cm)
Collection of Betsy Wittenborn Miller; courtesy Robert Miller Gallery,
New York

PLATE 48

La Grande Vallée XIII, 1983
Oil on canvas, 110 x 78¾ in. (279.4 x 200 cm)
Private collection

174

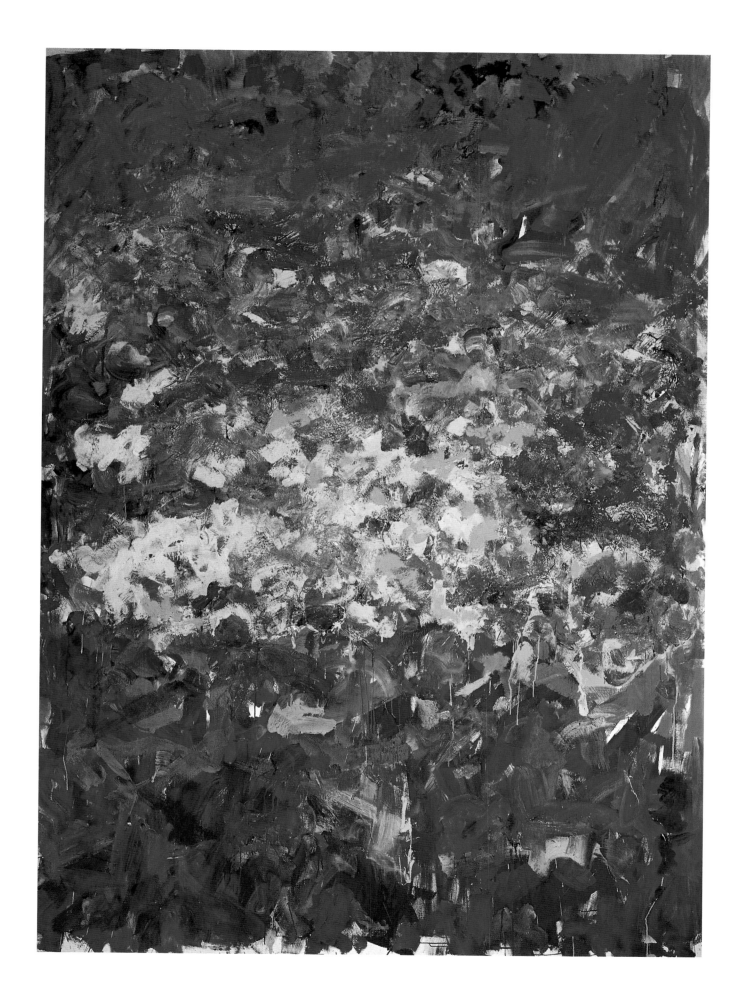

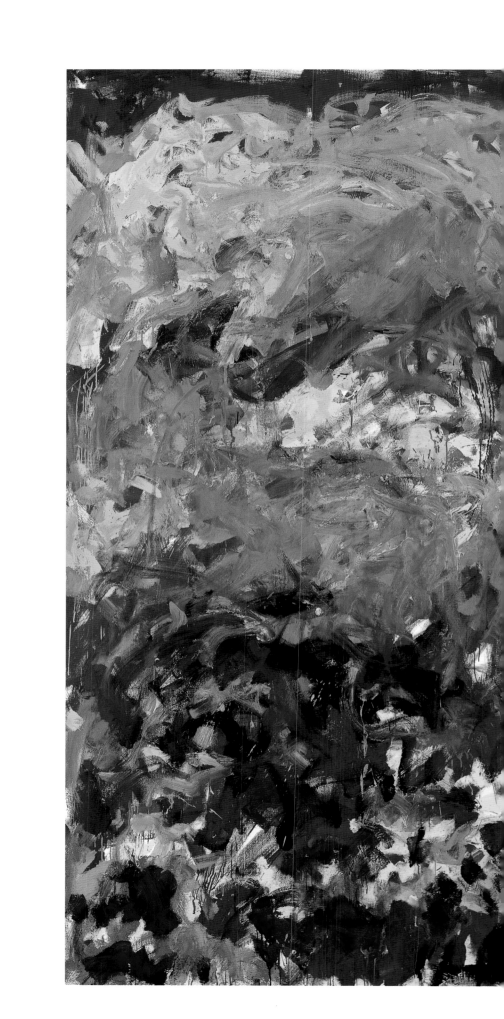

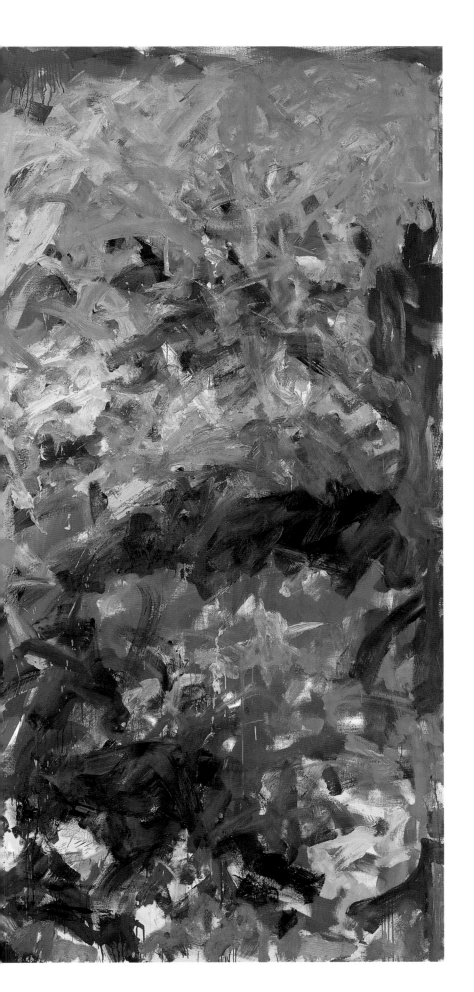

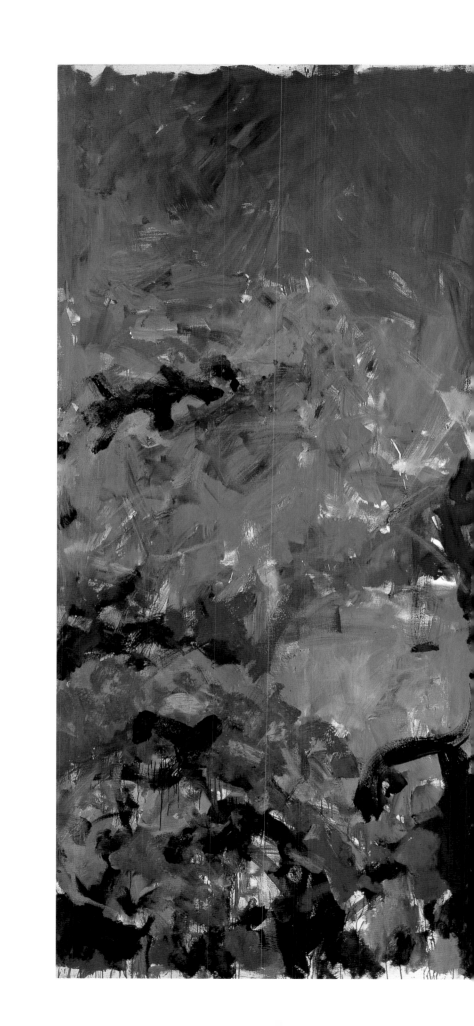

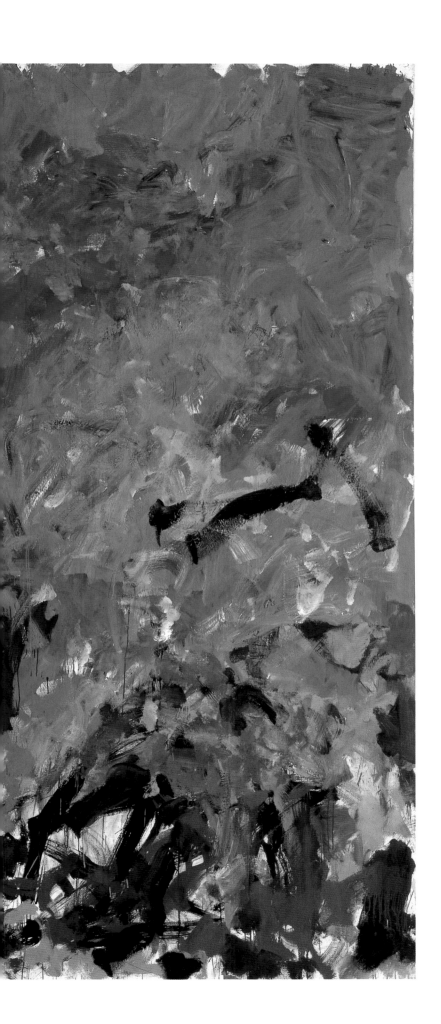

PLATE 50

La Grande Vallée VI, 1984

Oil on canvas, diptych, 110¼ x 102½ in. (280 x 260.4 cm)

Fondation Cartier pour l'art contemporain, Paris

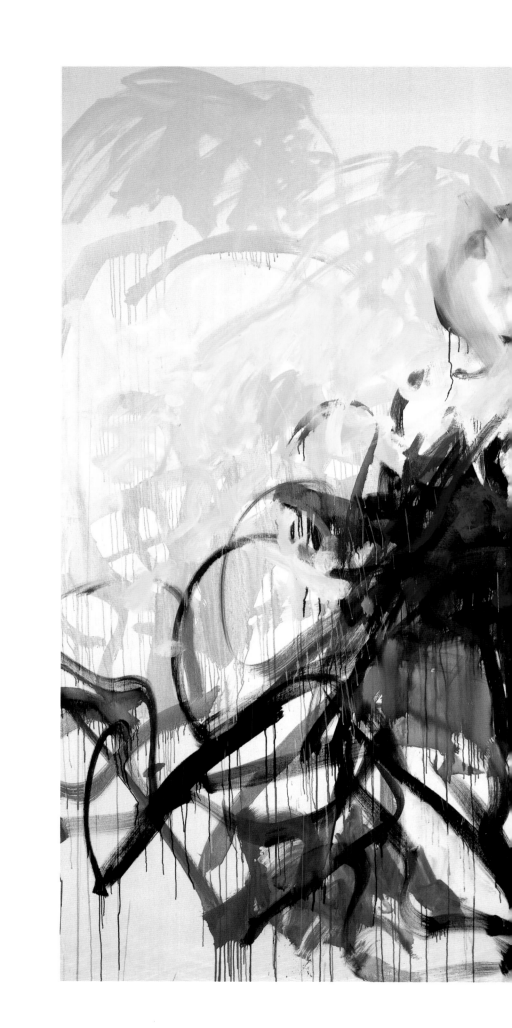

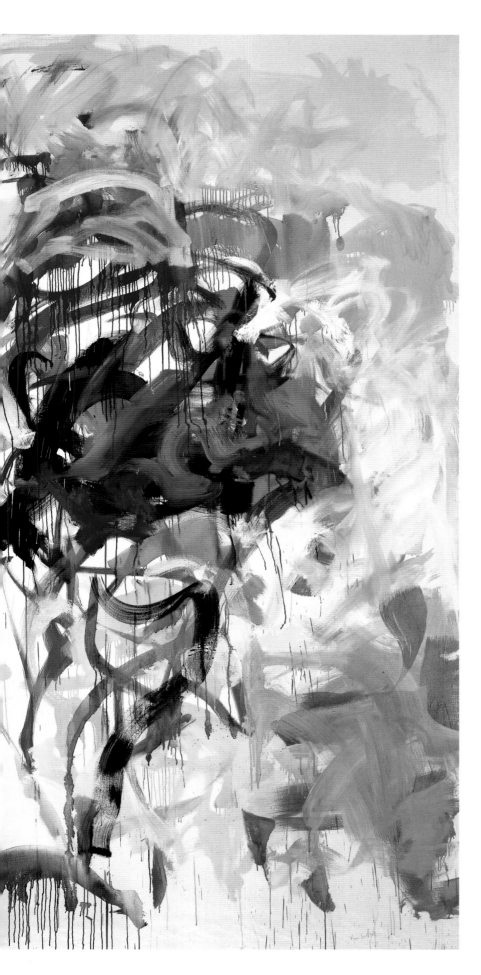

PLATE 51

Faded Air I, 1985

Oil on canvas, diptych, 102 x 102 in. (259.1 x 259.1 cm)

Collection of Thomas and Darlene Furst

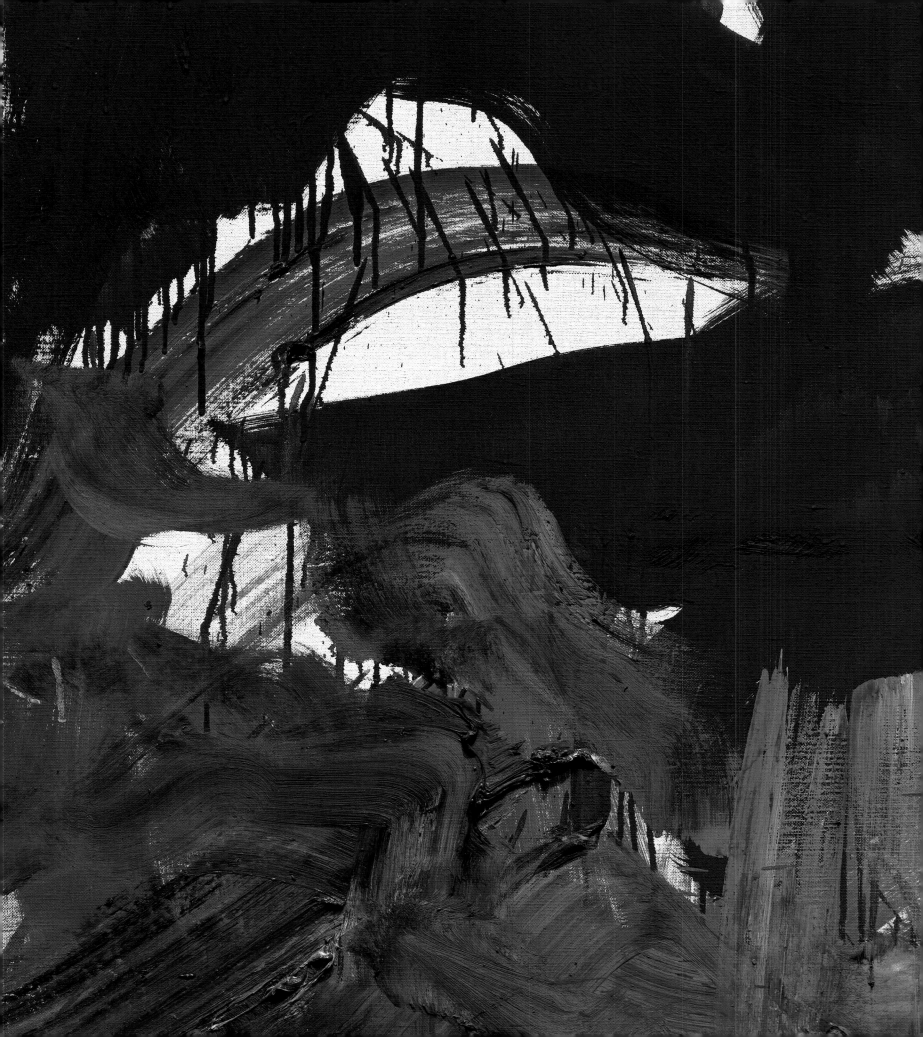

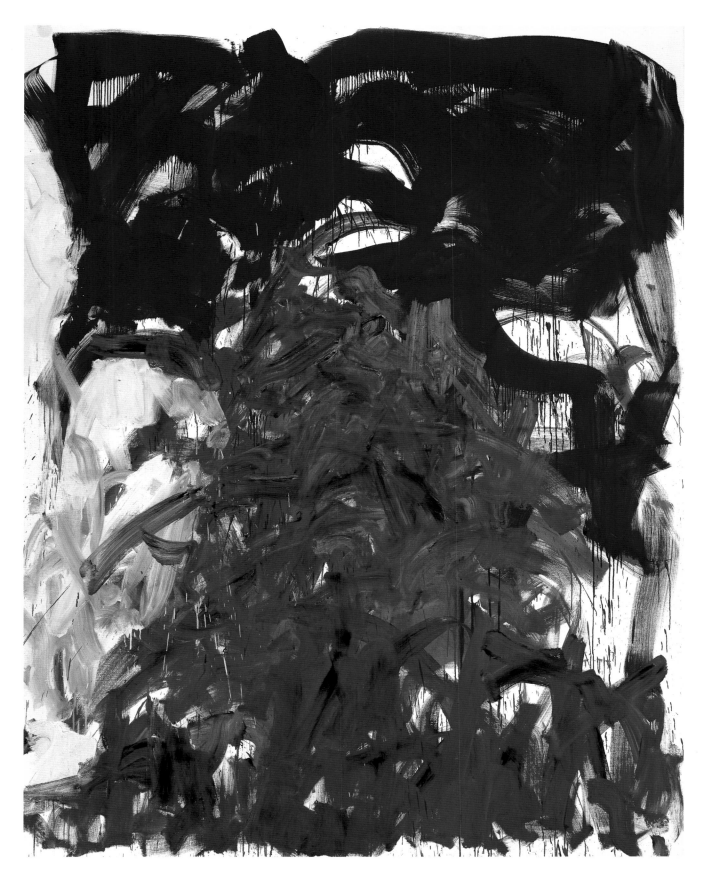

PLATE 52

Then, Last Time No. 4, 1985 (detail opposite)
Oil on canvas, 102 x 78¾ in. (259.1 x 200 cm)
Estate of Joan Mitchell

PLATE 53

Chord VII, 1987

Oil on canvas, 94 x 78¾ in. (238.8 x 200 cm)

Collection of Mr. and Mrs. Robert B. Goergen

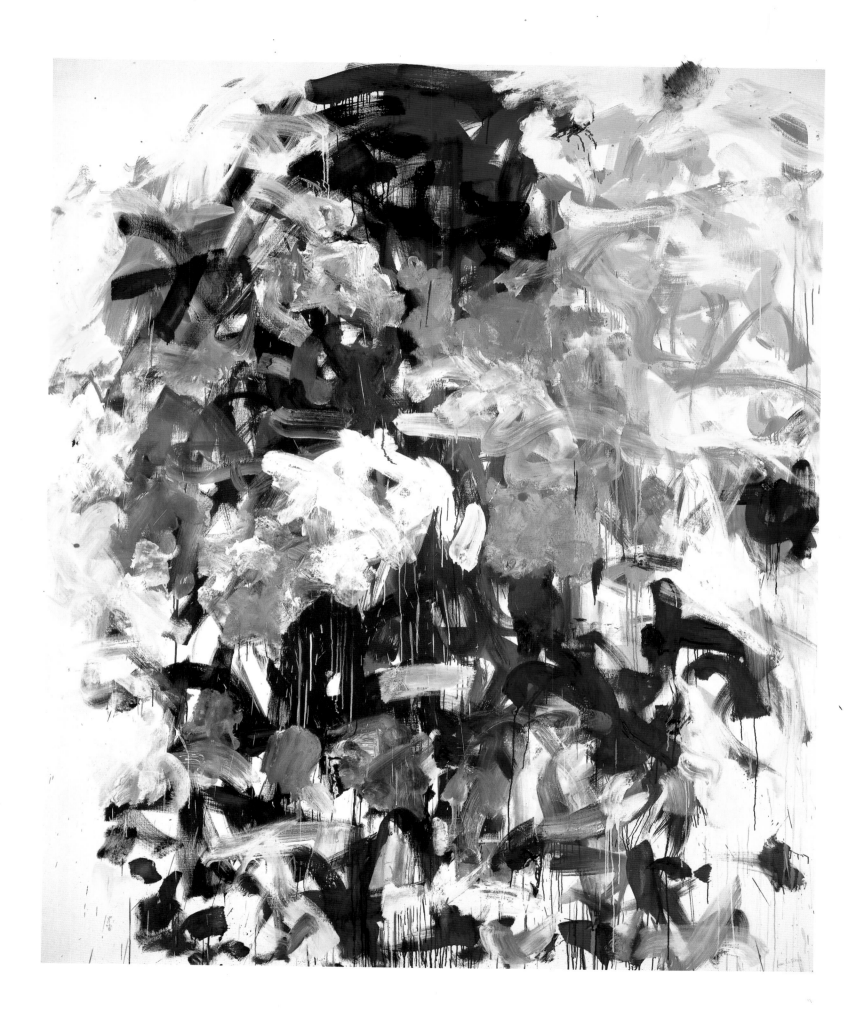

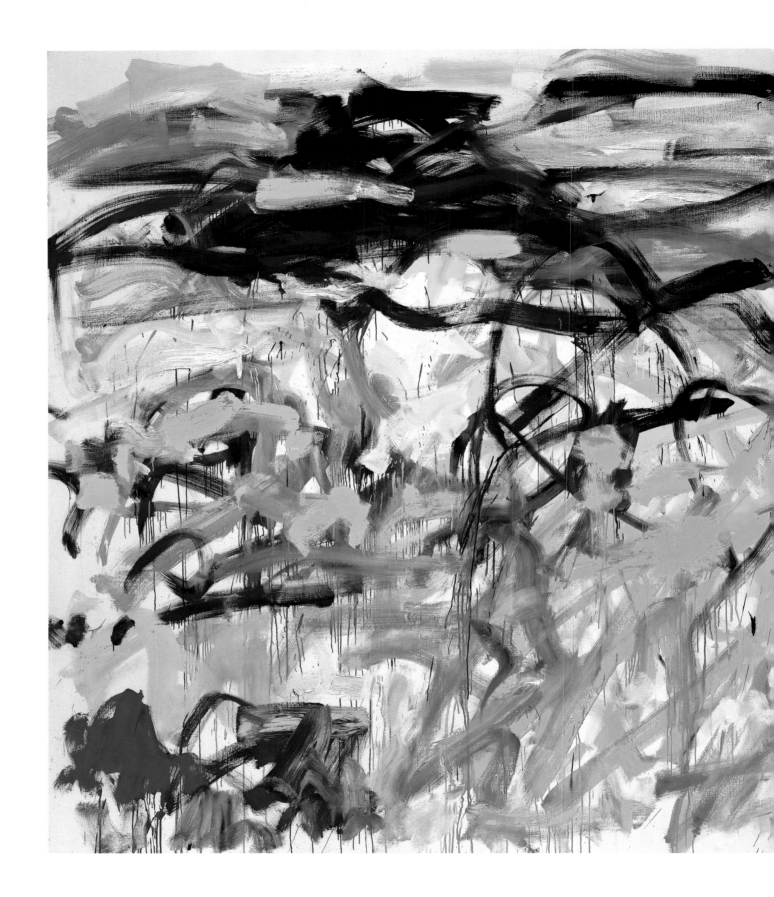

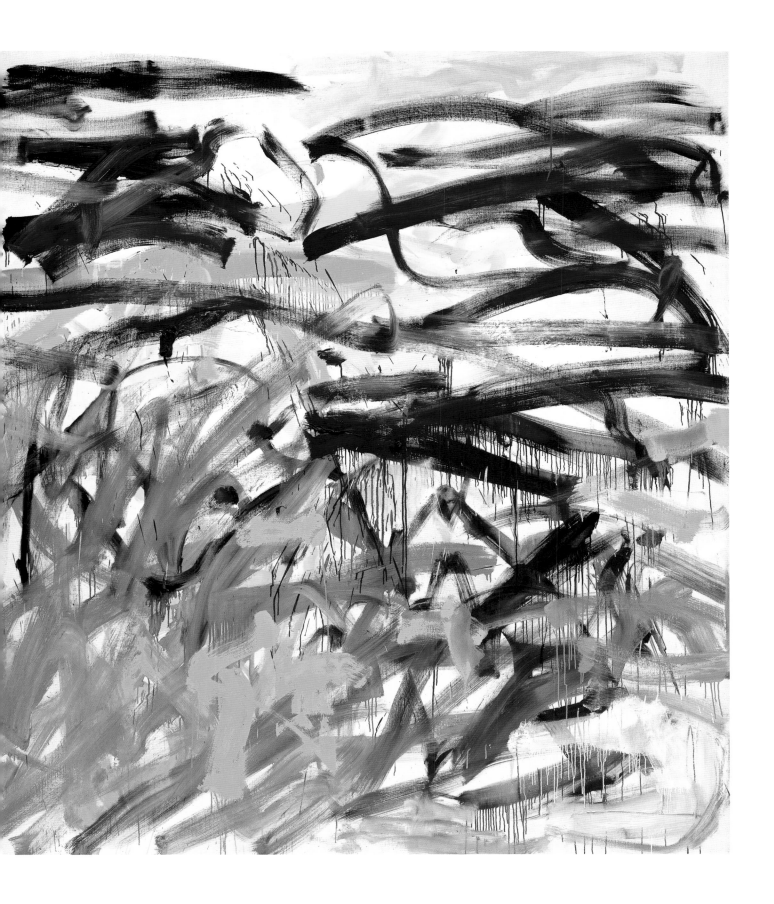

PLATE 54

No Birds, 1987–88

Oil on canvas, diptych, 87½ x 156 in. (222.3 x 396.2 cm)

Estate of Joan Mitchell

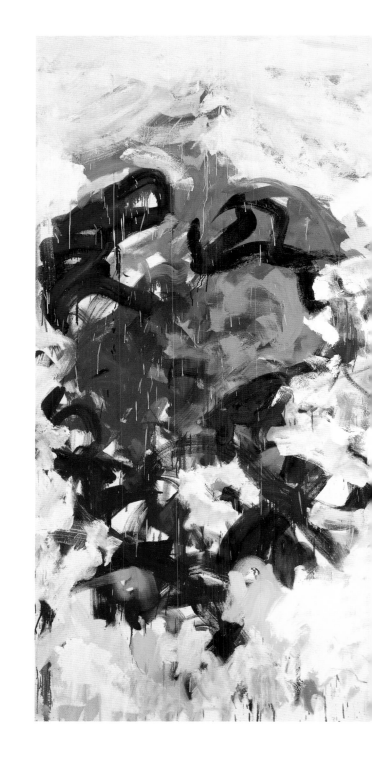

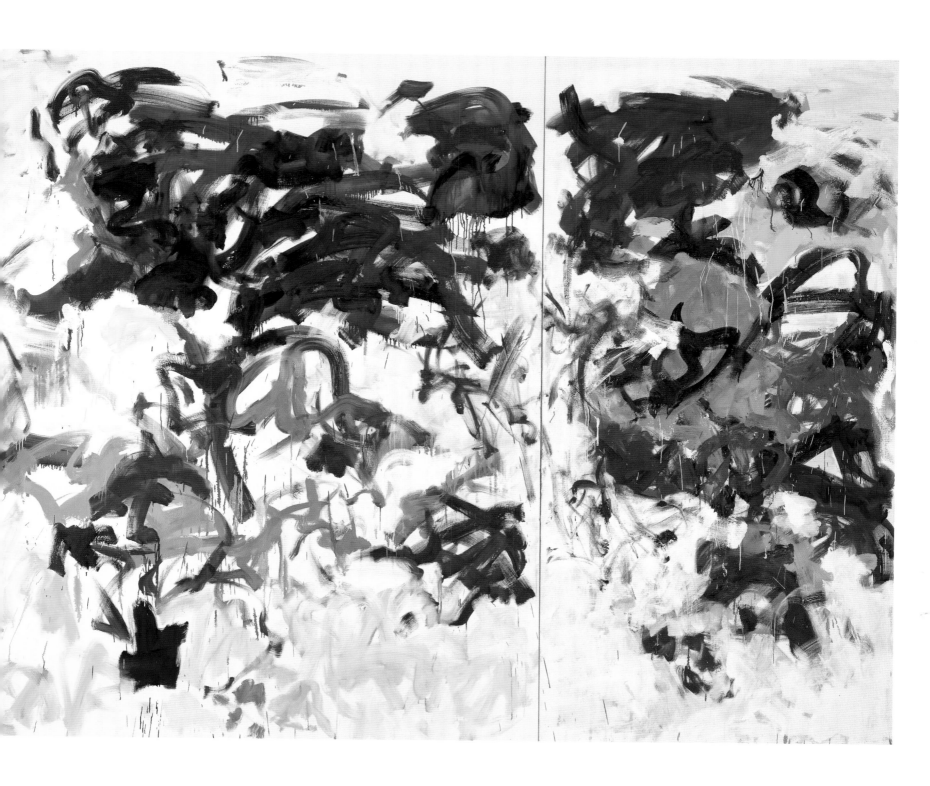

PLATE 55

Bracket, 1989

Oil on canvas, triptych, 102½ x 181¾ in. (260.4 x 461.6 cm)

Daros Collection, Switzerland

189

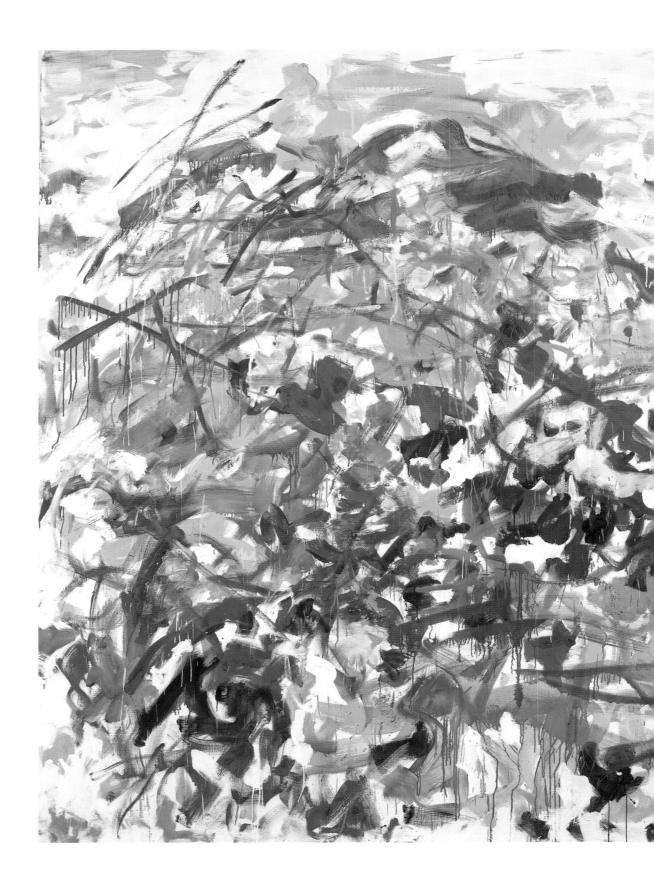

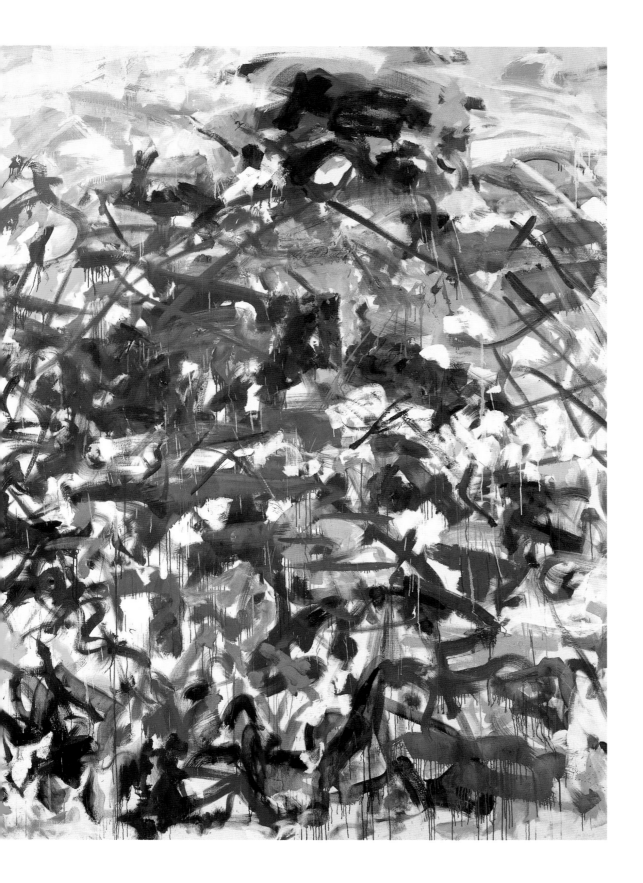

PLATE 56
South, 1989
Oil on canvas, diptych, 102½ x 157½ in. (260.4 x 400.1 cm)
Collection of Betsy Wittenborn Miller and Robert Miller; courtesy
Robert Miller Gallery, New York

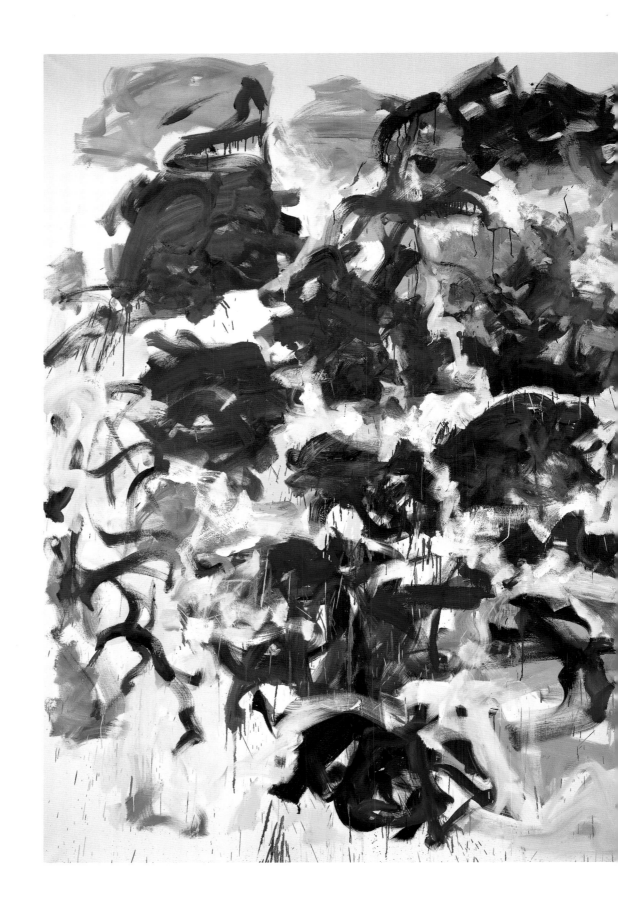

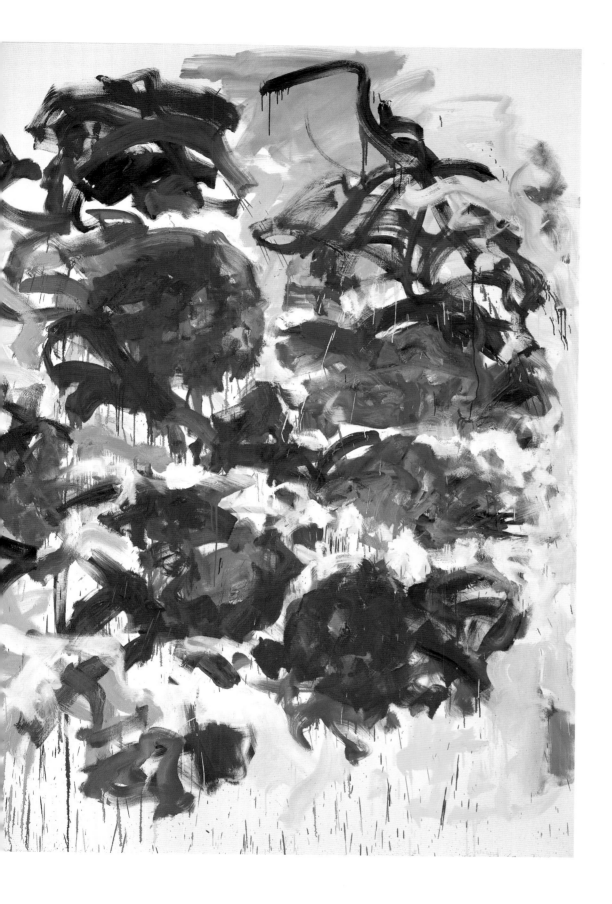

PLATE 57

Sunflowers, 1990–91

Oil on canvas, diptych, 110¼ x 157½ in. (280 x 400.1 cm)

Collection of John Cheim

193

PLATE 58
L'Arbre de Phyllis, 1991
Oil on canvas, 110¼ x 78¾ in. (280 x 200 cm)
Private collection

194

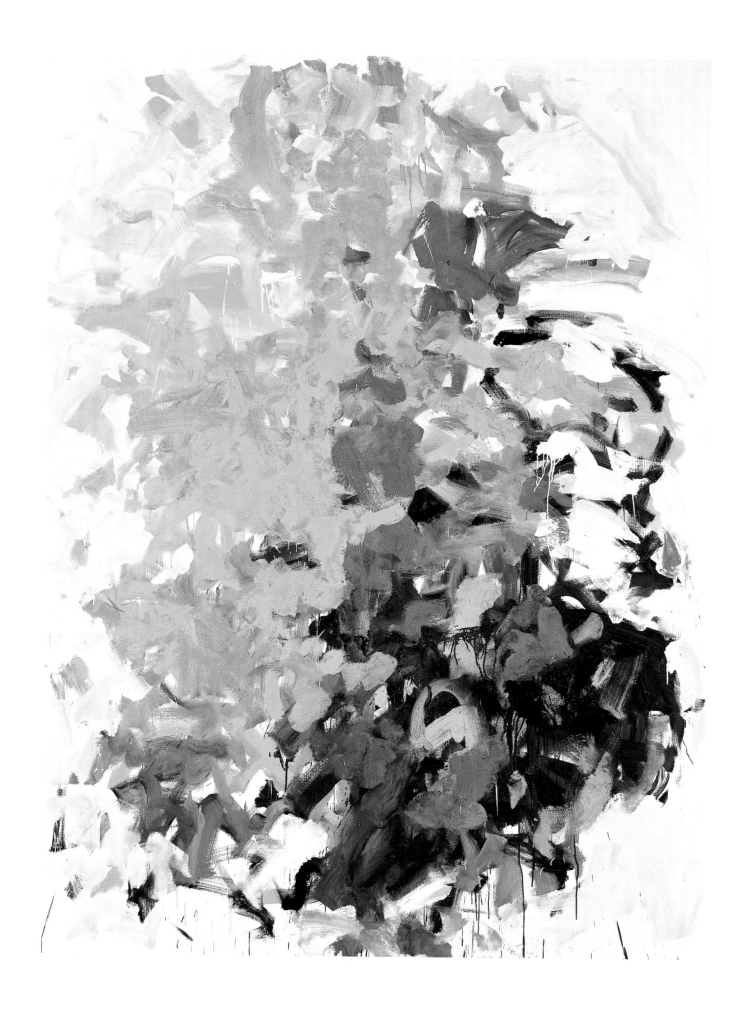

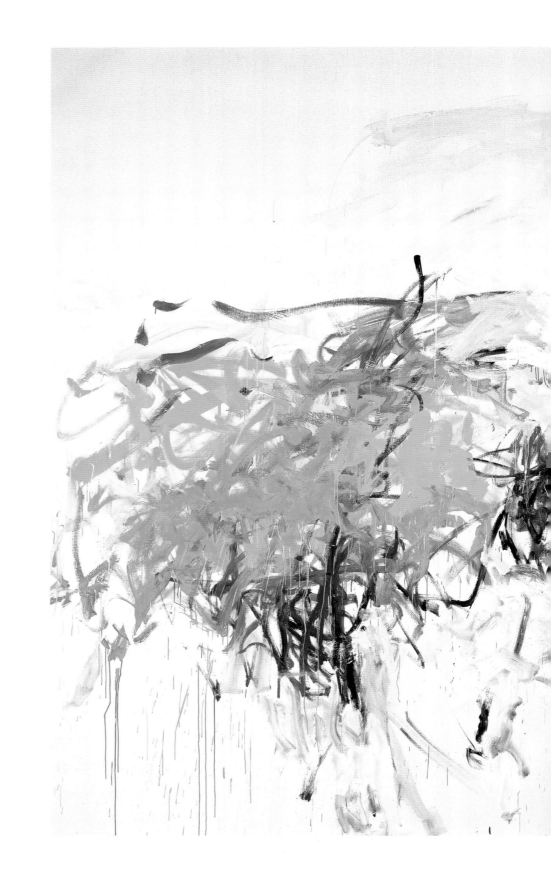

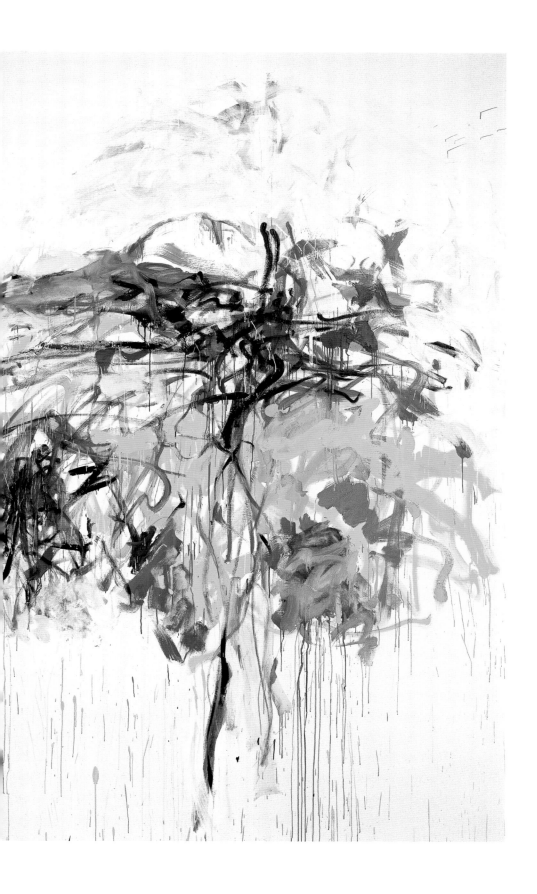

PLATE 59

Untitled, 1992

Oil on canvas, diptych, 110¼ x 141¾ in. (280 x 360 cm)

Private collection

197

Works in the Exhibition

Dimensions are in inches, followed by centimeters; height precedes width.

Cross Section of a Bridge, 1951
Oil on canvas, 79¾ x 119¾ (202.6 x 304.2)
Osaka City Museum of Modern Art, Japan

Untitled, 1951
Oil on canvas, 72 x 78 (182.9 x 198.1)
Estate of Joan Mitchell

Rose Cottage, 1953
Oil on canvas, 71¾ x 68¼ (182.2 x 173.4)
Collection of W. Stephen Croddy

Untitled, 1953–54
Oil on canvas, 81 x 69¼ (205.7 x 175.9)
Estate of Joan Mitchell

Untitled, 1954
Oil on canvas, 96 x 77 (243.8 x 195.6)
Estate of Joan Mitchell

City Landscape, 1955
Oil on canvas, 80 x 80 (203.2 x 203.2)
The Art Institute of Chicago; Gift of the Society for
Contemporary American Art

Hudson River Day Line, 1955
Oil on canvas, 79 x 83 (200.7 x 210.8)
McNay Art Museum, San Antonio; Museum purchase with funds
from the Tobin Foundation

Hemlock, 1956
Oil on canvas, 91 x 80 (231.1 x 203.2)
Whitney Museum of American Art, New York; purchase, with
funds from the Friends of the Whitney Museum of American Art
58.20

King of Spades, 1956
Oil on canvas, 91½ x 78½ (232.4 x 199.4)
Private collection; courtesy Edward Tyler Nahem Fine Art,
New York

Untitled, 1956
Oil on canvas, 94⅜ x 59⅝ (239.7 x 151.4)
Estate of Joan Mitchell

Evenings on Seventy-third Street, 1956–57
Oil on canvas, 75 x 84 (190.5 x 213.4)
Collection of Bunny Adler

George Went Swimming at Barnes Hole, but It Got Too Cold, 1957
Oil on canvas, 85¼ x 78¼ (216.5 x 198.8)
Albright-Knox Art Gallery, Buffalo, New York; Gift of Seymour
H. Knox, Jr., 1958

Ladybug, 1957
Oil on canvas, 77⅞ x 108 (197.8 x 274.3)
The Museum of Modern Art, New York; Purchase, 1961

Untitled, 1957
Oil on canvas, 40⅝ x 38⅜ (103.2 x 97.5)
Estate of Joan Mitchell

Untitled, 1957
Oil on canvas, 29½ x 22 (74.9 x 55.9)
Estate of Joan Mitchell

Untitled, 1957
Oil on canvas, 94⅛ x 87⅝ (239.1 x 222.6)
Estate of Joan Mitchell

Untitled (La Fontaine), 1957
Oil on canvas, 78½ x 64½ (199.4 x 163.8)
Estate of Joan Mitchell

Untitled, 1958
Oil on canvas, 80¾ x 108 (205.1 x 274.3)
Estate of Joan Mitchell

Untitled, 1958
Oil on canvas, 29⅜ x 30 (74.6 x 76.2)
Estate of Joan Mitchell

Untitled, 1959–60
Oil on canvas, 76 x 114 (193 x 289.6)
Kemper Museum of Contemporary Art, Kansas City, Missouri;
Bebe and Crosby Kemper Collection, Gift of the Enid and Crosby
Kemper Foundation

Chatière, 1960
Oil on canvas, 76¾ x 58 (194.9 x 147.3)
Estate of Joan Mitchell

Untitled, 1960
Oil on canvas, 78¾ x 69 (200 x 175.3)
Estate of Joan Mitchell

Untitled, c. 1960
Oil on canvas, 24 x 19⅝ (61 x 49.9)
San Francisco Museum of Modern Art; Gift of Sam Francis

Grandes Carrières, 1961–62
Oil on canvas, 78¾ x 118¼ (200 x 300.4)
The Museum of Modern Art, New York; Gift of The Estate of
Joan Mitchell, 1994

Untitled, 1963
Oil on canvas, 108 x 79½ (274.3 x 201.9)
Estate of Joan Mitchell

Blue Tree, 1964
Oil on canvas, 97⅝ x 78 (248 x 198.1)
Worcester Art Museum, Massachusetts; Museum purchase

Calvi, 1964
Oil on canvas, 96 x 78 (243.8 x 198.1)
Private collection

Untitled (Cheim Some Bells), 1964
Oil on canvas, 84 x 78¼ (213.4 x 198.8)
Collection of John Cheim

Untitled, 1965
Oil on canvas, 28½ x 21 (72.4 x 53.3)
Estate of Joan Mitchell

My Landscape II, 1967
Oil on canvas, 103 x 71½ (261.6 x 181.6)
Smithsonian American Art Museum, Washington, D.C.; Gift of
Mr. and Mrs. David K. Anderson, Martha Jackson Memorial
Collection

Low Water, 1969
Oil on canvas, 112 x 79 (284.5 x 200.7)
Carnegie Museum of Art, Pittsburgh; Patrons Art Fund, 1970

Sunflower III, 1969
Oil on canvas, 112½ x 78½ (285.8 x 199.4)
Smithsonian American Art Museum, Washington, D.C.; Gift of
Mr. and Mrs. David K. Anderson, Martha Jackson Memorial
Collection

Salut Sally, 1970
Oil on canvas, 112 x 79 (284.5 x 200.7)
Collection of Jean Fournier

La Ligne de la Rupture, 1970–71
Oil on canvas, 112 x 79 (284.5 x 200.7)
Collection of Moya Connell-McDowell

Mooring, 1971
Oil on canvas, 95 x 71 (241.3 x 180.3)
Museum of Art, Rhode Island School of Design, Providence; Gift
of the Bayard and Harriet K. Ewing Collection

Wet Orange, 1971–72
Oil on canvas, triptych, 112 x 245 (284.5 x 622.3)
Carnegie Museum of Art, Pittsburgh; National Endowment for
the Arts Matching Grant and Kaufmann's Department Stores
Purchase Grant, 1974

Blue Territory, 1972
Oil on canvas, 102⅜ x 70⅞ (260 x 180)
Albright-Knox Art Gallery, Buffalo, New York; Gift of Seymour
H. Knox, Jr., 1972

Belle Bête, 1973
Oil on canvas, 102¼ x 70¾ (259.7 x 179.7)
Private collection; courtesy Edward Tyler Nahem Fine Art,
New York

Clearing, 1973
Oil on canvas, triptych, 110¼ x 236 (280 x 599.4)
Whitney Museum of American Art, New York; purchase, with
funds from Susan Morse Hilles in honor of John I.H. Baur 74.72

Field for Skyes, 1973
Oil on canvas, triptych, 110¼ x 204¾ (280 x 520.1)
Hirshhorn Museum and Sculpture Garden, Smithsonian
Institution, Washington, D.C.; Gift of Mr. and Mrs. David T.
Workman, 1975

Aires Pour Marion, 1975–76
Oil on canvas, diptych, 94 x 142 (238.8 x 360.7)
Collection of Phil Schrager

Tilleul, 1978
Oil on canvas, 102⅜ x 70⅞ (260 x 180)
Musée national d'art moderne/Centre de création industrielle,
Centre Georges Pompidou, Paris, en dépôt au Musée des Beaux-
Arts de Nantes, Dation en 1995

La Vie en Rose, 1979
Oil on canvas, quadriptych, 110⅜ x 268¼ (280.4 x 681.4)
The Metropolitan Museum of Art, New York; Purchase and
Anonymous Gift, George A. Hearn Fund, by exchange, 1991

Salut Tom, 1979
Oil on canvas, quadriptych, 110⁷⁄₁₆ x 314½ (280.5 x 798.8)
The Corcoran Gallery of Art, Washington, D.C.; Gift of the
Women's Committee of The Corcoran Gallery of Art, with the
aid of funds from the National Endowment of Arts

Two Pianos, 1980
Oil on canvas, diptych, 110 x 142 (279.4 x 360.7)
Estate of Joan Mitchell

Begonia, 1982
Oil on canvas, 110 x 78¾ (279.4 x 200)
Castellani Art Museum of Niagara University Collection, Niagara
University, New York; Gift of Dr. and Mrs. Armand J. Castellani,
1991

Gently, 1982
Oil on canvas, 21½ x 18 (54.6 x 45.7)
Collection of Betsy Wittenborn Miller; courtesy Robert Miller
Gallery, New York

La Grande Vallée XIII, 1983
Oil on canvas, 110 x 78¾ (279.4 x 200)
Private collection

La Grande Vallée IX, 1983–84
Oil on canvas, diptych, 102⅜ x 102⅜ (260 x 260)
Fonds Régional d'Art Contemporain de Haute-Normandie,
Sotteville-lès-Rouen, France

La Grande Vallée VI, 1984
Oil on canvas, diptych, 110¼ x 102½ (280 x 260.4)
Fondation Cartier pour l'art contemporain, Paris

Faded Air I, 1985
Oil on canvas, diptych, 102 x 102 (259.1 x 259.1)
Collection of Thomas and Darlene Furst

Then, Last Time No. 4, 1985
Oil on canvas, 102 x 78¾ (259.1 x 200)
Estate of Joan Mitchell

Chord VII, 1987
Oil on canvas, 94 x 78¾ (238.8 x 200)
Collection of Mr. and Mrs. Robert B. Goergen

No Birds, 1987–88
Oil on canvas, diptych, 87½ x 156 (222.3 x 396.2)
Estate of Joan Mitchell

Bracket, 1989
Oil on canvas, triptych, 102½ x 181¾ (260.4 x 461.6)
Daros Collection, Switzerland

South, 1989
Oil on canvas, diptych, 102½ x 157½ (260.4 x 400.1)
Collection of Betsy Wittenborn Miller and Robert Miller; courtesy
Robert Miller Gallery, New York

Sunflowers, 1990–91
Oil on canvas, diptych, 110¼ x 157½ (280 x 400.1)
Collection of John Cheim

L'Arbre de Phyllis, 1991
Oil on canvas, 110¼ x 78¾ (280 x 200)
Private collection

Untitled, 1992
Oil on canvas, diptych, 110¼ x 141¾ (280 x 360)
Private collection

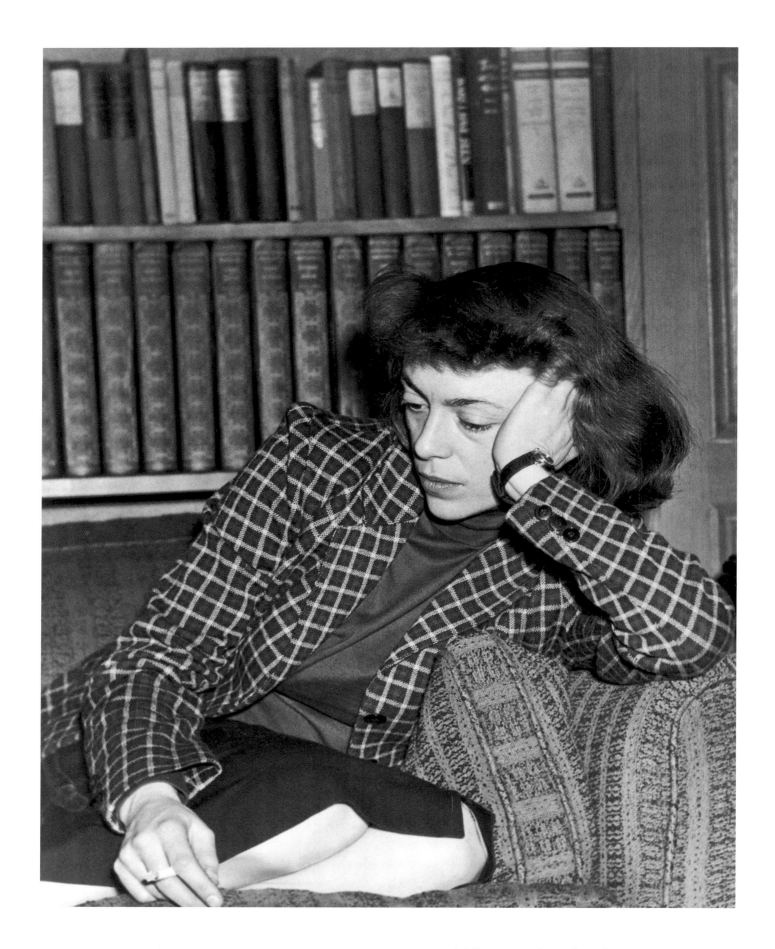

Joan Mitchell. Courtesy Robert Miller Gallery, New York

Selected Exhibition History

1950
St. Paul Gallery and School of Art, Minnesota.

1952
The New Gallery, New York (brochure, with an essay by Nicolas Calas).

1953
Stable Gallery, New York.

1954
Stable Gallery, New York.

1955
Stable Gallery, New York.

1957
Stable Gallery, New York.

1958
Stable Gallery, New York.

1960

Galleria dell'Ariete, Milan (catalogue, with an essay by Franco Russoli).

Galerie Neufville, Paris.

1961

Dwan Gallery, Los Angeles.

Holland-Goldowsky Gallery, Chicago.

Joan Mitchell: Paintings, 1951–61, Mr. & Mrs. John Russell Mitchell Gallery, Southern Illinois University, Carbondale.

Stable Gallery, New York.

1962

Jacques Dubourg, Paris, and Galerie Lawrence, Paris (catalogue, with an essay by Pierre Schneider).

J. Mitchell: Ausstellung von Ölbildern, Klipstein und Kornfeld, Bern, Switzerland (catalogue).

Paintings by Joan Mitchell, The New Gallery, Hayden Library, Massachusetts Institute of Technology, Cambridge (brochure).

1965
Stable Gallery, New York.

1967
Galerie Jean Fournier, Paris (announcement, with a poem by Jacques Dupin).

1968
Joan Mitchell: Recent Paintings, Martha Jackson Gallery, New York.

1969
Galerie Jean Fournier, Paris.

1971
Galerie Jean Fournier, Paris.

1972
"My Five Years in the Country": An exhibition of forty-nine paintings by Joan Mitchell, Everson Museum of Art, Syracuse, New York. Traveled to Martha Jackson Gallery, New York, as *Joan Mitchell: Blue Series 1970–1971* and *Joan Mitchell: The Fields Series 1971–1972* (catalogue, with an introduction by James Harithas).

1973
Ruth S. Schaffner Gallery, Los Angeles (announcement, with introductory notes by Ruth S. Schaffner).

1974
Joan Mitchell: Recent Paintings, The Arts Club of Chicago (pamphlet).

Ruth S. Schaffner Gallery, Los Angeles.

Whitney Museum of American Art, New York (catalogue, with an essay by Marcia Tucker).

1976
Joan Mitchell: New Paintings, Xavier Fourcade, New York (catalogue).

Galerie Jean Fournier, Paris.

1977
Joan Mitchell: New Paintings, 1977, Xavier Fourcade, New York.

1978
Galerie Jean Fournier, Paris.

Joan Mitchell: New Paintings and Pastels, Ruth S. Schaffner Gallery, Los Angeles (announcement, with a dedicatory note by Sam Francis).

Webb and Parsons Gallery, Bedford Village, New York.

1979
Gallery Paule Anglim, San Francisco (announcement, with a dedicatory poem by Sam Francis).

1980
Joan Mitchell: The Fifties. Important Paintings, Xavier Fourcade, New York.

Galerie Jean Fournier, Paris (announcement, with introductory notes by Pierre Schneider).

Joan Mitchell: Major Paintings, Richard Hines Gallery, Seattle.

1981
Joan Mitchell: New Paintings, Xavier Fourcade, New York.

Joan Mitchell: Paintings and Works on Paper, Janie C. Lee Gallery, Houston.

Gloria Luria Gallery, Bay Harbor Islands, Florida.

1982
Joan Mitchell: Choix de peintures 1970–1982, ARC, Musée d'Art Moderne de la Ville de Paris (catalogue, with an introduction by Suzanne Pagé and essays by Marcelin Pleynet and Barbara Rose).

1983
Joan Mitchell: New Paintings, Xavier Fourcade, New York.

1984
Joan Mitchell: La Grande Vallée, Galerie Jean Fournier, Paris (catalogue, with an essay by Yves Michaud).

Galerie Jean Fournier at FIAC 84 (Foire Internationale d'Art Contemporain), Grand Palais, Paris.

1985
Joan Mitchell: The Sixties, Xavier Fourcade, New York (catalogue).

1986

Joan Mitchell: New Paintings, Xavier Fourcade, New York (catalogue, with a conversation with Yves Michaud).

Joan Mitchell: An exhibition of paintings and works on paper, Keny & Johnson Gallery, Columbus, Ohio (brochure, with an essay by Mathew Herban, III).

1987

Joan Mitchell: River, Lille, Chord. Peintures 1986 & 1987, Galerie Jean Fournier, Paris (catalogue, with an essay by Yves Michaud).

1988

The Paintings of Joan Mitchell: Thirty-six Years of Natural Expressionism (organized by the Herbert F. Johnson Museum of Art, Cornell University, Ithaca, New York). Traveled to: The Corcoran Gallery of Art, Washington, D.C.; San Francisco Museum of Modern Art; Albright-Knox Art Gallery, Buffalo, New York; La Jolla Museum of Contemporary Art, California; Herbert F. Johnson Museum of Art, Cornell University, Ithaca, New York (catalogue, *Joan Mitchell*, by Judith E. Bernstock, and brochure, with a foreword by Judith E. Bernstock and an essay by Yves Michaud).

Joan Mitchell: Selected Paintings Spanning Thirty Years, Manny Silverman Gallery, Los Angeles (catalogue, with an essay by Donna Stein).

1989

Robert Miller Gallery, New York (catalogue).

1990

Joan Mitchell: Champs, Galerie Jean Fournier, Paris (brochure, with an essay by Yves Michaud).

Joan Mitchell: Paintings and Drawings, Barbara Mathes Gallery, New York.

1991

Robert Miller Gallery, New York.

1992

Joan Mitchell: Trees and Other Paintings, 1960 to 1990, Laura Carpenter Fine Art, Santa Fe (catalogue, with an essay and poem by John Yau).

Un choix dans la collection du FRAC de Haute-Normandie: Joan Mitchell, Fonds Régional d'Art Contemporain de Haute-Normandie, Saint-Maurice-d'Etelan, France.

Galerie Jean Fournier, Paris (brochure, with an insert of an essay by Yves Michaud).

Joan Mitchell: Recent Lithographs, Susan Sheehan Gallery, New York.

Sunflowers and *Trees*, Tyler Graphics, Mount Kisco, New York.

Joan Mitchell: Pastel, Whitney Museum of American Art, New York (brochure, with an essay by Klaus Kertess).

1993

Joan Mitchell: 26 farbige Radierungen, 1972–1989, Galerie Daniel Blau, Munich.

Maier Museum of Art, Randolph-Macon Woman's College, Lynchburg, Virginia.

Joan Mitchell 1992, Robert Miller Gallery, New York (catalogue, edited by John Cheim with a foreword by John Ashbery).

Joan Mitchell: Prints and Illustrated Books. A Retrospective, Susan Sheehan Gallery, New York (catalogue, with an essay by Susan Sheehan).

1994

Joan Mitchell: Pastels, Galerie Jean Fournier, Paris.

Joan Mitchell, les dernières années (1983–1992), Galerie nationale du Jeu de Paume, Paris (catalogue, *Joan Mitchell*, published in association with Musée des Beaux-Arts de Nantes, France, with an essay by Robert Storr and an interview by Yves Michaud).

Joan Mitchell: "... my black paintings ..." 1964, Robert Miller Gallery, New York (catalogue).

Joan Mitchell, œuvres de 1951 à 1982, Musée des Beaux-Arts de Nantes, France (catalogue, *Joan Mitchell*, published in association with Galerie nationale du Jeu de Paume, Paris, with an essay by Robert Storr and an interview by Yves Michaud).

Joan Mitchell in Vétheuil, Newport Harbor Art Museum, Newport Beach, California.

1995

Joan Mitchell: Selected Paintings and Pastels 1950–1990, Baumgartner Galleries, Washington, D.C.

Joan Mitchell: Pastels, Les Cordeliers Châteauroux, France (catalogue).

Joan Mitchell: Tilleuls 1978. Huiles sur toile & Pastels, Galerie Jean Fournier, Paris (catalogue, with texts by Pierre Schneider).

1996

Joan Mitchell: Paintings 1956 to 1958, Robert Miller Gallery, New York (catalogue).

1997

IVAM Centre Julio González, Valencia, Spain (catalogue, with an introduction by Juan Manuel Bonet and essays by Richard D. Marshall and Marcelin Pleynet).

Joan Mitchell: Selected Paintings 1975–1977, Lennon, Weinberg, New York.

Joan Mitchell: Pastels, Musée des Beaux-Arts de Rouen, France.

Pastels by Joan Mitchell, The Phillips Collection, Washington, D.C.

Galerie Won, Seoul, Korea (catalogue, with an essay by Yves Michaud).

1998

Joan Mitchell: Paintings 1950 to 1955, Robert Miller Gallery, New York (catalogue, with an essay by Hal Fondren).

Joan Mitchell: From Nature to Abstraction, Nave Museum, Victoria, Texas (brochure).

1999

The Nature of Abstraction: Joan Mitchell Paintings, Drawings, and Prints, Walker Art Center, Minneapolis.

SELECTED GROUP EXHIBITIONS

1944

Forty-eighth Annual Exhibition by Artists of Chicago and Vicinity, The Art Institute of Chicago (catalogue).

1945

Forty-ninth Annual Exhibition by Artists of Chicago and Vicinity, The Art Institute of Chicago (catalogue).

1947

51st Annual Exhibition by Artists of Chicago and Vicinity, The Art Institute of Chicago (catalogue).

1949

Fifty-third Annual Exhibition by Artists of Chicago and Vicinity, The Art Institute of Chicago (catalogue).

Ninth Annual Exhibition of the Society for Contemporary American Art, The Art Institute of Chicago.

An Exhibition of Paintings and Sculpture Owned by Its Members, The Society for Contemporary American Art, Associated American Artists Galleries, Chicago.

1950

Tenth Annual Society for Contemporary American Art Exhibition, The Art Institute of Chicago.

1951

Eleventh Annual Society for Contemporary American Art Exhibition, The Art Institute of Chicago.

9th Street: Exhibition of Paintings and Sculpture (organized by The Club with the assistance of Leo Castelli), Ninth Street, New York.

1951 Annual Exhibition of Contemporary American Painting, Whitney Museum of American Art, New York (catalogue).

1953

13th Annual Exhibition of the Society for Contemporary American Art, The Art Institute of Chicago.

Second Annual Exhibition of Painting and Sculpture, Stable Gallery, New York (announcement, with an acknowledgment by Clement Greenberg).

1954

Third Annual Exhibition of Painting and Sculpture, Stable Gallery, New York.

1955

Society for Contemporary American Art: 15th Annual Exhibition, The Art Institute of Chicago.

The 1955 Pittsburgh International Exhibition of Contemporary Painting, Department of Fine Arts, Carnegie Institute, Pittsburgh (catalogue).

Ernest Briggs, Dugmore, Joan Mitchell, Stable Gallery, New York.

Fourth Annual Exhibition of Painting and Sculpture, Stable Gallery, New York.

U.S. Painting: Some Recent Directions (curated by Thomas B. Hess), Stable Gallery, New York.

Vanguard 1955: A Painter's Selection of New American Paintings, Walker Art Center, Minneapolis. Traveled to Stable Gallery, New York (catalogue, with a foreword by H. Harvard Arnason and an introduction by Kyle Morris).

1955 Annual Exhibition of Contemporary American Painting, Whitney Museum of American Art, New York (catalogue).

1956

4 Younger Americans: Paul Brach, Michael Goldberg, Robert Goodnough, Joan Mitchell, Sidney Janis Gallery, New York.

41 Aquarellistes américains d'aujourd'hui (organized by The Museum of Modern Art, New York, and circulated by the Association Française d'Action Artistique). Traveled in France to: Musée Municipal, Laon; Musée Antoine Lecuyer, Saint-Quentin; Musée des Beaux-Arts, Reims; Bibliothèque Municipale et Universitaire, Clermont-Ferrand; Musée des Ponchettes, Nice (catalogue, with an introduction by Frank O'Hara).

Fifth Annual Exhibition of Painting and Sculpture, Stable Gallery, New York.

1957

17th Annual Exhibition of the Society for Contemporary American Art, The Art Institute of Chicago.

Sixty-second American Exhibition: Paintings, Sculpture, The Art Institute of Chicago (catalogue).

John Ferren, Julio Girona, John Grillo, Angelo Ippolito, Marca-Relli, Joan Mitchell, The Arts Club of Chicago (brochure).

25th Biennial Exhibition of Contemporary American Oil Paintings, The Corcoran Gallery of Art, Washington, D.C. Traveled to The Toledo Museum of Art, Ohio (catalogue).

Abstract Impressionism, Dwight Art Memorial, South Hadley, Massachusetts.

The New York School: Second generation. Paintings by twenty-three artists, The Jewish Museum of The Jewish Theological Seminary of America, New York (catalogue, with an introduction by Leo Steinberg).

American Paintings: 1945–1957, The Minneapolis Institute of Arts (catalogue, with an introduction by Stanton L. Catlin).

The Fourth International Art Exhibition of Japan (U.S. section organized by Frank O'Hara, curator, International Program of The Museum of Modern Art, New York; exhibition sponsored by The Mainichi Newspapers, Tokyo). Traveled in Japan to: Metropolitan Art Gallery, Tokyo; Sogo Gallery, Osaka; Watanabe Memorial Hall, Ube; Iwataya Gallery, Fukuoka; Public Hall Gallery, Saseho; Tsuruya Gallery, Kumamoto; Fukuya Gallery, Hiroshima; Modern Art Museum, Takamatsu; Oriental Nakamura, Nagoya (catalogue).

New York Artists' 6th Annual Exhibition, Stable Gallery, New York.

1957 Annual Exhibition: Sculpture, Paintings, Watercolors, Whitney Museum of American Art, New York (catalogue).

1958

Society for Contemporary American Art: 18th Annual Exhibition, The Art Institute of Chicago.

The 1958 Pittsburgh Bicentennial International Exhibition of Contemporary Painting and Sculpture, Department of Fine Arts, Carnegie Institute, Pittsburgh (catalogue, with an introduction by Gordon Bailey Washburn).

Action Painting, Dallas Museum for Contemporary Arts (catalogue, with a conversation between Thomas B. Hess and Harold Rosenberg).

American Symbolic Realists: Fifteen American Artists/Realisti Simbolici Americani: Quindici Artisti Americani, Festival of Two Worlds/Festival dei Due Mondi, Spoleto, Italy (catalogue, with a text by Thomas B. Hess).

Abstract Impressionism, Nottingham University Art Gallery, England. Traveled in England to: Arts Council Gallery, Cambridge; Laing Art Gallery, Newcastle upon Tyne; Arts Council Gallery, London (catalogue, including an essay by Lawrence Alloway).

American Artists of Younger Reputation, Rome-New York Art Foundation, Rome (catalogue, with a text by James Johnson Sweeney).

The International Art of a New Era: "Informel and Gutai" (organized by Sankei Shinbun), Takashimaya, Tokyo (catalogue, with an introduction by Michel Tapié).

Twenty-ninth Venice Biennale, International Young Artists Section, Palazzo Centrale, Venice (catalogue, with an essay by Franco Russoli).

The Museum and Its Friends: Twentieth-century American Art from Collections of the Friends of the Whitney Museum, Whitney Museum of American Art, New York (catalogue).

Nature in Abstraction: The Relation of Abstract Painting and Sculpture to Nature in Twentieth-Century American Art, Whitney Museum of American Art, New York. Traveled to: The Phillips Gallery, Washington, D.C.; Fort Worth Art Center, Texas; Los Angeles County Museum; San Francisco Museum of Art; Walker Art Center, Minneapolis; City Art Museum of St. Louis (catalogue, with a text by John I.H. Baur).

1959

Two Centuries of American Art 1750–1950, The Art Institute of Chicago.

Arte Nuova: Esposizione Internazionale di Pittura e Scultura, Circolo degli Artisti, Palazzo Graneri, Turin (catalogue, with a preface by Michel Tapié and an introduction by Luciano Pistoi).

26th Biennial Exhibition of Contemporary American Painting, The Corcoran Gallery of Art, Washington, D.C. (catalogue).

Premio dell'Ariete: Selezione biennale di pittura internazionale—20 Quadri 1959, Galleria dell'Ariete, Milan (catalogue).

V. Bienal de São Paulo, Museu de Arte Moderna, São Paulo, Brazil (catalogue, with an introduction by Sam Hunter).

New York and Paris Painting in the Fifties, The Museum of Fine Arts of Houston (catalogue, with a foreword by Bernard Dorival and an essay by Dore Ashton).

Kunst nach 1945: Internationale Ausstellung. Malerei, Skulptur, Druckgrafik (American artists selected by Porter McCray, director, International Program of The Museum of Modern Art, New York), Museum Fridericianum, Kassel, Germany (catalogue, with an essay by Werner Haftmann).

Some Younger American Artists, Stable Gallery, New York (circulated by The American Federation of Arts, New York). Traveled to: Southern Illinois University, Carbondale; John Herron Art Institute, Indianapolis, Indiana; Florida State University, Tallahassee; Holiday Art Center, Watch Hill, Rhode Island; The White Art Museum, Cornell University, Ithaca, New York; Kent State University, Ohio; Atlanta Public Library; Wells College, Aurora, New York.

1959 Annual Exhibition of Contemporary American Painting, Whitney Museum of American Art, New York (catalogue).

1960

Contemporary American Painting, The Columbus Gallery of Fine Arts, Ohio (brochure, with an introduction by Tracy Atkinson).

16e Salon de Mai, Musée d'Art Moderne de la Ville de Paris (catalogue).

Antagonismes, Musée des Arts Décoratifs, Paris (catalogue, with an introduction by Herbert Read and a text by Julien Alvard).

Neue Malerei: Form, Struktur, Bedeutung, Städtische Galerie München, Munich (catalogue).

60 American Painters: 1960. Abstract Expressionist Painting of the Fifties, Walker Art Center, Minneapolis (catalogue, with a text by H.H. Arnason).

Business Buys American Art: Third Loan Exhibition by the Friends of the Whitney Museum of American Art, Whitney Museum of American Art, New York (catalogue).

1961

The 1961 Pittsburgh International Exhibition of Contemporary Painting and Sculpture, Department of Fine Arts, Carnegie Institute, Pittsburgh (catalogue, with an introduction by Gordon Bailey Washburn).

International Selection 1961, The Dayton Art Institute, Ohio (brochure).

17e Salon de Mai, Musée d'Art Moderne de la Ville de Paris. Traveled to Stedelijk Museum, Amsterdam (catalogue).

Recent Acquisitions, The Museum of Modern Art, New York.

American Abstract Expressionists and Imagists, The Solomon R. Guggenheim Museum, New York (catalogue, with a foreword and introduction by H.H. Arnason).

1945–1961: Schilders uit Parijs, Stedelijk van Abbe-museum, Eindhoven, The Netherlands (catalogue, with an essay by R.V. Gindertael).

Paintings for Purchase Consideration, The University of Michigan Museum of Art, Ann Arbor.

Annual Exhibition 1961: Contemporary American Painting, Whitney Museum of American Art, New York (catalogue).

Contemporary Paintings Selected from 1960–1961 New York Gallery Exhibitions, Yale University Art Gallery, New Haven.

1962

65th Annual American Exhibition: Some Directions in Contemporary Painting and Sculpture, The Art Institute of Chicago (catalogue).

Contemporary American Painting—The Arts Around Us,
Birmingham Museum of Art, Alabama (catalogue).

Women Artists in America Today, Dwight Art Memorial, South
Hadley, Massachusetts (catalogue).

*Art: USA. The Johnson Collection of Contemporary American
Painting*, Milwaukee Art Center, Wisconsin. Traveled to:
Bridgestone Gallery, Tokyo; Academy of Arts, Honolulu; Royal
Academy of Arts, London; Zappeion, Athens; Palazzo Venezia,
Rome; Haus der Kunst, Munich; Casino de Monte-Carlo,
Salons Privés, Monaco; Congress Hall, Berlin; Charlottenborg,
Copenhagen; Liljevalchs Konsthall, Stockholm; Civico Padiglione
d'Arte Contemporanea, Milan; Palais des Beaux Arts, Brussels;
Municipal Gallery of Art, Dublin; Cason del Buen Retiro, Madrid;
Kunst-Museum, Lucerne; Musée d'Art Moderne de la Ville de
Paris; Akademie der Bildenden Künste, Vienna; Whitney Museum
of American Art, New York; Rhode Island School of Design,
Providence; Museum of Fine Arts, Boston; Detroit Institute of
Arts; Minneapolis Institute of Arts; University of Illinois, Urbana;
City Art Museum of St. Louis; Contemporary Arts Center,
Cincinnati; Joslyn Art Museum, Omaha, Nebraska; Denver Art
Museum; Seattle Art Museum; Palace of the Legion of Honor, San
Francisco; Fine Arts Gallery of San Diego, California; Fort Worth
Art Center, Texas; Des Moines Art Center, Iowa; Tennessee Fine
Arts Center, Nashville; Birmingham Museum of Art, Alabama;
Art Gallery of Toronto; Cornell University, Ithaca, New York;
Ringling Museum of Art, Sarasota, Florida; Columbia Museum
of Art, South Carolina (catalogue).

Art Since 1950, American Section, Seattle World's Fair (organized
by Sam Hunter). Traveled as *American Art Since 1950* to: Rose Art
Museum, Brandeis University, Waltham, Massachusetts; Institute
of Contemporary Art, Boston (catalogue, including an introduc-
tion to the American Section by Sam Hunter; reprinted in the
catalogue for traveling venues).

*The First Five Years: Acquisitions by the Friends of the Whitney
Museum of American Art, 1957–1962*, Whitney Museum of
American Art, New York (catalogue).

Forty Artists Under Forty, Whitney Museum of American Art, New
York (circulated by The American Federation of Arts, New York).
Traveled in New York to: Munson-Williams-Proctor Institute,
Utica; University of Rochester Memorial Art Gallery; Roberson
Memorial Center, Binghamton; Albany Institute of History and
Art; Everson Museum of Art, Syracuse; Andrew Dickson White
Museum of Art, Cornell University, Ithaca; Albright-Knox Art
Gallery, Buffalo (catalogue, with a foreword by Lloyd Goodrich).

1963

Three Young Americans, Allen Memorial Art Museum, Oberlin
College, Ohio.

19e Salon de Mai, Musée d'Art Moderne de la Ville de Paris.

Directions: American Painting, San Francisco Museum of Art.

Women in Contemporary Art, Woman's College Gallery, Duke
University, Durham, North Carolina (catalogue).

1964

Dix tableaux, Galerie Jean Fournier, Paris.

1965

*Critics' Choice: Art Since World War II, 1965 Kane Memorial
Exhibition in honor of the Bicentennial of Brown University* (artists
selected by Thomas B. Hess, Hilton Kramer, and Harold
Rosenberg), Annmary Brown Memorial, Providence; Museum of
Art, Rhode Island School of Design, Providence; Providence Art
Club (catalogue).

Women Artists of America: 1707–1964, The Newark Museum, New
Jersey (catalogue, with a text by William H. Gerdts).

1965 Annual Exhibition of Contemporary American Painting,
Whitney Museum of American Art, New York (catalogue).

1966

*The First Flint Invitational: An Exhibition of Contemporary Painting
and Sculpture*, Flint Institute of Arts, Michigan (catalogue).

21ème Salon des Réalités Nouvelles, Musée Municipal d'Art
Moderne, Paris (catalogue).

Two Decades of American Painting (curated by Waldo Rasmussen,
The Museum of Modern Art, New York, and sponsored by The
International Council of The Museum of Modern Art, New York;
The National Museum of Modern Art, Tokyo; The Asahi
Shimbun, Tokyo). Traveled to: The National Museum of Modern
Art, Tokyo; The National Museum of Modern Art, Kyoto; Lalit
Kala Academy, New Delhi; National Gallery of Victoria,
Melbourne; Art Gallery of New South Wales, Sydney (catalogue,
with a preface by Waldo Rasmussen and essays by Irving Sandler,
Lucy R. Lippard, and G.R. Swenson).

*The One Hundred and Sixty-first Annual Exhibition of American
Painting and Sculpture*, The Pennsylvania Academy of the Fine
Arts, Philadelphia (catalogue).

1967

27th Annual Exhibition by the Society for Contemporary American Art, The Art Institute of Chicago.

Dix Ans d'Art Vivant: 1955–1965, Fondation Maeght, Saint-Paul, France (catalogue).

Large Scale American Paintings, The Jewish Museum, New York, under the auspices of The Jewish Theological Seminary of America, New York.

Contemporary American Painting and Sculpture 1967, Krannert Art Museum, University of Illinois, Urbana (catalogue, with an introduction by Allen S. Weller).

In Memory Of My Feelings: Frank O'Hara, The Museum of Modern Art, New York (catalogue, with an afterword by Bill Berkson).

American Art of the Twentieth Century, Whitney Museum of American Art, New York.

1967 Annual Exhibition of Contemporary Painting, Whitney Museum of American Art, New York (catalogue).

Contemporary American Painting and Sculpture from New York Galleries, The Wilmington Society of the Fine Arts, Delaware Art Center, Wilmington (brochure).

1968

Painting as Painting, The Art Museum of The University of Texas at Austin (catalogue, with texts by Donald B. Goodall, Dore Ashton, George McNeil, and Louis Finkelstein).

L'Art vivant: 1965–1968, Fondation Maeght, Saint-Paul, France (catalogue).

American Painting: The 1950's (organized and circulated by The American Federation of Arts, New York). Traveled to: Georgia Museum of Art, The University of Georgia, Athens; Wichita Art Museum, Kansas; Charles & Emma Frye Art Museum, Seattle; Roberson Memorial Center for the Arts & Sciences, Binghamton, New York; University of Pittsburgh; The Huntington National Bank, Columbus, Ohio; Edmonton Art Gallery, Alberta, Canada.

Group exhibition including works by Appel, Domoto, Falkenstein, Hartigan, Hultberg, Jenkins, Jenson, Johnson, Mitchell, Pomodoro, Roth, Tàpies, and Thompson, Martha Jackson Gallery, New York.

Second Kent Invitational, Kent State University, Ohio (catalogue).

In Honor of Dr. Martin Luther King, Jr. (benefit for the Southern Christian Leadership Foundation), The Museum of Modern Art, New York.

1969

Society for Contemporary Art: 29th Annual Exhibition, The Art Institute of Chicago.

From the Martha Jackson Gallery: At the Esther Bear Gallery, Esther Bear Gallery, Santa Barbara, California.

Wallworks, Part I, Martha Jackson Gallery, New York.

Wallworks, Part II, Martha Jackson Gallery, New York.

Seven Decades of 20th Century American Art, Whitney Museum of American Art, New York.

1970

L'art vivant aux Etats-Unis, Fondation Maeght, Saint-Paul, France (catalogue, with an introduction by Dore Ashton).

January '70: Contemporary Women Artists, Hathorn Gallery, Skidmore College, Sarasota Springs, New York. Traveled to National Arts Club, New York (brochure, with an essay by Harry F. Gaugh).

Group exhibition including works by Appel, Bluhm, Brooks, Domoto, Hartigan, Jenkins, Mitchell, Pond, Roth, and Stanczak, Martha Jackson Gallery, New York.

Wallworks, Part III: Graphics, Martha Jackson Gallery, New York.

1970 Pittsburgh International: Exhibition of Contemporary Art, Museum of Art, Carnegie Institute, Pittsburgh (catalogue, with an introduction by Leon Anthony Arkus).

American Painting: 1970, Virginia Museum, Richmond (catalogue).

Women in the Permanent Collection, Whitney Museum of American Art, New York.

1971

A New Consciousness: The CIBA-GEIGY Collection, The Hudson River Museum, Yonkers, New York (catalogue).

Younger Abstract Expressionists of the Fifties, The Museum of Modern Art, New York.

American Art of Our Century: The Permanent Collection. 1945–Present, Whitney Museum of American Art, New York.

1972

Fresh Air School: Exhibition of Paintings. Sam Francis, Joan Mitchell, Walasse Ting, Museum of Art, Carnegie Institute, Pittsburgh. Traveled to: Toledo Museum of Art, Ohio; William Rockhill Nelson Gallery, Kansas City, Missouri; Oklahoma Art Center, Oklahoma City; University Art Museum, University of

Texas, Austin (catalogue, with an introduction by Leon Anthony Arkus).

Free Form Abstraction, Whitney Museum of American Art, New York.

1973

Peinture, Galerie Jean Fournier, Paris.

Women Choose Women (organized by Women In the Arts), The New York Cultural Center, in association with Fairleigh Dickinson University, Teaneck, New Jersey (catalogue, with an essay by Lucy R. Lippard).

Visual R & D: A Corporation Collects. The CIBA-GEIGY Collection of Contemporary Paintings, University Art Museum, The University of Texas at Austin (catalogue, with an introduction by Donald B. Goodall).

The Private Collection of Martha Jackson, University of Maryland Art Gallery, College Park. Traveled to: The Finch College Museum of Art, New York; Albright-Knox Art Gallery, Buffalo, New York (catalogue, including an essay by Elayne H. Varian).

American Drawings, 1963–1973, Whitney Museum of American Art, New York (catalogue, with an essay by Elke M. Solomon).

1973 Biennial Exhibition: Contemporary American Art, Whitney Museum of American Art, New York (catalogue).

Contemporary American Painting, The Wilmington Society of Fine Arts, Delaware.

1974

5 American Painters: Recent Work. De Kooning, Mitchell, Motherwell, Resnick, Tworkov, The Art Galleries, University of California, Santa Barbara (catalogue, with a text by Phyllis Plous).

Nineteenth National Print Exhibition, The Brooklyn Museum, New York. Traveled to Fine Arts Gallery of San Diego (catalogue, with an introduction by Jo Miller).

Painting and Sculpture Today: 1974, Contemporary Art Society of the Indianapolis Museum of Art, Indiana. Traveled to: The Contemporary Arts Center, Cincinnati, and The Taft Museum, Cincinnati (catalogue).

Group exhibition including works by Bluhm, Brooks, Johnson, Mitchell, Pond, Stanczak, and Thomas, Martha Jackson Gallery, New York.

Contemporary American Painting and Sculpture 1974, Krannert Art Museum, University of Illinois, Urbana-Champaign (catalogue, with an introduction by James R. Shipley and Allen S. Weller).

Works by Women from the CIBA-GEIGY Collection, Kresge Art Center Gallery, Michigan State University at East Lansing. Traveled to Weatherspoon Art Gallery, The University of North Carolina at Greensboro (catalogue, with an essay by Emily Genauer).

Frank O'Hara, a Poet among Painters (organized by participants of the Whitney Museum of American Art Independent Study Program), Whitney Museum of American Art, New York (brochure).

Selections from the Permanent Collection, Whitney Museum of American Art, New York.

1975

34th Biennial Exhibition of Contemporary American Painting, The Corcoran Gallery of Art, Washington, D.C. (catalogue, with an introduction by Roy Slade).

Group exhibition including works by Cornell, de Kooning, Heizer, Mitchell, and Steir, Fourcade-Droll, New York.

Critique—théorie—art, *Numéro 5*, Galerie Rencontres, Paris (catalogue, with an essay by Pierre Schneider).

1976

American Artists '76: A Celebration, Marion Koogler McNay Art Institute, San Antonio (catalogue, with an introduction by Alice C. Simkins).

Art américain: Collection du musée, Musée Grenoble, France (catalogue).

Visions/Painting and Sculpture: Distinguished Alumni 1945 to the Present, The School of the Art Institute of Chicago (catalogue).

1977

Art actuel américain et européen, Fondation Château de Jau, Cases-de-Pène, France (catalogue).

Works from the Gallery Collections: Bob Thompson, Antoni Tàpies, Jean-Paul Riopelle, Joan Mitchell, James Brooks, Martha Jackson West, New York.

Paris–New York, Musée national d'art moderne, Centre Georges Pompidou, Paris (catalogue, including essays by Marcelin Pleynet and Alfred Pacquement).

New York: The State of Art, The New York State Museum, Albany (catalogue, including a foreword by Governor Hugh L. Carey and an essay by Thomas B. Hess).

Künstlerinnen: International, 1877–1977, Schloss Charlottenburg, Berlin (catalogue).

1978

American Painting of the 1970s, Albright-Knox Art Gallery, Buffalo, New York. Traveled to: Newport Harbor Art Museum, Newport Beach, California; The Oakland Museum, California; Cincinnati Art Museum; Art Museum of South Texas, Corpus Christi; Krannert Art Museum, University of Illinois, Champaign (catalogue, with an essay by Linda L. Cathcart).

L'art américain dans les collections privées françaises, Espace Lyonnais d'Art Contemporain, Lyon (journal, with texts by Bernard Ceysson, Robert Butheau, and Jean-Louis Maubant).

Perspective '78: Works by Women, Freedman Gallery, Albright College, Reading, Pennsylvania (catalogue, with an essay by Therese Schwartz).

American Art 1950 to the Present, Whitney Museum of American Art, New York.

1979

100 Artists, 100 Years: Alumni of the School of the Art Institute of Chicago, Centennial Exhibition, The Art Institute of Chicago (catalogue, with texts by Donald J. Irving, Norman L. Rice, and Katharine Kuh).

Abstract Expressionism: A Tribute to Harold Rosenberg. Paintings and Drawings from Chicago Collections, The David and Alfred Smart Gallery, The University of Chicago (catalogue, with essays by Saul Bellow and Harold Rosenberg).

Americans in Paris: The 50s, Fine Arts Gallery, California State University, Northridge (catalogue, with an introduction by Merle Schipper).

Tendances de l'art en France 1968–1978/79, ARC, Musée d'Art Moderne de la Ville de Paris (catalogue, with essays by Suzanne Pagé and Marcelin Pleynet).

1980

From the Twenties to the Seventies: Paintings from The Museum of Modern Art, The Brooklyn Museum, New York.

One Major New Work Each: Tony Berlant, Louise Bourgeois, William Crozier, Willem de Kooning, Raoul Hague, Michael Heizer, Roy Lichtenstein, Joan Mitchell, Malcolm Morley, Catherine Murphy, H.C. Westermann, Xavier Fourcade, New York.

Avatars: Questions, transformations & traces. Cent deux œuvres 1950–1980, Galerie Jean Fournier, Paris.

The Fifties: Aspects of Painting in New York, Hirshhorn Museum and Sculpture Garden, Smithsonian Institution, Washington, D.C. (catalogue by Phyllis Rosenzweig).

1981

45th Annual Midyear Show, The Butler Institute of American Art, Youngstown, Ohio (catalogue, with a statement by Sam Hunter).

The 37th Biennial Exhibition of Contemporary American Painting: Frank Stella, Joan Mitchell, Richard Diebenkorn, Agnes Martin, Richard Serra, The Corcoran Gallery of Art, Washington, D.C. (catalogue, with an essay by Jane Livingston).

Amerikanische Malerei: 1930–1980, Haus der Kunst, Munich (catalogue, with a text by Tom Armstrong).

Art américain: Œuvres des collections du Musée national d'art moderne, Musée national d'art moderne, Centre Georges Pompidou, Paris (catalogue, with an introduction by Hélène Lassalle).

1982

Mitchell, Morley, Rockburne: New Prints and Works on Paper, Xavier Fourcade, New York.

American Paintings 1900–82 (organized by The Museum of Fine Arts, Houston), National Pinakothiki, Athens (catalogue).

American Artists Abroad 1900–1950, Washburn Gallery, New York (brochure).

Art on Paper . . . since 1960: The 1982 Weatherspoon Annual Exhibition, Weatherspoon Art Gallery, University of North Carolina, Greensboro (catalogue).

1983

Drawings, Xavier Fourcade, New York.

In Honor of de Kooning, Xavier Fourcade, New York.

Une journée à la campagne, Pavillon des Arts, Paris (catalogue).

1983 Biennial Exhibition, Whitney Museum of American Art, New York (catalogue).

1984

La part des femmes dans l'art contemporain, Galerie Municipale, Vitry-sur-Seine, France (catalogue).

Vent'anni d'arte in Francia: 1960–1980, Association Française d'Action Artistique, Galleria d'arte moderna, Bologna (catalogue, with a text by Marcelin Pleynet).

Three Painters, Three Decades: Lee Krasner, Joan Mitchell, Pat Steir, Harcus Gallery, Boston.

American Women Artists, Part I: 20th Century Pioneers, Sidney Janis, New York (catalogue).

Master Drawings: 1928–1984, Janie C. Lee Gallery, Houston (catalogue).

Aspects de la peinture contemporaine: 1945–1983, Musée d'Art Moderne de Troyes, France (catalogue, with an introduction by Philippe Chabert and an essay by Francis Parent; brochure, with a text by Philippe Chabert).

Sur invitation, Musée des Arts Décoratifs, Paris (catalogue, with a text by François Mathey).

Selections from the Permanent Collection: Painting and Sculpture, The Museum of Modern Art, New York.

Action/Precision: The New Direction in New York, 1955–60, including works by Bluhm, Goldberg, Hartigan, Held, Leslie, and Mitchell, Newport Harbor Art Museum, Newport Beach, California. Traveled to: Worcester Art Museum, Massachusetts; Grey Art Gallery, New York University; Contemporary Arts Center, Cincinnati; Albright-Knox Art Gallery, Buffalo, New York; Archer M. Huntington Art Gallery, University of Texas at Austin (catalogue, with essays by Robert Rosenblum, Paul Schimmel, John Bernard Myers, and B.H. Friedman).

1985

Painting as Landscape: Views of American Modernism, 1920–1984, Baxter Art Gallery, California Institute of Technology, Pasadena. Traveled to The Parrish Art Museum, Southampton, New York (catalogue, with an essay by Klaus Kertess).

Champ/Émergence végétale, Centre d'Art Contemporain de Jouy-sur-Eure, France, and Musée de Bernay, France (catalogue).

Masters of the Fifties: American Abstract Painting from Pollock to Stella, Marisa del Re Gallery, New York.

The Martha Jackson Memorial Collection, National Museum of American Art, Smithsonian Institution, Washington, D.C. (catalogue, with an essay by Harry Rand).

Action/Precision: 1980–85, Washburn Gallery (East 57th Street and Greene Street galleries), New York.

1986

The 1950's: American Artists in Paris, Part III, Denise Cadé Gallery, Art Prospect Inc., New York (brochure, with an essay by Sidney Geist).

Un Musée éphémère: Collections privées françaises, 1945–1985, Fondation Maeght, Saint-Paul, France.

Drawings, Xavier Fourcade, New York.

Paintings, Sculpture, Collage, and Drawings, Janie C. Lee Gallery, Houston.

An American Renaissance: Painting and Sculpture Since 1940, Museum of Art, Fort Lauderdale, Florida (catalogue, with essays by Sam Hunter, Harry F. Gaugh, Robert C. Morgan, Richard Sarnoff, Malcolm R. Daniel, Karen Koehler, and Kim Levin).

The Inspiration Comes from Nature, Jack Tilton Gallery, New York.

1987

Art Against AIDS (a benefit exhibition for the American Foundation for AIDS Research [AmFAR]), Xavier Fourcade, New York (catalogue).

Drawings, Xavier Fourcade, New York.

In Memory of Xavier Fourcade: A Group Exhibition, Xavier Fourcade, New York.

Paintings: de Kooning, Heizer, Mitchell, Murphy, Palermo, Twombly, Smith, Xavier Fourcade, New York.

A Graphic Muse: Prints by Contemporary American Women, Mount Holyoke College Art Museum, South Hadley, Massachusetts. Traveled to: Yale University Art Gallery, New Haven; Santa Barbara Museum of Art, California; Virginia Museum of Fine Arts, Richmond; The Nelson-Atkins Museum of Art, Kansas City, Missouri (catalogue, with essays by Richard S. Field and Ruth E. Fine).

Inner Worlds: Norman Bluhm, Sam Francis, Helen Frankenthaler, Robert Goodnough, Joan Mitchell, Milton Resnick, Sarah Lawrence College Art Gallery, Bronxville, New York (brochure).

1988

Regard d'un collectionneur, Centre d'Art Contemporain, Château de Tanlay-Yonne, France (catalogue).

Des Américains à Paris, 1950/1965: James Bishop, Norman Bluhm, David Budd, Sam Francis, Shirley Jaffe, Ellsworth Kelly, Joan Mitchell, Jean-Paul Riopelle, Kimber Smith, Jack Youngerman, Château de Jau/L'Œil et Demi, Fondation du Château de Jau, Cases-de-Pène, France (catalogue, with an essay by Yves Michaud).

Un certain paysage/Abstrakte landskaber, Gammel Holtegaard, Holte, Denmark. Traveled to Kunstmuseum, Randers, Denmark (catalogue, with an essay by Yves Bourel).

L'Espace reversé (organized by ARTGO and Galerie La Main, Brussels), Galerie La Main, Brussels, and Galerie Fontainas, Brussels. Traveled to Château de Pondres, Sommières, France (catalogue).

Drawing on the East End, 1940–1988, The Parrish Art Museum, Southampton, New York (catalogue, with an essay by Klaus Kertess).

Abstract Work from the 50's, Manny Silverman Gallery, Los Angeles.

Aspects of Abstraction, Holly Solomon Gallery, New York.

Louise Fishman, Joan Mitchell, David Reed (curated by Marjorie Welish), Barbara Toll Fine Arts, New York.

1989

The Linear Image: American Master Works on Paper, Marisa del Re Gallery, New York (catalogue, with an essay by Sam Hunter).

Morceaux choisis 1: Sélections des acquisitions du FRAC de Haute-Normandie, 1983–1988, Fonds Régional d'Art Contemporain de Haute-Normandie, Rouen, France (catalogue, including an essay by Marcelin Pleynet).

Lines of Vision: Drawings by Contemporary Women, Hillwood Art Museum, Long Island University, Brookville, New York. Traveled to: Blum Helman Gallery, New York; Murray State University, Kentucky; Grand Rapids Art Museum, Michigan; University Art Gallery, University of North Texas, Denton; Richard F. Brush Gallery, St. Lawrence University, Canton, New York; University of Oklahoma Museum of Art, Norman (catalogue, with texts by Thomas W. Leavitt and Judith Wilson and an essay by Judy K. Collischan Van Wagner).

Works on Paper, Lennon, Weinberg, New York.

Emplois du temps: Exposition de peinture contemporaine, Salle des Procureurs du Palais de Justice de Rouen, France (catalogue).

Abstract Expressionism: Paintings, Drawings and Watercolors, Manny Silverman Gallery, Los Angeles.

Made in America, Virginia Beach Center for the Arts, Virginia (catalogue, with essays by Jane Kessler, Walter Darby Bannard, and Lowery S. Sims).

1950s: Bluhm, Bolotowsky, Held, Mitchell, Youngerman, Washburn Gallery, New York.

Art in Place: Fifteen Years of Acquisitions, Whitney Museum of American Art, New York (catalogue, with essays by Tom Armstrong and Susan C. Larsen).

The Gestural Impulse, 1945–60: Paintings from the Permanent Collection of the Whitney Museum of American Art, Whitney Museum of American Art, Downtown at Federal Reserve Plaza, New York (brochure, with an essay by Karl Emil Willers).

1990

Polyptyques et Paravents: Un Siècle de Création, 1890–1990, Galerie Bellier, Paris (catalogue).

Four Centuries of Women's Art: The National Museum of Women in the Arts (sponsored by The National Museum of Women in the Arts, Washington, D.C., and The Asahi Shimbun, Tokyo). Traveled in Japan to: The Bunkamura Museum of Art, Tokyo; The Museum of Modern Art, Kamakura; Sapporo Tokyu, Sapporo; Tenjin Iwataya, Fukuoka; Daimaru Museum Umeda, Osaka; Nagano Tokyu, Nagano; Hiroshima Museum of Art; Matsuzakaya Museum, Nagoya.

Group exhibition including works by Connelly, Fishman, Hague, Kirili, Mitchell, Murphy, Palazzolo, and Smith, Lennon, Weinberg, New York.

Some Seventies Works, Robert Miller Gallery, New York.

Contemporary Works from the Collection, The Museum of Modern Art, New York.

Abstract Expressionists: Studio 35/Downtown—Willem de Kooning, Hans Hofmann, Franz Kline, Lee Krasner, Joan Mitchell, Robert Motherwell, Jackson Pollock, Stux Modern, New York (catalogue).

L'Art en France: 1945–1990, Fondation Daniel Templon, Musée Temporaire, Fréjus, France (catalogue).

Künstlerinnen des 20. Jahrhunderts, Museum Wiesbaden, Germany (catalogue, including an essay by Renate Petzinger and Volker Rattemeyer).

1991

Too French: Contemporary French Art (organized by Fondation Cartier pour l'art contemporain, Jouy-en-Josas, France), Hong Kong Museum of Art. Traveled to Hara Museum ARC, Gunma-ken, Japan (catalogue).

Painting: Jake Berthot, Louisa Chase, Ron Janowich, Joan Mitchell, Milton Resnick, David Row, John Walker, Galerie Lelong, New York.

Landscape of America: The Hudson River School to Abstract Expressionism, Nassau County Museum of Art, Roslyn Harbor, New York (catalogue, with an essay by Constance Schwartz).

1991 Biennial Exhibition, Whitney Museum of American Art, New York (catalogue, with essays by Richard Armstrong, John G. Hanhardt, Richard Marshall, and Lisa Phillips).

1992

Scope: Abstraction from the 50's, Gimpel Fils, London.

From Brancusi to Bourgeois: Aspects of the Guggenheim Collection (part three of *The Guggenheim Museum and the Art of This Century*), Guggenheim Museum SoHo, New York.

American Art, 1930–1970 (organized by Independent Curators, New York), Lingotto Cultural Arts Center, Turin, Italy (catalogue, with texts by Attilio Codognato, Furio Colombo, Claudio Gorlier, Renato Barilli, Matthew Baigell, Sam Hunter, Alberto Boatto, and Kenneth Baker).

Les Nymphéas avant et après, Musée de l'Orangerie, Paris (catalogue, with texts by Michel Hoog and Dominique Dupuis-Labbé).

Slow Art: Painting in New York Now, P.S.1 Contemporary Art Center, Long Island City, New York.

From America's Studio: Twelve Contemporary Masters, The School of the Art Institute of Chicago (catalogue, with texts by Neal Benezra, James Yood, and Robert Storr and an essay by Dennis Adrian).

Manny Silverman Gallery, Los Angeles.

1993

Intérieurs: Cent une Œuvres choisies dans des collections privées d'art contemporain en Midi-Pyrénées, Centre d'art contemporain, Castres, France; Musée Goya, Castres, France; Musée Denys-Puech, Rodez, France (catalogue).

Azur, Fondation Cartier pour l'art contemporain, Jouy-en-Josas, France (catalogue).

1ère Triennale des Amériques: Présence en Europe 1945–1992 & Les Américains du FRAC Nord-Pas de Calais, Fonds Régional d'Art Contemporain, Maubeuge, France.

The American Livre de Peinture, The Grolier Club, New York (catalogue by Elizabeth Phillips and Tony Zwicker, with an introduction by Robert Rainwater).

An American Homage to Matisse, Sidney Janis Gallery, New York.

Abstract-Figurative, Robert Miller Gallery, New York.

Manifeste: Une histoire parallèle, 1960–1990, Musée national d'art moderne, Centre Georges Pompidou, Paris (catalogue).

Drawing the Line Against AIDS (organized in conjunction with Art Against AIDS Venezia under the aegis of the 45th Venice Biennale), Peggy Guggenheim Collection, Venice. Traveled to Guggenheim Museum SoHo, New York (catalogue, with essays by

John Cheim, Diego Cortez, Carmen Gimenez, Klaus Kertess, Mathilde Krim, Elizabeth Taylor, and Achille Bonito Oliva).

The Usual Suspects, Manny Silverman Gallery, Los Angeles.

1994

Martha Jackson Gallery: 1953 to 1979, Associated American Artists, New York (catalogue, with an introduction by Kathleen Bahet and Emilio Steinberger).

Selected Works from the Collection of Osaka City Museum of Modern Art: Joy of 20th Century Art, ATC Museum, Osaka.

Paths of Abstraction: Painting in New York 1944–1981. Selections from the Ciba Art Collection, The Bertha and Karl Leubsdorf Art Gallery, Hunter College, The City University of New York (catalogue, with essays by William C. Agee and Rachel Davis).

22a. Bienal internacional de São Paulo: Honrar e renovar a tradição, Fundação Bienal de São Paulo, Pavilhão Ciccillo Matarazzo, São Paulo, Brazil (catalogue, with essays by Nelson Aguilar, Klaus Kertess, and John Ashbery).

Reclaiming Artists of the New York School: Toward a More Inclusive View of the 1950s, Sidney Mishkin Gallery, Baruch College, The City University of New York (catalogue, with an essay by Sandra Kraskin).

Romantic Modernism: 100 Years, Museum of Fine Arts, Museum of New Mexico, Santa Fe (catalogue, with essays by Sandy Ballatore and Robert Rosenblum).

1995

XXV Years: An Exhibition Celebrating the 25th Anniversary of John Berggruen Gallery and Saluting the Opening of the New San Francisco Museum of Modern Art, John Berggruen Gallery, San Francisco (catalogue).

Carnegie International 1995, The Carnegie Museum of Art, Pittsburgh (catalogue, with texts by Phillip M. Johnston and Richard Armstrong).

. . . dites donc, à quelle date elle est morte, la peinture? Galerie Jean Fournier, Paris.

Papel, papel, Galerie Jean Fournier, Paris.

Seven from the Seventies: Diebenkorn, Frankenthaler, Krasner, Martin, Mitchell, Scully, Stella, Knoedler and Company, New York.

Summer 1995, Lennon, Weinberg, New York.

Elizabeth Murray: Modern Women (from the series *Artist's Choice*), The Museum of Modern Art, New York (brochure, with a foreword by Kirk Varnedoe and an essay by Elizabeth Murray).

Action and Edge: 1950's and 1960's, Katharina Rich Perlow Gallery, New York.

Views from Abroad: European Perspectives on American Art 1/ Amerikaanse Perspectieven: Europese Visies op Amerikaanse Kunst 1, Whitney Museum of American Art, New York. Traveled to Stedelijk Museum, Amsterdam (catalogue, including texts by Adam D. Weinberg, David A. Ross, Rudi Fuchs, and Hayden Herrera).

1996

American Art Today: Images from Abroad, The Art Museum, Florida International University, Miami (catalogue, with essays by Dahlia Morgan and Phyllis Tuchman).

Pintura estadounidense expresionismo abstracto, Centro Cultural Arte Contemporáneo, Mexico City (catalogue, including texts by Irving Sandler, Thomas B. Hess, and Clement Greenberg).

Changing Group Exhibition, Robert Miller Gallery, New York.

Forces of the Fifties: Selections from the Albright-Knox Art Gallery, Wexner Center for the Arts, The Ohio State University, Columbus (catalogue, with essays by Donna De Salvo and David Moos).

1997

Dorothy Blau Presents Robert Miller Gallery, Dorothy Blau Gallery, Bay Harbor Islands, Florida.

Founders and Heirs of the New York School, Museum of Contemporary Art, Tokyo. Traveled to: The Miyagi Museum of Art, Obarki, Japan; The Museum of Modern Art, Ibaraki, Japan (catalogue, with essays by Dore Ashton and Chieko Hirano).

Women and Abstract Expressionism: Painting and Sculpture, 1945–1959, Sidney Mishkin Gallery, Baruch College, The City University of New York. Traveled to Guild Hall Museum, East Hampton, New York (catalogue, with an essay by Joan Marter).

1998

Joan Mitchell, John Chamberlain: A Juxtaposition, Cheim & Read, New York.

Art and the American Experience, Kalamazoo Institute of Arts, Michigan (catalogue, with a text by Jan van der Marck).

Dreams for the Next Century: A View of the Collection, The Parrish Art Museum, Southampton, New York.

1999

Three Rooms: Catherine Murphy, Joan Mitchell, Harriet Korman, Lennon, Weinberg, New York.

Abstractions américaines: 1940–1960, Musée Fabre, Montpellier, France (catalogue, with essays by Michel Hilaire and Éric de Chassey).

Between Art and Life: From Abstract Expressionism to Pop Art (organized with Fundación "la Caixa," Barcelona), Schirn Kunsthalle, Frankfurt (catalogue, with an introduction by Thomas M. Messer and an essay by Irving Sandler).

Part II, 1950–2000, of *The American Century: Art & Culture 1900–2000*, Whitney Museum of American Art, New York (catalogue by Lisa Phillips).

2001

Abstrakter Expressionismus in Amerika, Pfalzgalerie, Kaiserslautern, Germany. Traveled to Ulmer Museum, Ulm, Germany (catalogue).

Selected Bibliography

MONOGRAPHS AND SELECTED EXHIBITION
CATALOGUES

Bernstock, Judith E. *Joan Mitchell* (exhibition catalogue). New York: Hudson Hills Press, in association with the Herbert F. Johnson Museum of Art, Cornell University, 1988.

Flohic, Catherine, et al. *Ninety: Art des Années 90/Art in the 90's. Joan Mitchell*, no. 10. Paris: Eighty Magazine, 1993. Additional contributions by Gisèle Barreau, Jacques Dupin, Pierre Schneider, Guy Bloch-Champfort, Joseph Strick, Monique Frydman, Christiane Rousseaux, Jill Weinberg, Marcelin Pleynet, Hervé Chandès, John Cheim, Klaus Kertess, Robert Storr, Philippe Richard, Frédérique Lucien, Jean Fournier, and Robert Miller.

Joan Mitchell (exhibition catalogue). Paris: Jacques Dubourg and Galerie Lawrence, 1962. Essay by Pierre Schneider reprinted as "Pour Joan Mitchell" in *XXe siècle*, 40 (June 1973), pp. 116–19 in French, p. 192 in English; and as "From Confession to Landscape" in *Art News*, 67 (April 1968), pp. 42–43, 72–73.

Joan Mitchell (exhibition catalogue). Nantes: Musée des Beaux-Arts de Nantes; Paris: Galerie nationale du Jeu de Paume, 1994. Essay by Robert Storr and interview with Yves Michaud.

Joan Mitchell (exhibition catalogue). Valencia, Spain: IVAM Centre Julio González, 1997. Introduction by Juan Manuel Bonet, and essays by Richard D. Marshall and Marcelin Pleynet.

Joan Mitchell: Bedford Series. A group of ten color lithographs. Bedford, New York: Tyler Graphics, 1981. Essay by Barbara Rose.

Joan Mitchell: Choix de peintures 1970–1982 (exhibition catalogue). Paris: ARC, Musée d'Art Moderne de la Ville de Paris, 1982. Introduction by Suzanne Pagé, and essays by Marcelin Pleynet and Barbara Rose.

Joan Mitchell: New Paintings (exhibition catalogue). New York: Xavier Fourcade, 1986. Conversation with Yves Michaud.

Joan Mitchell: Pastel. New York: Robert Miller Gallery, 1992. Introduction by Klaus Kertess, and edited by John Cheim.

Joan Mitchell: Pastel. New York: XXII International Biennial of São Paulo, The Estate of Joan Mitchell, and Robert Miller Gallery, New York, 1994. Introduction by Klaus Kertess, and edited by John Cheim. (Introduction reprinted from *Joan Mitchell: Pastel*, Whitney Museum of American Art, New York, 1992.)

Kertess, Klaus. *Joan Mitchell*. New York: Harry N. Abrams, 1997.

"My Five Years in the Country": An exhibition of forty-nine paintings by Joan Mitchell (exhibition catalogue). Syracuse, New York: Everson Museum of Art, 1972. Introduction by James Harithas.

Nochlin, Linda. "Tape-Recorded Interview with Joan Mitchell, April 16, 1986." Transcript. Archives of American Art, Smithsonian Institution, Washington, D.C.

Tucker, Marcia. *Joan Mitchell* (exhibition catalogue). New York: Whitney Museum of American Art, 1974.

Waldberg, Michel. *Joan Mitchell*. Paris: Éditions de la Différence, 1992.

DOCUMENTARY FILM

Joan Mitchell: A Portrait of an Abstract Painter. 16mm film, color; 58 minutes. Directed by Marion Cajori. Produced by Christian Blackwood and Marion Cajori. New York: Christian Blackwood Productions, 1992.

SELECTED ARTICLES AND BOOKS

Adams, Brooks. "Domestic Globalism at the Carnegie." *Art in America*, 84 (February 1996), pp. 32–37.

_____. "Expatriate Dreams." *Art in America*, 83 (February 1995), pp. 60–69, 109.

_____. "New Pop Reflections." *Art in America*, 80 (July 1992), pp. 88–91.

Anderson, John. "2 Views of Women In the Art World." *New York Newsday*, April 14, 1993, part 2, pp. 63, 82.

Armstrong, Elizabeth, et al. *Tyler Graphics: The Extended Image*. Minneapolis: Walker Art Center; New York: Abbeville Press, 1987.

Arnason, H.H. "Mitchell, Joan." In Milton Rugoff, ed. *The Britannica Encyclopedia of American Art*. Chicago: Encyclopaedia Britannica Educational Corporation, 1973, pp. 376–77.

"Art: A Puzzling Painter. Gordon Russell's Work at Durlacher's— Other Shows at Local Galleries." *The New York Times*, April 29, 1961, p. L21.

Artner, Alan G. "Obituaries: Chicago-born painter Joan Mitchell, 66." *Chicago Tribune*, October 31, 1992, sec. 1, p. 17.

"Art Tour: The Galleries—A Critical Guide." *New York Herald Tribune*, April 24, 1965, p. 11.

Ashbery, John. "Biennials Bloom in the Spring." *Newsweek*, April 18, 1983, pp. 93–94.

_____. "An expressionist in Paris." *Art News*, 64 (April 1965), pp. 44–45, 63–64.

_____. "Joan Mitchell." In David Bergman, ed. *Reported Sightings: Art Chronicles, 1957–1987*. New York: Alfred A. Knopf, 1989, pp. 98–101.

_____. "On Winter's Traces." *New York*, March 24, 1980, pp. 58–59.

_____. "Original Works of Art Now Popular as Christmas Gifts." *New York Herald Tribune* (Paris ed.), December 18, 1963, p. 5.

Ashton, Dore. "Art." *Arts & Architecture*, 74 (May 1957), pp. 10–11, 37.

_____. "Art." *Arts & Architecture*, 75 (May 1958), pp. 5, 28–29.

_____. "Art." *Arts & Architecture*, 78 (June 1961), pp. 4–5.

_____. "Art USA 1962." *The Studio*, 163 (March 1962), pp. 84–94.

_____. "Art: Younger Generation. Paintings by Joan Mitchell and Miriam Schapiro Go on Display Here." *The New York Times*, March 4, 1958, p. L59.

_____. "Kelly's unique spatial experiences." *Studio International*, 170 (July 1965), pp. 40–43.

_____. "New York Notes: Joan Mitchell." *Art International*, 5 (June–August 1961), pp. 100–101.

_____. "La signature américaine." *XXe siècle*, 10 (March 1958), pp. 62–64.

Bailey, Patricia. "Joan Mitchell In 1950's Remembered Landscapes." *Art/World*, 4 (March 19–April 18, 1980), pp. 4–5.

Baker, Kenneth. "The Colors of Concentration." *San Francisco Examiner*, June 12, 1988, pp. 12–13.

_____. "Second Generation: Mannerism or Momentum?" *Art in America*, 73 (June 1985), pp. 102–11.

Barlow, Margaret. *Women Artists*. Southport, Connecticut: Hugh Lauter Levin Associates, 1999.

Barr, Alfred H., Jr. "Painting and Sculpture Acquisitions: January 1, 1961 through December 31, 1961." *The Museum of Modern Art Bulletin* (New York), 29, nos. 2 & 3 (1962), pp. 3–8, 31.

Battcock, Gregory. "In the Galleries: Joan Mitchell." *Arts Magazine*, 42 (April 1968), p. 59.

Beatty, Frances. "New York Exhibitions. Madison Avenue: Joan Mitchell." *Art/World*, 1 (December 11, 1976), p. 5.

Beckett, Wendy. *Contemporary Women Artists*. New York: Universe Books, 1988.

Bellet, Harry. "Le peintre Joan Mitchell: La puissance de la couleur." *Le Monde* (Paris), November 1–2, 1992, p. 15.

Belnap, Gillian, ed. *The Carnegie Museum of Art: Collection Highlights*. Pittsburgh: The Carnegie Museum of Art, Carnegie Institute, 1995.

Berkson, Bill. "In Living Chaos: Joan Mitchell." *Artforum*, 27 (September 1988), pp. 96–99.

_____. "A Note on Smoke." In *Joan Mitchell: Recent Prints*. San Francisco: Limestone Press, 1989.

Bolger, Mildred. "Journey Into Jungles Nearing an End for The Junior Rossets." *Chicago Daily News*, September 8, 1950, p. 25.

Bonnardin, Simone. "La pastorale furieuse de Joan Mitchell." *La côte des arts*, no. 189 (September–October 1994), p. 6.

Bouisset, Maïten. "Portrait: Joan Mitchell." *Beaux Arts Magazine*, no. 60 (September 1988), pp. 80–81.

Bouzerand, Jacques. "Plein cadre: Joan Mitchell." *Le Point* (Paris), June 6, 1992, p. 101.

Brach, Paul. "Fifty-Seventh Street in Review: Joan Mitchell." *Art Digest*, 26 (January 15, 1952), pp. 17–18.

_____. "57th Street: Joan Mitchell." *Art Digest*, 27 (April 15, 1953), p. 16.

_____. "Review of Exhibitions: New York. Joan Mitchell at Fourcade." *Art in America*, 66 (March–April 1978), pp. 135, 143.

Bradley, Laurel. "Art Reviews: Joan Mitchell." *Arts Magazine*, 52 (February 1978), p. 26.

Breerette, Geneviève. "La dame de Vétheuil: Avec Joan Mitchell, décédée le 30 octobre à Paris, disparaît un grand peintre inclassable et puissant." *Le Monde* (Paris), November 1–2, 1992, p. 1.

_____. "Joan Mitchell à l'ARC: Le buisson ardent." *Le Monde* (Paris), August 22–23, 1982, p. 7.

Brenson, Michael. "An Art of Motion: Joan Mitchell's Abstract Expressionism." *The New York Times*, November 3, 1989, p. C30.

_____. "Art: Works by 7 Women, 'Aspects of Abstraction.'" *The New York Times*, January 22, 1988, p. C24.

_____. "Joan Mitchell—'The Sixties.'" *The New York Times*, April 26, 1985, p. C23.

_____. "Three Who Were Warmed By the City of Light." *The New York Times*, June 25, 1989, pp. H31–32.

Broude, Norma, and Mary D. Garrard, eds. *The Power of Feminist Art: The American Movement of the 1970s. History and Impact.* New York: Harry N. Abrams, 1994.

Burkhart, Dorothy. "Joan Mitchell—nature in abstraction." *San Jose Mercury News*, June 12, 1988, p. 19.

Burnside, Madeleine. "New York Reviews: Joan Mitchell." *Art News*, 77 (March 1978), pp. 173–74.

Butler, Barbara. "In the Galleries: Brach, Goldberg, Goodnough, Mitchell." *Arts*, 30 (June 1956), pp. 48–49.

Butler, Hiram Carruthers. "Downtown in the Fifties: The abstract expressionists from the famous Ninth Street Show—thirty years after." *Horizon*, 24 (June 1981), pp. 15–29.

Calder, John. "Obituaries: Joan Mitchell." *The Independent* (London), November 4, 1992, p. 19.

Campbell, Joyce. "In the Land of Monet, American Painter Joan Mitchell More Than Pulls Her Weight." *People Weekly*, December 6, 1982, pp. 81, 83–84.

Canavier, Elena Karina. "Mitchell Abstract Landscapes." *Artweek* (West Coast ed.), December 15, 1973, p. 1.

Carrier, David. "Exhibition Reviews. New York: Abstract painting and sculpture." *The Burlington Magazine*, 137 (January 1995), pp. 52–53.

————. "Reviews. Pittsburgh: Carnegie International, Carnegie Museum of Art." *Artforum*, 34 (January 1996), pp. 88–89.

Cebulski, Frank. "Joan Mitchell's 'Projective Vision.'" *Artweek*, December 15, 1979, p. 6.

Cena, Olivier. "La morsure de l'instant." *Télérama* (Paris), September 7, 1994, p. 52.

Chalumeau, Jean-Luc. "Il faut sentir quelque chose, on ne peut expliquer. . . ." *Eighty*, no. 23 (May/June 1988), pp. 4–32.

————. "Joan Mitchell, le dernier peintre américain?" *Arts* (Paris), 72 (July 30, 1982), p. 3.

Chayat, Sherry. "Joan Mitchell retrospective." *Syracuse, NY, Herald-American*, April 16, 1989, pp. 31–32.

Chetham, Charles, David F. Grose, and Ann H. Sievers, eds. *A Guide to the Collections: Smith College Museum of Art.* Northampton, Massachusetts: Smith College Museum of Art, 1986.

Cohen, Cora, and Betsy Sussler. "Joan Mitchell" (interview). *Bomb*, no. 17 (Fall 1986), pp. 20–25.

Cornand, Brigitte. "L'expressionisme abstrait de Joan Mitchell." *Libération* (Paris), July 19, 1982, p. 30.

Cotter, Holland. "Art in Review: 'Joan Mitchell: Pastel.'" *The New York Times*, May 8, 1992, p. C31.

————. "Art in Review: Melancholy Mitchells." *The New York Times*, November 4, 1994, p. C30.

————. "100 Works by Women, Not Intended for Women Only." *The New York Times*, July 21, 1995, p. C15.

Courcelles, Pierre. "Joan Mitchell, une Américaine à Paris." *Révolution*, August 25–31, 1994, pp. 30–31.

Cyphers, Peggy. "New York in Review: Joan Mitchell (Robert Miller)." *Arts Magazine*, 64 (January 1990), p. 96.

————. "New York in Review: Louise Fishman, Joan Mitchell, David Reed (Barbara Toll)." *Arts Magazine*, 64 (October 1988), p. 106.

Dagen, Philippe. "Des artistes et le marché. Joan Mitchell: 'Les mêmes règles partout'" (interview). *Le Monde* (Paris), October 9, 1987, p. 22.

————. "La fureur de Joan Mitchell: De Chicago aux bords de la Seine, la recherche d'une indépendance absolue." *Le Monde* (Paris), August 2–3, 1992, pp. 1, 11.

————. "Fureur et mystère: Les œuvres récentes d'un grand peintre." *Le Monde* (Paris), June 10, 1992, p. 18.

————. "Joan Mitchell à Nantes et au Jeu de Paume à Paris: La danse au-dessus du vide." *Le Monde* (Paris), June 26–27, 1994, p. 13.

————. "Notes. Joan Mitchell: peintures récentes." *Le Monde* (Paris), July 8, 1987, p. 12.

————. "Peinture sous tension." *Connaissance des arts*, no. 508 (July–August 1994), pp. 42–51.

Danziger, James, ed. *Photographs of Joan Mitchell by Barney Rosset* (exhibition catalogue). New York: James Danziger Gallery, 1998.

Davis, Douglas. "Art without Limits." *Newsweek*, December 24, 1973, pp. 68–74.

————. "The Painters' Painters." *Newsweek*, May 13, 1974, pp. 108–13.

Davis, Lydia. "Joan Mitchell: Les Bluets (The cornflowers), 1973." *Artforum*, 34 (January 1996), pp. 72–73.

Dearborn, Cholly. "Smart Set." *Chicago Herald-American*, May 31, 1949, p. 10.

————. "Smart Set." *Chicago Herald-American*, September 19, 1949, p. 10.

————. "Smart Set: Artist's Dream Comes True for Joan Mitchell—N.Y. Solo Show." *Chicago Herald-American*, October 22, 1951, p. 10.

————. "Smart Set and Women's Magazine: Barnet Rosset Jr. Sues His Socialite Artist Wife." *Chicago Herald-American*, May 8, 1952, p. 14.

DeCarlo, Tessa. "A Very Abstract Expressionist." *The Wall Street Journal*, November 30, 1995, p. A18.

Dobbels, Daniel. "Joan Mitchell, la douleur des couleurs." *Libération* (Paris), July 7, 1987, p. 26.

Edinborough, Arnold. "'American Accents': A tribute to the passion to communicate." *The Financial Post* (Toronto), June 25, 1983, p. 21.

Ellis, Simone. "Mitchell is 'the' Abstract Expressionist." *The Santa Fe New Mexican*, May 22, 1992.

Ferrier, Jean-Louis. "Expositions." *Le Point* (Paris), August 16, 1982, p. 9.

Fineberg, Jonathan. *Art Since 1940: Strategies of Being*. 2nd ed. New York: Harry N. Abrams, 2000.

Finkelstein, Louis. "Gotham News, 1945–60." In Thomas B. Hess and John Ashbery, eds. *The Avant-Garde: Art News Annual XXXIV*. New York: The Macmillan Company, 1968, pp. 114–22.

————. "New look: Abstract-Impressionism." *Art News*, 55 (March 1956), pp. 36–39, 66–68.

Fitzsimmons, James. "Art." *Arts & Architecture*, 70 (May 1953), pp. 4, 6–10.

Flam, Jack. "The Gallery: Joan Mitchell; East Europe's Avant-Garde." *The Wall Street Journal*, March 29, 1988, p. 29.

Flohic, Catherine. "Joan Mitchell." *Eighty*, no. 23 (May/June 1988), pp. 2–3.

Forgey, Benjamin. "The Clarity of the Corcoran Biennial." *The Washington Star*, February 22, 1981, pp. E1–2.

————. "A Painter Who Has Yet to Get Her Due." *The Washington Star*, February 28, 1981, pp. C1, C3.

Francblin, Catherine. "Reviews. Paris/Nantes: Joan Mitchell." Translated by J. O'Toole. *Art Press*, 194 (September 1994), p. 65.

Frank, Elizabeth. "Review of Exhibitions: New York. Joan Mitchell at Fourcade." *Art in America*, 68 (May 1980), p. 154.

Frankel, Sara. "Color her 'Joan Mitchell': Abstract artist's work on display at SFMMA." *San Francisco Examiner*, May 27, 1988, pp. C1–2.

Frankenstein, Alfred. "A Trio of Contemporary New York Shows." *San Francisco Examiner*, December 26, 1976, p. 31.

Frankfurter, Alfred. "The year's best: 1955." *Art News*, 54 (January 1956), pp. 40, 69.

Freilicher, Jane. "Editor's Letters." *Art News*, 60 (December 1961), p. 6.

Freudenheim, Susan. "Joan Mitchell's show shines." *The (San Diego) Tribune*, December 7, 1988, pp. C1, C7.

Galy-Carles, Henry. "Joan Mitchell, Kallos. . . ." *Lettres françaises*, May 12, 1971, p. 26.

Gaugh, Harry. "Dark Victories." *Art News*, 87 (Summer 1988), pp. 154–59.

Gauville, Hervé. "Joan Mitchell: Les Couleurs de l'ennui." *Libération* (Paris), August 1, 1994, p. 28.

————. "Joan Mitchell, une sensation disparaît." *Libération* (Paris), November 2, 1992, p. 42.

Gayford, Martin. "Not Much Like Home." *Modern Painters*, 8 (Winter 1995), pp. 68–73.

Genauer, Emily. "Art Exhibition Notes: Mitchell, at Stable." *New York Herald Tribune*, April 18, 1953, p. 11.

————. "A Sudden Discovery." *New York Herald Tribune*, May 14, 1961, sec. 4, p. 18.

Gibson, Michael. "Galleries in Paris." *International Herald Tribune* (Paris), May 31–June 1, 1980, p. 10W.

————. "Joan Mitchell: Au-delà des mots (Beyond Words)." *Cimaise*, no. 221 (November–December 1992), pp. 9–24. (Reprinted as a brochure by Special Project Jacob Baal-Teshuva, Paris.)

_____. "Joan Mitchell's Glowing Paintings." *International Herald Tribune* (Paris), July 24–25, 1982, p. 5.

_____. "Leisure: Joan Mitchell." *International Herald Tribune* (Paris), June 16–17, 1984, p. 5.

_____. "Paris Fair: One-Man Shows the Rule." *International Herald Tribune* (Paris), October 20–21, 1984, p. 6.

_____. "Revelations of Color in Joan Mitchell's Paintings." *International Herald Tribune* (Paris), July 9–10, 1994, p. 7.

_____. "The World. Paris: Fractured dreams." *Art News*, 79 (September 1980), pp. 230–31.

Glueck, Grace. "Action/Precision: 1980–1985 (Washburn Gallery)." *The New York Times*, January 18, 1985, p. C22.

_____. "Art: Gestural Approach in Grey Gallery Show." *The New York Times*, January 18, 1985, p. C22.

_____. "Art: Show Honors De Kooning." *The New York Times*, December 23, 1983, p. C22.

_____. "Board Spat Threatens Joan Mitchell Grants." *The New York Observer*, February 6, 1995, pp. 1, 18.

_____. "Critics' Choices: Art." *The New York Times*, March 1, 1981, sec. 2A, p. 3.

Goddard, Donald. *American Painting*. Southport, Connecticut: Hugh Lauter Levin Associates, 1990.

Godfrey, Tony. "Exhibition Reviews. New York: The Whitney Biennial and other exhibitions." *The Burlington Magazine*, 127 (July 1985), pp. 486, 488.

"Goings on About Town. Art: Last Spring." *The New Yorker*, April 26, 1993, p. 16.

"Goings on About Town. Joan Mitchell." *The New Yorker*, November 20, 1989, pp. 14, 16.

"Goings on About Town. Some Seventies Works." *The New Yorker*, July 16, 1990, p. 13.

"Goings on About Town. Whitney Museum of American Art." *The New Yorker*, May 4, 1992, p. 14.

Gomez, Edward M. "Abstract Art's Gutsy Poet—Joan Mitchell." *Art & Antiques*, 19 (May 1996), pp. 80–87.

Goodman, Lila. "Mitchell." In Lee Nordness, ed. *Art USA Now*. Vol. 2. New York: The Viking Press, 1963.

Goodnough, Robert. "Reviews and previews. Joan Mitchell." *Art News*, 52 (April 1953), p. 41.

Groft, Tammis K. "Joan Mitchell." In *The Empire State Collection: Art for the Public*. Albany, New York: Empire State Plaza Art Commission; New York: Harry N. Abrams, 1987, pp. 114–15.

Grossberg, Jacob. "In the Galleries: Joan Mitchell." *Arts Magazine*, 39 (May–June 1965), p. 58.

Gruen, John. "Women Artists: 25 Best Investments." *Working Woman*, 5 (July 1980), pp. 30–33.

Haftmann, Werner, et al. *Art Since Mid-Century: The New Internationalism*. Vol. 1, *Abstract Art*. Greenwich, Connecticut: New York Graphic Society, 1971.

Hapgood, Susan. "Flash Art Reviews: New York. Drawings: Xavier Fourcade." *Flash Art*, no. 114 (November 1983), p. 68.

Harithas, James. "Weather Paint." *Art News*, 71 (May 1972), pp. 40–43, 63.

Hartt, Frederick. *Art: A History of Painting, Sculpture, Architecture*. 4th ed. Englewood Cliffs, New Jersey: Prentice Hall; New York: Harry N. Abrams, 1993.

Harvey, John H. "Joan Mitchell's Paintings Displayed at Art Gallery." *St. Paul (Minnesota) Dispatch*, October 27, 1950.

Heller, Nancy G. *Women Artists: An Illustrated History*. New York: Abbeville Press, 1987.

Heller, Nancy G., et al. *Works from the National Museum of Women in the Arts*. Washington, D.C.: National Museum of Women in the Arts; New York: Rizzoli International Publications, 2000.

Henry, Gerrit. "New York Reviews: Joan Mitchell." *Art News*, 80 (September 1981), pp. 236, 238.

Herman, J. "Joan Mitchell." *Arts*, 54 (June 1980), pp. 33–35.

Herrera, Hayden. "Reviews and Previews. Joan Mitchell." *Art News*, 73 (Summer 1974), pp. 111–12.

Hess, Elizabeth. "Joan Mitchell, 1926–1992." *The New York Village Voice*, November 11–17, 1992, p. 3.

_____. "Upstairs, Downstairs." *The New York Village Voice*, April 30, 1991, pp. 93–94.

Hess, Thomas B. "Sensations of Landscape." *New York*, December 20, 1976, pp. 76–79.

_____. "U.S. Painting: Some Recent Directions." *Art News Annual 1956: 25th Christmas Edition*, part 2, 54 (November 1955), pp. 76–98, 174.

Hobbs, Robert. "Internationalism and American Art." *Woman's Art Journal*, 12 (Fall 1991/Winter 1992), pp. 38–40.

Hoffman, Katherine. *Explorations: The Visual Arts Since 1945*. New York: Icon Editions, 1991.

Holden, Stephen. "Cinematic Portrait Of the Life Of an Artist." *The New York Times*, April 14, 1993, p. C14.

Holliday, Betty. "Reviews and previews. Joan Mitchell." *Art News*, 50 (January 1952), p. 46.

Hunter, Sam, John Jacobus, and Daniel Wheeler. *Modern Art*. 3rd rev. ed. New York: Harry N. Abrams, 2000.

Jessup, Sally. "Heroic-Sized Metaphors Of Mitchell's Landscapes." *Art/World*, 5 (February 20–March 20, 1981), p. 7.

"Joan Mitchell." In Charles Moritz, ed. *Current Biography*, 47 (March 1986), pp. 37–40. (Reprinted in Charles Moritz, ed. *Current Biography Yearbook 1986*. New York: The H.W. Wilson Company, 1986, pp. 370–73.)

"Joan Mitchell." *It Is*, 2 (Autumn 1958), pp. 27, 52.

"Joan Mitchell, de Chicago à Vétheuil: De l'expressionnisme à l'impressionnisme abstrait." *Le Journal Des Arts*, 5 (July–August 1994), p. 16.

"Joan Mitchell Remembered." *Flash Art* (International ed.), 26 (May–June 1993), p. 104.

"Joan Mitchell: Retrospective." *San Valero 7*, *Institut Français de Valencia*, no. 3 (October/December 1997), pp. 22–23.

Johnson, Ellen H. "Is Beauty Dead?" *Allen Memorial Art Museum Bulletin*, 20 (Winter 1963), pp. 56–65.

_____. *Modern Art and the Object: A Century of Changing Attitudes*. Rev., enlarged ed. New York: Icon Editions, 1995.

Johnson, Ken. "Review of Exhibitions: New York. Joan Mitchell at Robert Miller." *Art in America*, 79 (October 1991), pp. 146–47.

Johnson, Patricia C. "Mitchell's large paintings overshadow small ones." *Houston Chronicle*, October 28, 1981, sec. 6, p. 7.

Kandel, Susan. "L.A. in Review." *Arts Magazine*, 63 (April 1989), pp. 109–10.

Karmel, Pepe. "Also of Note: 'Action and Edge.'" *The New York Times*, April 28, 1995, p. C34.

Kertess, Klaus. "In Memory of Joan Mitchell." *Tema Celeste* (International ed.), no. 39 (Winter 1993), p. 9.

_____. "Joan Mitchell: The Last Decade." *Art in America*, 80 (December 1992), pp. 94–101.

Kimmelman, Michael. "Art in Review. Joan Mitchell." *The New York Times*, April 9, 1993, p. C26.

_____. "At the Whitney, a Biennial That's Eager to Please." *The New York Times*, April 19, 1991, pp. C1, C24.

_____. "Joan Mitchell." *The New York Times*, November 9, 1990, p. C26.

_____. "Looking for the Magic in Painting." *The New York Times*, October 21, 1994, pp. C1, C28.

_____. "This American in Paris Kept True to New York." *The New York Times*, April 17, 1988, p. H43.

Kingsley, April. "New York Letter." *Art International*, 18 (Summer 1974), pp. 43–45, 64.

Kino, Carol. "Joan Mitchell at Robert Miller." *Art & Auction*, 18 (April 1996), p. 60.

Koestenbaum, Wayne. "The Best of 1998: Wayne Koestenbaum." *Artforum*, 37 (December 1998), pp. 100–101.

Kozloff, Max. "New York: Joan Mitchell, Jackson." *Artforum*, 6 (Summer 1968), p. 50.

Kramer, Hilton. "Joan Mitchell." *The New York Times*, April 6, 1968, p. 35.

_____. "Joan Mitchell." *The New York Times*, March 21, 1980, p. C19.

Krauss, Rosalind. "Painting Becomes Cyclorama." *Artforum*, 12 (June 1974), pp. 50–52.

Kupcinet, Irv. "Kup's column." *Chicago Sun-Times*, September 16, 1949, p. 67.

Kuspit, Donald. "Reviews: Joan Mitchell, Robert Miller and Susan Sheehan." *Artforum* (international ed.), 32 (October 1993), p. 88.

Lanes, Jerrold. "Current and Forthcoming Exhibitions: New York." *The Burlington Magazine*, 110 (May 1968), pp. 295–99.

Larson, Kay. "Mixed Messages." *New York*, April 15, 1991, pp. 68–69.

_____. "Voice Choices. Art: Joan Mitchell." *The New York Village Voice*, March 24, 1980, p. 59.

Le Clair, Charles. *Color in Contemporary Painting*. New York: Watson-Guptill Publications, 1991.

Lehman, David. *The Last Avant-Garde: The Making of the New York School of Poets*. New York: Doubleday, 1998.

Lerman, Ora. "The Elusive Subject: Joan Mitchell's Reflections on van Gogh." *Arts Magazine*, 65 (September 1990), pp. 42–46.

Lévêque, Jean-Jacques. "Arts: Joan Mitchell." *Les Nouvelles Littéraires* (Paris), July 1–6, 1982, p. 34.

_____. "Les expositions à Paris: Joan Mitchell." *Aujourd'hui*, no. 37 (June 1962), p. 40.

Levy, Mark. "Joan Mitchell." *Vanguard*, 9 (Summer 1980), p. 44.

Lewis, Jo Ann. "The New of The Best. But The Best of The New?" *Art News*, 80 (May 1981), pp. 152–55.

Lippard, Lucy R. *From the Center: Feminist Essays on Women's Art*. New York: E.P. Dutton, 1976.

Lubell, Ellen. "Celebrating Beautiful Visual Objects." *The New York Soho Weekly News*, December 15–21, 1977, pp. 27, 45.

_____. "New York Galleries: Joan Mitchell." *Arts Magazine*, 46 (Summer 1972), p. 60.

_____. "N.Y. Gallery Reviews: Joan Mitchell." *Arts Magazine*, 47 (September–October 1972), pp. 60–61.

Lucie-Smith, Edward. *American Art Now*. New York: William Morrow and Company, 1985.

_____. *Artoday*. London: Phaidon Press Limited, 1995.

Lufkin, Liz. "Triumph For 'Lady Painter': Joan Mitchell gets a retrospective." *San Francisco Chronicle*, May 26, 1988, pp. D3, D5.

Marin, Juan. "Cronica de Paris." *Goya: Revista de Arte*, nos. 241–42 (July–October 1994), pp. 103–09.

Marshall, Richard D. "Willem de Kooning and Joan Mitchell: The Late Paintings." In Peter Fischer, ed. *Abstraction, Gesture, Ecriture: Paintings from the Daros Collection*. Zurich: Scalo, 1999, pp. 35–60.

Masters, Greg. "Arts Reviews: Group Show." *Arts Magazine*, 60 (April 1986), pp. 139–40.

McCann, Cecile N. "Our Land, Our Sky, Our Water." *Artweek* (West Coast ed.), June 1, 1974, pp. 1, 3.

McMullen, Roy. "L'école de New York: des concurrents dangereux." *Connaissance des arts*, no. 115 (September 1961), pp. 30–37.

Mellow, James R. "Joan Mitchell." *The New York Times*, March 30, 1974, p. L27.

Mellquist, Jerome. "In the Galleries: Joan Mitchell." *Arts*, 31 (March 1957), p. 54.

Messinger, Lisa M. "Recent Acquisitions: A Selection, 1991–1992. Joan Mitchell, *La Vie en Rose*." *The Metropolitan Museum of Art Bulletin* (New York), 50 (Fall 1992), pp. 68–69.

Michaud, Yves. "Joan Mitchell." *Galeries Magazine*, no. 19 (June–July 1987), pp. 62–65.

_____. "Joan Mitchell, une américaine à Vétheuil." *Beaux Arts Magazine*, no. 101 (May 1992), pp. 36–41.

_____. "Reviews and Previews: Joan Mitchell." Translated by Catsou Roberts. *Galeries Magazine* (international ed.), 60 (Summer 1994), pp. 89–90.

Monte, James. "Reviews. San Francisco: Directions—American Painting, San Francisco Museum of Art." *Artforum*, 2 (November 1963), pp. 43–44.

Moorman, Margaret. "New York Reviews: Joan Mitchell." *Art News*, 85 (October 1986), p. 129.

_____. "Reviews. New York: Joan Mitchell." *Art News*, 89 (January 1990), p. 159.

_____. "Reviews. New York: Painting." *Art News*, 90 (November 1991), p. 134.

"La mort de Joan Mitchell." *Le Quotidien de Paris*, November 2, 1992, p. 20.

"Mort du peintre américain Joan Mitchell: L'ivresse des couleurs." *Le Figaro* (Paris), November 3, 1992, p. 23.

Moutet, Anne-Elisabeth. "An American in Paris: Ex-Patriartist Joan Mitchell." *Elle*, 3 (February 1988), pp. 74, 76.

"Multiples & Objects & Books: Joan Mitchell & Nathan Kernan." *The Print Collector's Newsletter*, 24 (March–April 1993), p. 23.

Munro, Eleanor. "The found generation." *Art News*, 60 (November 1961), pp. 38–39, 75–76.

_____. *Originals: American Women Artists*. New York: Simon and Schuster, 1979.

_____. "Reviews and previews: Four Americans." *Art News*, 55 (Summer 1956), p. 50.

Nadaner, Dan. "On Relatedness between the Arts: Crossovers between Painting and Poetry." *The Journal of Aesthetic Education*, 27 (Spring 1993), pp. 31–39.

Nemser, Cindy. "An Afternoon with Joan Mitchell." *The Feminist Art Journal*, 3 (Spring 1974), pp. 5–6, 24.

"New at the Museum: Joan Mitchell's *Ici*." *The Saint Louis Art Museum Magazine* (November–December 1993), p. 8.

Newbill, Al. "Fortnight in Review: Joan Mitchell." *Arts Digest*, 29 (March 1, 1955), p. 28.

Newhall, Edith. "Diff'rent Strokes." *New York*, April 28, 1986, p. 38.

Newman, David. "Arts Reviews: Joan Mitchell." *Arts Magazine*, 55 (April 1981), p. 30.

Nochlin, Linda. "Joan Mitchell: Art and Life at Vétheuil." *House & Garden*, 156 (November 1984), pp. 192–97, 226, 228, 232, 236, 238.

Nordland, Gerald. "Variety and Expansion." *Arts Magazine*, 36 (November 1961), pp. 48–50.

O'Beil, Hedy. "Arts Reviews: Joan Mitchell." *Arts*, 54 (June 1980), p. 35.

"Obituaries: Abstract Painter Joan Mitchell Dies at 66." *The Washington Post*, November 1, 1992, p. B14.

"Obituaries: Joan Mitchell." *The Times* (London), November 6, 1992, p. 23.

O'Hara, Frank. "Reviews and previews: Ernest Briggs, Dugmore, Joan Mitchell." *Art News*, 54 (September 1955), pp. 51–52.

Passagem, Aline Rios. "Joan Mitchell: Le paysage lyrique." *Beaux Arts Magazine*, no. 125 (July–August 1994), Summer supplement, p. 20.

Patton, Phil. "Reviews. New York: Joan Mitchell." *Artforum*, 15 (February 1977), pp. 71–72.

Perl, Jed. "After Monet." *Modern Painters*, 6 (Spring 1993), pp. 30–34.

_____. *Gallery Going: Four Seasons in the Art World*. San Diego: Harcourt Brace Jovanovich, Publishers, 1991.

_____. "Half a dozen contemporaries." *The New Criterion*, 8 (February 1990), pp. 45–51.

_____. "The Joans of Art." *Vogue*, 178 (March 1988), p. 110.

_____. "Through a blighted landscape." *The New Criterion*, 11 (September 1992), pp. 64–67.

_____. "Tradition-conscious." *The New Criterion*, 9 (May 1991), pp. 55–59.

_____. "What there was to see." *The New Criterion*, 11 (June 1993), pp. 48–55.

Pierrard, Jean. "La peinture à corps perdu: Deux Expositions pour montrer comment Joan Mitchell s'est donnée à l'abstraction." *Le Point* (Paris), August 27, 1994, p. 67.

Piguet, Philippe. "À propos de polyptyque." *L'Oeil*, no. 419 (June 1990), pp. 42–47.

_____. "Les champs de Joan Mitchell." *Le Quotidien de Paris*, June 28, 1990, p. 27.

_____. "Galeries: Paris, Joan Mitchell." *L'Oeil*, no. 383 (June 1987), pp. 80–81.

_____. "Joan Mitchell, la peinture comme un chant." *L'Oeil*, no. 464 (September 1994), pp. 70–72.

_____. "Livres d'art: *Joan Mitchell*, par Michel Waldberg." *L'Oeil*, no. 450 (April 1993), p. 85.

Pincus, Robert L. "La Jolla retrospective shows artist deserved a closer look." *The San Diego Union*, December 22, 1988, p. E6.

Pinte, Jean-Louis. "Joan Mitchell, la quête du bonheur." *Figaroscope* (Paris), June 10–18, 1992, p. 52.

_____. "Joan Mitchell: Un souffle de vie." *Figaroscope* (Paris), December 13–19, 1995, p. 48.

Plagens, Peter. "Reviews: Joan Mitchell." *Artforum*, 12 (March 1974), pp. 85–86.

Pleynet, Marcelin. "Desidées, des critiques, de la peinture et des galeries." *Art International*, 15 (June 20, 1971), pp. 77–79.

_____. *Les Etats-Unis de la peinture*. Paris: Éditions du Seuil, 1986.

Polsky, Richard. *Art Market Guide: Contemporary American Art*. New York: D.A.P./Distributed Art Publishers, 1995.

Pomeroy, Ralph. "Mitchell, Joan." In Joann Cerrito, ed. *Contemporary Artists*. 4th ed. Detroit: St. James Press, 1996, pp. 782–83.

Porter, Fairfield. "Art." *The Nation*, 192 (May 20, 1961), pp. 446–47.

Preston, Stuart. "Art and Industry: A New Synthesis." *The New York Times*, April 25, 1965, p. X23.

_____. "Chiefly Abstract: New Shows Include Work By Picasso and Calder." *The New York Times*, January 20, 1952, p. X9.

_____. "Diverse Exhibitions." *The New York Times*, March 10, 1957, p. X14.

_____. "Styles, Mediums Vary in Art Shows: Realism, Abstraction Vie With Landscapes in Wood Blocks, Paints and Prints Here." *The New York Times*, April 11, 1953, p. 15.

Prodhon, Françoise-Claire. "Joan Mitchell." *Flash Art*, no. 5 (Autumn 1984), pp. 42–43.

Putnam, Jacques, Pierre Schneider, and Jean-François Revel. "Au Salon de Mai." *L'Oeil*, no. 78 (June 1961), pp. 46–53, 78–80.

Ratcliff, Carter. "Joan Mitchell: Letting in the Light." *Vogue*, 173 (March 1983), p. 110.

_____. "Joan Mitchell's Envisionments." *Art in America*, 62 (July–August 1974), pp. 34–37.

_____. "New York Letter." *Art International*, 15 (September 20, 1971), pp. 68–72.

_____. "New York Letter." *Art International*, 16 (Summer 1972), pp. 72–79.

_____. "New York Letter." *Art International*, 22 (January 1978), pp. 85–92.

_____. "The Short Life of the Sincere Stroke." *Art in America*, 71 (January 1983), pp. 73–79, 137.

Read, Sir Herbert, and H. Harvard Arnason. "Dialogue on modern U.S. painting." *Art News*, 59 (May 1960), pp. 32–36.

Richard, Paul. "Abstract Audacity: The Corcoran's Provocative American Biennial. . . . " *The Washington Post*, February 19, 1981, pp. D1, D7, D11.

_____. "Joan Mitchell's Bleak Horizons: At the Corcoran, A 40-Year Look Back." *The Washington Post*, February 27, 1988, pp. D1, D11.

Riding, Alan. "French Ask: Is Art Still a Hobby?" *The New York Times*, January 30, 1996, pp. C11, C15.

Robinson, Walter, and Anastasia Wilkes. "Obituaries: Joan Mitchell." *Art in America*, 80 (December 1992), pp. 134, 136.

Romano, Lois. "Focus on Abstract Art At the Corcoran Gallery." *The Washington Star*, February 19, 1981, pp. D1–D2.

Rose, Barbara. "First-Rate Art by the Second Sex." *New York*, April 8, 1974, pp. 80–81.

_____. "The Landscape of Light, Joan Mitchell." *Vogue*, 171 (June 1981), pp. 206–09, 245.

_____. "The Second Generation: Academy and Breakthrough." *Artforum*, 4 (September 1965), pp. 53–63.

Rosenberg, Harold. *Art on the Edge: Creators and Situations*. New York: Macmillan Publishing Co., 1975.

_____. "The Art World: Artist Against Background." *The New Yorker*, April 29, 1974, pp. 71–72, 74, 76, 78. [Translated by Christian Bernard and reprinted in *Avant-Guerre*, 2 (January–March 1981), pp. 33–38.]

_____. "Tenth Street: A Geography of Modern Art." *1959 Art News Annual XXVIII*, part 2, *Art News*, 57 (November 1958), pp. 120–43, 184, 186, 188, 190, 192.

Rosenblum, Robert. "Month in Review: Dugmore, Briggs, Mitchell." *Arts Digest*, 29 (August 1, 1955), p. 28.

Rosenthal, Deborah. "Making a Mark: Nature transformed. Joan Mitchell." *Art & Antiques*, 7 (March 1990), p. 155.

Rubin, William. "Younger American Painters." *Art International*, 4 (1960), pp. 24–31.

Rubinstein, Charlotte Streifer. *American Women Artists: From Early Indian Times to the Present*. New York: Avon Books, 1982.

Russell, John. "Joan Mitchell." *The New York Times*, December 3, 1976, p. C20.

_____. "Joan Mitchell." *The New York Times*, April 25, 1986, p. C24.

_____. "Joan Mitchell, Abstract Artist, Is Dead at 66." *The New York Times*, October 31, 1992, p. L11.

_____. "New Paintings by Joan Mitchell." *The New York Times*, December 9, 1977, p. C18.

_____. "Paintings That Liberate the Viewer's Imagination." *The New York Times*, April 12, 1991, p. C22.

_____. "Why The Latest Whitney Biennial Is More Satisfying." *The New York Times*, March 25, 1983, pp. C1, C26.

Sandler, Irving H. "Is today's artist with or against the past? Part 2, Answers by: David Smith, Frederick Kiesler, Franz Kline, Joan Mitchell" (interviews). *Art News*, 57 (September 1958), pp. 38–41, 58, 62–63.

_____. "Joan Mitchell." In B.H. Friedman, ed. *School of New York: Some Younger Artists*. New York: Grove Press; London: Evergreen Books, 1959, pp. 42–47.

_____. "Mitchell paints a picture." *Art News*, 56 (October 1957), pp. 44–47, 69–70.

_____. *The New York School: The Painters and Sculptors of the Fifties*. New York: Icon Editions, 1978.

_____. "Reviews and previews: Joan Mitchell." *Art News*, 57 (April 1958), p. 12.

_____. "Reviews and previews: Joan Mitchell." *Art News*, 60 (May 1961), p. 11.

_____. "Young moderns and modern masters: Joan Mitchell." *Art News*, 56 (March 1957), pp. 32, 64.

Santacreu, Élisabeth. "La Lumière de Joan Mitchell." *Le Parisien*, August 19, 1994, p. 4.

Sawin, Martica. "In the Galleries: Joan Mitchell." *Arts*, 32 (April 1958), p. 59.

_____. "A Stretch of the Seine: Joan Mitchell's Paintings." *Arts Magazine*, 62 (March 1988), pp. 29–31.

Schipper, Merle. "French Painting, American Style." *Artweek* (West Coast ed.), April 15, 1978, pp. 1, 16.

Schjeldahl, Peter. "Different Strokes." *The New York Village Voice*, April 27, 1993, p. 95.

_____. "Joan Mitchell: To Obscurity And Back." *The New York Times*, April 30, 1972, p. D23.

Schneider, Pierre. "Art news from Paris." *Art News*, 59 (Summer 1960), p. 50.

_____. "Art news from Paris." *Art News*, 61 (Summer 1962), p. 43.

_____. "L'éternel et l'éphémère." *L'Express*, June 22–28, 1990, p. 130.

_____. "Joan Mitchell." *L'Express*, May 17–23, 1971, p. 37.

_____. "Joan Mitchell entre East village et Vétheuil." *Art Press*, 38 (June 1980), pp. 10–11.

_____. "Joan Mitchell et le tilleul de Monet." *L'Express Magazine*, November 25–December 2, 1978, p. 49.

_____. "Les libérateurs américains." *L'Express*, August 19–25, 1988, p. 88.

_____. "Miracle à Argenteuil." *L'Express*, November 26, 1992, pp. 186–87.

_____. "Mitchell: La conscience et la terre." *L'Express*, August 27–September 2, 1982, p. 19.

Schwendener, Martha. "Reviews: Joan Mitchell." *Flash Art*, 28 (March–April 1995), p. 105.

Scott, Bill. "In the Eye of the Tiger." *Art in America*, 83 (March 1995), pp. 70–77.

Seckler, Dorothy Gees. "Reviews and previews: Joan Mitchell." *Art News*, 54 (March 1955), p. 51.

Seeney, Lynn. "Mitchell Art At Fourcade." *Art/World*, 10 (April 1986), pp. 1, 3.

Seidner, David. "Joan Mitchell." *Vogue* (Paris), no. 735 (April 1993), pp. 164–71.

Slivka, Rose C.S. "Breathtaking Show." *The East Hampton (New York) Star*, May 22, 1997, pp. III-1, III-7.

Smith, Roberta. "From New York Painters, Work That Takes Time." *The New York Times*, May 1, 1992, p. C31.

_____. "The Gallery Doors Open to the Long Denied." *The New York Times*, May 26, 1996, pp. H1, H29.

_____. "Joan Mitchell: 'Paintings, 1950–1955.'" *The New York Times*, May 22, 1998, p. E35.

_____. "Louise Fishman, Joan Mitchell, David Reed." *The New York Times*, July 22, 1988, p. C25.

_____. "No Muss, No Fuss At 1995 Carnegie." *The New York Times*, November 8, 1995, pp. C13, C15.

_____. "Representation: An Abstract Issue." *The New York Village Voice*, March 11–17, 1981, p. 75.

_____. "Tops of the Town: Experts Tell All. Art Galleries." *The New York Times*, November 24, 1989, p. C30.

Solomon, Deborah. "In Monet's Light." *The New York Times Magazine*, November 24, 1991, pp. 44–47, 50, 62, 64.

Somers, Marion. "Creative Exit." *Art Journal*, 53 (Spring 1994), pp. 76–78.

Stefanides, Manos. "Critical notes and reviews: Joan Mitchell." *Arti, Art Today* (Athens), 22 (November–December 1994), pp. 218–19.

Stein, Deidre. "New York Reviews: Joan Mitchell." *Art News*, 92 (September 1993), pp. 168–69.

Steinberg, Leo. "Month in Review." *Arts*, 30 (January 1956), pp. 46–48.

Storr, Robert. "Mitchell's Mitchells." *MoMA Magazine* (The Museum of Modern Art, New York), no. 19 (Spring 1995), p. 23.

Stoullig, Claire. "Joan Mitchell." In *La collection du Musée national d'art moderne*. Paris: Éditions du Centre Pompidou, 1986, p. 436.

Strickland, Carol. "Old Friend Films a Portrait of an Artist." *The New York Times* (Long Island ed.), June 21, 1992, p. LI13.

Stuckey, Charles F. *French Painting*. Southport, Connecticut: Hugh Lauter Levin Associates, 1991.

Tallmer, Jerry. "Life & times of Joan of art. *Joan Mitchell: Portrait of an Abstract Painter*." *New York Post*, April 14, 1993, p. 24.

Tasset, Jean-Marie. "À Nantes et à Paris, Joan Mitchell: La jardinière de Vétheuil." *Le Figaro* (Paris), July 26, 1994, p. 26.

————. "Joan Mitchell, jardinier de l'azur." *Le Figaro* (Paris), June 12, 1990, p. 39.

Terbell, Melinda. "A Woman's Place Is in the Gallery." *Art News*, 73 (February 1974), p. 73.

Tillim, Sidney. "In the Galleries: Joan Mitchell." *Arts*, 35 (May–June 1961), pp. 84–85.

————. "New York Exhibitions: Month in Review." *Arts Magazine*, 36 (December 1961), pp. 42–43.

Tobler, Jay, ed. *The American Art Book*. London: Phaidon Press Limited, 1999.

Tuchman, Phyllis. "Joan Mitchell Paints Chaos in Color." *New York Newsday*, April 13, 1986, part 2, p. 13.

Turner, Elisa. "The American Artist Abroad: Sprawling FIU show, a pleasant trip, casts worldwide web." *The Miami Herald*, February 25, 1996, sec. 1, pp. 1I, 6I.

Van Proyen, Mark. "Atmosphere and Elan Vital, San Francisco." *Artweek*, June 25, 1988, p. 1.

"The Vocal Girls." *Time*, May 2, 1960, p. 74.

Wat, Pierre. "Jean Fournier ou la discrétion à l'œuvre." *Beaux Arts Magazine*, no. 125 (July–August 1994), pp. 42–43.

Westfall, Stephen. "Review of Exhibitions: New York. Joan Mitchell at Fourcade." *Art in America*, 73 (October 1985), pp. 156–57.

————. "Then and Now: Six of the New York School Look Back" (interviews). *Art in America*, 73 (June 1985), pp. 112–21.

Wheeler, Daniel. *Art Since Mid-Century: 1945 to the Present*. New York: The Vendome Press, 1991.

Wilkin, Karen. "At the Galleries." *Partisan Review*, 60, no. 2 (1993), pp. 459–68.

Willard, Charlotte. "A Singular View." *New York Post*, April 6, 1968, p. 46.

Wilson, William. "Abstracting an Abstract Expressionist." *Los Angeles Times*, June 19, 1988, Calendar sec., pp. 93–94.

————. "Art Walk: A Critical Guide to the Galleries." *Los Angeles Times*, April 7, 1978, part 4, p. 10.

"Women Artists in Ascendance: Young Group Reflects Lively Virtues of U.S. Painting." *Life*, 42 (May 13, 1957), pp. 74–77.

Woodville, Louisa. "Three Painters, Three Decades." *Arts Magazine*, 59 (January 1985), p. 19.

Wooster, Ann Sargent. "New York Reviews: Joan Mitchell." *Art News*, 76 (February 1977), pp. 125–26.

Yau, John. "Reviews. New York: 'Action/Precision.'" *Artforum*, 23 (May 1985), p. 105.

————. "Reviews. New York: Joan Mitchell." *Artforum*, 28 (February 1990), pp. 137–38.

Zimmer, William. "Art Pick. Joan Mitchell: The Fifties." *The New York Soho Weekly News*, March 19–25, 1980, p. 36.

————. "Joan Mitchell, Xavier Fourcade." *The New York Soho Weekly News*, March 4–10, 1981, pp. 50, 64.

Lenders to the Exhibition

Bunny Adler

Albright-Knox Art Gallery, Buffalo, New York

The Art Institute of Chicago

Carnegie Museum of Art, Pittsburgh

Castellani Art Museum of Niagara University Collection,
Niagara University, New York

John Cheim

Moya Connell-McDowell

The Corcoran Gallery of Art, Washington, D.C.

W. Stephen Croddy

Daros Collection, Switzerland

Estate of Joan Mitchell

Fondation Cartier pour l'art contemporain, Paris

Fonds Régional d'Art Contemporain de Haute-Normandie,
Sotteville-lès-Rouen, France

Jean Fournier

Thomas and Darlene Furst

Mr. and Mrs. Robert B. Goergen

Hirshhorn Museum and Sculpture Garden,
Smithsonian Institution, Washington, D.C.

Kemper Museum of Contemporary Art, Kansas City, Missouri

McNay Art Museum, San Antonio

The Metropolitan Museum of Art, New York

Betsy Wittenborn Miller

Betsy Wittenborn Miller and Robert Miller

Musée national d'art moderne/Centre de création industrielle,
Centre Georges Pompidou, Paris, en dépôt au Musée des
Beaux-Arts de Nantes

Museum of Art, Rhode Island School of Design, Providence

The Museum of Modern Art, New York

Osaka City Museum of Modern Art, Japan

San Francisco Museum of Modern Art

Phil Schrager

Smithsonian American Art Museum, Washington, D.C.

Whitney Museum of American Art, New York

Worcester Art Museum, Massachusetts

Six private collections

Acknowledgments

This project began in the fall of 1999, when the Whitney Museum of American Art agreed to host a guest-curated Joan Mitchell painting retrospective. That first step—Maxwell L. Anderson's commitment to present the show—enabled us to enlist many other essential partners. First among them was the Estate of Joan Mitchell, headed by John Somers, whose cooperation has been invaluable.

In the process of viewing works in the Mitchell estate, several individuals have been helpful. In New York, we want to thank James Hansen and George Singly, whose assistance in accessing work and archival materials has been indispensable.

We want to acknowledge the particular generosity of Mitchell's longtime Paris dealer, Jean Fournier, and his staff, who worked tirelessly in assisting us to view dozens of works and conduct research throughout Paris. Fournier's devoted colleagues Jean-Louis Oudin and Anitra Delmas gave us generous time and advice, and Vincent Demeusoy has been extraordinarily attentive and helpful.

We have been granted steadfast cooperation from Gisèle Barreau, who has given freely of her hospitality and her memories. To Gisèle we offer a special tribute, both for her insights and her loyalty to Joan Mitchell's legacy.

Mitchell's New York dealer Robert Miller has served as a constantly available advisor and an unfailingly encouraging presence. Many of his colleagues—including his wife, Betsy; Amy Young; and Richard Bruce—also deserve credit for contributing to research and providing documentary materials.

Several other friends and dealers of Mitchell's work have participated indispensably in this event. First, we want to thank John Cheim, whose support and access to sources have been invaluable. Second, we thank Jill Weinberg, another longtime friend of Mitchell's and specialist in the market of her art—and a loyal helper in our efforts. A more recent dealer and expert in Mitchell's work, Edward Tyler Nahem, has helped in identifying for us, and gaining access to, privately held works of art.

Klaus Kertess, a longtime friend and ally of Mitchell, and the author of a monograph on her work published in 1997, has given freely of his time and advice.

Linda Nochlin has contributed an important essay to the catalogue in addition to her resourceful interview with Mitchell, which was conducted in 1986 for the Archives of American Art.

The Whitney Museum of American Art has again shown itself able to step up to a project not automatically embraced by the establishment. For this we are eternally grateful. Maxwell L. Anderson, newly appointed Alice Pratt Brown Director when this exhibition was proposed, took it on. Willard Holmes, deputy director and chief operating officer; Marvin Suchoff, chief financial officer; Christy Putnam, associate director for exhibitions and collections management; Mary Haus, director of communications; Stephen Soba, senior publicist; Lennox Hannon, director of foundation and government relations; Terri Coppersmith, director of corporate partnerships; Carol Mancusi-Ungaro, director of conservation; Raina Lampkins-Fielder, associate director, Helena Rubinstein Chair of Education; Maura Heffner, assistant curator and manager, Touring Exhibitions Program; Suzanne Quigley, head registrar, collections and exhibitions; and Marla Prather, curator of postwar art, have helped to make this a reality. Lana Hum has collaborated with us to design the installation of the exhibition.

For the publication of this ambitious book, we are indebted to Garrett White, director of publications and new media; Anita Duquette, manager, rights and reproductions; Karen Jacobson, text editor, with assistance from Alison Pearlman; and Katy Homans, catalogue designer, with production assistance from Nerissa Dominguez Vales and Sally Fisher. We also want to acknowledge the unusual commitment of James Clark and Deborah Kirshman of the University of California Press.

For her meticulous work in researching the bibliography and exhibition history and for assisting with photography arrangements, we thank Carrie Springer. Interns Marissa Vigneault and Kathy Grayson have also provided much-needed support on this aspect of the project.

Many individuals have given hours, sometimes much more than one office meeting, or a session over tea or drinks or a meal, to this effort. First on this list is Barney Rosset, without whom the authenticity of any text on Mitchell would be in question. Others—most of them close friends or associates of Joan Mitchell—who have granted interviews and moral support are: Guy Bloch-Champfort, Marion Cajori, Hervé Chandès, Michael Goldberg, Robert Harms, Grace Hartigan, Shirley Jaffe, Paul Jenkins, Betsy Jolas, Joseph LeSueur, Zuka Mitelberg, Astrid Myers, Alfred Pacquement, Yseult Riopelle, Lawrence Rubin, Pierre Schneider, Valerie Septembre, Peter Soriano, Darthea Speyer, Robert Storr, Joseph Strick, Marcia Tucker, Ken Tyler, and Rufus Zogbaum.

The Paintings of Joan Mitchell is supported by grants from The Florence Gould Foundation and the National Endowment for the Arts. The accompanying catalogue was published with the support of the Dedalus Foundation, Inc.

Marla Price and Michael Auping at the Modern Art Museum of Fort Worth, Texas; Jay Gates and Eliza Rathbone at The Phillips Collection, Washington, D.C.; and Gail Trechsel and David Moos at the Birmingham Museum of Art, Alabama, have proved their support of Joan Mitchell by hosting the exhibition at their institutions.

We want to thank our families, who have given us their inestimable support and counsel, in particular, Lisle C. Carter, Jr., and Eunice E. Lee. Glenn R. Phillips has also provided much encouragement.

Finally, we wish to acknowledge the lenders to the exhibition. It takes a special act of selflessness to part with a Mitchell painting, both because so many of their owners are attached to them in their daily lives, and because they are large, and fragile, and difficult to transport. We are thus all the more grateful to our lenders, and trust that they will enjoy the experience of seeing their works in the company of so many of their magnificent companions.

—Jane Livingston and Yvette Y. Lee

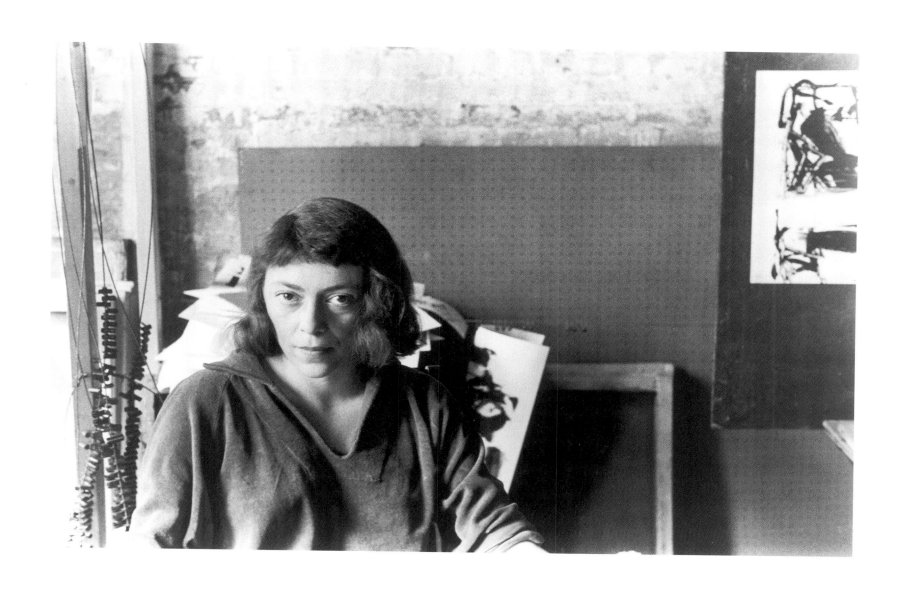

Walt Silver, *Joan Mitchell*. Estate of Joan Mitchell

Index

Page numbers in *italics* refer to illustrations. Titles of artworks by Joan Mitchell are listed alphabetically within the index.

PHOTOGRAPH AND REPRODUCTION CREDITS

In the majority of cases, photographs of works of art have been provided by the owners. The following list applies to photographs for which an additional acknowledgment is due:

All artwork © The Estate of Joan Mitchell

© 2001, The Art Institute of Chicago. All Rights Reserved: 91; Cecil Beaton/© *Vogue*, The Condé Nast Publications Inc.: 53; Ben Blackwell: 125; Cathy Carver: 149; Courtesy Cheim & Read, New York: 135; © Christie's Images: 185; CNAC/MNAM/Distribution Réunion des Musées Nationaux/Philippe Migeat © ARS, NY: 70–71; CNAC/MNAM/Distribution Réunion des Musées Nationaux/Jean-Claude Planchet © ARS, NY: 163; Sheldan C. Collins, N.J.: 37; Matt Flynn: 11 (top), 13 (both on top right), 14, 15 (both); Biff Henrich: 103; J. Hyde: 176–77; Courtesy Lennon, Weinberg, Inc.: 72–73; © 2001 David O. Marlow: 155; Tim McAfee: 101; © 2001 The Metropolitan Museum of Art: 164–65; © 2001 The Museum of Modern Art, New York: 105, 127; Phillips/Schwab: 188–89; Pollock-Krasner House and Study Center, East Hampton, NY © Estate of Hans Namuth: 50; Steven Sloman © 2000: cover, title page, 8, 29, 45, 48, 83, 86, 87, 89, 95, 98, 99, 107, 109, 111, 113, 115, 117, 121, 123, 128, 129, 137, 156–57, 168–69, 182, 183, 186–87, 192–93; Lee Stalsworth: 158–59; Richard Stoner: 141; P. Trawinski: 69, 145; Dan Wayne: 119; Graydon Wood: 85; Zindman/Fremont: 133, 180–81

This exhibition and catalogue were organized by Jane Livingston, with the assistance of Yvette Y. Lee, assistant curator for special projects, Whitney Museum.

This publication was produced by the Department of Publications and New Media at the Whitney Museum: Garrett White, director of publications and new media; *Editorial*: Susan Richmond, managing editor; Thea Hetzner, assistant editor; Libby Hruska, assistant editor; *Design*: Makiko Ushiba, senior graphic designer; Christine Knorr, graphic designer; *Production*: Vickie Leung, production manager; *Rights and Reproductions*: Anita Duquette, manager, rights and reproductions; Jennifer Belt, photographs and permissions coordinator; Carolyn Ramo, publications and new media assistant.

Text editor: Karen Jacobson
Catalogue design: Katy Homans; production: Nerissa Dominguez Vales and Sally Fisher
Printing and binding: Butler & Tanner Ltd, Somerset, England
Color separations: Radstock Reproductions, England
Printed and bound in England